FUTURE IMAGES

edited by
MARIO CRESCI

FUTURE IMAGES

Motta

Edited and published by
24 ORE Motta Cultura srl, Milan

Translations
Speedy Language Studio (Fiona Grace Peterson)

Cover
Andrea Galvani, *L'intelligenza del male #5*
courtesy Artericambi, Verona

First edition October 2009
ISBN 978-88-6413-017-0

Printed in Italy

SPECIAL **THANKS**

I have always considered a book project the result of a collective work which—all rhetoric aside—is the coordinated sum of the knowledge and competencies of many people. Especially in a case such as this, where those involved are a collectivity of artists, who express themselves through images and short written pieces.

I would like to thank Radu Stern, historian of art and photography, who helped me choose some of the artists present in this book; to him must go the credit for having created and long directed one of the most important high schools of its kind in the world; the Department of Photography at the Ecole Supérieure d'Arts Appliqués in the Centre d'Enseignement Profes-sionnel de Vevey. Together with Arno Minkkinen, Sarah Moon, Duane Michals, Ralph Gibson, Martin Paar, Lee Friedlander, Joel Meyerowitz, William Eggleston and many others who have run seminars by invitation of Stern, I had the privilege to teach photography there, and towards the end of the Nineties I decided to promote the school of Vevey as an important educational model of reference for Italy too. This book has also been created with the aim of promoting the research of some of the most important artists who studied at the Vevey school; a demonstration of the quality of the education received, especially at theo-retical and technical-professional level. Radu Stern is currently Director of Education at the Musée d'Elysée in Lausanne, and has collaborated—among the numerous cultural projects of the museum—with William Ewing, Jean-Christophe Blaser and Nathalie Herschdorfer on the exhibition *reGeneration*, featuring images by young artists from the most important photography schools throughout the world.

A special thank-you must go to Davide Tranchina, a young artist who was fundamental in determining the choice of art-ists, but above all for having contributed to developing the parameters of critical assessment, as seen from the perspective of his belonging to the same generation of artists using the medium of photography. Without his precious contribution, knowledge of the material and calm judgement, I would never have been able to put together this book, which is the result of various viewpoints on an artistic situation in rapid evolution, certainly not suited yet to any historical analysis.

Particular thanks must go to all the galleries and gallery managers, both Italian and overseas, for their vital help in contacting the various important artists featured in this book.

I also wish to thank Roberta Valtorta, historian and critic of photography and contemporary art, director of the Museum of Contemporary Photography in Cinisello Balsamo (Milan), for her precious help and advice.

My thanks also go to Maria Grazia Dilemmi for her tremendous patience in helping me lay out the project and the text; Arianna Foresti, for a series of scrupulous historical checks; Carloalberto Treccani, for his committed research into iconographic material, and last but not least Alessandra Murolo, Arianna Fantoni and Gianluca Turturo, who put the book together at editorial level with great diligence and professionalism.

INTRODUCTION

The idea behind *Future Images* is to act as a kind of litmus test for the partial analysis of the modes of expression used by a selection of artists from all over the world, who have long been using the medium of photography in a manner profoundly different to that of photographers. Indeed the Seventies saw the crumbling of the last boundaries between the expressive languages and instruments of contemporary art; it would thus seem superfluous to reiterate this age-old problem. It is nevertheless true even today that "different bases of evaluation and divisions of expertise persist between historians of art and of photography. Divisions which cannot be ignored, given the need to understand—among other things—the field in which certain artists have attained greater recognition."[1]

Historically confined within its own specific language, intended as "a declaration, a certification of the truthfulness of the real" so dear to the dogma of Cartier-Bresson's *fleeting moment*, photography used in this way gave the idea of being a precarious and highly unstable form of art, if considered exclusively within its self-referentiality.

Personally speaking, ever since my first years of studying the language of photography at the Venice School of Design (1963-1967), I have considered photography an authentic means of expression, on equal terms to any other used by artists. Especially following the Biennial of Venice (1964), which saw the explosion of American Pop Art, from Warhol to Rauschenberg, when I lost interest in the concept of photography for photography's sake.

Indeed the future was already there in that changing society, and hopes and illusions turned to a hypothetical scenario, which for us—graduates who had just finished our studies—represented the exciting utopia of belonging to an age in which the fragmentary nature of the disciplines and very knowledge of artistic research—including photography—would be resolved.

It was perhaps in this sense that the Seventies, for some of my generation who used photography as their preferred means of expression, were the years of greatest activity in seeking to understand—in the relationship between art and photography—those theoretical points of contact born from the essays of Jean Baudrillard, Jacques Derrida, Michel Foucault and others, such as those on photography by Susan Sontag and Roland Barthes. The fall of the great interpretative systems in favour of a reality which opened itself up to differences and to all that was no longer associated with any kind of certainty, but to a pluriverse of knowledge transversal even to the sphere of art, could not but cause our desire for knowledge to converge with that of a freedom of thought and action in the production of photographic works which not necessarily could be classified into the traditional photographic genres.

And with the publication of *The Postmodern Condition* (*La condition postmoderne*)[2] by Jean-François Lyotard in 1979, the certainty of the great interpretative systems of scientific and humanistic knowledge was lost, and finally along with them, in artistic terms, the identity of photography, still closely bound to its own specific language, closer to cinema and to television than to the state of contemporary art.

Over these last thirty years, the new media technologies have certainly influenced visual culture in general, and photography in particular. The multiplicity of the *points of view* in constant movement—author-spectator-space, for example: poetics and communication, fruition, real or virtual dimension—has led to a relationship characterised by constant changes in the thinking and vision of the artists who use photography as a medium.

What happens when the analogue matter of photography, its very nature ever since its origins, the visible result of a photo-chemical process, is transformed into a new computerised and digital process, consisting of numbers and codes used without distinction by artists and photographers? We can define this new technological state of photography as the medium of choice for art in this age, which some define as "post-media" in nature.

Signs, codes and regulations have multiplied out of all proportion, forcing us to perceive greatly accelerated frequencies and spatial-temporal speeds, but also mixtures of senses taking in thinking, meaning and metaphor. This does not however mean thinking of photography as a great reign of the imagination, eternally suspended above circumstances, much less considering it an artistic *unicum* without further investigation as to what it effectively is.

An extended critical debate (Sontag, Barthes, Peirce, Deleuze, Dubois, Van Lier, Krauss...) had already developed around these issues as far back as the Seventies. Currently there is a vast demand for a greater knowledge of photography, even from outside the world of art, as a form of expression unique in its genre because it is used by everyone: billions of people producing billions of images.

In this sense it is interesting to note a critical reflection on the theme of the *ubiquity* of the image by Caujolle, Fontcuberta and Stern, who in a public debate this year at the SCAN in Barcelona[3] focused attention on the passage of time between the photograph and the image, and consequently from that of a liveable, structured space to that which is highly imaginative and virtual, free from any kind of genre referent. The image is an integral part of us, and we are living the new spaces and new times as if they were virtual, such is their speed and imponderability. In a "highly rapid" world, relationships and ways of communication linked to information and knowledge are changing just as quickly. It therefore seems that the great "world-sheet" is preparing to support an immense archive of texts, images, sounds and knowledge from which to draw, a database activated by us, and preparing to provide all the responses possible and imaginable to the most diverse range of questions in real time. This new technological dimension is changing the relationship between time and space in which we were used to thinking and looking at the world: but the youngest generations feel completely at ease with the "accelerations" of life and thinking, which mark their experiences of growth and learning. In this sense, the illusion of normality in communication and knowledge becomes reality and is accepted as such, and use of the Internet forms a significant part of the various kinds of writing which appear on our mobile phones and computer screens: illusion becomes normality.

There is no doubt that the advent of the digital image corresponds to the direction in which the entire computer and communication system of the languages of expression, signs and accelerated methods of writing in real time is changing, in a new pluriverse of modified times and spaces, which have influenced not only technological procedures, but also and above all the manner of thinking, where photography has been forced to face up to its new constitution. Its entire traditional photo-chemical process has changed (for better and for worse) into something else; no longer analogue but numerical and digital, in which the new images are formed, making up most of those in this book. On this subject, in her introduction to the exhibition *Alterations* (*Alterazioni*), Roberta Valtorta quotes an excellent text by Hubertus von Amelunxen, who writes: "It is improbable—there is no doubt—that the digital image will take the place of traditional photography in the same way that the latter took the place of painting, or that cinema will replace photography, or video will replace cinema, etc. The digitalisation of photography simply means its translation into numerical (as opposed to visual) code, a translation it shares with other sound media, with writing, with cinema [...]. Multimediality does not mean variety of media, but *correspondence between media*, implicit in the computer. And so digitalisation offers us new spaces for the

image, within which the possibilities of modulation are determined only by arithmetic, and ties with reality can be established arbitrarily. The concepts of image, space, representation, historic- and human archive (memory) are destined to undergo an incredible change."[4]

If the direction indicated by Amelunxen is that to which the media necessarily corresponds, it is logical to think that our conceptual and perceptive understanding of this new multimedia condition must pass through ways of perceiving and sensing never experienced before.

This is a way for reflecting on the analogous correspondence between our ways of thinking and producing images from within our Being, in that every scientific transformation requires new ways of thinking and planning.

Henry Miller wrote:"A writer or an artist is simply someone who enters into syntony with certain cosmic currents. It is a medium [...] People are hungry for dreams, they need them. What do artists do? They dream in the place of others. They dream for those who have no dreams to keep them alive."[5] The oneiric dimension of the dream is not so far from that of the real, and the places imagined are often the consequence of those actually experienced. In the production of art, the two dimensions become equal, in such a way that the places of the non-visible become confused with those of the visible; between imagination and reality, the differences diminish and often the virtual world takes the place of the real and the everyday.

THE INHERITED **THOUGHT**

■ *The visible and the invisible*

It was between the visible and the invisible of the thinking of Merleau-Ponty that I began to place the direction of the experimentation in photography, intended as a language and writing within the system of art and culture of the project; indeed it was during my years at the Venice School of Design that I began thinking how images could be considered as objects, and that the aspects of vision, the perception of reality and the knowledge of photo-chemical and multi-media techniques were not inferior to those of the materials and infinite behavioural and aesthetic modes of art itself. In this way the divisions between the various areas of knowledge diminished; the *sense of seeing* was strongly linked to the *sense of doing*, and both required the substantial contribution of our bodily senses.

Reading the essay by Merleau-Ponty dedicated to Cézanne, I understood the usefulness of those studies in beginning not only to produce, but also to read, images based on a series of concepts which began from the study of perception, to arrive at a progressive knowledge of an open and non-dogmatic projection of the representations of the real through photography, the media, relationships with others and the spaces in which everything manifests itself.

I had discovered that words such as "method", "rule" and "project" were not foreign to artistic expression, and that an understanding of art history also required scientific and economic knowledge in terms of the "manufacture" of the work itself, the dictates of clients, the cost of the materials used and relevant subject areas.

The work becomes visible and acquires a visibility which is not limited to the whole of the visible, but includes the dimensions, lines of force, perspective and points of view which form part of the vision, despite being apparently invisible, absent from the perception of the real. In this sense Merleau-Ponty writes:"The invisible is the relief and the depth of the visible, and the visible has no more pure positivity than the invisible."[6]

■ *The Verifications by Ugo Mulas*

As far back as the end of the Sixties, and in 1972 in particular, when photographer Ugo Mulas created the *Verifications (Le Verifiche)* before his death—a series of photographic diptychs intended as a radical overhaul of the "photographic"—some of us began shifting our own vision of reality. No longer a privileged *unicum* of seeing, but part of a conceptual and perceptive whole, far more complex and articulated. In that period Mulas performed a courageous act, cancelling out the presumed historic certainties of a photographic culture rampant in Italy in the amateur and professional photographic clubs. The *Verifications* were the result of a series of interviews carried out by Mulas a few years earlier in New York with Marcel Duchamp during a chess match. When, during a pause in the game, Mulas asked Duchamp about the freedom of choice a photographer has towards others, but above all for himself outside his relationship with the referent—beyond what is actually seen to leave room for what is sensed at a subconscious level—the sense of the reply, although friendly, was short and dry, as was Duchamp's way: "Why don't you take pictures for yourself and not just for others?". Having returned to Milan, with *Tribute to Niepce* in 1971, Mulas began the cycle of the *Verifications*. He wrote: "And so, at a certain point, I began carrying out operations unrelated to other people, ignoring my desire to be a witness and to gather the experiences of others, to experience the sensation of feeling alone in the face of what has to be done. To experience how it feels to no longer seek props, to no longer seek the truth in others, but finding it only in yourself, and to understand what this profession is, analysing the individual operations, taking it apart as if it were a machine, to get to know it [...] I dedicated this first work to Niepce, because the first thing I had to reckon with was the photographic film, the sensitive surface, the key element of my whole profession, the nucleus around which Niepce's invention had taken shape [...]. For once the medium, the sensitive surface, becomes the key player; it represents nothing other than itself."[7]

It was a conquest of extraordinary interest, the tangible legacy of a photographer who, for the first time in the history of Italian photography, had established the infinite expressive potential of a medium whose signs had begun to lose touch with the meaning of things. Like other disciplines, photography was preparing itself for the loss of a unitary and coherent vision of a single truth, and Mulas' final work represented a first step towards a knowledge of the medium of photography which could not disregard thinking, and a re-discovered freedom to observe the world from within itself. Not only "seeing", but also "sensing" the world, looking around itself freely without dogmas or limits in its quest for meaning.

■ *Battle for an Image*

Another event in 1973 which represented one of the most significant moments of the ongoing debate at that time between art and photography was *Battle for an Image. Photographers and Painters (Combattimento per un'immagine. Fotografi e pittori)*, by Luigi Carluccio and Daniela Palazzoli.

An exhibition featuring more than four hundred works, held at the Civic Gallery of Modern Art in Turin, divided and compared in chronological order, creating a historical vision never seen up to then. The paintings were situated near the photographs, together providing an unprecedented approach to viewing the works, not without its surprises, even for the two curators who had devised the exhibition and the idea of a compared viewing.

Many years on from that exhibition, the critical essays of the two curators—particularly the more intense and articulated work by Daniela Palazzoli—are still of considerable interest, also with regard to the images by the artists in this book. The essay *Painting and Photography: Two Extensions of our Eye* notes: "By linking painting and photography, we can see from these beginnings what happens in their simultaneous development each time a new technology, with its own articulated conventions and codes, intervenes in a certain discipline. The shared presence of works by painters and photographers, which come together in the different linguistic sections or on certain themes tackled by both, reveals a myriad of affinities, and an equally great refusal of possible affinities, which show how the reciprocal ignorance of each other is simply a well-calculated artifice."[8]

Other chapters are dedicated to critical reflections, such as *Privileged optics and inclusive perception (Ottica privilegiata e percezione inclusiva)*, indicating a common denominator in the dialectic between painting and photography; an identical linguistic matrix—perspective—destined to reveal itself each time a new technology appears in the disciplines of the image. The perspective space in both cases (painting and photography) seems to create an inalienable limitation at the moment the images are produced and formed. With regard to the optics of the technical means and to the visible perceived, Palazzoli writes: "In this initial doubling of the optical image in painting and photography, the process of alienation is revealed for the first time, a process which occurred at the moment when man extended his powers to instruments and to language. The artistic image, whether a painting, photograph or film, reveals all its conditioning in this process of differentiation."[9] In the Seventies, however, it was not foreseeable that our various means of communication would be transformed through a process of advanced information technology, to the point of overturning the static space and time of the simulated Renaissance perspective in a representation of time and space in movement. Photographic and pictorial optics prepared to modify their own constitution in a new digital multi-perspective rendering.

■ *Painting and the invention of photography*

Before Photography (Prima della Fotografia) by Peter Galassi, which opens various avenues of investigation into painting, drawing, engraving and photography, could be considered one of the initial texts for the study of the reciprocal aesthetic and theoretical contaminations, often unmentioned by artists and photographers themselves. Published for the first time in 1981 as the catalogue of an exhibition at the Museum of Modern Art in New York, it later saw the addition of further studies by the author, who retraced the history of the original project, inspired by a conference by Heinrich Schwarz, before being picked up once more in 1979 by the director of the department of photography at MoMA, John Szarkowski, who invited Galassi to organise the exhibition.

The book explores only certain aspects of the relationship between art and photography within the sphere of the pictorial Vedutism of the eighteenth and nineteenth centuries, with Corot's work at the centre. Nevertheless, the "eagerness to unveil reality reaches fever pitch" in Galassi's texts when he writes about the pre-photographic vision refined by artists via the use of the "camera obscura", drawing what they saw of the upside-down subject illuminated by the light, and transferring it on to a sheet of semi-transparent white paper. Or when he describes the two paintings by Pierre-Henri de Valenciennes, featuring several roofs in Rome; in the first instance they are painted lit by the sun, then a few hours later, on another canvas of the same size, the same subject is painted without light, similar to a back-lit photograph, from the same position as before.

Finally, one of the conclusions drawn by the author, which deserves particular attention, is that "photography was not an illegitimate creature abandoned by science on the doorstep of art, but a legitimate heir of Western pictorial tradition."[10]

■ *The Düsseldorf School*

Many remember the 1990 Biennial of Venice, when the prize for sculpture went to the German artists Bernd and Hilla Becher and their photographic works: powerfully built industrial structures, in perfect black and white, with the same grey sky in the background, devoid of pictorial effects. Their images are the antithesis of the post-romantic Vedutism of so much photography of that time, if we exclude the American "new photography". The nine-photograph series, in grid formation and entitled *Cooling Towers, Gelsenkirchen Ruhr*, from 1972-1973, is one of the most emblematic realised by the Bechers in many years of work, using a language with a syntax of extreme rationality similar to the scientific gaze of an entomologist: "Victims of their magnificent obsession, rendering their work very similar, in terms of perseverance, to the narrative repetitions of the Bruegel family, or to Monet when he paints the cathedral of Rouen, the Bechers offer us a visual paradigm of an amplitude and continuity unique in the history of photography."[11]

Awarding the prize, the jury stressed another aspect of their work - the definitive breaking down of the divisions between the language of photography and the other expressive instruments used for some time in contemporary art. This gesture created a point of critical reflection for many young artists, who would take the poetics of the Bechers as a starting point for their own artistic research, meaning they no longer viewed photography as a form of artistic expression isolated and disconnected from art itself, as had happened to many photographers of my generation. In 1990, the results of many years of the Bechers' teaching at the Fine Arts Academy in Düsseldorf were already beginning to show in the training of artists such as Thomas Struth, Andreas Gursky, Thomas Ruff and Candida Höfer. In the school of the Bechers and in adopting the theory of the "new objectivity" lay the premise for preparing a terrain in which the photographic vision of the world—prevalently through the use of medium-format negatives and sheet film for large dimension shots, obtained mainly through the use of the optical bench - led photography to become the most powerful means of deciphering the real through the frontal vision of the photographer with respect to the subject: a language suited to reproducing the smallest of details, even those invisible to our naked eye. And so the culture of artistic teaching opened itself up to the future, while maintaining its own historic identity, and the school of Düsseldorf, thanks to the Bechers, was chosen by the German government as an invaluable place of learning for the vicissitudes of German contemporary art. It is certainly true that, as far back as the end of the Fifties, the art of Bernd and Hilla Becher came from a sense of renewal of a vision of the world as an alternative to the chaos and fragmentation of knowledge, contrary to the Expressionist thinking of so much painting and photography which had remained unaltered, as if the world had not changed.

■ *Images of memory between literature and photography*

I believe that Georges Perec, together with Italo Calvino and Jorge Luis Borges, belongs to that elite group of twentieth-century writers who, more than any others, had the gift of using writing as an evocative language of images.

It is no accident that they all shared a profound interest in art and photography, having written—among other things—essays of extraordinary importance in the sphere of art criticism. A crucial aspect for them was the relationship with the artwork, and in general with that which it inspired within the individual poetics. When I began reading *Species of Spaces and Other Pieces (Specie di spazi)* by Perec, I had just finished Calvino's *Six Memos for the Next Millennium (Lezioni americane)* and was about to study certain aspects of it, described in the chapter dedicated to *Lightness*, before discussing them with my students and transforming them into images via an analysis of the written text.

My intention was to bring the pleasure *of reading* the text alongside the pleasure *of seeing* with the photograph, an essential passage for a transversal understanding of the languages of art: in this sense *Species of Spaces* by Georges Perec is undoubtedly a fundamental work.

The guiding thread of the book is two-fold, encompassing *memory* and *space*, both referring to the *places* which the writer frequented, also after a period of *time*.

Perec's spaces, however, are not real: they are no longer the same spaces he experienced; they no longer exist because they have changed with the passing of time. He writes: "I wish there were stable places, places which are intangible, untouched and almost untouchable, unchangeable, deeply-rooted; places which would be points of reference and departure—sources."[12]

The spaces are not those which we actually see, nor those which have a sense of emptiness; the subject of this book is not exactly emptiness, but rather what surrounds, or lies inside it. They are not even those in which we live, because being forced to see and live them continuously, we do not see them and we do not consider them; it is as if they did not exist. "But it is not evident, it is not expected [...] Nothing, for example, prevents us from conceiving something which is neither city nor countryside (nor the suburbs), or metropolitan corridors, which are gardens at the same time."[13]

In conclusion, then, for Perec, there are no spaces formed as such from the very beginning, there are no spaces which are beautiful or ugly, liveable or unliveable; the problem instead is one of realising there are many infinite kinds of fragmented spaces around us; dismantled, re-composed and once more broken up and subdivided, like many small pieces of an unstable universe in constant transformation. "Living is moving from one space to another, seeking as much as possible not to hurt ourselves too much."[14]

THE INFINITE **WORLD**

Hokusai tried to paint without using his hands. It is said that one day, after having unrolled his parchment in front of the shogun, he poured a jar of blue paint over it. Then, dipping the feet of a rooster in a jar of red paint, he let the bird run across the parchment, so that its footprints would be left behind. On the parchment, the waters of a stream called Tatsouta, which brought the maple leaves reddened by the autumn, was recognised by all those present.[15]

This is a famous quotation from the tales of Hokusai, certainly known to the artists featured in *Future Images* because it generates a reflection of thought between the "semantic memory" acquired from the experience of the real everyday, and that which undermines the same, through unforeseen modes of its representation. Modes

which belong to other fields of knowledge, other histories, which suddenly intervene to modify the reasons of cause and effect of our everyday *modus vivendi*. It is interesting to remember that the whirling seas, such as those in the colour woodcut *The Great Wave Off Kanagawa* by Hokusai, created a "wonderful bridge with the East" for Van Gogh, who transformed his wonder into the energy painted in his skies. He was not interested in the subject of the sea as much as the potential abstract equivalent he perceived, transferring it to the pictorial nature of his skies.

In a brief 1994 essay for the magazine *Parkett* on the relationship between form and content, Vik Muniz wrote: "In the West, the antagonistic perception of the relationship between form and content has generated material for centuries of incessant discussion. Plato, for example, is perhaps the most pre-eminent figure to have separated form from content (which for him did not count at all). This "pure form" (virtually invisible for Aristotle) was to be perceived with the "eye of the soul". Plato's method lay not in beginning from the starting point (mechanically gathering the elements shared by all the species and consequently putting these elements together in a new whole), but in discerning the totality of that generic form in every particular idea, just as we would deduce the form of an unclear image."[16]

With the introduction of the idea of abstraction, moving from the Illuminism (before photography) to the Positivism of the XIX century, when photography appeared and with it the new media languages of cinema and television, the histories of photography and art have moved closer and closer together. In this progressive coming together, the role of twentieth century philosophical thinking has undoubtedly, to say the least, played a fundamental role in the quest for the sense of the medium of photography with respect to reality (and its infinite modes of representation by photographers and artists), to the extent that today we can think in terms of a definitive integration between the two.

Indeed many of the unknown artists in *Future Images* come from important art and photography schools in Anglo-Saxon and Mediterranean countries, including Italy; many others, meanwhile, have been included thanks to their training in other disciplines and other, non-academic, fields of knowledge. It is just as true, however, that a good school is useful to those who attend it, at least in terms of teaching the basic analytical skills which will allow students to acquire their first ideas and allow them to conduct their own, independent research in the sphere of contemporary art.

Cultivating the pleasure of reading the declarations written by artists such as Muniz, Strutt, Wall and Orozco which I have taken up once more in connection with *Future Images*, I continue to discover ideas and design values which are not always clear from the works as the final result of an artistic process.

It is true that the images "recount" that which each of us wants to recognise through our own experience, our own way of seeing and sensing the artwork through our own sensibilities. But it is also true that the exercise of viewing, intended as an exploration for the purposes of increasing our own knowledge, permits the viewer to continually discover meanings which help to better understand the process of "constructing" the artwork.

In this way, the cognitive relationship between image and text becomes crucial in better understanding what the artist is thinking even before he creates his work. Indeed we are not satisfied with seeing the finished work as much as the process which generated it, and the written text (with any cautionary notes) accompanying it helps to better understand its meaning.

On this subject, reading the long essay by Richard Milazzo (written on the occasion of the 1993 Vik Muniz exhibition *Equivalents* in New York) has stimulated many associations with ideas I had long since forgotten.

If I had simply seen the images in the catalogue of the Muniz exhibition, I would have been left with many doubts; the critical text, meanwhile, provided the answers.

With "sculptures" in white cotton, simplified renderings of animals such as cats, dogs, snails—and objects such as teapots and boats—Muniz "constructs" his photographs, leaving the task of constructing the work to the image, while the elements of the pretence are hidden. The image substitutes the object which has produced it.

At the end of his essay on clouds, Milazzo wrote on Muniz: "All of our interpretations are in actual fact frustrated, all of our meanings neutralised, all our perceptions mined at the base, in the sculptures of the clouds, by these secondary ontogeneric lines of guarantee. All of our points of reference end up in a blind alley, in the evidently ridiculous figure of the "cloud" as a metaphysical anti-referent."[17]

The title *Equivalents* was borrowed from the famous photographic series on clouds, taken between 1923 and 1930 by Alfred Stieglitz, captured in their many forms and still considered today a milestone in the history of photography, an integral part of the history of twentieth century art. Many things have been written about this photographic series and the meaning—just as important—of its title. *Equivalents* "equals" a symbolic relationship between the real vision of nature (the clouds), represented in photography in the greatest details of form and light, and the immediate and opposite repercussion of also being an abstract vision with respect to a place of reference in landscape form.

The same subject of clouds is also present in the photographic works of Gerhard Richter. *Atlas* - created in the early Sixties from the photographer's desire to gather amateur, publicity and journalistic images in postcard format, collected together according to their formal similarity—is a series about the skies in which the images of the clouds are brought together, displayed in grid form on display panels. At the beginning of *Atlas,* Richter does not take any photographs; he conceals his position as photographer and artist, and accepts the condition of collector, a seeker of images created by others: he assembles them, putting them together by genre and by category, arranged in grid form so as to form various "wholes" with a veiled encyclopaedic grouping: nature, sky, sea, anonymous figures, landscapes, architecture, faces, and so on.

The *Atlas* series (clouds in great numbers captured over the course of the years) has an important historical precedent for Twenties culture in Europe; the monumental project of the *Mnemosyne Atlas* by Aby Warburg which, writes Benjamin H.D. Buchloh, "was created to gather recognisable forms of collective memory"; and again: "Even though the expert was forced to leave the project unfinished (on his death Warburg had collected more than 60 panels with over 1000 photographs) […] the *Mnemosyne Atlas* sought to construct a model of the mnemonic, where the humanistic thinking of Western Europe once again—perhaps for the last time—would have recognised its own origins and traced its own latent continuities into the present, through the confines of European humanistic culture, from ancient times to the present day."[18] From 1925 to 1929, the year of his death, Aby Warburg considered the images gathered in this way to be the icons of the memory of humanity, and therefore of knowledge and of consciousness, which were not to be lost. The mythological idea of the *Atlas* was thus born from the mind of an extraordinary intellectual with a profound knowledge of philosophy and the arts.

Towards the end of the Seventies, Gerhard Richter (professor of painting) and the Bechers (professors of photography) were teaching together at the Fine Arts Academy in Düsseldorf, and it is interesting to note how the idea of the *Atlas,* although different, was also adopted by the Bechers at teaching level, thus prolonging their research

on industrial architecture—which they had begun in the Fifties—within the school environment. In the two "souls" (painting and photography), therefore, remains an apparent coldness of gaze upon the world, which declares its own historical roots with no problem of linguistic limitations on the use of different expressive media.

Thomas Ruff was admitted to the photography course in 1976, by which time he had already begun assimilating Richter's research: his *Stars (Sterne)*, which he realised between 1989 and 1992, are not so distant from the previous historic series mentioned previously. In this case also, Ruff did not photograph the sky with a telescope—he could not use such complex technology—therefore he decided to use the photographic films realised by the ESO (European Southern Observatory) to photographically map the sky south of the Equator.

Here the concealment of the role of author is colder and more scientific than the previous *Atlases* and is the precise opposite of the clouds constructed by Muniz as tongue-in-cheek devices, and very far in terms of form from Stieglitz' skies. Nevertheless, the sky as a visual and conceptual metaphor of the idea of the infinite persists in Ruff when he decides to go beyond the conventional space of human sight to enter the realm of the gaze of science. In any case, Ruff's *Stars* maintains the sense of the infinite of the historical *Equivalents* and those of Richter's *Atlas*.

What has profoundly changed in the *Stars* series is the role of the collective memory which, as already mentioned, Warburg intended to give in his collection of images of the *Mnemosyne Atlas*: in Ruff's large black-and-white images there is in fact a profound and deliberate distance from any mnemonic sense of the past. Carolyn Christov-Bakargiev is correct when she writes: "But if there is one thing that Thomas Ruff's photographs seem emphatically to affirm, it is very much the absence of memory. They are also mute and devoid of any affection; Ruff talks to us of a contemporary subjectivity defined by amnesia, and talks to us about it through an amnesiac gaze, incapable of developing and linking the various images impressed in the memory, with the aim of creating a soloistic, sculptural and stratified sensation, from the depths of knowledge."[19]

In 1975, Luigi Ghirri used the title *Infinite (Infinito)* to refer to his 365 photographs of the sky. The nature of the colours and forms of the clouds is captured just as they were, with no visionary emphasis: the sense of memory in *Infinite* is not so distant from Stieglitz' *Equivalents,* as opposed to Richter's *Atlas* and Ruff's *Stars*. Nevertheless, the differences are clear from the very beginning of his idea, which sees him give a humorous twist to the indecipherable and unlimited term "infinite"—a time limit of 365 days. One photograph per day, a quick glance towards the sky without seeking any spectacular effect, with apparent indifference, without filters or any desire to emphasise forms or light. Sometimes the sky is devoid of clouds, and so it must be. Finally comes the montage, which does not follow the order in which the shots were taken: small colour prints which form an enormous grid of images arranged on the wall, where we can sense Ghirri's desire to compose an idea of the sky, no longer that which is observed day after day, but a new sky composed of many parts which together form a whole of abstractions, in which the gaze is unable to linger on a certain point: his new sky.

To conclude my brief reflections, I believe that the approaches to be taken in viewing the "photographic" in contemporary art are still many, all worthy of attention. On the theme of the sky, for example, much has been written, but the putting into action of that which has been theorised, even only in terms of the analysis of photographic language (such as in Jean-Marie Schaeffer's essay *The Precariousness of the Image*[20]), can only lead to a consequent *theoretical precariousness* of photography, especially in this brief context of *Future Images,* which has chosen to focus on the aspect of art. Still today, and who knows for how much longer, we continue to study and ask ourselves which aesthetics of photography are able to satisfy the profound understanding of the photographic before a

world in constant transformation. The great theoretical and philosophical studies of the twentieth century on the subject of photography certainly could not foresee a transformation of the photo-chemical process of photography to the extent of a real passage between *camera obscura* and *camera chiara* (bright room). The complexity, then, of the history of an expressive language remains open, one which will be difficult to define in its most profound form, as is—and always has been—that of art, for that matter.

In thanking the artists who have contributed to the publication of this book, I would like to mention a wonderful note by Roberto Signorini, taken from the presentation of the aforementioned book by Schaeffer: "Nor can we, without foundations and without a thought of our principles, face the "storm" which pushes unstoppably towards the future... while the pile of ruins climbs... to the sky" (Benjamin 1939-40). What can we say, then, twenty years on and with the digital era in full swing, about the aesthetic reflections initiated by Schaeffer? [...] I believe that the idea of the photographic, as a push towards the liberation of the gaze, remains central and topical. But this liberation is not a "vacation", it is a responsibility: the photographic remains a theoretical crux which evokes the unresolved paradoxes of the late-modern condition and its nihilism; and the photographic work—whether analogue or digital—above and beyond any demiurgic dream of parallel worlds, remains the act, full of unknowns and discoveries, of naturally opening oneself up to another, to that which we do not know (Vaccari, 2001). The act of a human being, aware and restless, who looks at this world to be amazed by it every time, each time wishing it to be a little less inhuman, despite knowing it will be others who will see it in such a condition. Perhaps."[21]

Mario Cresci

Notes

[1] F. Tedeschi, *Uno sguardo parallelo*, in *Sperimentalismo fotografico in Italia, 1970-2000*, edited by I. Zannier, Edizioni CRAF, Lestans 2001.

[2] Italian translation of *La condizione postmoderna. Rapporto sul sapere*, Feltrinelli, Milan 1997.

[3] C. Caujolle, J. Fontcuberta, R. Stern, *La ubiqüitat de la image*, edited by J. Urtado, Generalitat de Catalunya, Department de Cultura i Mitjans de Comunicació, Barcelona 2009.

[4] *Photography after Photography. Memory and Representation in the Digital Age*, edited by H. von Amelunxen *et al.*, G+B Arts, Amsterdam 1996.

[5] H. Miller, *Tropico del Cancro*, Feltrinelli, Milan 1962.

[6] M. Merleau-Ponty, *Il visibile e l'invisibile,* edited by M. Carbone, Bompiani, Milan 2003.

[7] U. Mulas, *La fotografia*, Einaudi, Turin 1973.

[8] *Combattimento per un'immagine. Fotografi e pittori*, exhibition catalogue, edited by D. Palazzoli and L. Carluccio, Galleria Civica d'Arte Moderna, Turin 1973.

[9] *Ivi.*

[10] P. Galassi, *Prima della fotografia. La pittura e l'invenzione della fotografia*, Bollati Boringhieri, Turin 1989.

[11] *100 al 2000. Il secolo della Fotoarte*, exhibition catalogue, edited by D. Faccioli, Photology, Bologna 2000.

[12] G. Perec, *Specie di spazi,* Bollati Boringhieri, Turin 1989.

[13] *Ivi.*

[14] *Ivi.*

[15] In *Vik Muniz*, exhibition catalogue, edited by G. Celant, Electa, Milan 2003.

[16] *Ivi.*

[17] *Vik Muniz. The wrong logician*, edited by T. Collins and R. Milazzo, Ponte Pietra, Verona 1993.

[18] *Gerhard Richter, Atlas der Fotos, Collagen und Skizzen*, edited by H. Friedel and U. Wilmes, Oktagon, Köln 1997.

[19] *Thomas Ruff*, exhibition catalogue, edited by C. Christov-Bakargiev, Skira, Milan 2009.

[20] J.-M. Schaeffer, *L'immagine precaria: sul dispositivo fotografico*, edited by M. Andreani and R. Signorini, CLUEB, Bologna 2006.

[21] *Ivi.*

THOMAS**ALLEN**_GRETA**ANDERSON**_BROOK**ANDREW**_MIRIAM**BÄCKSTRÖM**_

ARNIS**BALČUS**_EMMANUELLE**BAYART**_CARLO**BENVENUTO**_ELIN**BERGE**_

MATHIEU**BERNARD-REYMOND**_RICHARD**BILLINGHAM**_LIU**BOLIN**_

MELANIE**BONAJO**_ANDREA**BOTTO**_CANDICE**BREITZ**_MATTHIEU**BROUILLARD**_

MATTHIAS**BRUGGMANN**_MAGGIE**CARDELÚS**_CRISTIAN**CHIRONI**_

DANIEL**GUSTAVCRAMER**_LEA**CRESPI**_ALEXANDRA**CROITORU**_PAOLA**DEPIETRI**_

WIM**DELVOYE**_ALEXANDRA**DEMENKOVA**_PAOLA**DIBELLO**_

DOTT.PORKA'S**P-PROJ**_OLEG**DOU**_OLAFUR**ELIASSON**_LÉA**EOUZAN**_

HARIS**EPAMINONDA**_IGOR**EŠKINJA**_JANIETA**EYRE**_DAVINA**FEINBERG**_MICHAEL**FLIRI**_

SAMUEL**FOSSO**_JULIA**FULLERTON-BATTEN**_STEFANIA**GALEGATI**_ANDREA**GALVANI**_

SHADI**GHADIRIAN**_GAURI**GILL**_CLAUS**GOEDICKE**_

GJOKE**GOJANI**_ALEXANDER**GRONSKY**_ALBERT**GUSI**_WOLFRAM**HAHN**_

CAROLINEEMANUELA**HEIDER**_CÉCILE**HESSE+GAËLROMIER**_PETRINA**HICKS**_

REBECCAANN**HOBBS**_ZHANG**HUAN**_PIETER**HUGO**_JR_YEONDOO**JUNG**_

MISTY**KEASLER**_PERTTI**KEKARAINEN**_IDRIS**KHAN**_HANNA**KOIKKALAINEN**_

_FELIX**KRIS**_EVA**LAUTERLEIN**_JANNE**LEHTINEN**_LEUNGCHIWO_**LUBRI**

_MARCELLO**MALOBERTI**_TANCREDI**MANGANO**_MARCELLO**MARIANA**_EDGAR**MARTINS**

_MARY**MCINTYRE**_MARZIA**MIGLIORA**_OTTONELLA**MOCELLIN**+NICOLA**PELLEGRINI**

_LUIS**MOLINA-PANTIN**_YOUSSEF**NABIL**_SABAH**NAIM**_MARTIN**NEWTH**_LOAN**NGUYEN**

_LUCIA**NIMCOVA**_MELISA**ÖNEL**_GABRIEL**OROZCO**_SELINA**OU**_ADRIAN**PACI**

_DANAÉ**PANCHAUD**_JYRKI**PARANTAINEN**_MATTHEW**PILLSBURY**_NICHOLAS**PRIOR**

_PHILIPPE**RAMETTE**_MOIRA**RICCI**_SOPHY**RICKETT**_SANDRA**ROCHA**_DANIELA**ROSSELL**

_SARA**ROSSI**_MICHAEL**SAILSTORFER**_ANRI**SALA**_TXEMA**SALVANS**

_MARCO**SAMORÈ**_FABIO**SANDRI**_TOMAS**SARACENO** FUTURE IMAGES

_HIRAKI**SAWA**_TOMOKO**SAWADA**_JOÃOPAULO**SERAFIM**_SHIRANA**SHAHBAZI**

_ELISA**SIGHICELLI**_FRANCESCO**SIMETI**_ANNA**SKLADMANN**_ALESSANDRA**SPRANZI**

_ANNA**STRAND**_MIKHAEL**SUBOTZKY**_ANGELA**SVORONOU**_RICHARD**SYMPSON**

_MARIE**TAILLEFER**_SHIGERU**TAKATO**_VIBEKE**TANDBERG**_DAVIDE**TRANCHINA**

_GUIDO**VANDERWERVE**_MARCO**VANDUYVENDIJK**_MARIANNE**VIERØ**

_LI**WEI**_SASCHA**WEIDNER**_FU**YUZHU**_DARIUS**ŽIŪRA**

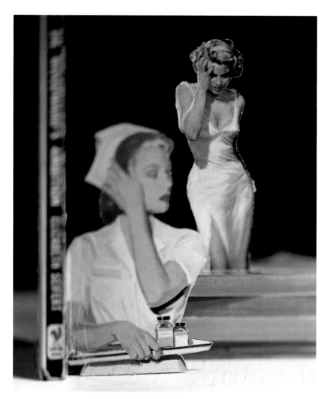

Remedy, 2008, C-print / courtesy 1000eventi, Milan

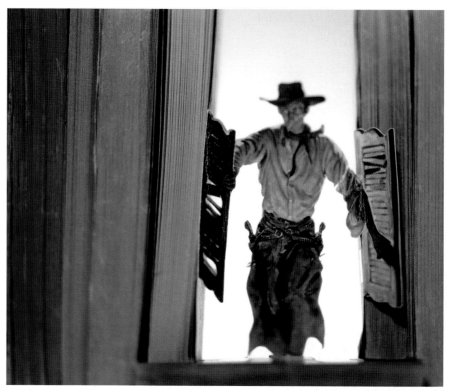

Stranger, 2006, C-print / courtesy 1000eventi, Milan

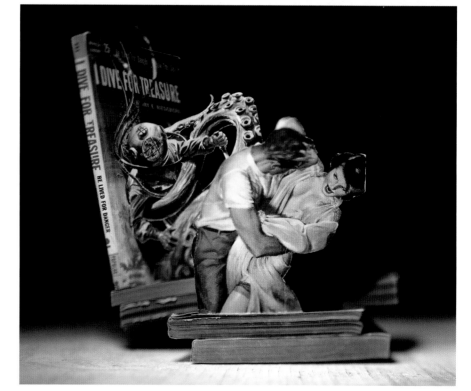

Tangle, 2008, C-print / courtesy 1000eventi, Milan

Working with an X-ACTO knife, I cut and crease the covers of vintage paperbacks to form 3-dimensional tableau and photograph them. Once sprung from their 2-D prisons, outlaws and thugs are rounded up and confined to a new, flat space—film.

This re-imagined look at a period of pop culture, whose success relied on provocative surface visuals, proves that you can judge a book by its cover!

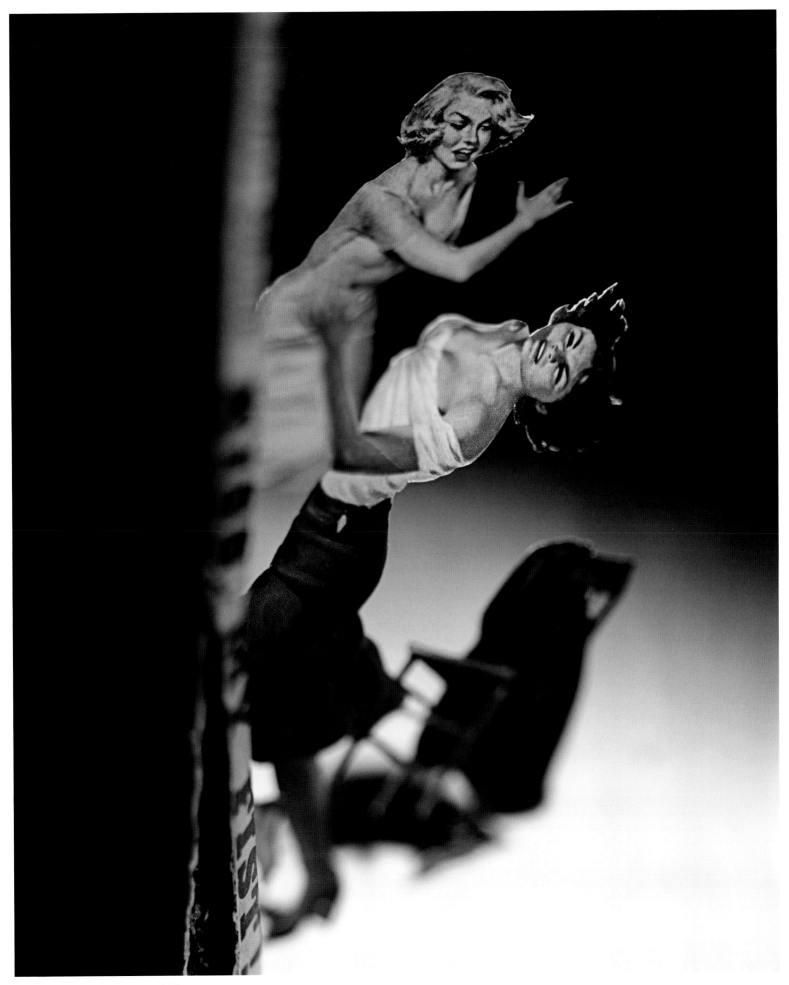

Fury, 2006, C-print / courtesy 1000eventi, Milan

Float like a feather, 2002, lambda print / courtesy of the artist

I was born in New Zealand in 1968.
My photographs are of and about New Zealand.
My photographs are about the people and the place.
But... it's nothing specific.

The good boy, 2003, lambda print / courtesy of the artist

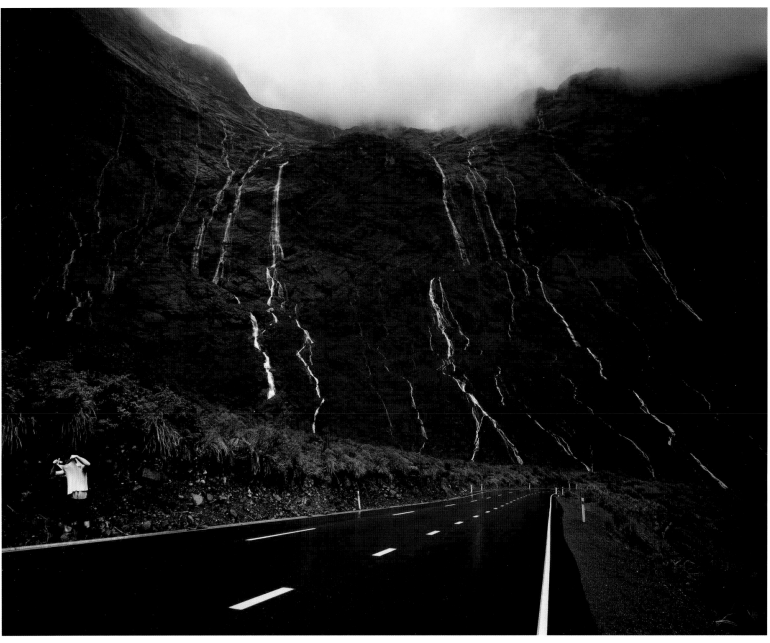

The trip, 2005, lambda print / courtesy of the artist

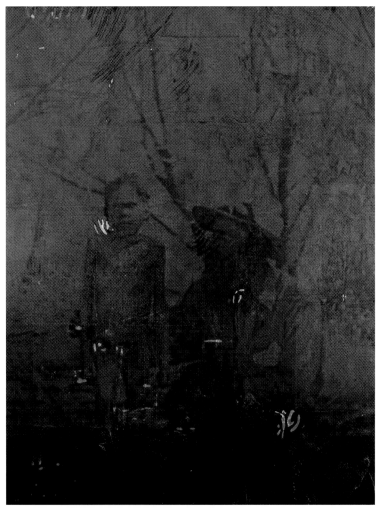

H142. First female Aboriginal seen and captured. Camp XL. Yarruudang I (dream), 2007, mixed media / courtesy Tolarno Galleries, Melbourne

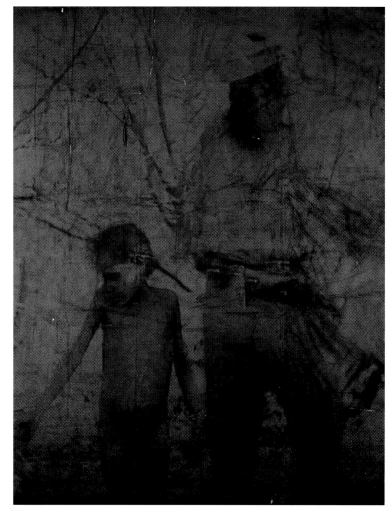

H142. First female Aboriginal seen and captured. Camp XL. Yarruudang II (dream), 2007, mixed media / courtesy Tolarno Galleries, Melbourne

The *Gun-metal Grey* and *H142* series aims to make visible
19th century Australian ethnographic photography as social-
political imagery in contemporary art. Colonial politics, activism
and personal experience in Australia has shared experience
internationally with other disappeared people and should be
contextualised in a broader public domain.

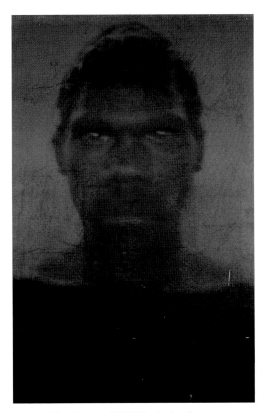

Gun-metal Grey. Muuruun (life), 2007, mixed media / courtesy
Tolarno Galleries, Melbourne

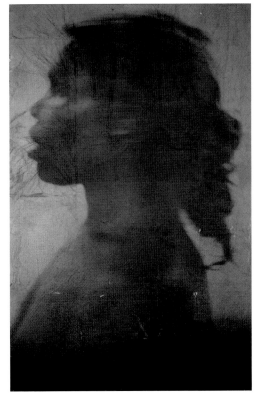

Gun-metal Grey. Ngalan (light), 2007, mixed media / courtesy
Tolarno Galleries, Melbourne

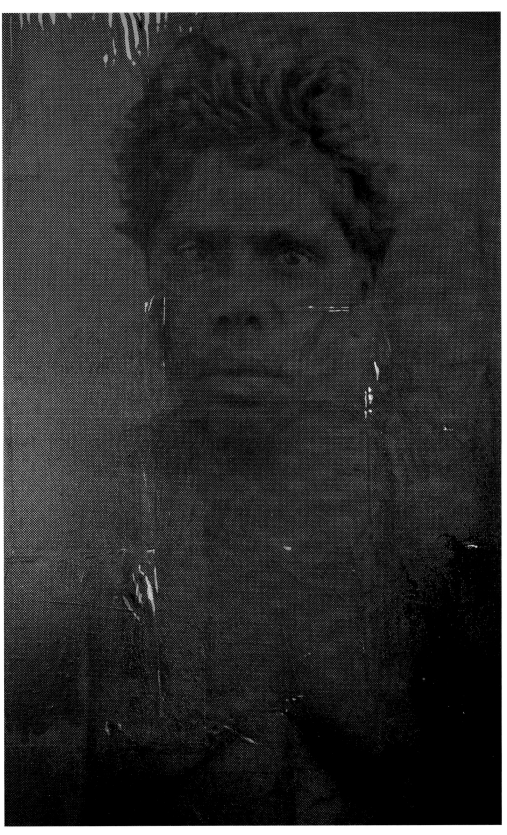

Gun-metal Grey. Galang-galang (locust), 2007, mixed media /
courtesy Tolarno Galleries, Melbourne

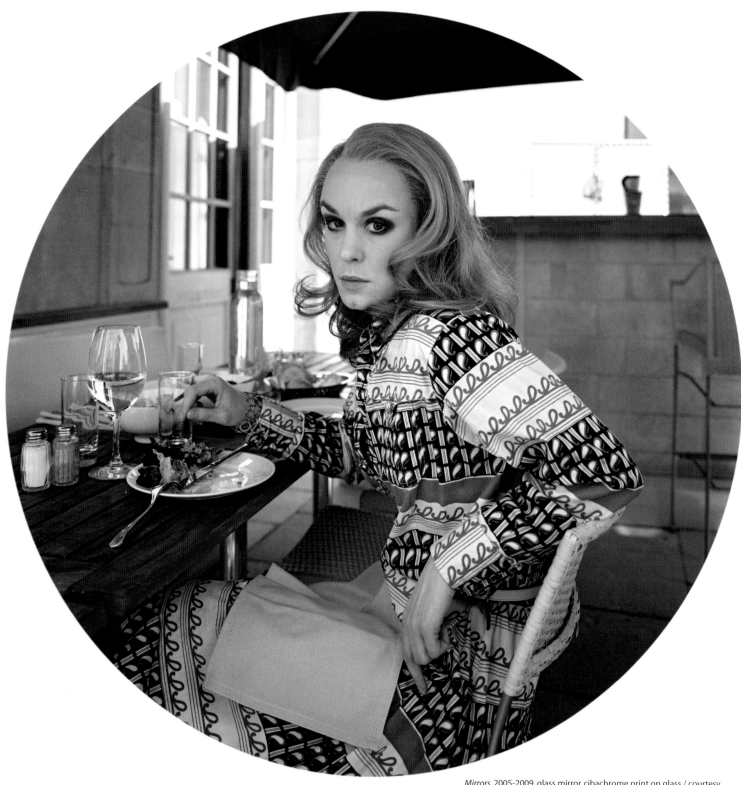

Mirrors, 2005-2009, glass mirror, cibachrome print on glass / courtesy
Nils Stærk Gallery, Copenhagen; Niklas Belenius Gallery, Stockholm;
Elba Benítez Galleria, Madrid

Separate your thinking from your Self, combine with
all the senses, mix thoroughly, chop up the mixture
into smaller parts and feed to fish and birds.

Mirrors, 2005-2009, glass mirror, cibachrome print on glass / courtesy
Nils Stærk Gallery, Copenhagen; Niklas Belenius Gallery, Stockholm;
Elba Benítez Gallería, Madrid

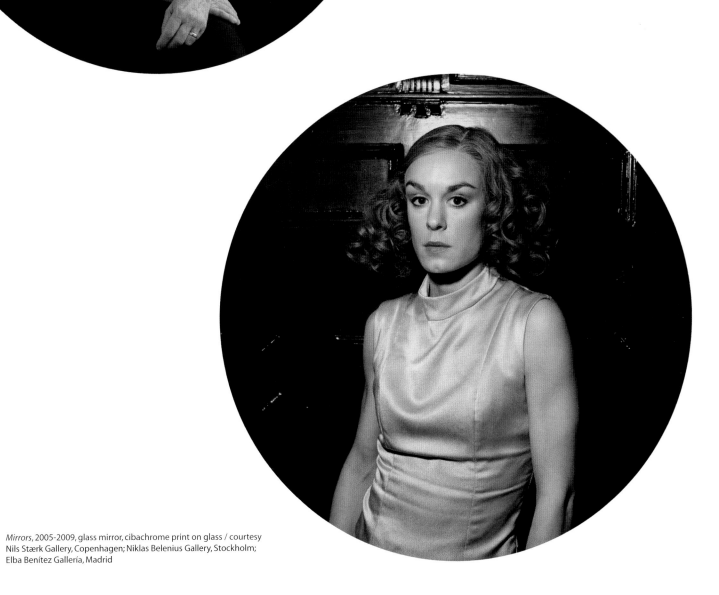

Mirrors, 2005-2009, glass mirror, cibachrome print on glass / courtesy
Nils Stærk Gallery, Copenhagen; Niklas Belenius Gallery, Stockholm;
Elba Benítez Gallería, Madrid

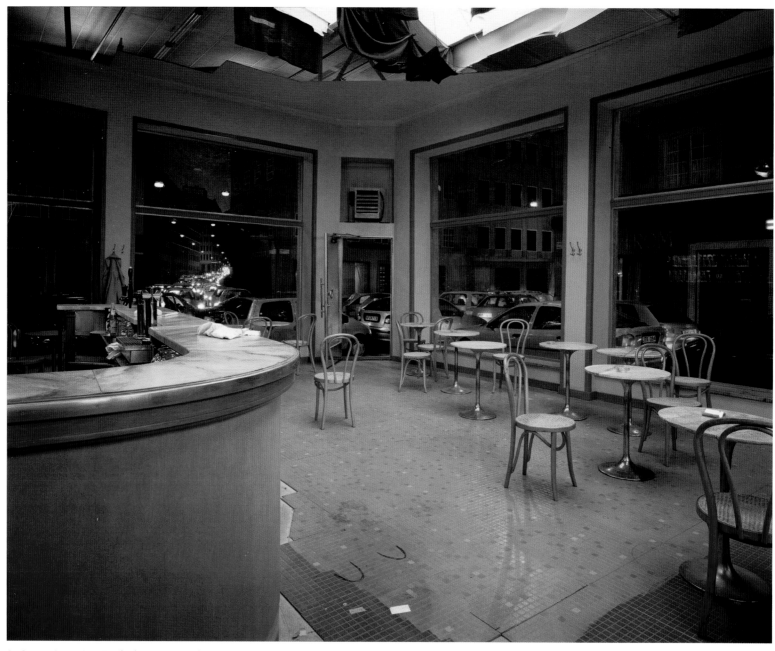

Set Constructions, 1995-2002, cibachrome print on aluminium / courtesy Nils Stærk Gallery, Copenhagen; Niklas Belenius Gallery, Stockholm; Elba Benítez Gallería, Madrid

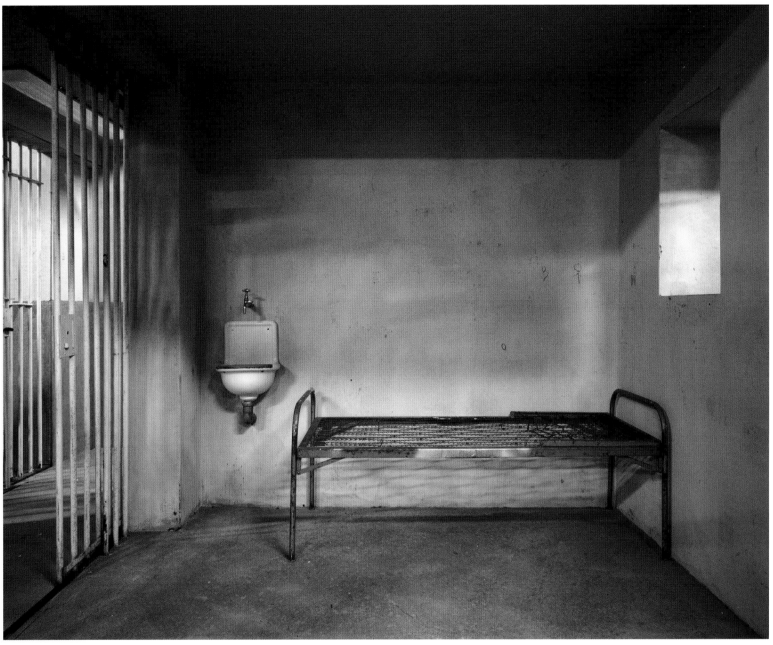

Set Constructions, 1995-2002, cibachrome print on aluminium / courtesy Nils Stærk Gallery, Copenhagen; Niklas Belenius Gallery, Stockholm; Elba Benítez Gallería, Madrid

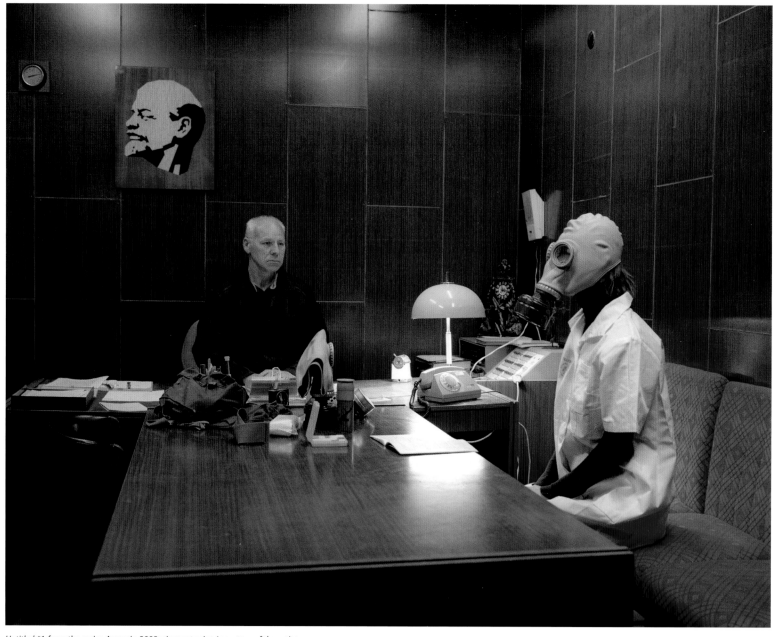

Untitled #1, from the series *Amnesia*, 2008, pigment print / courtesy of the artist

The artist works around the subjects of identity, history and
sexuality, exploring various photographic practices and aesthetics,
from snapshots in the series *Myself, Friends, Lovers and Others* to
cinematic photo stories in the project *Episodes*. The most current
projects work around the issues of post-Soviet legacy and collective
memory in modern Latvia and Eastern-bloc countries.

Untitled #4, from the series *Amnesia*, 2008, pigment print / courtesy of the artist

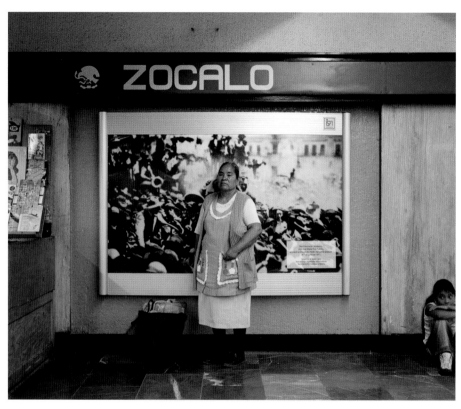

My works question the place of the individual in society, the notions of reality and identity. For this project, I explored the subway of Mexico City and the meanders of its loneliness. In the age of globalisation, the strong presence of cultural representations reflects the attachment of Mexico to its personal archaeology and to the foundation of its complex identity.

Don Francisco L. Madero and don José Maria Pino Suarez entering full popular jubilation on Zocalo on June 7th 1911, photographic reproduction, Station: Zocalo, Line 2, 2008, C-print on aluminium / courtesy of the artist

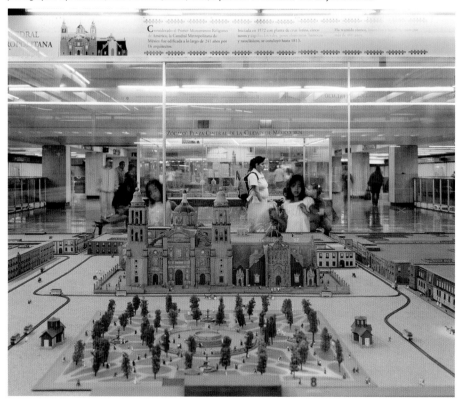

Maquette of the metropolitan cathedral of Mary's Assumption, Station: Zocalo, Line 2, 2008, C-print on aluminium / courtesy of the artist

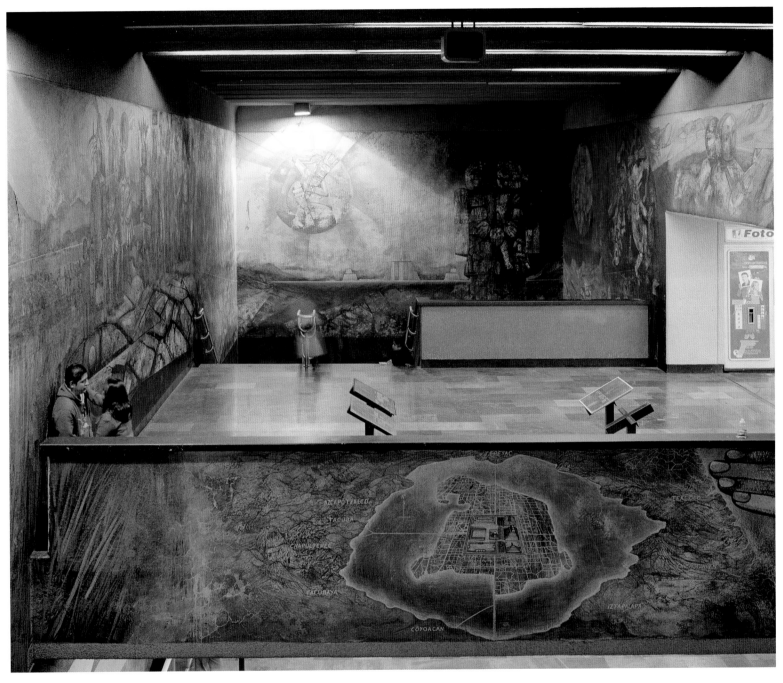

From the codex to the fresco, Guillermo Ceniceros, acrylic / glass fiber, 600m², Station: Tacubaya, Line 1, 2008, C-print on aluminium / courtesy of the artist

Senza titolo, 2009, C-print on aluminium / courtesy Galleria Suzy Shammah, Milan

The poetics of Carlo Benvenuto are determined by his desire
to communicate as little as possible. The artist works in his own home
with his own objects, reducing individual choice to a minimum.
He photographs what he has to hand on a scale of 1:1 against a neutral
background, in a rarefied atmosphere of delicacy and suspense.
The absence of surrounding elements transforms ordinary objects—
such as the cap of a Bic ballpoint pen—into a mystery shrouded
in a soft light of undeniable pictorial quality.
The conventional framing, almost in the style of a catalogue, negates
any expressive intention. The minimal approach is followed
by a study to the very bounds of perfection. In the artist's *modus
operandi*, form and composition together with a skilled balancing
of the light and colour tones take on a fundamental role, revealing
his admiration for classical painting. The beauty of his compositions
calmly and skilfully show the order we try to bring to chaos.

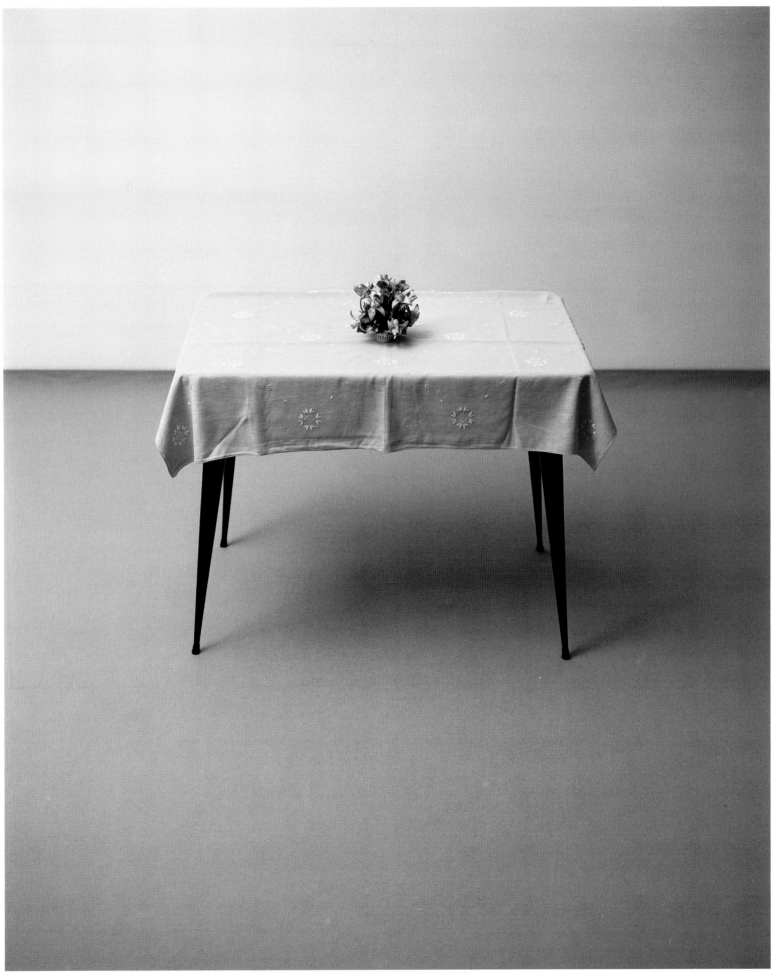

Senza titolo, 2007, C-print on aluminium / courtesy Galleria Mazzoli, Modena

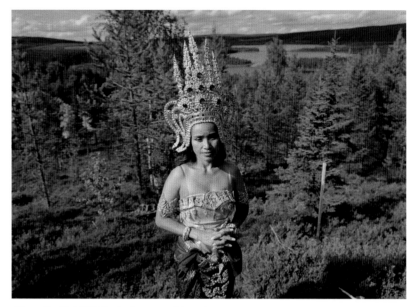

Thitaree (Fredrika), 2008, C-print / courtesy of the artist

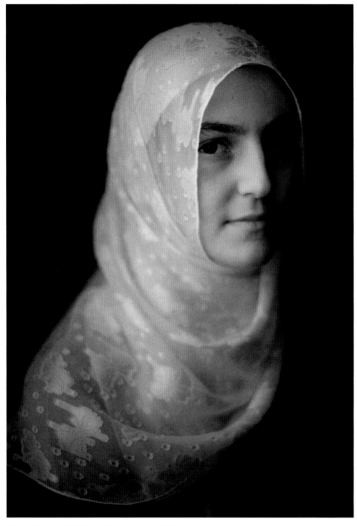

Tügba (Istanbul), 2003, C-print / courtesy of the artist

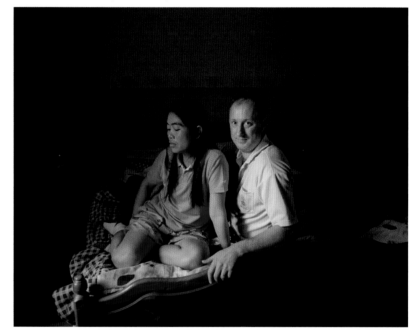

Suvanan and Mikael (Bjurholm), 2007, C-print / courtesy of the artist

Today religions, ideals and ways of living are mixed together into something that resembles sheer confusion. In the middle of this, the importance of controlling the female body seems more defined than ever. I'm interested in depicting women who try to break free and find their space in ways you might not expect.

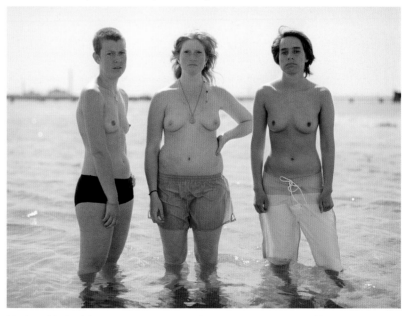

Members of the Swedish activist group Bara Bröst (Malmö), 2008, C-print / courtesy of the artist

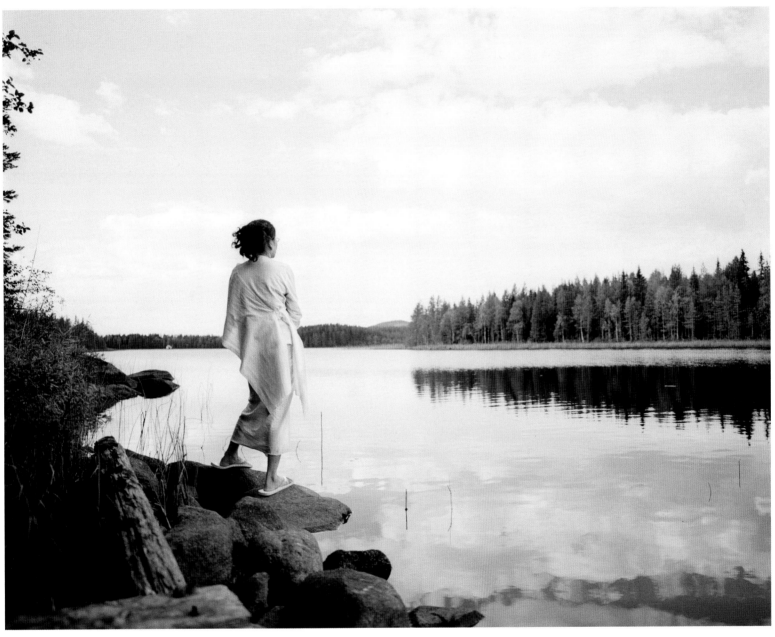

Buddhist nun (Fredrika), 2006, C-print / courtesy of the artist

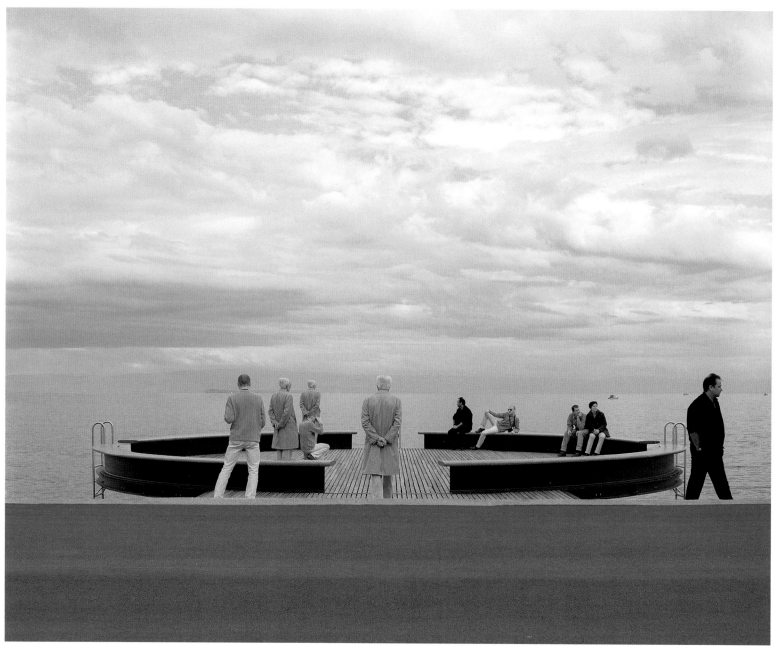

N°18, from the series *Intervalles*, 2001, pigment inkjet print / courtesy Galerie Baudoin Lebon, Paris

The issue in my pictures is landscape and the way we try to exist
in a world of perpetual change. We travel fast, build fast, live fast,
linked to the world by a strange bond of speed and illusion.
The people in my photographs are presented as visitors, temporary
figures—not residents. When I take photographs I try to expose
the paradox of the image in its resemblance to the paradox
of our existence now: a perpetual back and forth between
the imaginary and the real, a vital yet doomed-in-advance striving
to know where we are.

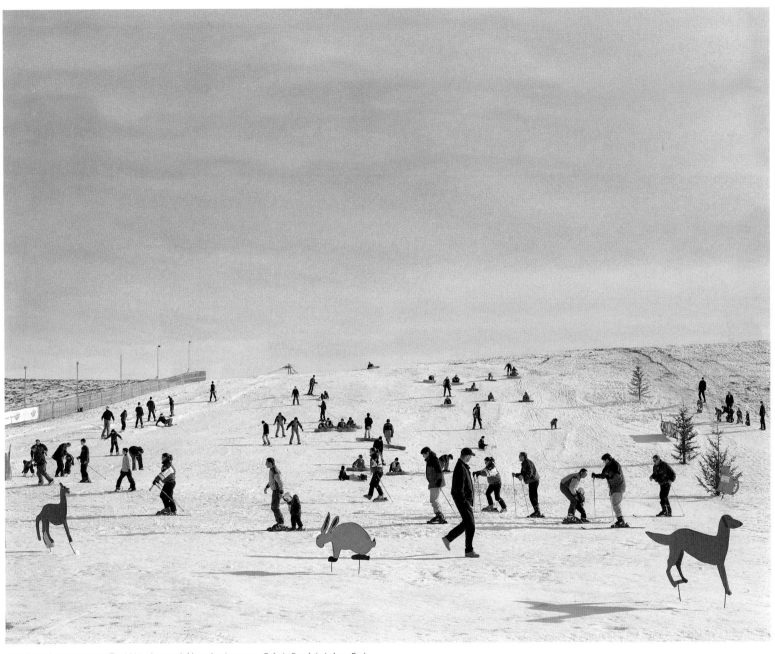

N°10, from the series *Intervalles*, 2001, pigment inkjet print / courtesy Galerie Baudoin Lebon, Paris

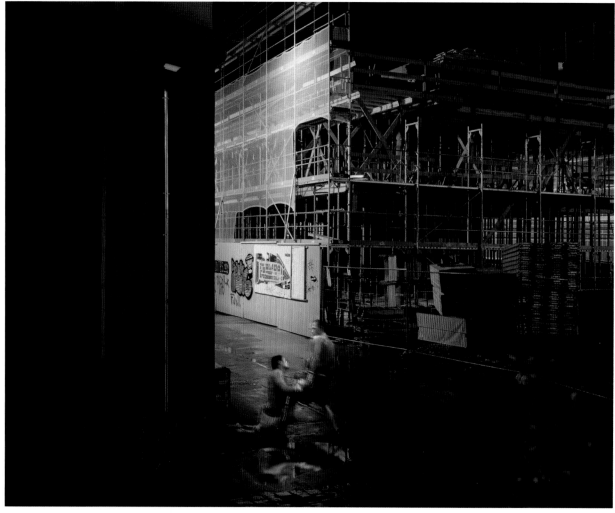

N°35, from the series *TV*, 2007, pigment inkjet print / courtesy Galerie Baudoin Lebon, Paris

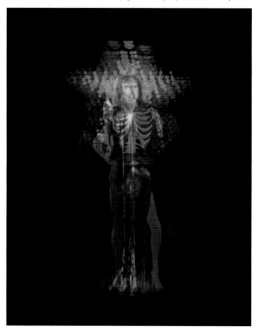

Star, from the series *TV lucioles*, 2008, pigment inkjet print /
courtesy Galerie Baudoin Lebon, Paris

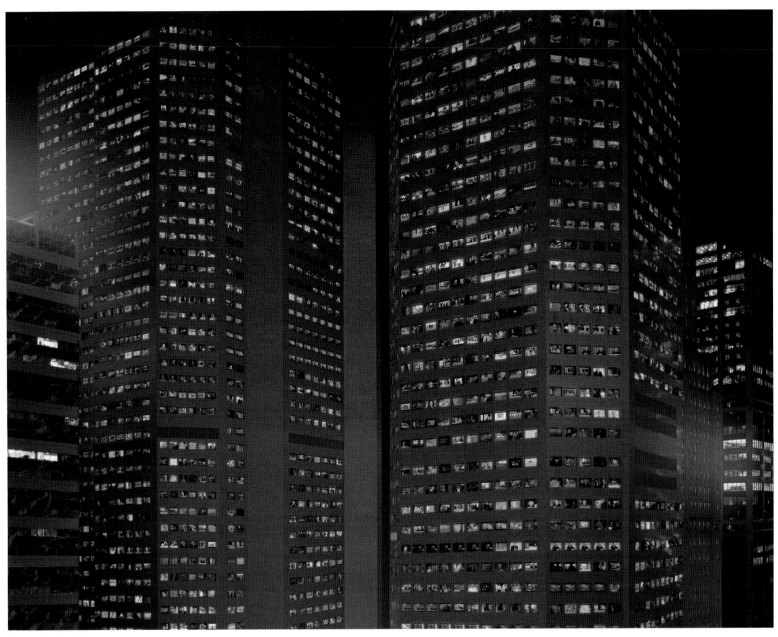

N° 19, from the series *TV*, 2007, pigment inkjet print / courtesy Galerie Baudoin Lebon, Paris

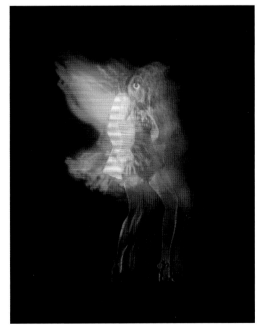

Beauty, from the series *TV lucioles*, 2008, pigment inkjet print / courtesy Galerie Baudoin Lebon, Paris

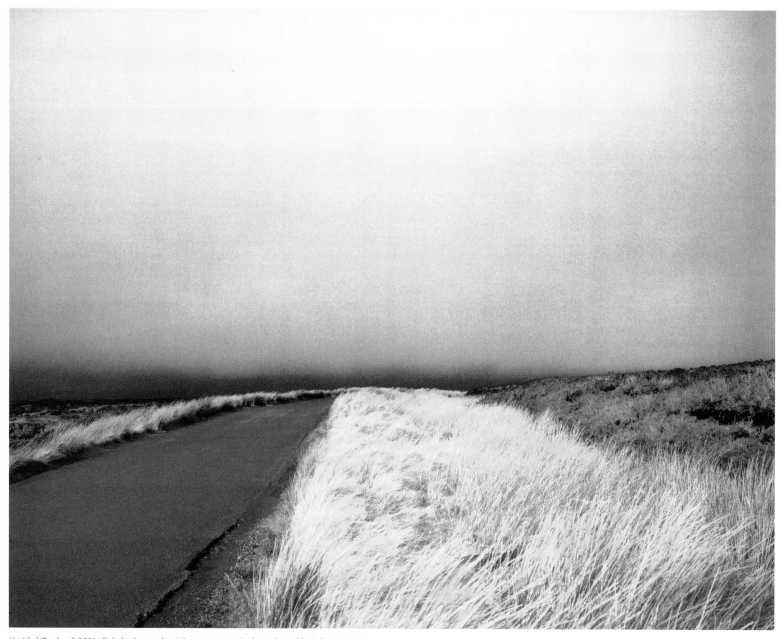

Untitled (Bogland), 2001, digital print on aluminium / courtesy Anthony Reynolds Gallery, London

In 2003, I wanted to see how my relationship to my hometown had changed. I decided to take detailed photographs on a medium-format camera and at night using long exposures. Making much slower work in this way forced a different kind of attention before taking each picture. I also found that my senses seemed more heightened at night due to the silence and the darkness and the fact that no one else was around.

Instead I feel very collected and thoughtful in zoos but I am not sure why… perhaps it is because of the melancholy of knowing that when I leave a zoo in the evening, I have the certainty that when I arrive the next morning the same individuals will still be there and doing much the same thing as the day before…

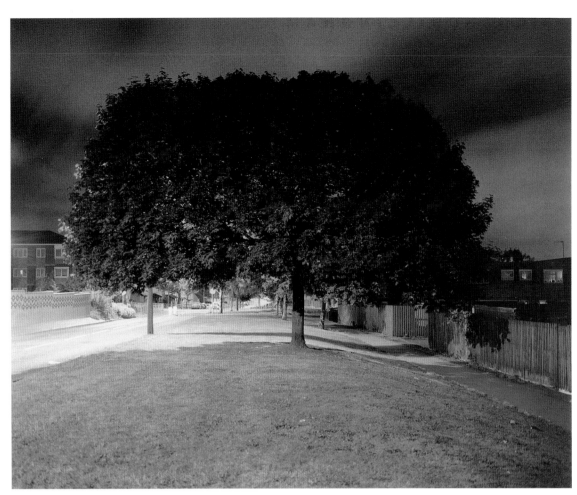

Untitled (Black Country) #1, 2003, lightjet print / courtesy Anthony Reynolds Gallery, London

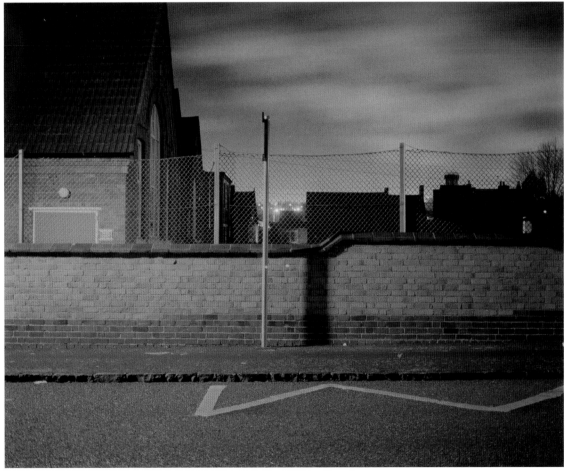

Untitled (Black Country) #3, 2003, lightjet print / courtesy Anthony Reynolds Gallery, London

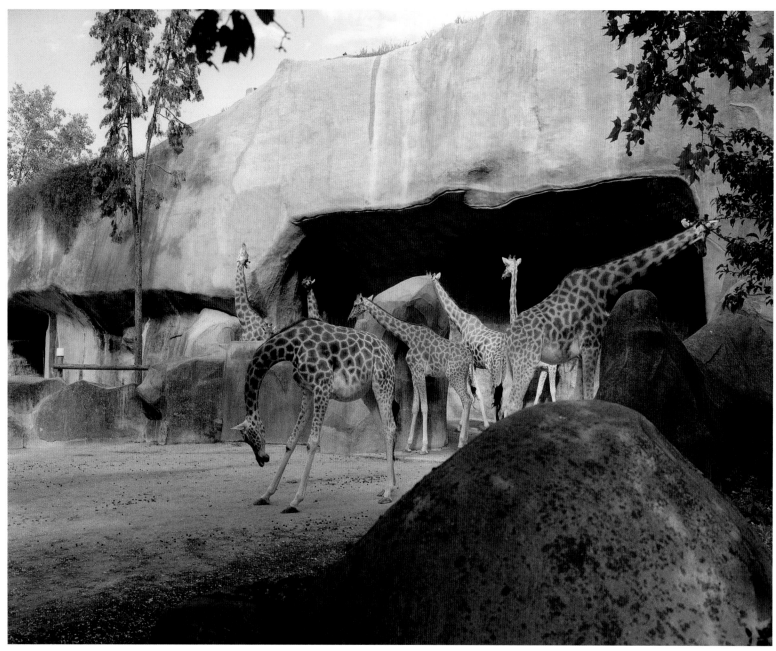

Giraffes, 2006, C-print / courtesy Anthony Reynolds Gallery, London

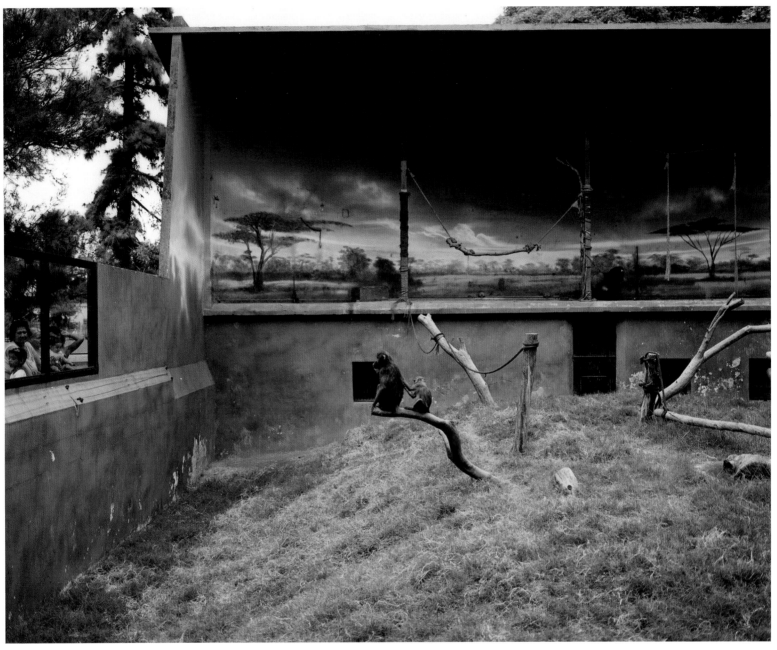

Mandrills, 2005, C-print / courtesy Anthony Reynolds Gallery, London

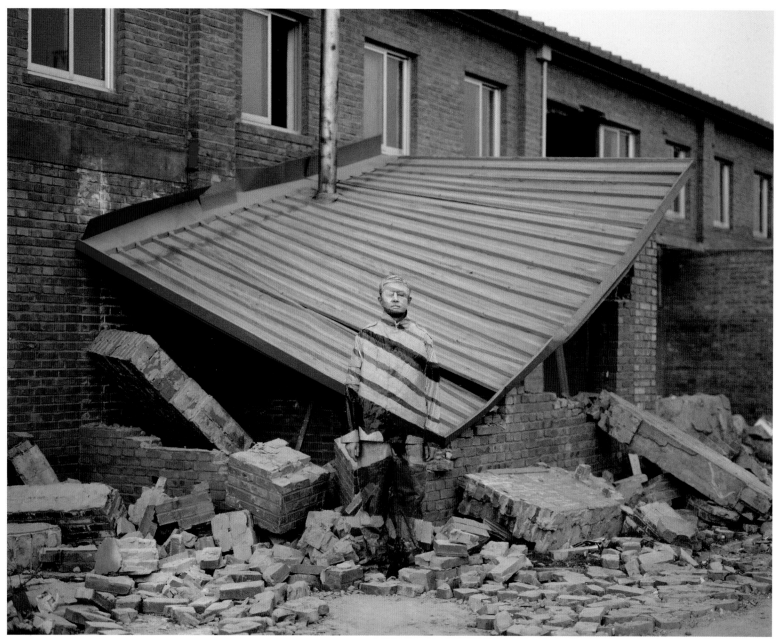

Suojia Village, 2006, C-print / courtesy Boxart Galleria d'Arte, Verona

Are human beings animals? Human beings are not animals. Because
they do not know how to protect themselves. All chameleon species
are able to change their skin colour. In order to survive, hiding is often
key. In a context that emphasizes cultural heritage, concealment is
actually no place to hide. Mental enthrallment is more terrible than
physical disappearance.

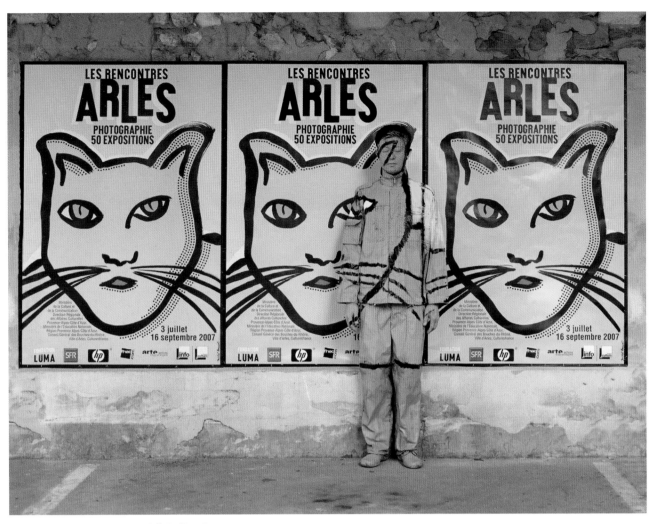

Arles, 2007, C-print / courtesy Boxart Galleria d'Arte, Verona

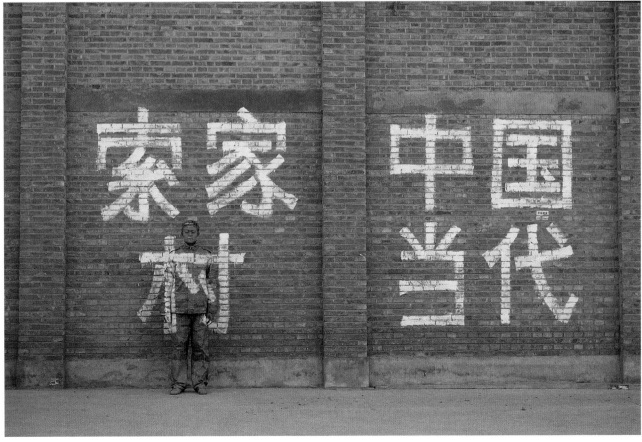

Chinese Contemporary, 2006, C-print / courtesy Boxart Galleria d'Arte, Verona

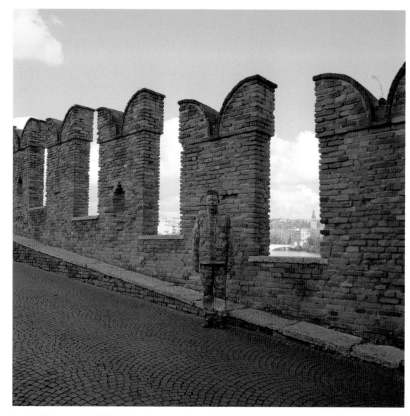

Ponte di Castelvecchio, 2008, C-print / courtesy Boxart Galleria d'Arte, Verona

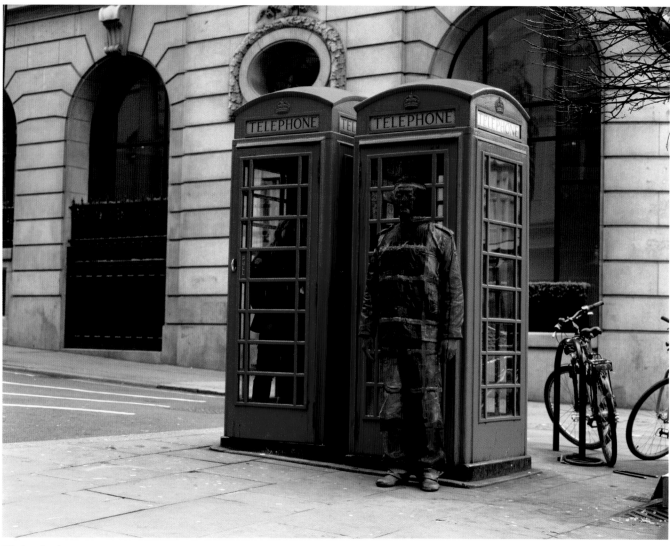

Telephone booth, 2008, C-print / courtesy Boxart Galleria d'Arte, Verona

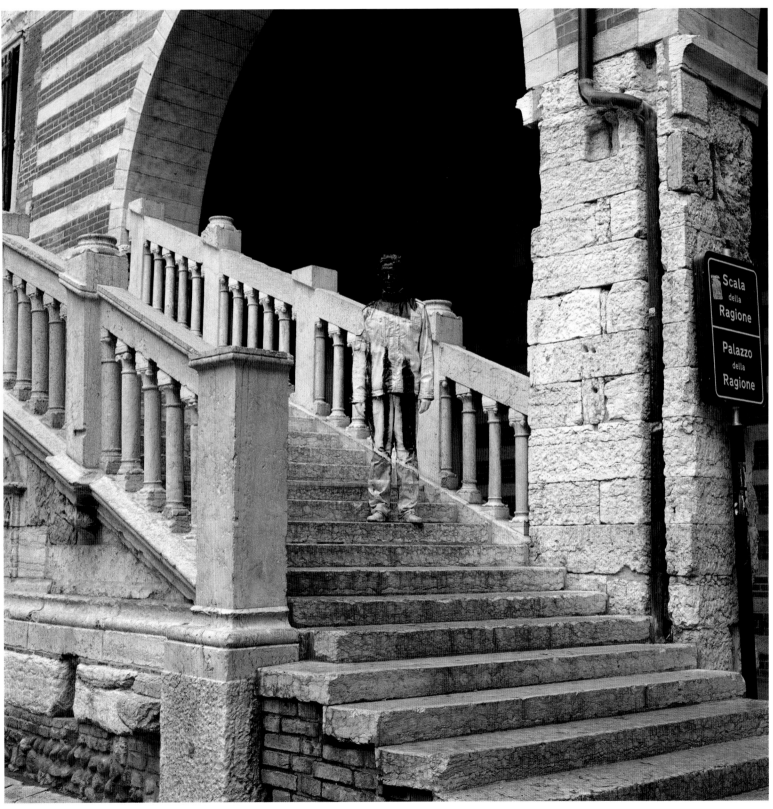

Scala della Ragione, 2008, C-print / courtesy Boxart Galleria d'Arte, Verona

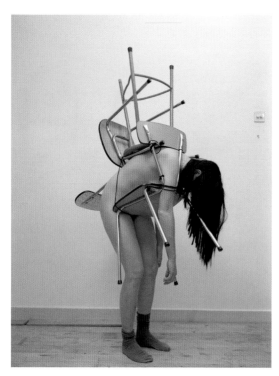

Anne, 2007, C-print / courtesy P·P·O·W Gallery, New York

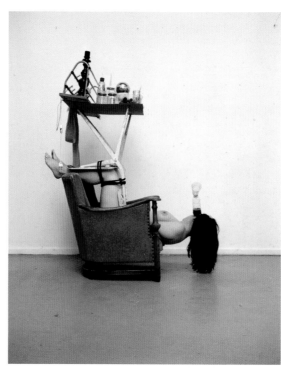

Katja, 2009, C-print / courtesy P·P·O·W Gallery, New York

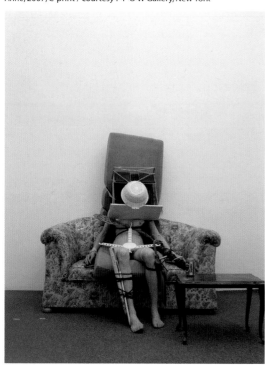

Celine, 2009, C-print / courtesy P·P·O·W Gallery, New York

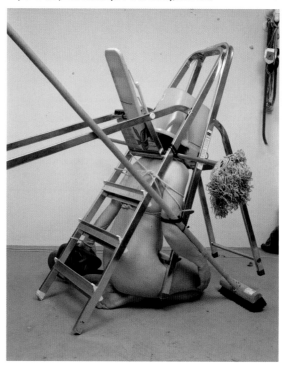

Janneke, 2007, C-print / courtesy P·P·O·W Gallery, New York

Melanie Bonajo works with fictive interventions blending seemingly opposing elements into the everyday and ordinary. She synchronizes various mental arrangements inspired by religion, anthropology, mythology, unconsciousness structures, sociological experiments and her own surroundings. These often carry their own logic and are a symbolic intercom of confused mystical ideas, emotional patterns and states of mind lingering between our depth and the relatively thin consciousness by which we govern our daily existence.

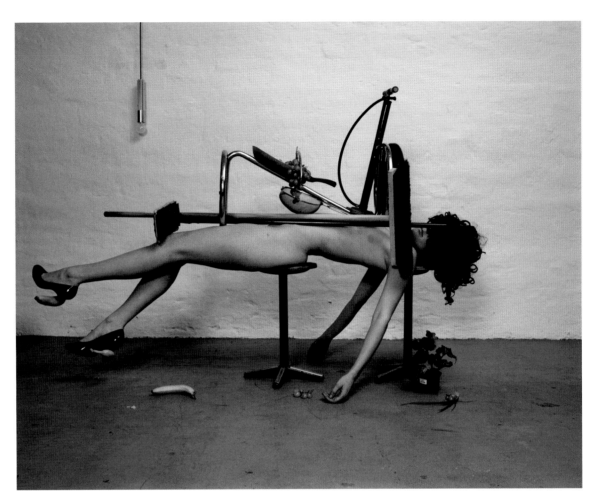

Sara, 2007, C-print / courtesy P·P·O·W Gallery, New York

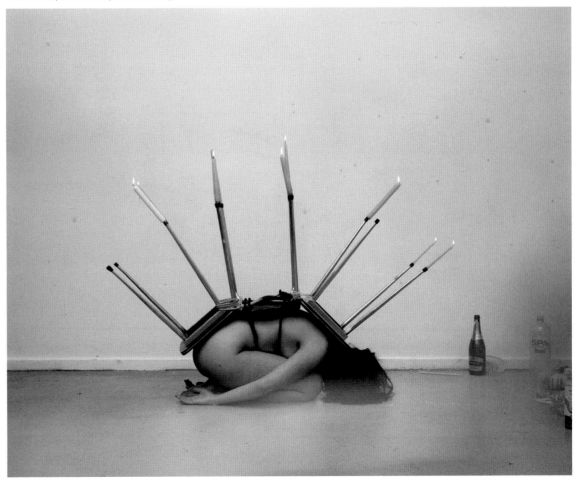

Özlem, 2009, C-print / courtesy P·P·O·W Gallery, New York

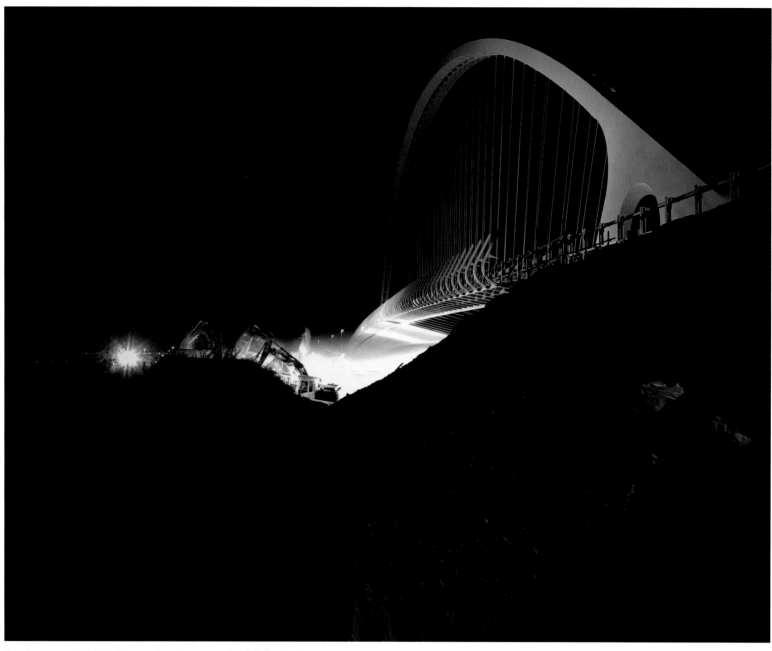

Tutto in una notte #04, 2006, colour negative print / courtesy Jarach Gallery, Venice

I believe in photography as a *pretence* of the real, from which I never expect any answers. With this conviction, over the last five years I have been following the activities of various industrial decontamination and demolition sites in Italy, large areas of land transformation and recovery, where many interests are concentrated. It is no accident that that biggest company in the international building trade is one specialising in implosions, and that the time to obsolescence of a building is ever-decreasing. The series *Tutto in una notte* ("All in one night"),

realised between 2003 and 2006 during the night-time demolition of various bridges on the A1 Milan-Bologna highway to make way for the passage of the new TAV high-speed railway line, is a piece of research into *time*—the time/limit of each site, which must be contained between the hours of 22.00 on the Saturday night and 06.00 on the following Sunday, when the traffic on the highway is closed in both directions, but also the *suspended* and *dilated* time of a theatre *play,* without rehearsals or repeat performances, whose main actors are men and machines.

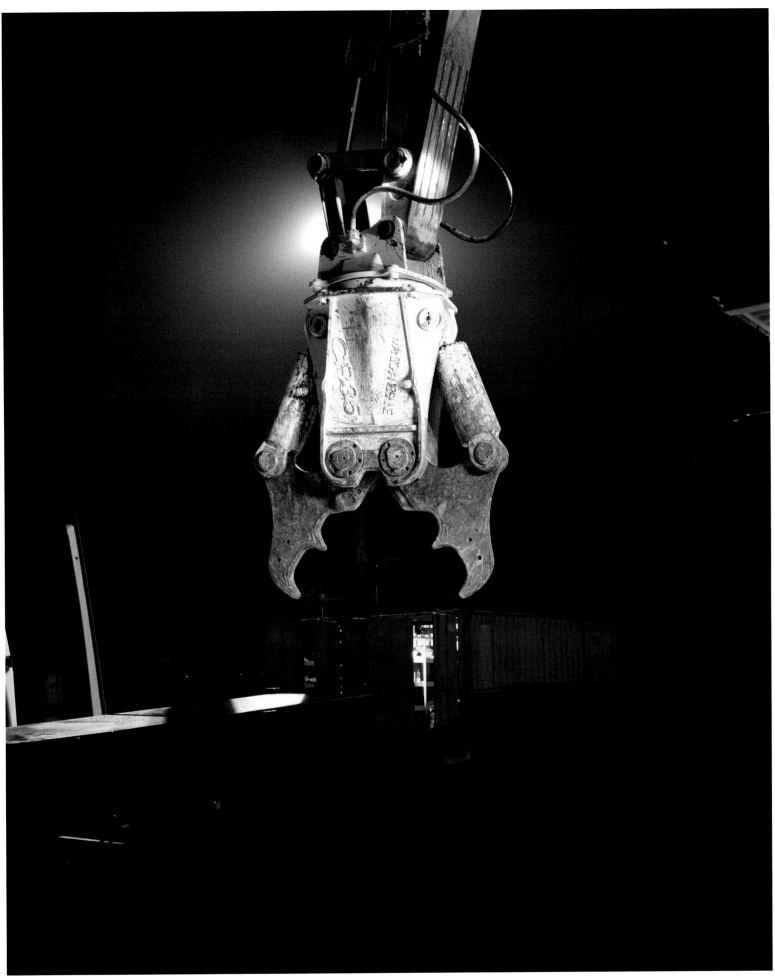

Tutto in una notte #11, 2003, colour negative print / courtesy of the artist

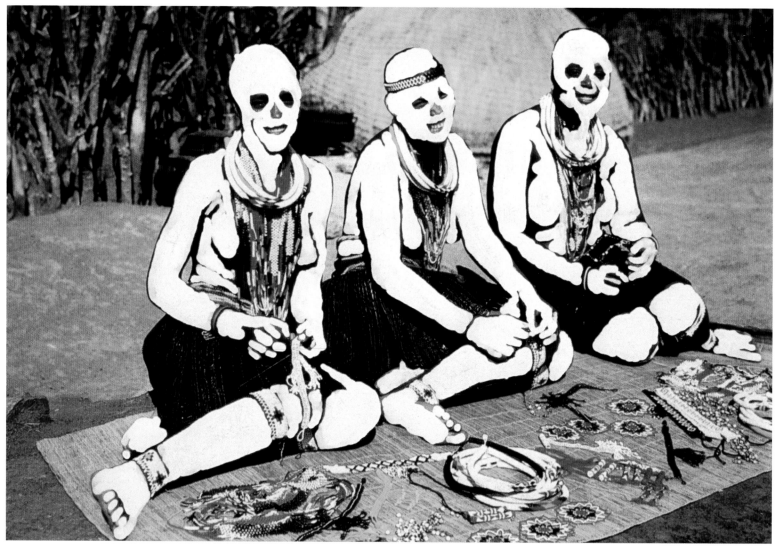

Ghost Series #8, 1994-1996, C-print / courtesy francesca kaufmann, Milan

My work questions the process by which our identity is formed,
how we become what we are, and the degree to which this process
is influenced by our absorption of the values transmitted
by the various means of mass-communication. In increasing
measure, what we learn does not come from our parents or the social
context to which we belong, but from the entertainment industry.

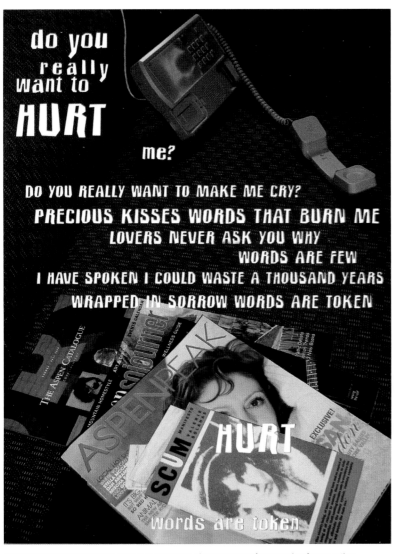

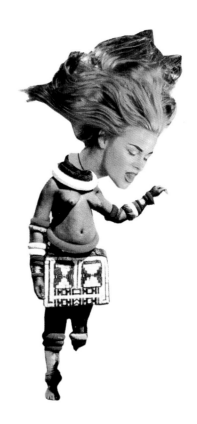

Do You Really Want To Hurt Me, 2006, inkjet print on glass / courtesy francesca kaufmann, Milan

Rainbow Series #1, 1996, cibachrome print / courtesy francesca kaufmann, Milan

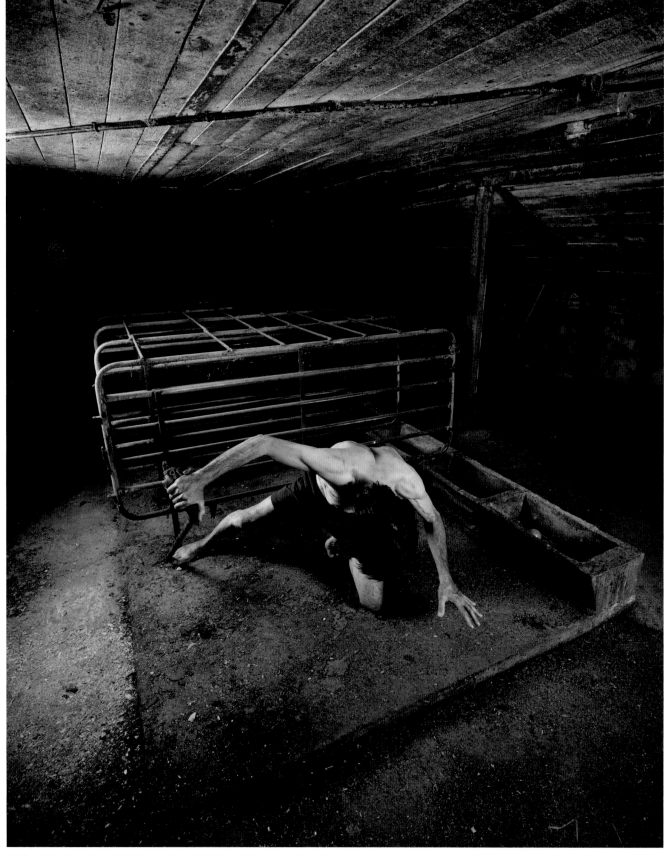

A Falling Soldier, from the series *The Resurrection,* 2009, inkjet print / courtesy of the artist

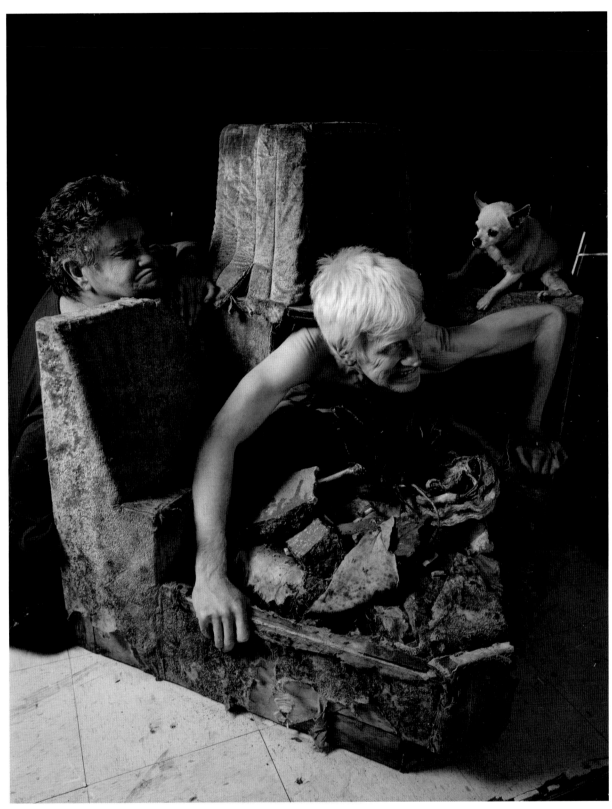

Children of Broken Symmetry, 2009, inkjet print / courtesy of the artist

Scrutinize Matthieu Brouillard's pictures closely and you will never see
a hand extended to another hand anymore. And yet, I know of very few
works that send us back so significantly to our starving tenderness.
To our dread of being the bodies that we are, quivering with the electric
fear of succumbing to suicide, everything here answers with the plasticity
of our metaphysical condition.

Gaétan Soucy

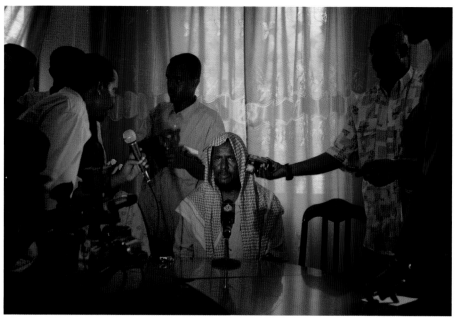

_MG_0621 (Somalia), Inda'ade gives a press conference, 2006, giclée print / courtesy Galerie Polaris, Paris

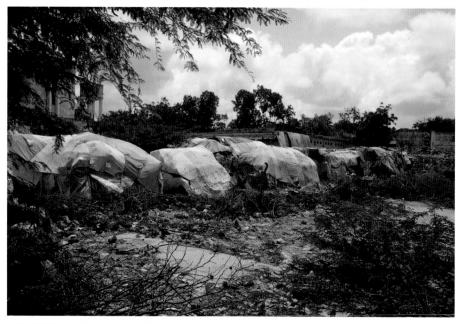

_MG_1215 (Somalia), Refugee camp, 2006, giclée print / courtesy Galerie Polaris, Paris

While the construction of photojournalism in general, and of war photography in particular, appears geared towards a maximal amount of transparency, it is in fact both one the most reactionary areas of the field, and one of the most obtuse. My work, by using the tools of contemporary art, works towards a demystification of these forms of representation. Because conflict photography is considered, within the sub-genre of photojournalism, to be the most prestigious, my work is a study on the systems of representation of warfare. The protean nature of the Somali conflict, which could be a breeding ground for the next generation of warfare, is one of the current grounds of it.

_MG_1814 (Somalia), *The new central bank*, 2007, giclée print / courtesy Galerie Polaris, Paris

_MG_0447 (Somalia), *Government-run checkpoint*, 2008, giclée print / courtesy Galerie Polaris, Paris

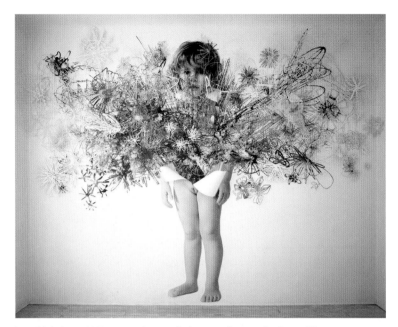

Laura's inheritance, 2003, cut-out photographs / courtesy francesca kaufmann, Milan

My work rescues the overlooked family snapshot from the everyday and launches it into the world through a labour intimately connected to my work as a woman. I build a family album that gives me a way to project my viewpoint on to the everyday, changing condition of motherhood. Domestic and artistic work collapse into one. In the process I find a way to survive the dramatic complexity of the human community.

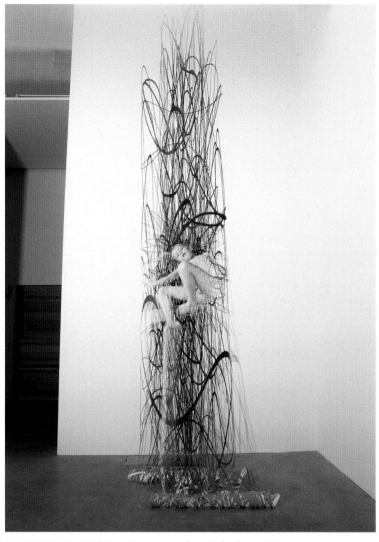

Zoo'age 5, 2002, cut-out photographs / courtesy francesca kaufmann, Milan

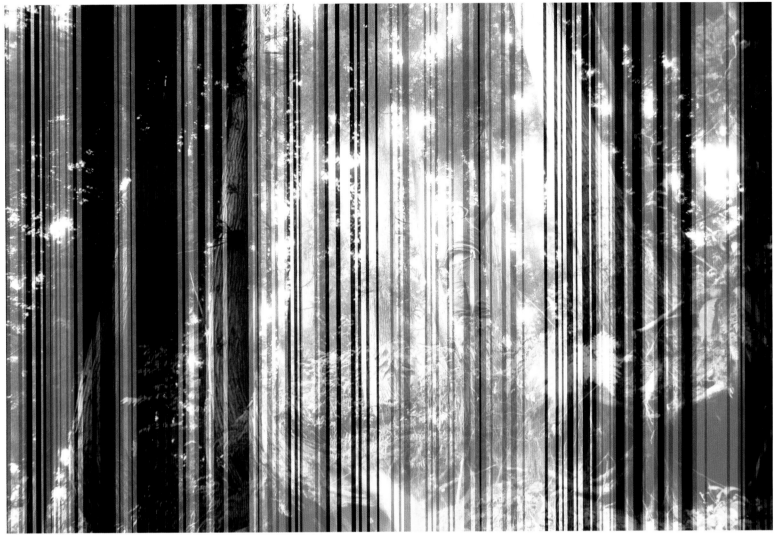

Echigo Forest with Zoo, 2008, four layers of cut-out photographs / courtesy francesca kaufmann, Milan

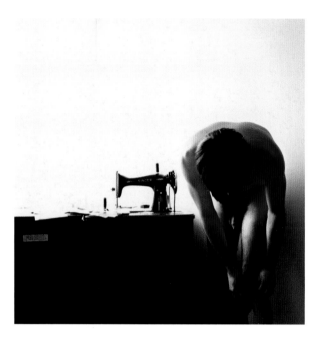

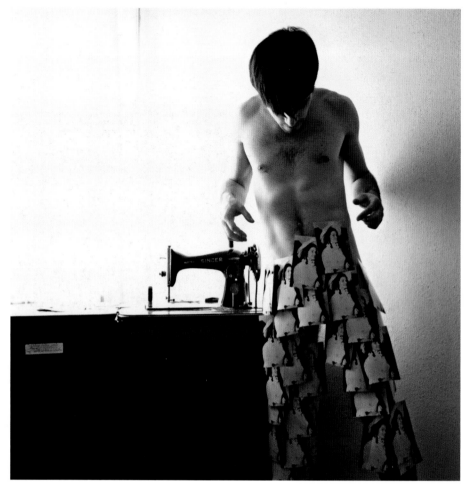

Senza titolo #2, 2001, C-print on dibond / private collection

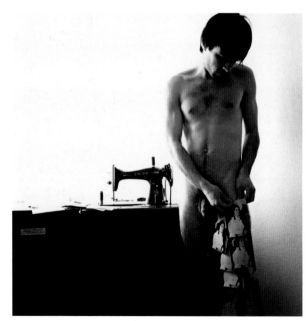

Senza titolo #2, 2001, C-print on dibond / private collection

Senza titolo #2, 2001, C-print on dibond / private collection

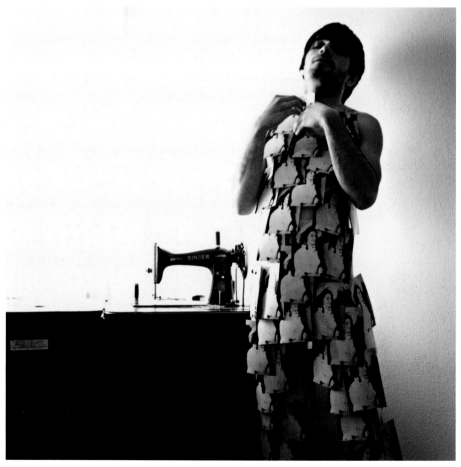

His research aims to place a plurality of contexts, in which opposites attract, in relation to each other; such as reality and pretence, memory and contemporaneity, figure and image, the two- and the three-dimensional, conflict and integration.

Senza titolo #2, 2001, C-print on dibond / private collection

Offside #3, 2007, C-print on dibond / private collection

Offside #4, 2007, C-print on dibond / private collection

If Cramer's photographs show us something like a post-romantic, post-environmental view of nature, they do it by acknowledging that nature now is a kind of science fiction. In that sense, the closest analogues to these photographs […] are cinematic, not photographic.

Brian Dillon

Untitled (Woodland) #62, 2008, C-print / courtesy BolteLang, Zürich; Vera Cortês, Lisbon

Untitled (Woodland) #72, 2008, C-print / courtesy BolteLang, Zürich; Vera Cortês, Lisbon

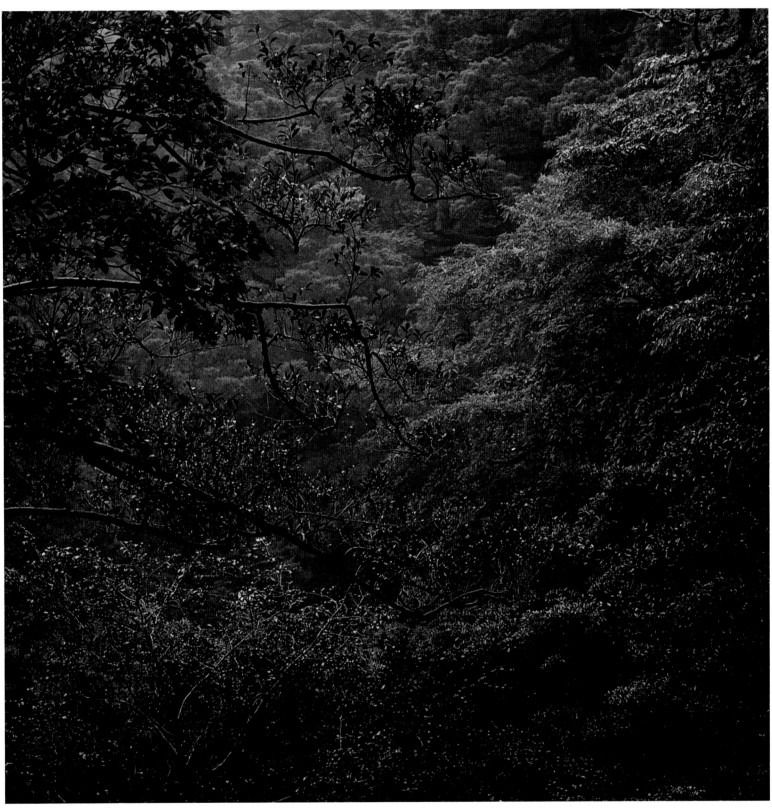

Untitled (Woodland) #73, 2008, C-print / courtesy BolteLang, Zürich; Vera Cortês, Lisbon

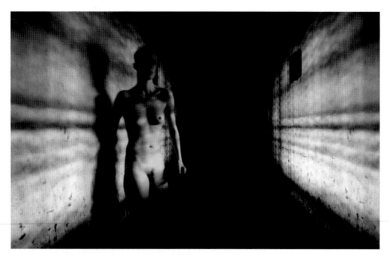

Lieux. Brest, Prison de Pointaniou (France), 2007, lambda print / courtesy Galerie VU', Paris

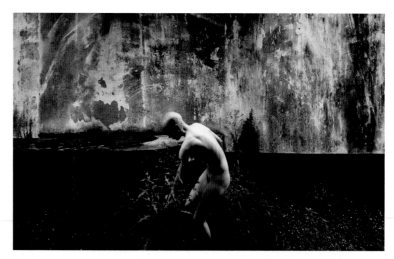

Lieux. Brest, Prison de Pointaniou (France), 2007, lambda print / courtesy Galerie VU', Paris

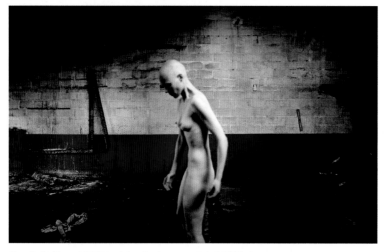

Lieux. Bellot (France), 2008, lambda print / courtesy Galerie VU', Paris

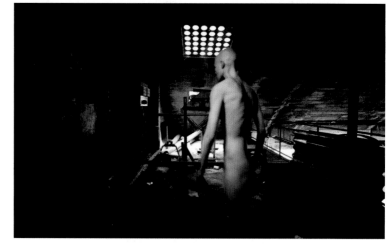

Lieux. Bellot (France), 2008, lambda print / courtesy Galerie VU', Paris

Shaven-headed, she journeys through her chosen *Lieux* ("Places"),
using her figure as a decoy. We initially assume her proposition
is nudes and self-portraits. But while she demands obvious effort
from her body, twisting it into particular positions, pushing it to
the very limit of erasure and disappearance, there and yet absent,
we soon realise that the real issue is the space in which her
body moves.

Christian Caujolle

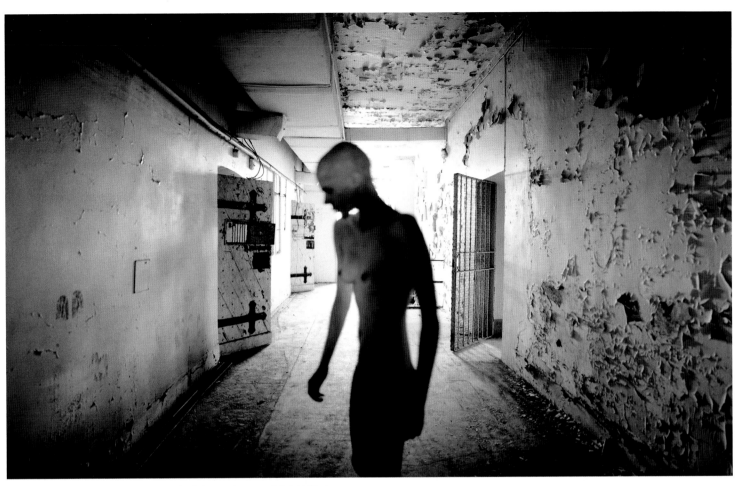

Lieux. Brest, Prison de Pointaniou (France), 2007, lambda print / courtesy Galerie VU', Paris

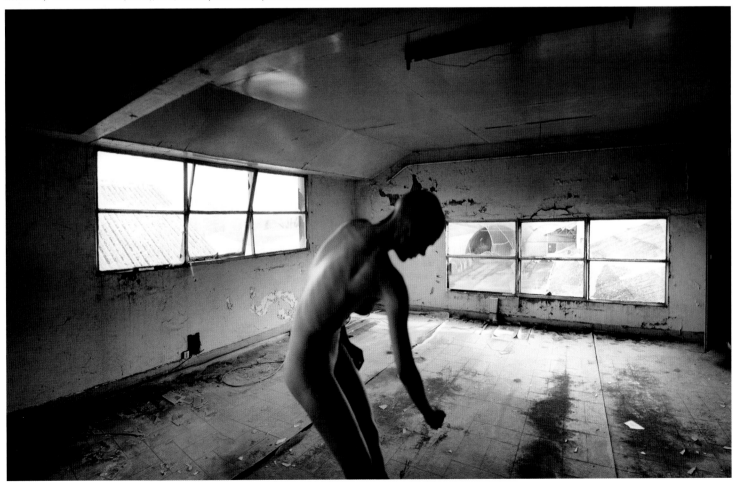

Lieux. Bellot (France), 2008, lambda print / courtesy Galerie VU', Paris

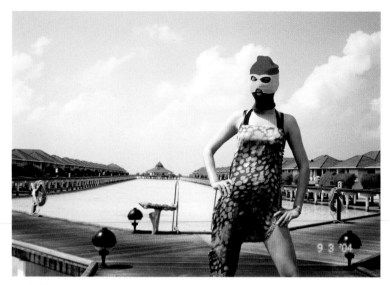

Untitled, from the series *ROM_*, 2004-2006, C-print / courtesy of the artist

Alexandra Croitoru works with a politically charged subject matter as she observes and makes social mechanisms visible through photography, installation or video. Very aware, the artist enters various circulations of images and established visual discourses by playing on the structuring and use of images in advertising, mass media or even by simulating the tourist snapshot. The both critical and analytical approach often involves humour, which borders on irony and cynicism as Croitoru, in some series, performs identities for the camera. The commenting can also take the form of documenting marginal transformations in an urban context or of recording controversial spaces that have played a political role in recent history. Whether it is transformations of institutions in an urban context, changing articulations of the civic sphere, new visual codes in the commercial circulation of images or an ongoing revision of a national identity, Alexandra Croitoru follows it attentively in order to make her artistic projects underscore social and political fact.

June Maestri Ditlevsen

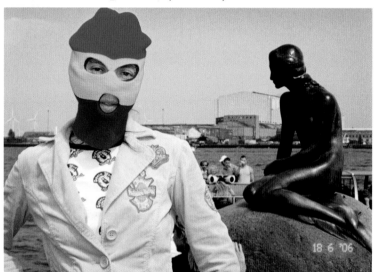

Untitled, from the series *ROM_*, 2004-2006, C-print / courtesy of the artist

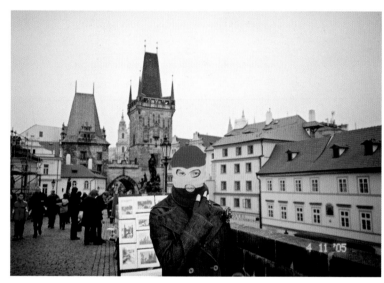

Untitled, from the series *ROM_*, 2004-2006, C-print / courtesy of the artist

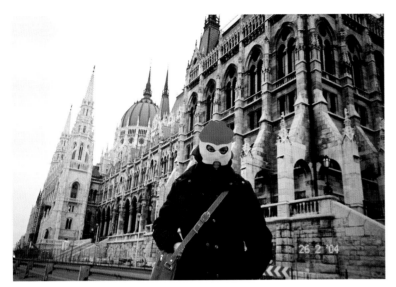

Untitled, from the series *ROM_*, 2004-2006, C-print / courtesy of the artist

Untitled, from the series *ROM_*, 2004-2006, C-print / courtesy of the artist

Untitled, from the series *ROM_*, 2004-2006, C-print / courtesy of the artist

Untitled, from the series *ROM_*, 2004-2006, C-print / courtesy of the artist

Storie immaginate, 2007, inkjet print / courtesy Alberto Peola, Turin

Her continued research defines the quality of the space inhabited
by man and expands its meaning: it is the space of the everyday,
in which small and sometimes intimate personal stories are played
out, but at the same time it is the immense space of the world,
the cosmos, in which the human figure sets itself in a precise
but at the same time precarious and mysterious way.

Roberta Valtorta

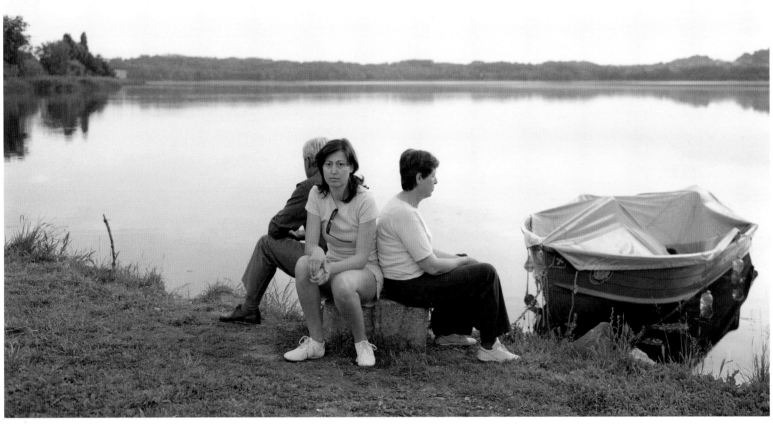

Storie immaginate, 2007, inkjet print / courtesy Galerie Les Filles du Calvaire, Paris

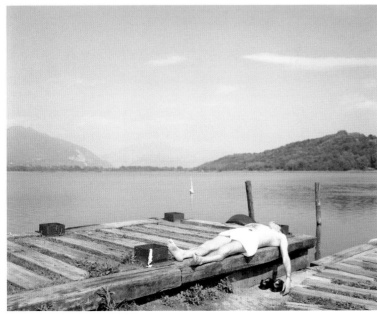

Storie immaginate, 2007, inkjet print / courtesy Alberto Peola, Turin

Storie immaginate, 2007, inkjet print / courtesy Alberto Peola, Turin

Lick 3, 2000, cibachrome print on aluminium / courtesy of the artist

My works play on the classic oppositions between the temporary
and the permanent, the old and the new, the public and the private.
The border between art and life—the friction and the oscillation
between the two—is what interests me as an artist.

Fuck 1, 2000-2001, cibachrome print on dibond / courtesy of the artist

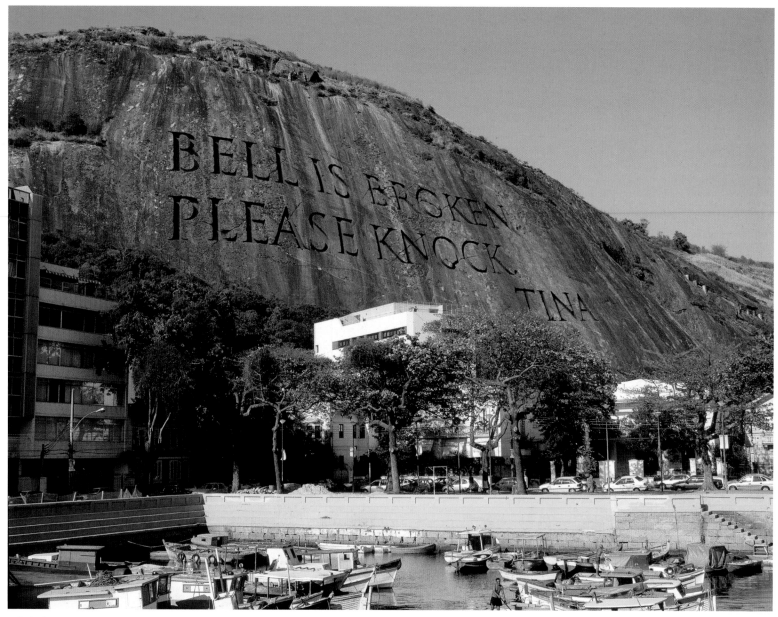

Bell is broken, 2000, C-print on aluminium / courtesy of the artist

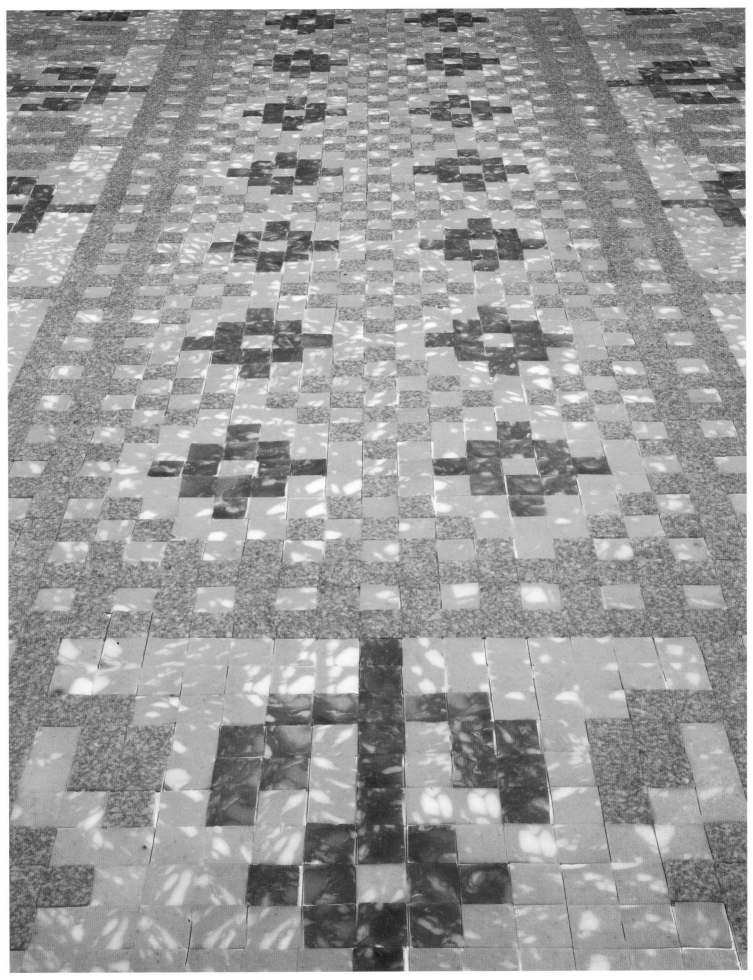

Marble Floor #102, 1999, C-print on aluminium / courtesy of the artist

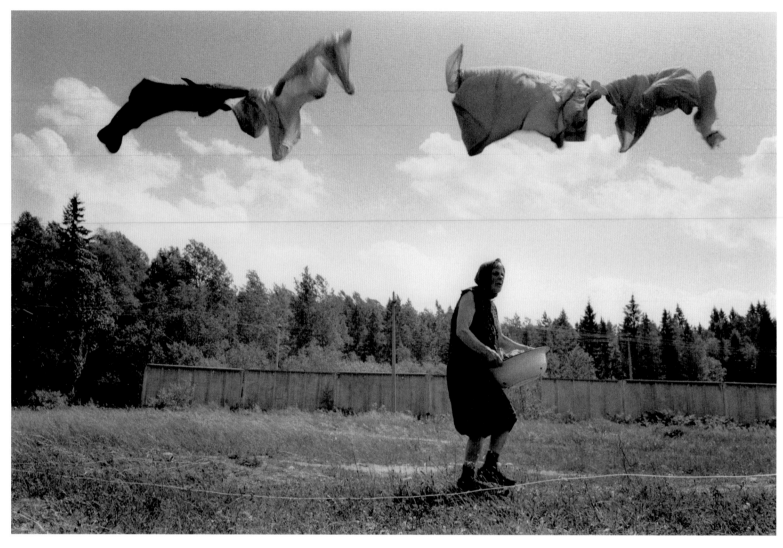

A patient of a mental institution hanging linen to dry (Neppovo, Saint-Petersburg Region, Russia), 2006, black and white photograph / courtesy of the artist

To me, one of the basics of true art is its closeness to mankind.
After all, if art is not about man and not intended for man,
if it is not one of the forms of communication and comprehension
—then what purpose does it serve?
Being a photographer, I get a unique opportunity to become
acquainted with people of different social backgrounds, lifestyles
and nationalities; I find myself in a completely new environment
and even become part of it for a while. This way, I am able to see
how people live, to communicate with them, and to explore their
way of life, daily occupations and activities through the use
of photography so as to tell others about them.

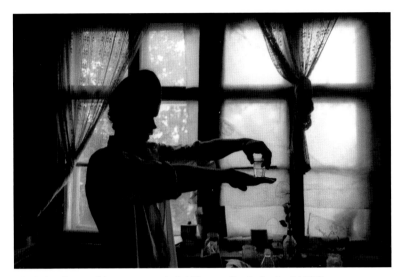

"Skachok" with a cup of cheap surrogate alcohol (Shuvaevo, Tver Region, Russia), 2007,
black and white photograph / courtesy of the artist

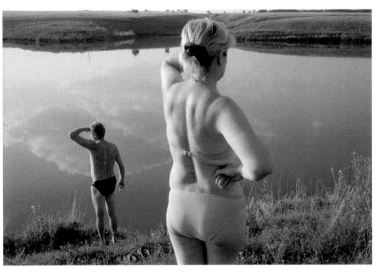

A couple coming to swim in the lake in the evening (Krasnaya Dolina, Kursk Region, Russia), 2008,
black and white photograph / courtesy of the artist

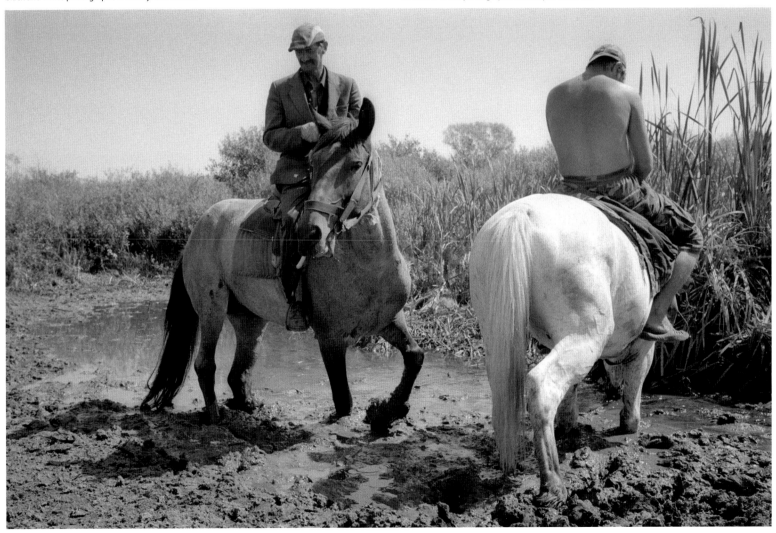

Two shepherds bring their horses to drink on a hot summer day (Krasnaya Dolina, Kursk Region, Russia), 2008, black and white photograph / courtesy of the artist

Bildung, 2009, colour photograph / courtesy Federico Bianchi
Contemporary Art, Lecco

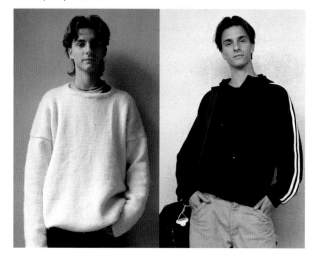

Bildung, 2009, colour photograph / courtesy Federico Bianchi
Contemporary Art, Lecco

My research explores some of the social and political issues affecting
the contemporary city, examining situations of everyday life,
often characterised by profound human suffering. I am interested
in focusing attention on our pre-established conventions
and showing new points of view as a stimulus for a new awareness
of the reality in which we live.

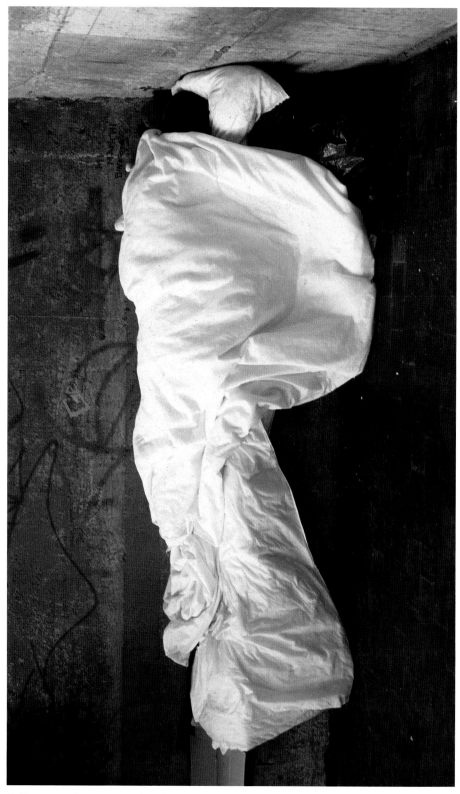

Rischiano pene molto severe, 1998, colour photograph / courtesy Fondazione Sandretto Re Rebaudengo, Turin

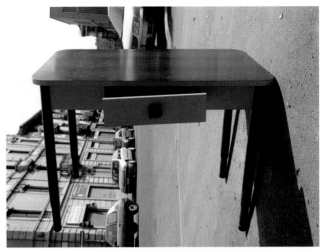

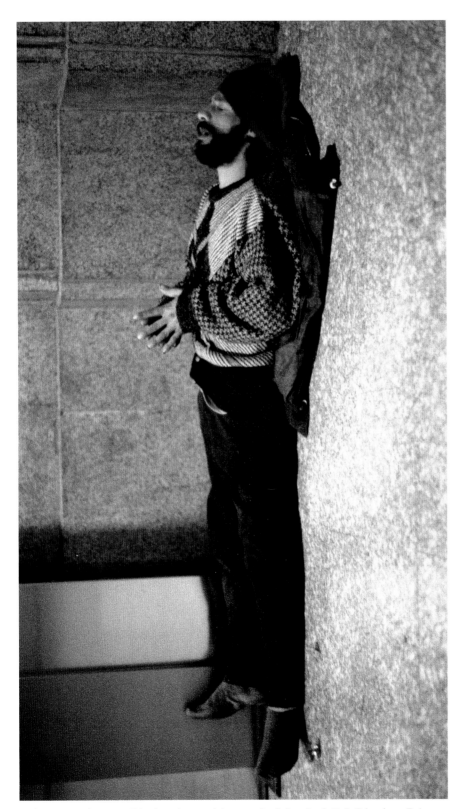

Concrete Island, 2001, colour photograph / courtesy Museo di Fotografia Contemporanea, Cinisello Balsamo

Rischiano pene molto severe, 1998, colour photograph / courtesy Fondazione Sandretto Re Rebaudengo, Turin

Concrete Island, 1999, colour photograph / courtesy Museo di Fotografia Contemporanea, Cinisello Balsamo

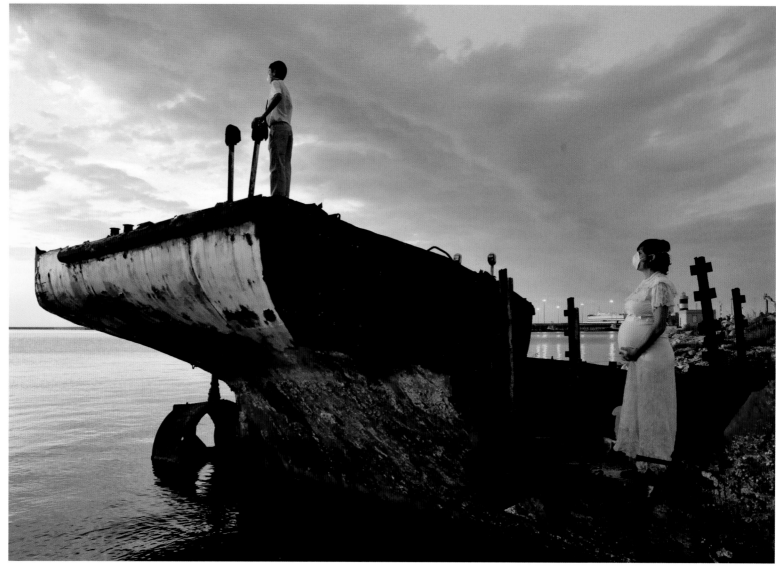

Capitani coraggiosi, 2008, street-photo performance / courtesy of the artist

Creators of the technique of *street-photo performance*, the group Dott. Porka's P.Proj is one of the most interesting "anti-artistic" collectives on the contemporary artistic scene. In the wake of the Dada-Situationist anti-lesson, P.Proj offers up a mixture of provocation, cognitive exploration and creative repossession of the urban fabric. Indeed it is a technique of "emotional disorientation"—a nod to Debord's "psychogeographical drift"—performed by the group in an urban setting, with illegal street performances in areas under sequestration, which they define *readymade areas*. "Exploring" the land, they offer it to us in a manner not seen before. Through their startling *alter-ego* Dott. Porka (an underground comic produced by P.Proj themselves), the group have been active on a national scale for some time. Drawings, photographs and comics are what remain of these operations in progress: aesthetics do not form the essence of their work, rather the desire to activate extended forms of "grassroots" communication. The grotesque register with which they operate shuffles the cards long since thrown into disarray by reality and pretence. Deliberately clambering over the fences of the art system, they urge a quest for new relationships, encouraging us to take a fresh look at that which surrounds us.

Antonella Marino

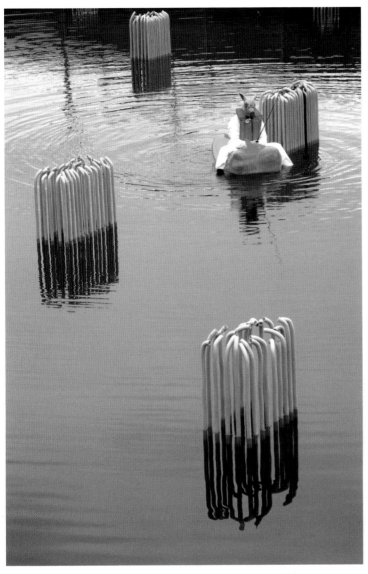

L'ultimo giorno dell'Ekomostr0, 2006, street-photo performance / courtesy of the artist

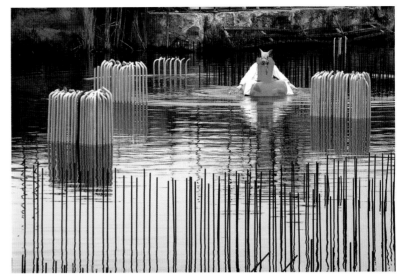

L'ultimo giorno dell'Ekomostr0, 2006, street-photo performance / courtesy of the artist

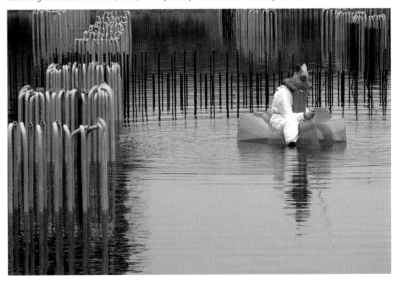

L'ultimo giorno dell'Ekomostr0, 2006, street-photo performance / courtesy Galleria Le Pleiadi, Mola di Bari

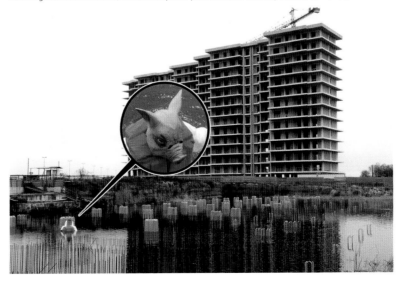

L'ultimo giorno dell'Ekomostr0, 2006, street-photo performance / courtesy of the artist

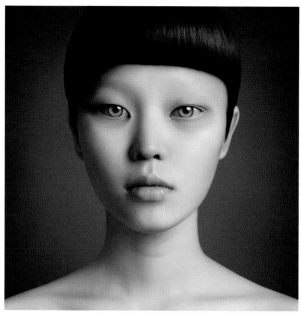

Duza's tears, 2008, C-print on diasec / courtesy Russian Tea Room, Paris

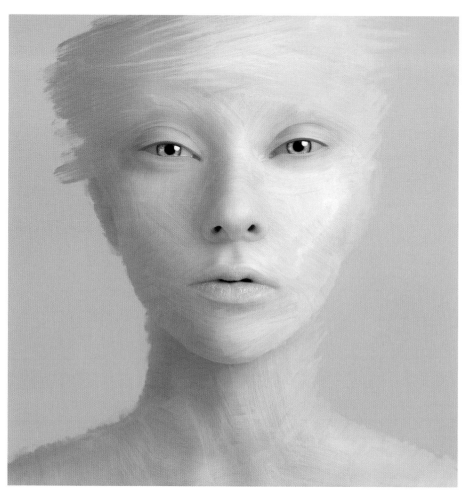

White, 2007, C-print on diasec / courtesy Russian Tea Room, Paris

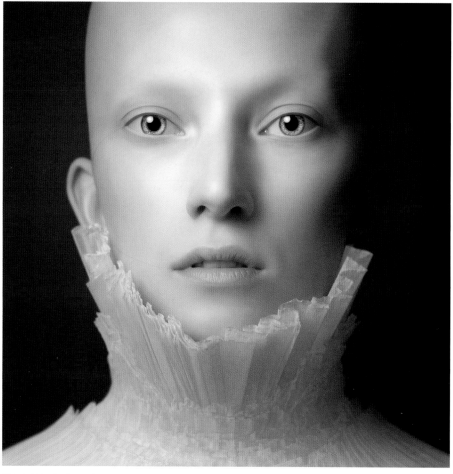

Tight 2, 2007, C-print on diasec / courtesy Russian Tea Room, Paris

I have a passion for the human face.
I use the artificial nature of digital photography as a tool to reach
the point between opposites such as alive and dead, attractive
and disturbing, beautiful and ugly. Thus I'm searching to transcribe
the feeling of presence that you get while passing a plastic mannequin.

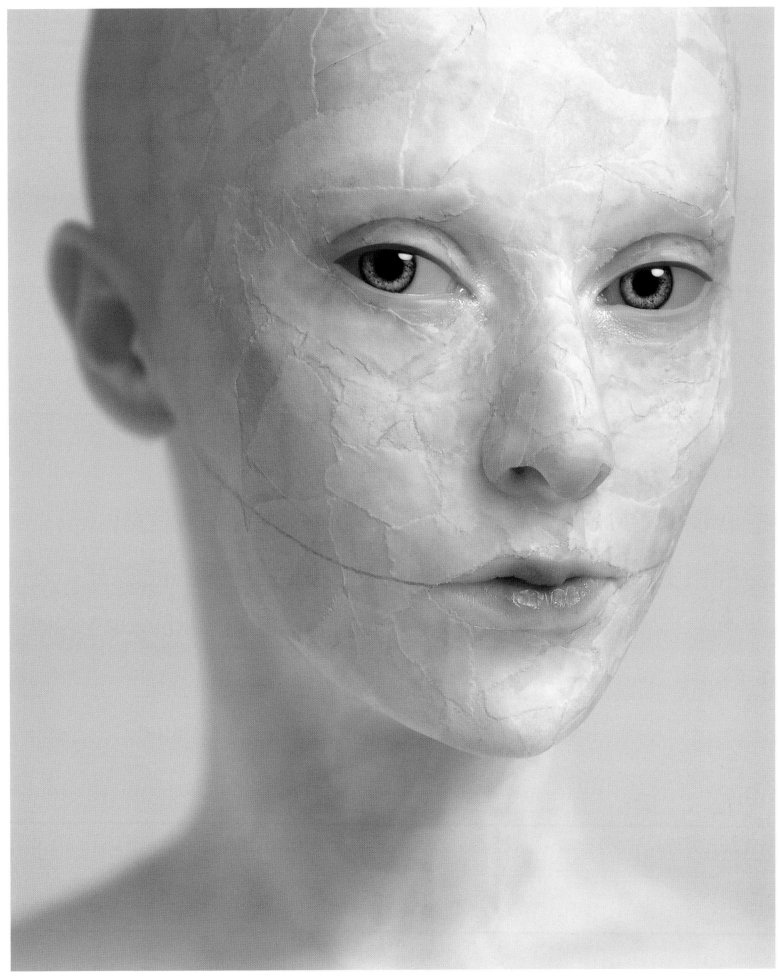

Paper 2, 2007, C-print on diasec / courtesy Russian Tea Room, Paris

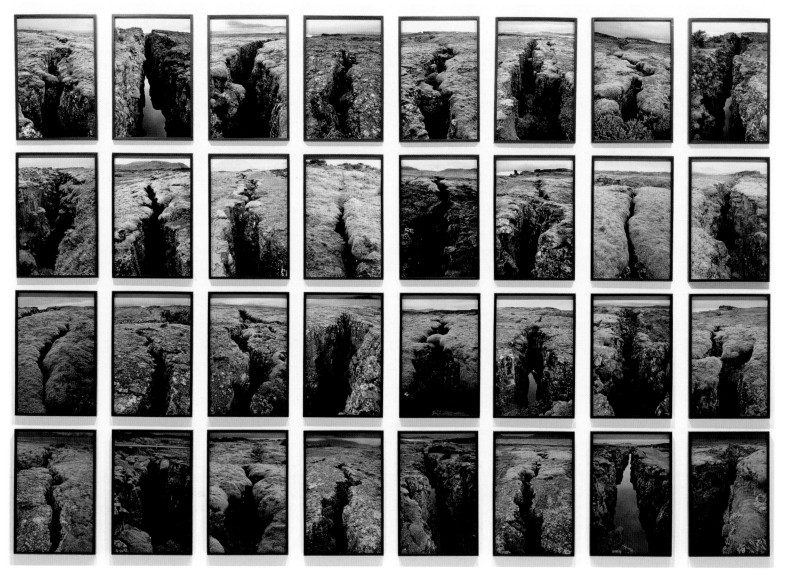

The fault series, 2001, 32 C-prints / courtesy neugerriemschneider, Berlin; Tanya Bonakdar Gallery, New York / photo Oren Slor

When I look at nature, I find nothing except, perhaps, my own
relationship to its spaces, or aspects of my relationship to them…
There is no true nature, only the construct that you and I make of it.

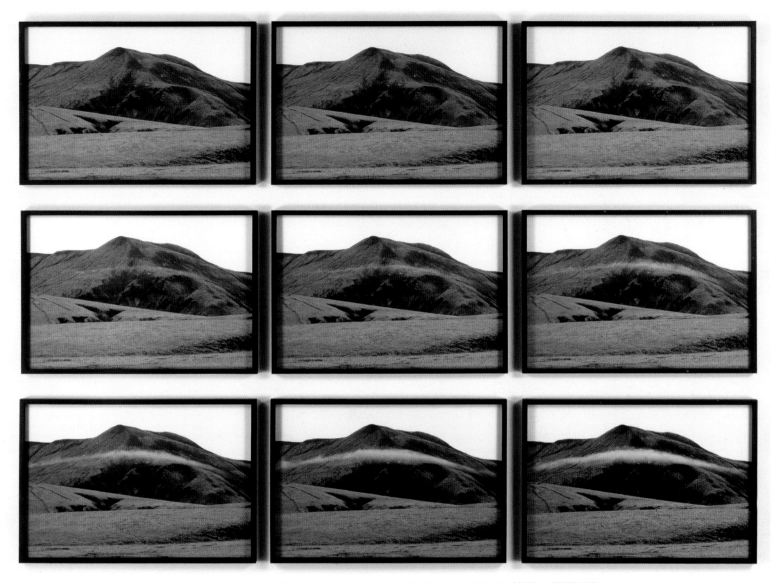

The morning small cloud series, 2006, 9 C-prints / courtesy neugerriemschneider, Berlin; Tanya Bonakdar Gallery, New York / photo Fabian Birgfeld (PhotoTECTONICS)

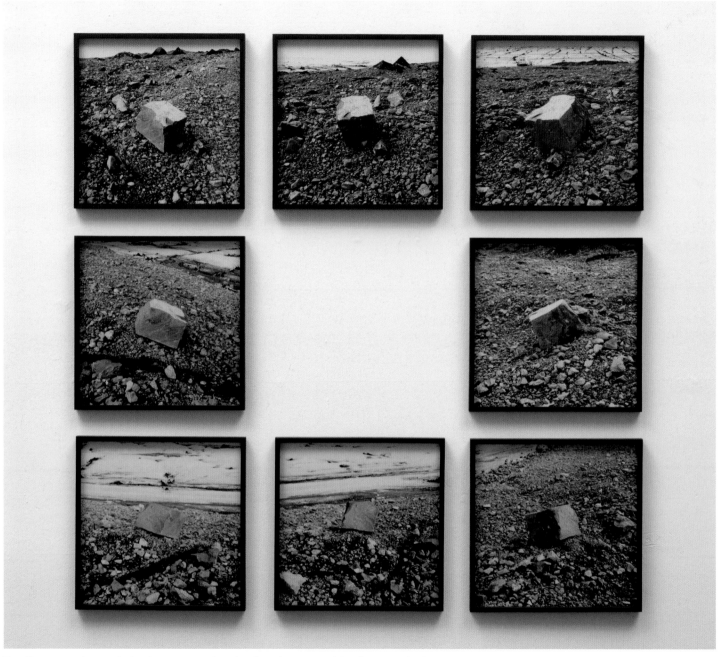

The cubic compass rock, 2007, 8 C-prints / courtesy neugerriemschneider, Berlin; Tanya Bonakdar Gallery, New York / photo Jens Ziehe

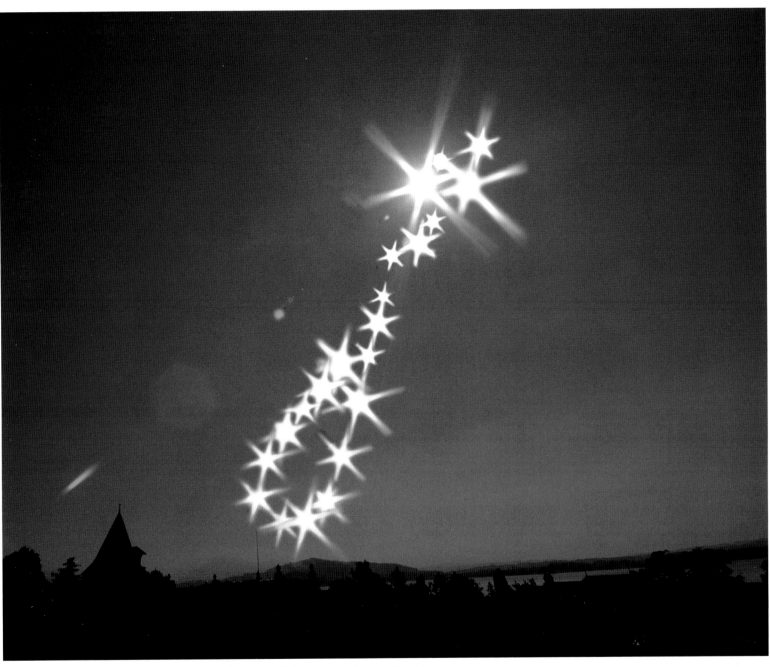

Analemma for Kunsthaus Zug, 2009, C-print / courtesy neugerriemschneider, Berlin; Tanya Bonakdar Gallery, New York

My work is not historical. I do not want to perpetuate
the memory of a place but to examine and visualize
contemporary attitudes towards memory and history.
My intention was not to document the extermination camps
but to document the contemporary perception of those
places. My images are about memory, about its selectivity,
and about the banalization of evil.

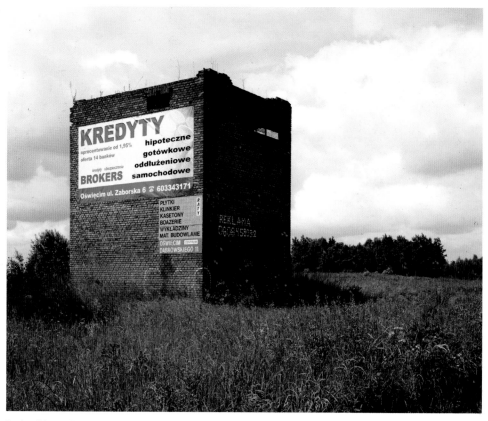

Bunker d'observation, zone concentrationnaire IG Farben (Monowice), 2008, inkjet print /
courtesy Galerie Le Bleu du Ciel - Burdeau, Lyon

Bunker individuel antiaérien, Auschwitz III-Monowitz (Monowice), 2006, inkjet print /
courtesy Galerie Le Bleu du Ciel - Burdeau, Lyon

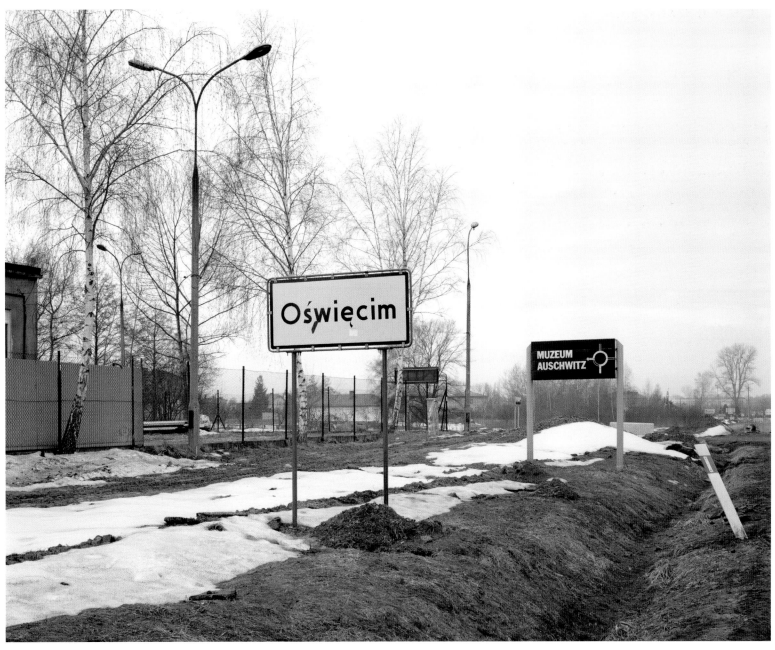

Entrée de la ville d'Oświęcim, zone concentrationnaire IG Farben (Monowice), 2006, inkjet print / courtesy Galerie Le Bleu du Ciel - Burdeau, Lyon

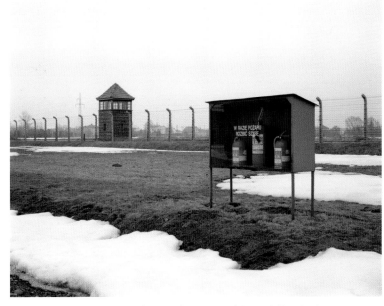

En cas d'incendie, briser la vitre (Auschwitz II-Birkenau, Brzezinska), 2006, inkjet print /
courtesy Galerie Le Bleu du Ciel - Burdeau, Lyon

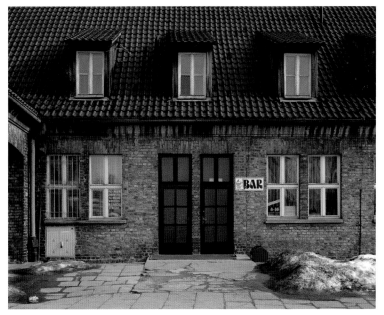

*Bar, block d'origine, où se trouvait un circuit de douches pour les prisonniers déjà enregistrés,
Musée d'Auschwitz*, 2006, inkjet print / courtesy Galerie Le Bleu du Ciel - Burdeau, Lyon

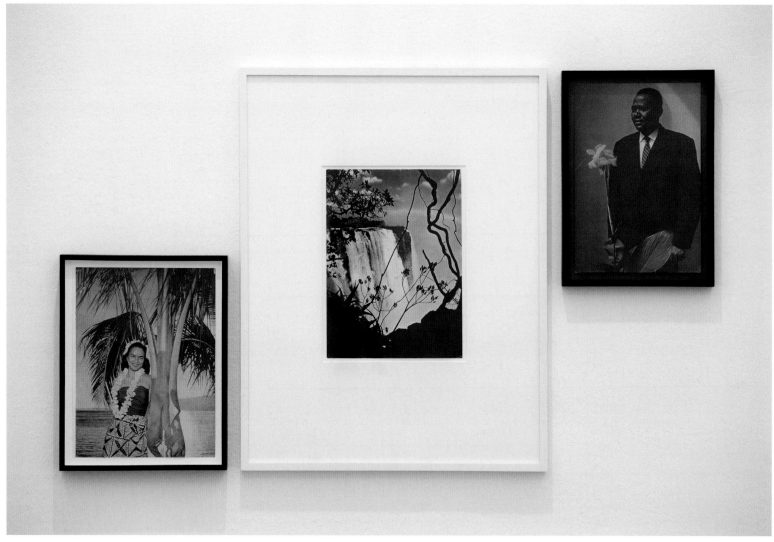

Installation view from solo exhibition at Künstlerhaus Bethanien, Berlin, June 2008 / courtesy of the artist / photo David Brandt

I find much pleasure in taking something that already exists and changing it into something else or putting it into a new context. Cutting is one way of achieving that. But I get the same pleasure when I take photographs or when I make a video or film. Moving image works in similar ways, for example.

After you have gathered the material, you can start editing/cutting, overlaying and restructuring the original footage/s to achieve the result you wish. I guess I like images of the past because of their aesthetic qualities; the colours, tones and textures, but also because I can keep a distance from them.

Untitled 004c/g, 2007, paper collage / private collection

Eškinja's photographs are surprising in their simplicity, subtly seductive despite seeming to limit themselves to being a simple documentation of an extremely spare interior staging. Seductive in their accuracy, the transparency and readability of their details, their "nudity".

Riccardo Caldura

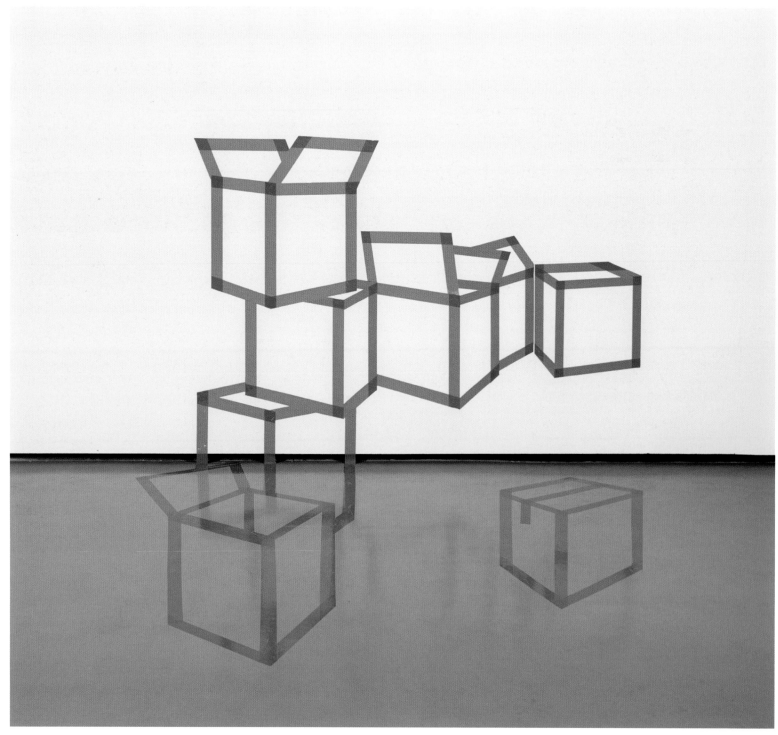

Made In:Side, 2008, lambda print / courtesy Federico Luger Gallery, Milan

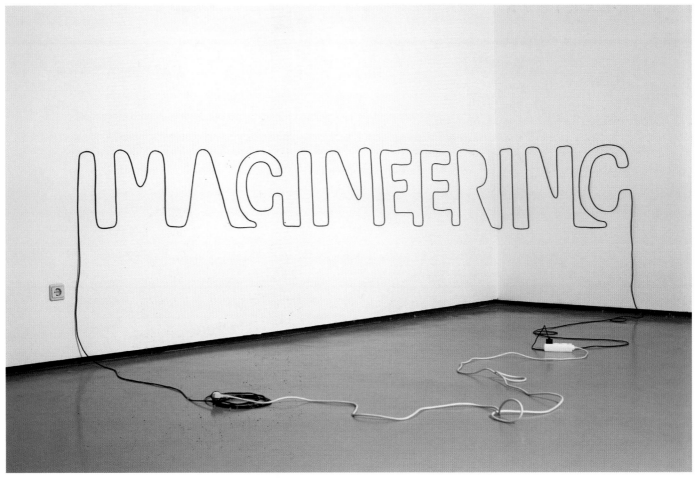

Imagineering, 2006, lambda print / courtesy Federico Luger Gallery, Milan

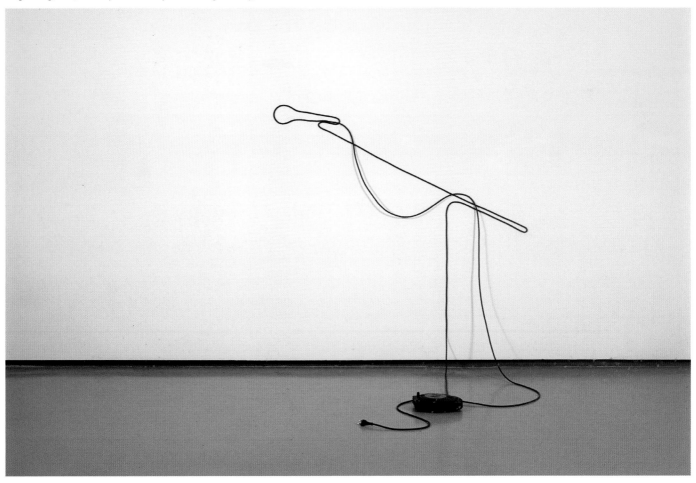

Microphone, 2005, lambda print / courtesy Federico Luger Gallery, Milan

I'm interested in exploring the magic function of photography.

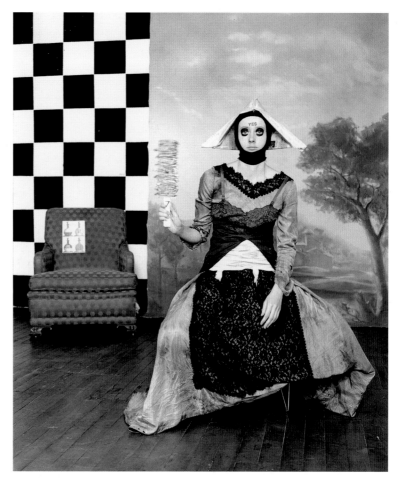

The Yes Queen, 1998, black and white photograph / courtesy of the artist

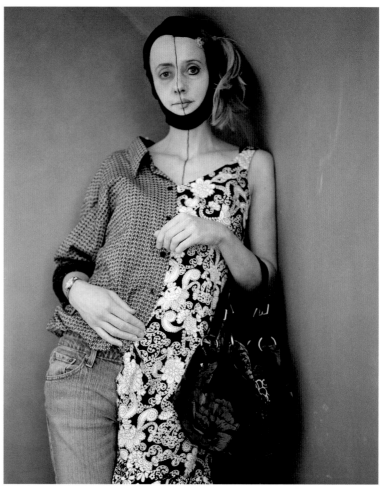

The Mute Book #2, 2009, black and white photograph / courtesy of the artist

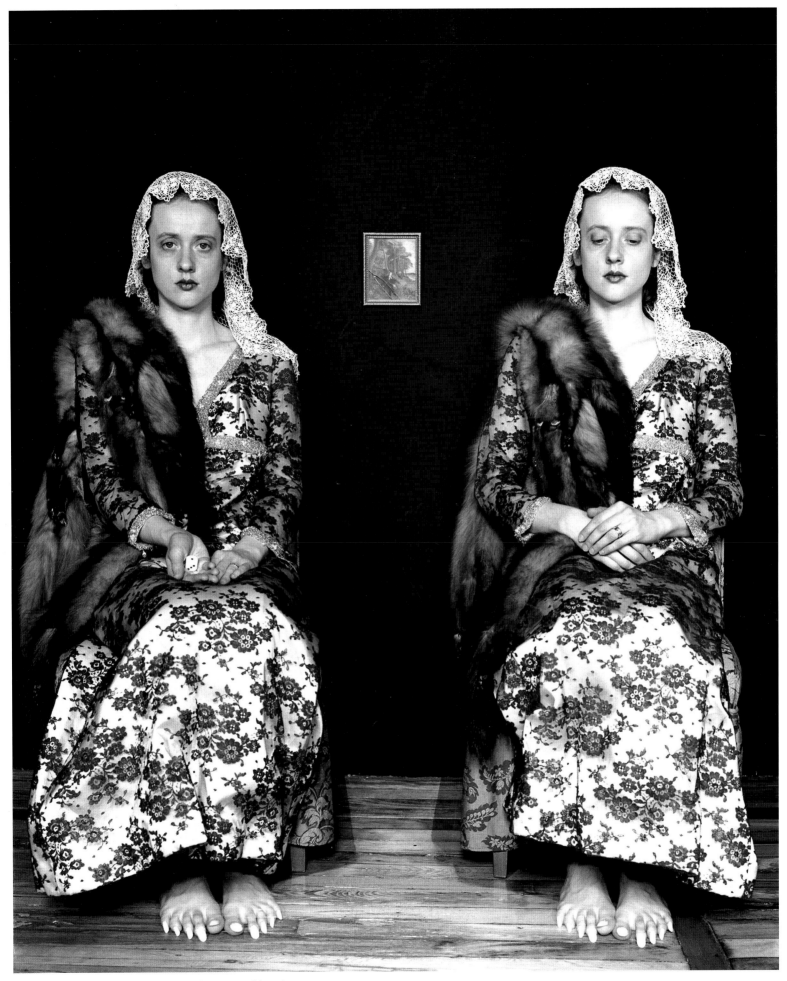

Twin Manicurists, 1996, black and white photograph / courtesy of the artist

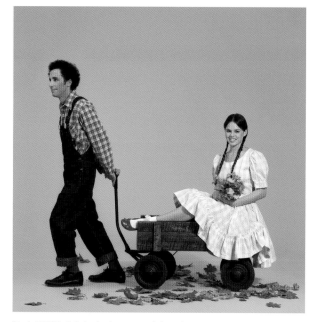

Study 2, 2006, digital print / courtesy of the artist

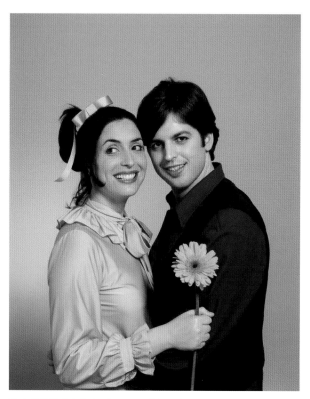

Study 3, 2005, digital print / courtesy of the artist

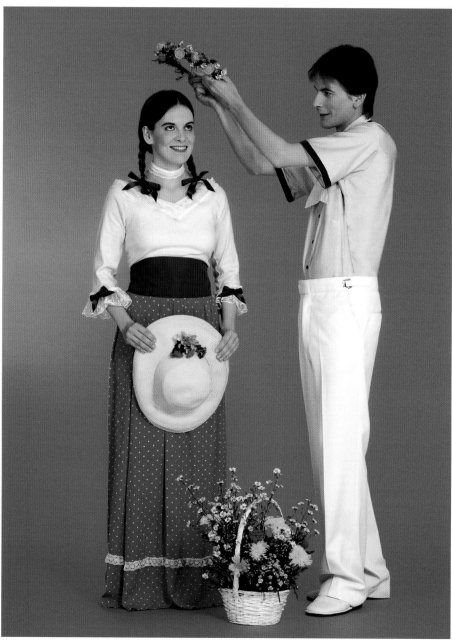

Referencing historic postcards, the series *Love Triangle* questions how mass-media culture glamorizes "love" through images that we believe we must mirror in order to realize our own dreams of happiness. To create this series, I have cast couples, created costumes and constructed sets to evoke these universal expectations and aspirations. *Love Triangle* stages and subverts this cycle, revealing both our need for and our failure to have the perfect love story in our lives. By inviting each couple into my studio, giving them their entire image, I was both defining their relationship and questioning it.

Study 4, 2005, digital print / courtesy of the artist

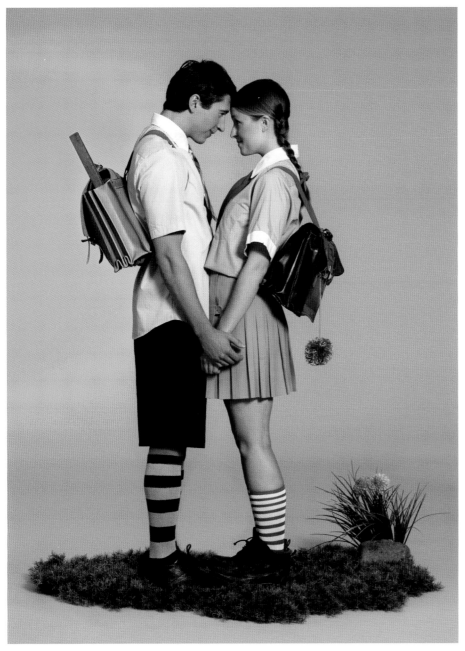

Study 5, 2007, digital print / courtesy of the artist

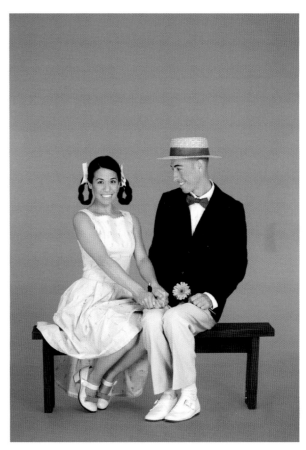

Study 10, 2005, digital print / courtesy of the artist

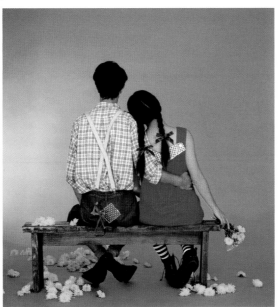

Study 1, 2005, digital print / courtesy of the artist

Sometimes I have the feeling that everything around me was built
to create my artworks. Like a big filmset, I just need to start rolling.
This situation causes doubts in me.

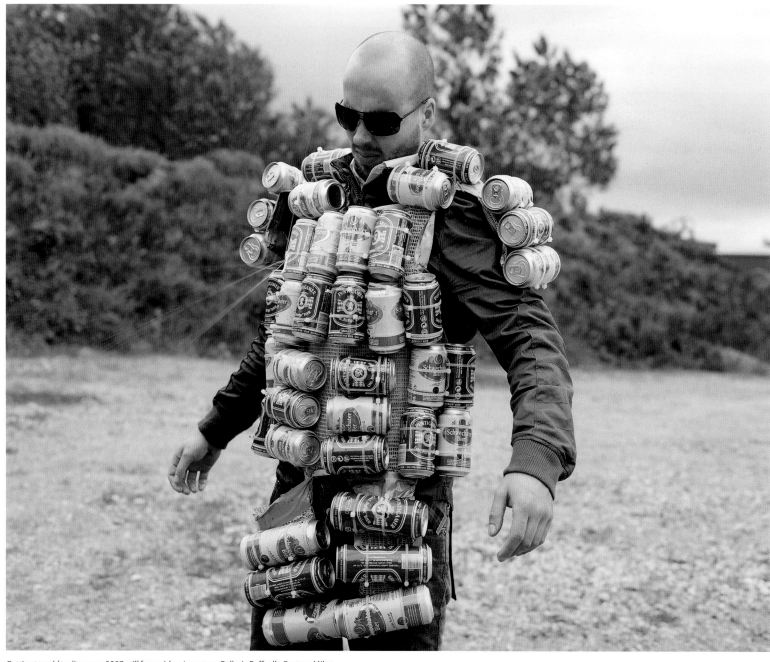

Getting too old to die young, 2007, still from video / courtesy Galleria Raffaella Cortese, Milan

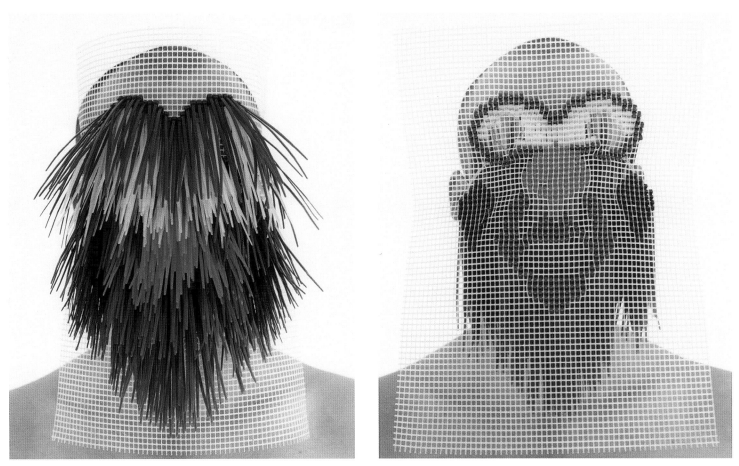

All right... All right, 2007, colour photograph / courtesy Galleria Raffaella Cortese, Milan / photo Rainer Frimmel

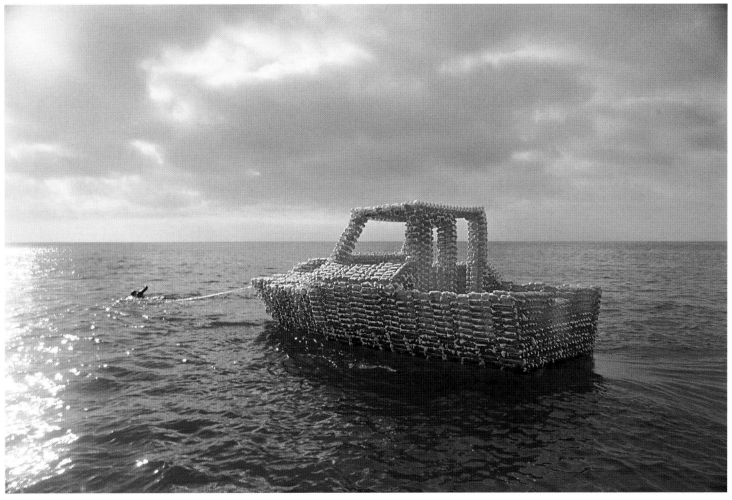

Early one morning with time to waste, 2007, colour photograph / courtesy of the artist / photo Ela Bialkofska

I have no photographs of myself as a child.
This is one of the reasons I create self-portraits.
I do not put myself in the photographs: my work is based
on determined situations and characters I know, I imagine
them once again, I dream, then create my work. I borrow an identity.
To succeed in doing so, I immerse myself in the necessary mental
and physical state. It is a way of freeing me from myself.
A solitary path. I am a solitary man.

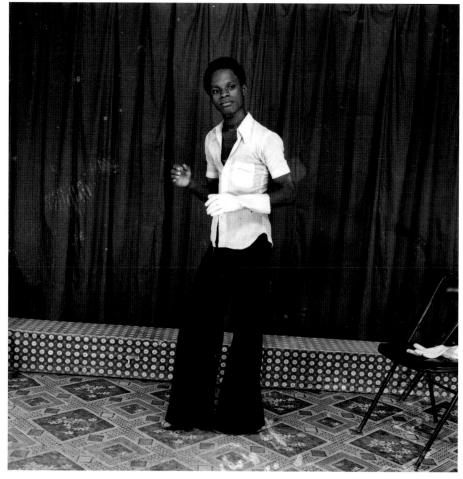

Self-portrait (SM08), 1977-2003, silver gelatin print / courtesy e x t r a s p a z i o, Rome

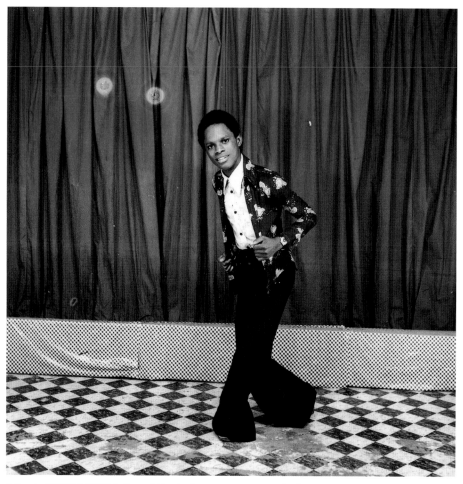

Self-portrait (SM12), 1976-2003, silver gelatin print / courtesy e x t r a s p a z i o, Rome

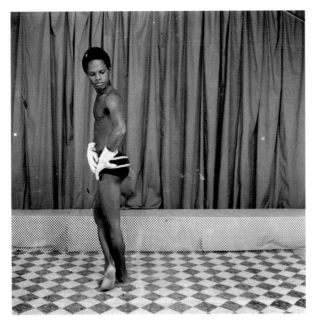

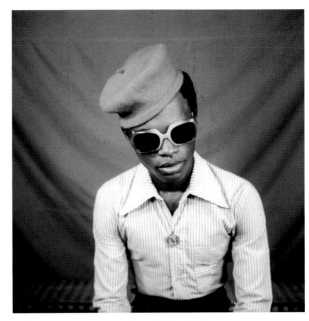

Self-portrait (SM14), 1976-2003, silver gelatin print /
courtesy e x t r a s p a z i o, Rome

Self-portrait (SM18), 1977-2003, silver gelatin print /
courtesy e x t r a s p a z i o, Rome

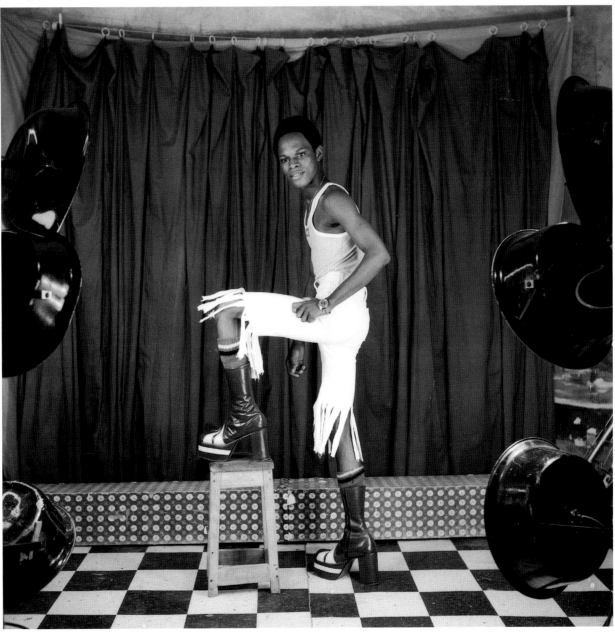

Self-portrait (SM30), 1977-2003, silver gelatin print / courtesy e x t r a s p a z i o, Rome

In her three-part project on teenage girls, Julia sensitively handles the transition of teenage girls to womanhood, capturing the lives and feelings of young girls as they change from relative innocence to a heightened awareness of their future adult life. In the first part of the project, *Teenage Stories*, she captures the inner tensions experienced by teenage girls relating to their changing appearance and their new role in society. In the second part, *School Play*, Julia compares the cultural differences between schoolgirls: the Chinese girls are shown as being disciplined and behaving as a unit, contrasting with the English girls' individuality and greater cynicism to situations. In the third part, *In Between*, girls are no longer stationary, but floating. This symbolises that the transition to womanhood has progressed, but it is not yet accomplished by far.

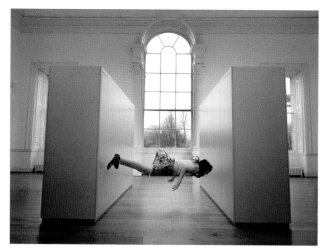

Cupboards, 2008, C-print / courtesy of the artist

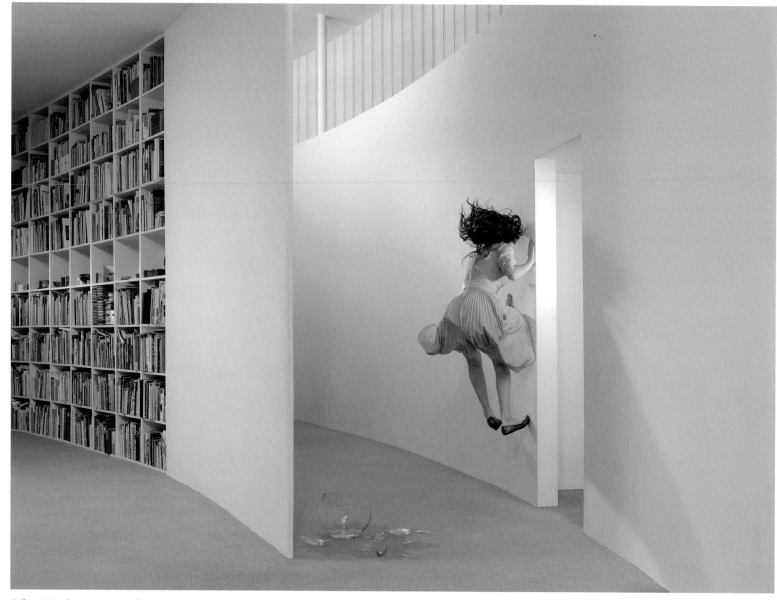

Hallway, 2008, C-print / courtesy of the artist

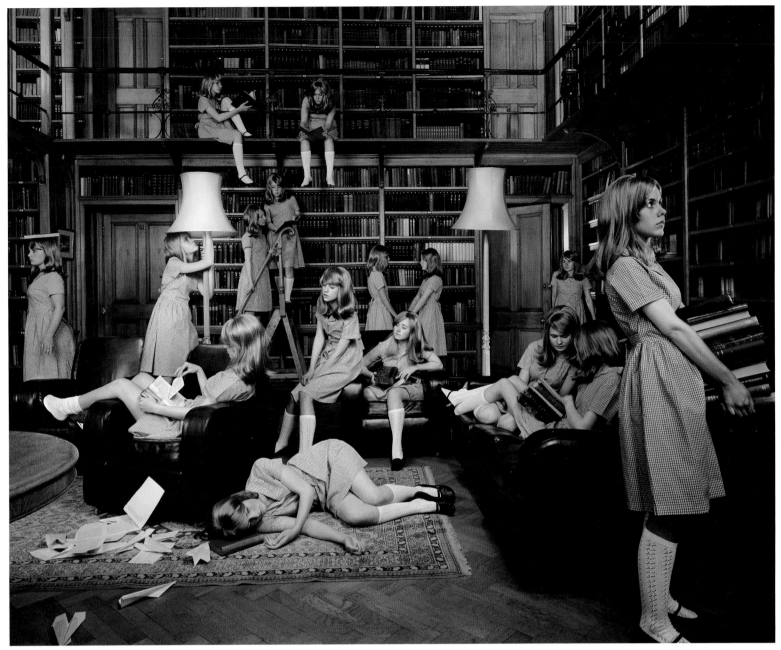

Library, 2007, C-print / courtesy of the artist

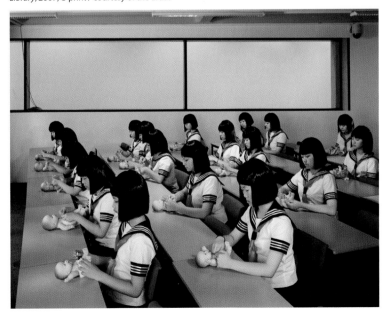

Nappy change, 2007, C-print / courtesy of the artist

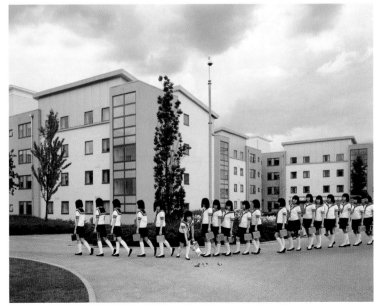

Broken lunchbox, 2007, C-print / courtesy of the artist

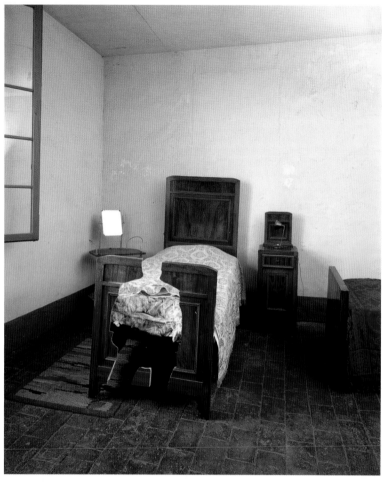

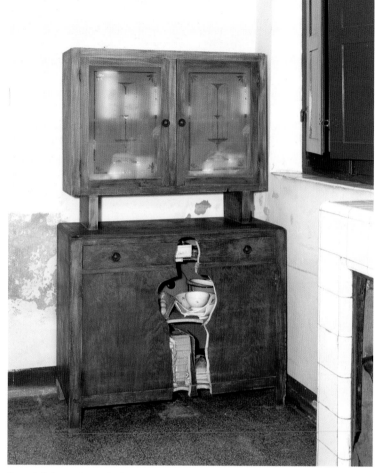

Senza titolo (nano#2), 2001, lambda print / courtesy francesco pantaleone arte Contemporanea, Palermo; pinksummer, Genoa / photo Gian Paolo Ossani

Senza titolo (nano#4), 2001, lambda print / courtesy francesco pantaleone arte Contemporanea, Palermo; pinksummer, Genoa / photo Gian Paolo Ossani

I first got to know your stubborn side when you were very young, when you wanted us to do something and you insisted so much that we had to please you. I would always give in right away, because I knew I would have to, sooner or later, such was your insistence.

Mariagrazia Galegati, Stefania's aunt

Coca (04), (notes by chance #8), 2007, digital print / courtesy francesco pantaleone arte Contemporanea, Palermo; pinksummer, Genoa

Coca (13), (notes by chance #8), 2007, digital print / courtesy francesco pantaleone arte Contemporanea, Palermo; pinksummer, Genoa

Coca (10), (notes by chance #8), 2007, digital print / courtesy francesco pantaleone arte Contemporanea, Palermo; pinksummer, Genoa

N⁻¹ #5, 2005-2007, C-print on dibond / courtesy Artericambi, Verona

In the project *La trilogia dell'intelligenza del Male* ("The trilogy of the intelligence of Evil", 2006-2008), Andrea Galvani orchestrates a slow process of disappearance of the subject carried out by natural phenomena which make up the landscape itself, or by temporary actions, often violent and brief in duration. A group of rabbits set free in the middle of a glacier at an altitude of 3400 metres involuntarily collaborates on the staging of a change in its own grouping. Various black smoke-producers detonated in the whiteness

of the snow-covered landscape transfigure and re-design the limit and sense of an action. Just like a magical feedback of light from the dilated pupils of a colony of cats surprised by a flash in the darkness re-opens and extends the perception of Space. On the contrary, in the series *La morte di un'immagine* ("The death of an image", 2005-2008), various objects installed physically at the location of shooting, in keeping with a strict hierarchical perspective, set themselves in the vision of the landscape, doubling and re-organising it on various levels.

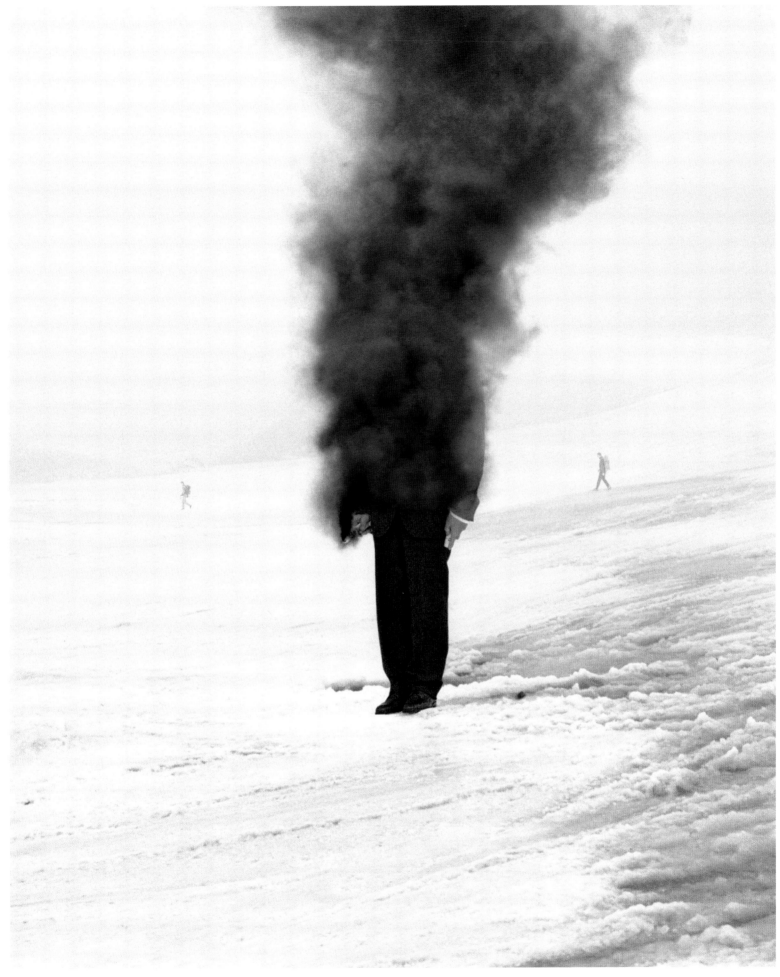

L'intelligenza del male #5, 2007, C-print on dibond / courtesy Artericambi, Verona

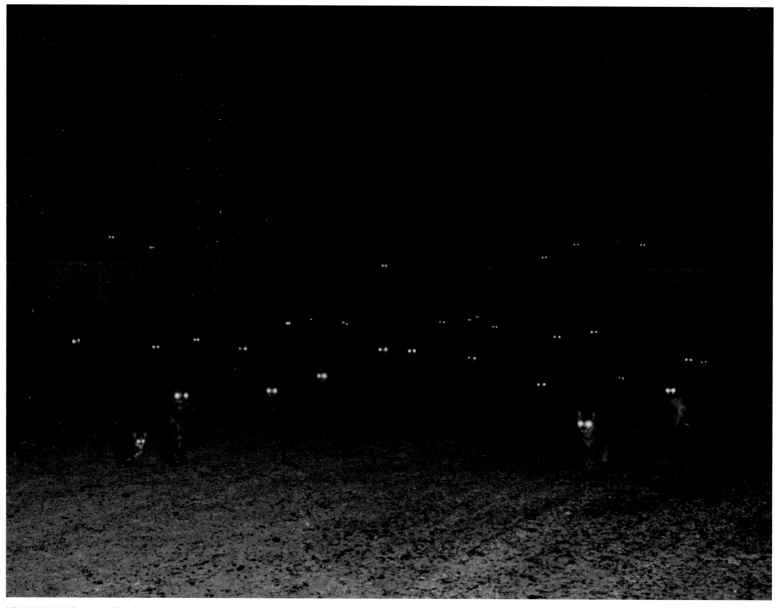

N¹ #1, 2005-2007, C-print on dibond / courtesy Artericambi, Verona

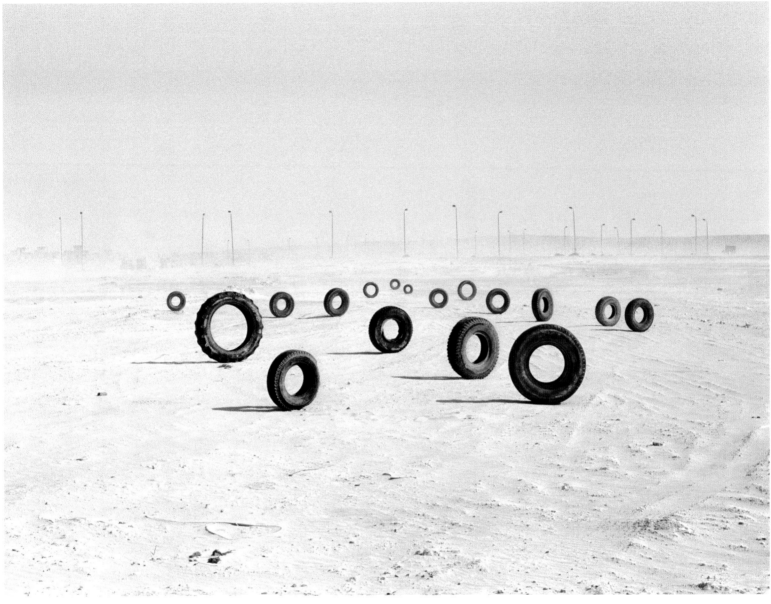

La morte di un'immagine #13, 2008, C-print on dibond / courtesy of the artist

In the series *Qajar* and *Like Everyday (Domestic Life)*, Shadi Ghadirian explores the theme of conflict between tradition and modernity, and the position of women dominated by male stereotypes. She warns against a literal reading, though, and stresses the universal dimension of the theme woman-object. While *Ctrl-Alt-Del* queries the taboo surrounding the female body, *White Square*, *Nil Nil* and *My Press Photos* extends the themes by adding the subject of war.

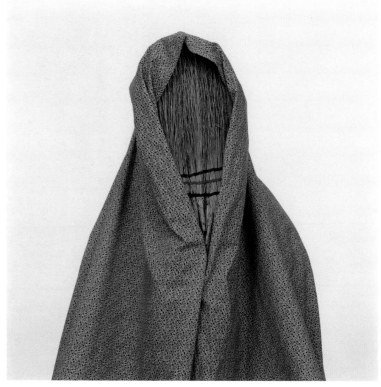

Domestic Life #09, 2002, C-print / courtesy aeroplastics contemporary***, Brussels

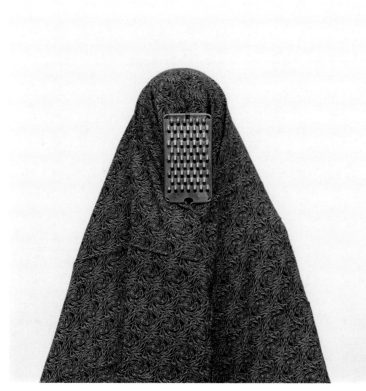

Domestic Life #01, 2002, C-print / courtesy aeroplastics contemporary***, Brussels

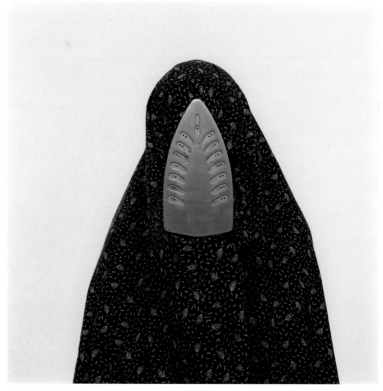

Domestic Life #08, 2002, C-print / courtesy aeroplastics contemporary***, Brussels

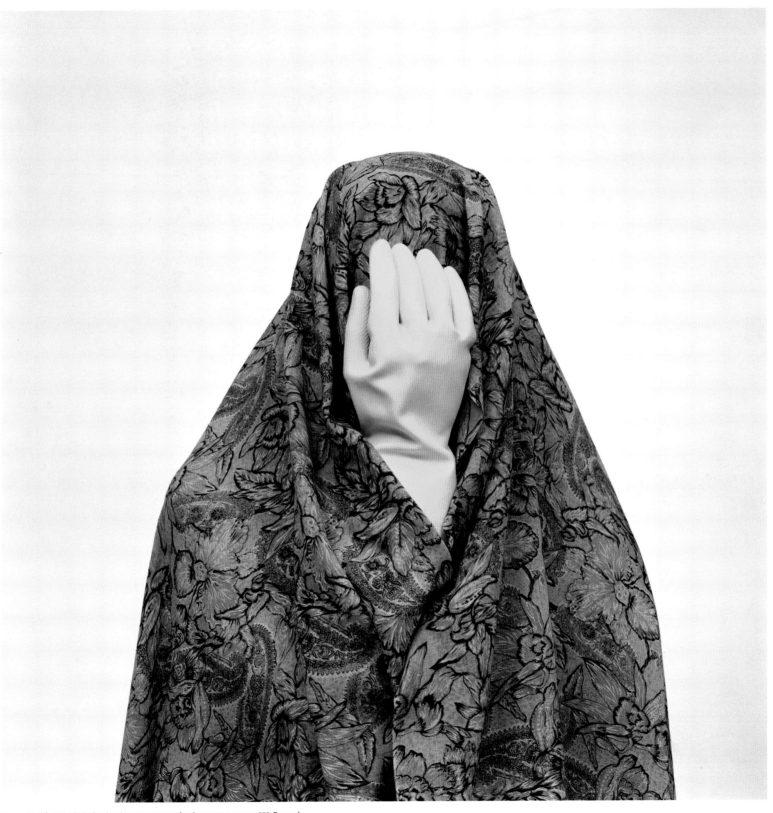

Domestic Life #61, 2002, C-print / courtesy aeroplastics contemporary***, Brussels

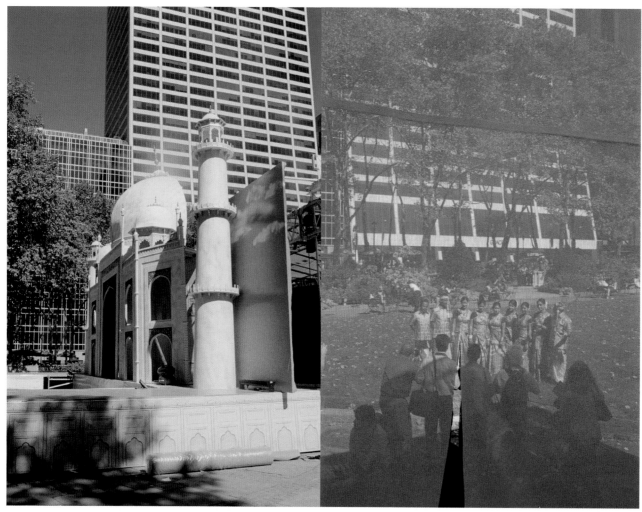

Incredible India Performance (Bryant Park, New York City), 2007, digital print /
courtesy Gallery Nature Morte, New Delhi

Mr Bassi's home (Yuba City, California), 2001, digital print /
courtesy Gallery Nature Morte, New Delhi

Nearly five decades after Robert Frank, Gauri Gill takes a series
of solitary journeys through America, traveling extensively from
New York and New Jersey to California, the Midwest and five
Southern states. She moves outward, from the nucleus of family
and friends to their networks, through a map lined with the
material and psychological presence of migrants. The resultant
body of photographs *The Americans* emerges as a palimpsest
that documents the new Americans—Indian immigrants. That Gill
addresses her subjects with the transnational gaze of the traveling
photographer brings her subject within the potent discourse
of migration and Diaspora, post-colonialism and the new world.
Set in the chromatic intimacy of the candid photograph, it is inscribed
with the material residue of two cultures; the glittering flecks
of Bollywood and Hollywood, the Indian and the American dream.

Gayatri Sinha

Stores in Jackson Heights (Queens, New York), 2004, digital print / courtesy Gallery Nature Morte, New Delhi

Jagdeepak Steven Sandhu's mother and wife, outside their home (Virginia), 2002, digital print / courtesy Gallery Nature Morte, New Delhi

How could it be possible to see and to photograph a thing
before having an idea about it? How can I free an object
from the imagination I have about it? These are questions
which always come back to me.

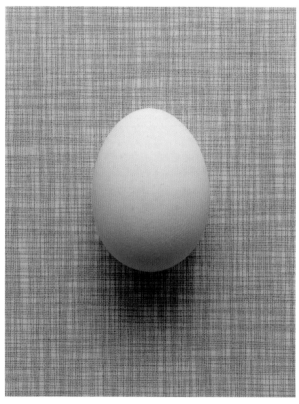

Egg, 2008, C-print on diasec / courtesy Galerie Ulrich Fiedler, Berlin

Circle, 2008, C-print on diasec / courtesy Galerie Ulrich Fiedler, Berlin

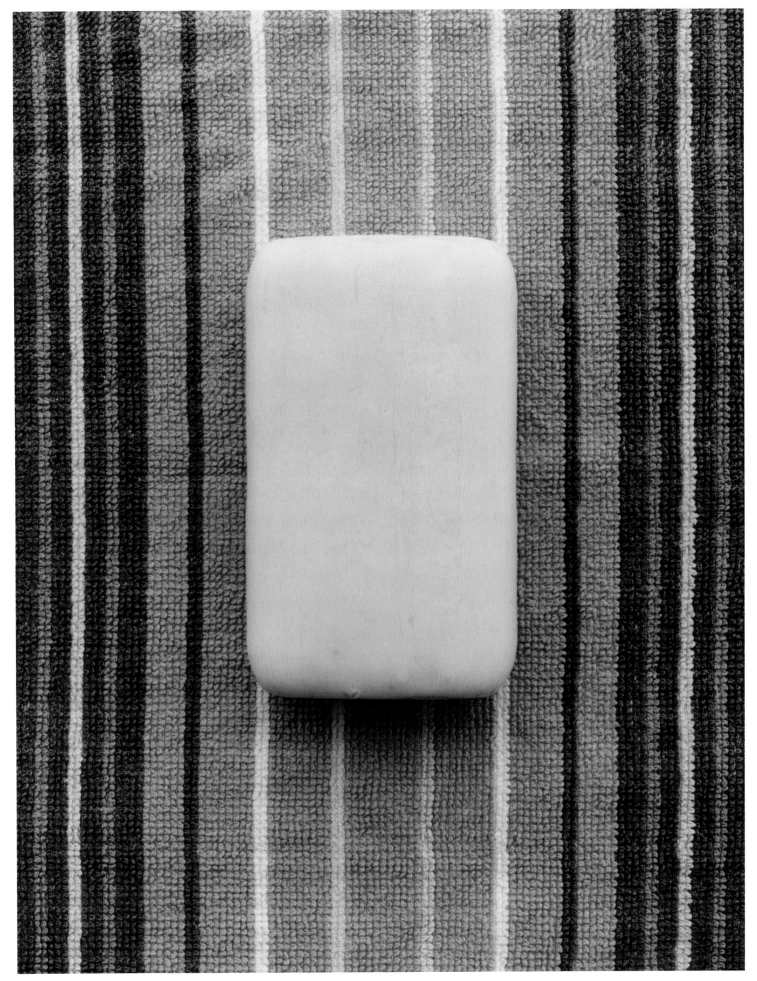

Soap, 2008, C-print on diasec / courtesy Galerie Ulrich Fiedler, Berlin

Andrea Galvani asked me to work at a certain time of the day, when the light began to fade, forcing me to seek out small natural phenomena, situations at the limit of the invisible which often take place without leaving a trace. At nightfall the gnats, little winged insects, moved in swarms, drawing black clouds along the sides of the roads. I tried to stop their rhythm, the geometry of an event. I used the flash to see them as they are, to violate a mystery. What happened is difficult to explain; it resembles a recognition. There is nothing extraordinary, the insects have always been there and they will be back, I will stop watching them and someone else will do it, but I have recognised something of myself in these images, something which seemed to be waiting for me outside.

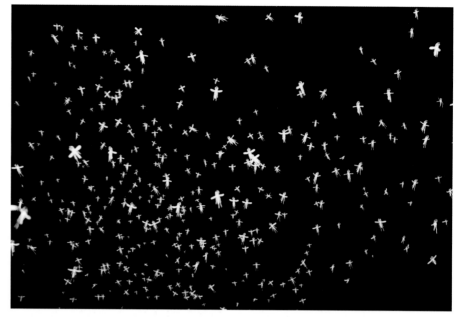

Insetti, 2008, lambda print / private collection

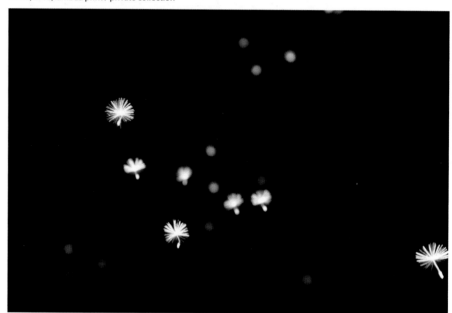

Soffioni, 2008, lambda print / private collection

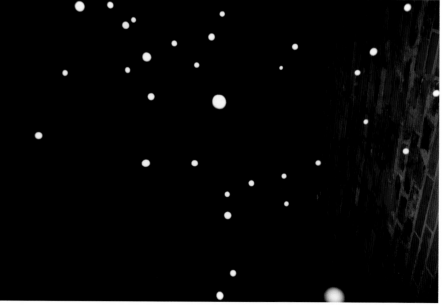

Palline, 2008, lambda print / private collection

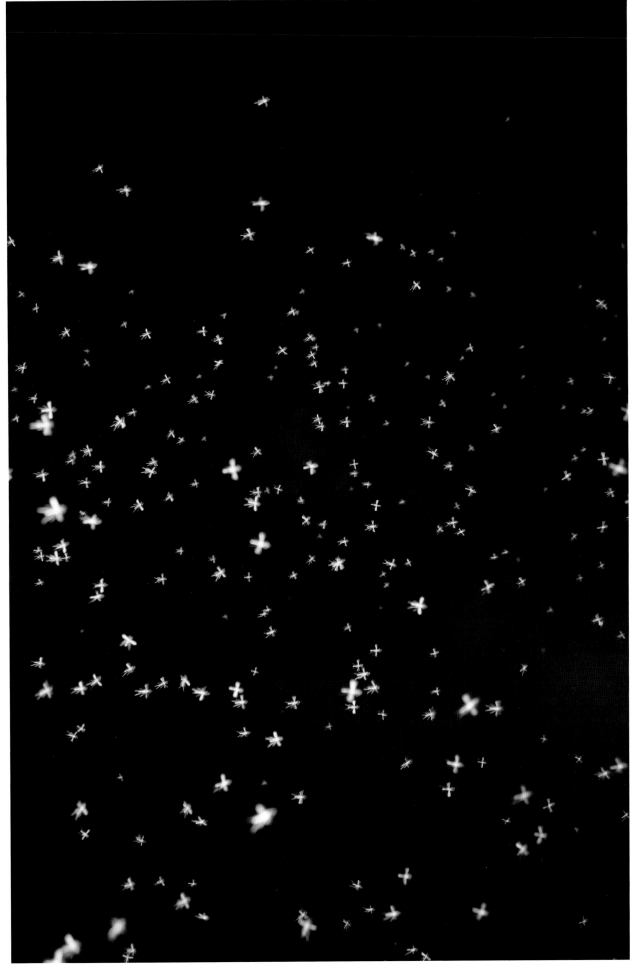

Insetti, 2008, lambda print / private collection

For me photography is a way of objectifying the surrounding
space that we call "reality". Space and scale are the key elements,
and people, if present, are only symbols, not individuals. Human
alienation to the landscape we ourselves created; the desire to find
a place for a "figure" within this landscape is my main motif.

Komsomolsk-na-Amure, 2006, pigment print / courtesy of the artist

Moscow, 2007, pigment print / courtesy of the artist

Port Vanino, 2008, pigment print / courtesy of the artist

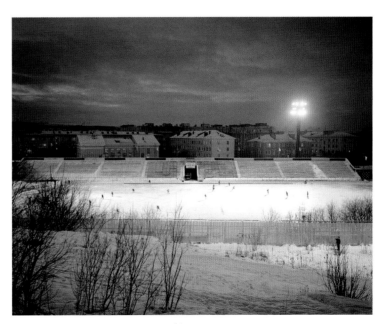

Murmansk, 2007, pigment print / courtesy of the artist

His works become photographic actions or collective performances where a recording remains at the end in graphic form, either photographic or video. The artist transfers the decision of taking or recording a photograph, making him the only one taking part in the tour as a mere spectator among the other spectators of his own artistic process.

Simulation of an eruption of the Montsacopa volcano in Olot (Spain), 2007, duraclear / courtesy of the artist / photo taken by the audience at the performance

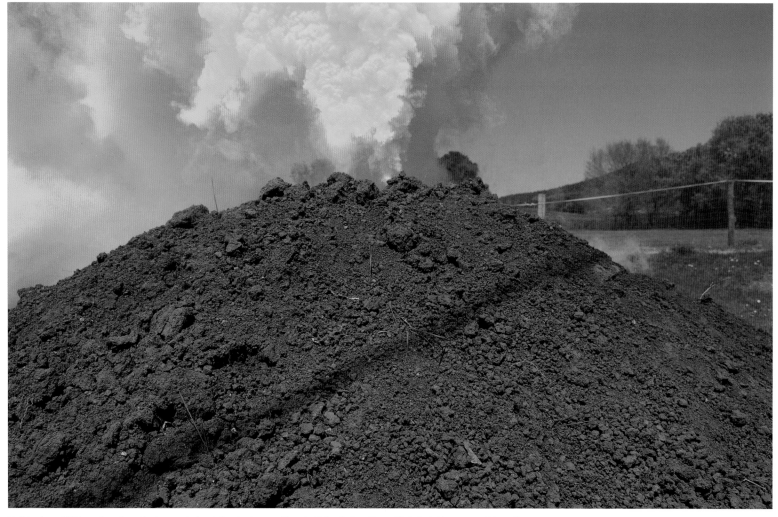

De (+) volcans, 2007, creation of small volcanoes in front of real volcanoes (Garrotxa Volcanic Area Natural Park, Spain) / courtesy of the artist

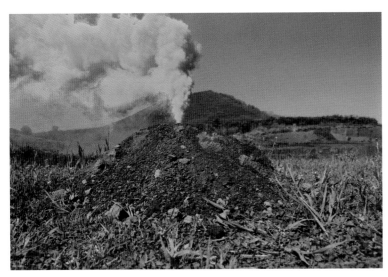

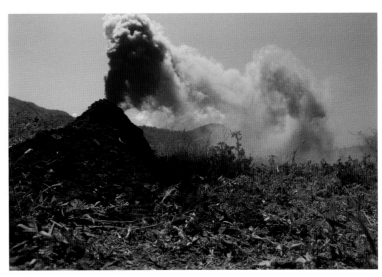

De (+) volcans, 2007, creation of small volcanoes in front of real volcanoes (Garrotxa Volcanic Area Natural Park, Spain) / courtesy of the artist

De (+) volcans, 2007, creation of small volcanoes in front of real volcanoes (Garrotxa Volcanic Area Natural Park, Spain) / courtesy of the artist

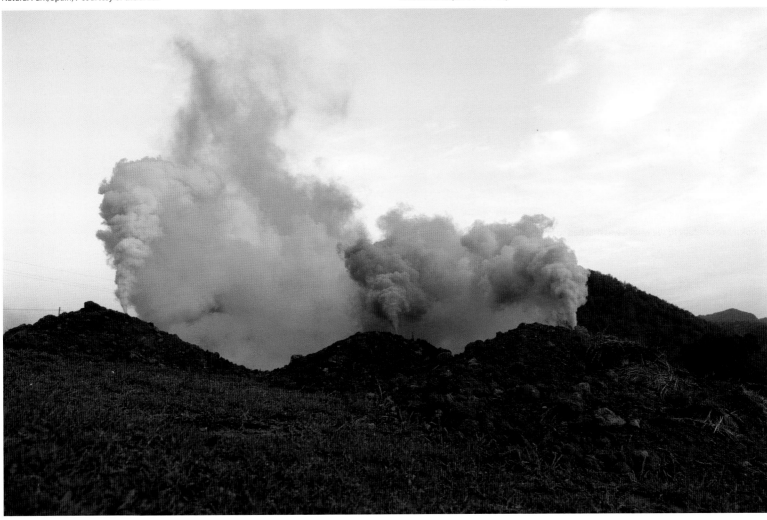

De (+) volcans, 2007, creation of small volcanoes in front of real volcanoes (Garrotxa Volcanic Area Natural Park, Spain) / courtesy of the artist

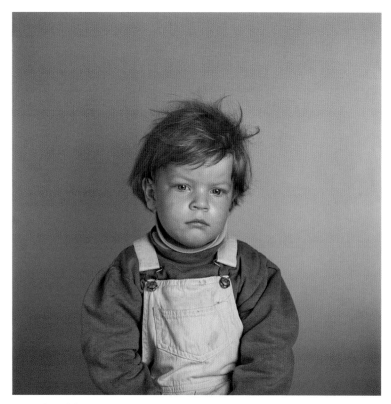

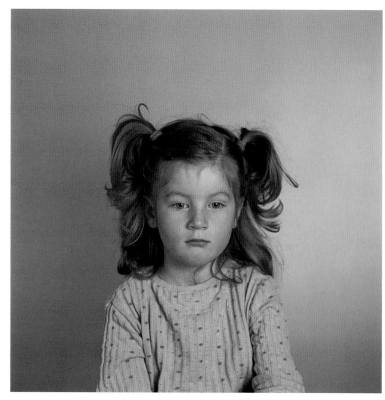

A Disenchanted Playroom, 2006, C-print / courtesy of the artist

A Disenchanted Playroom, 2006, C-print / courtesy of the artist

This work has its origins in an everyday situation: I saw a child watching television. Although it was just a normal scene, the child's facial expression remained fixed in my memory for a long time. After a while it began to occupy my thoughts so much that I decided to look more carefully to see what it was that had so fascinated me, or perplexed me. Taking virtually the same perspective that I had when looking at the child before, I then set about making the portraits. Only the scenic framework was different, that is, the background and lighting. But this framework was important to draw the viewer's full attention to the children's facial expressions. I didn't want to stylize them, however, but to show them as realistically and naturally as possible: some with dirty or sweaty clothes, just back from playing, with unkempt hair and without makeup. In these portraits it was important to record the precise moment in which the children showed absolutely no impulse or emotion at all, when it was most obvious that they had been taken in by the television in a certain way and had abandoned themselves to it—even when what they were watching was child-oriented programming. Far from demonizing the television and its possibilities, this reveals to me how the world is disenchanted for these children at that moment.

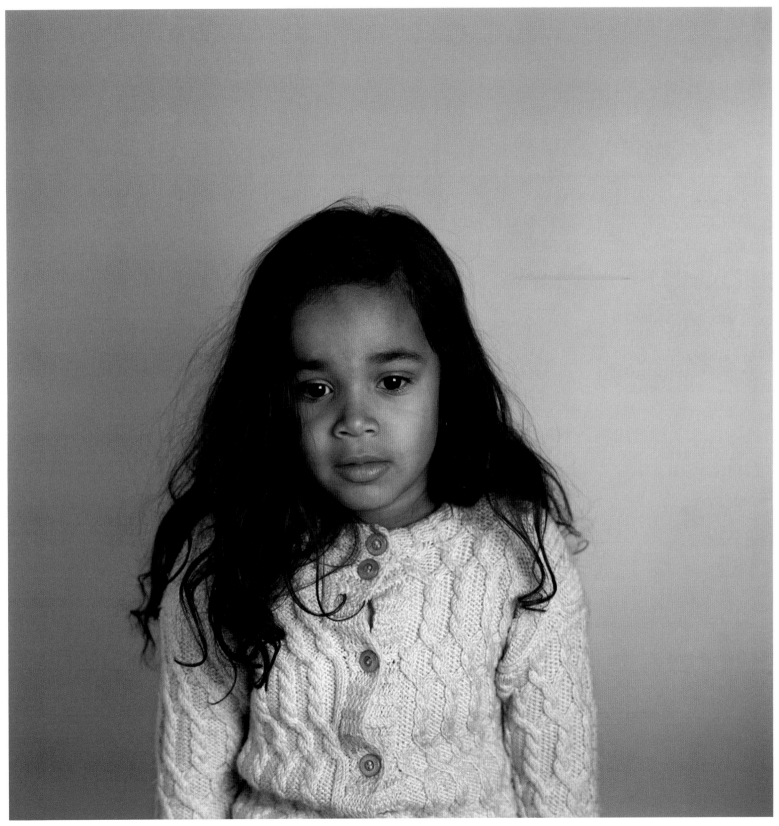

A Disenchanted Playroom, 2006, C-print / courtesy of the artist

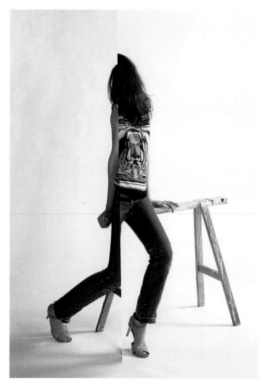

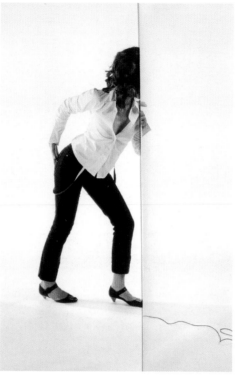

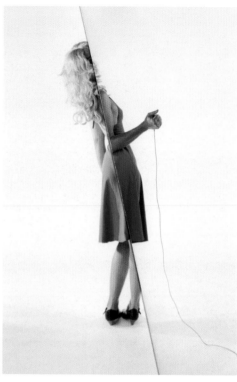

Like models (Ulrike), 2008, folded C-print / private collection

Like models (Alice), 2008, folded C-print / private collection

Like models (Marie), 2008, folded C-print / private collection

The politics of images, their purpose, their observation and cultural background are my main focus. But art today can not be limited to one specific medium; hence my work draws upon projects and involves the parameters of presentation.

"It is not by way of an incision, with its definitive separation and the thereby implied possibilities of an arbitrary re-grouping of body parts, or images of body parts, that Heider adds to the photograph. Instead, she folds the photograph, nothing is actually severed. A section of the photograph (and the body depicted in it) simply disappears into the fold, it is withdrawn from view, as if hidden behind a wall in space—and hence a significant aspect is also the resulting three-dimensionality, it is the shadow that lodges itself between the two edges of photographic paper and which thereby programmatically places the materiality of the photographic representation alongside its function of reproduction through the disruption of the fold" (Monika Faber).

The image and the surface carrying it are placed in a new relationship one to the other: haptic and hierarchical.

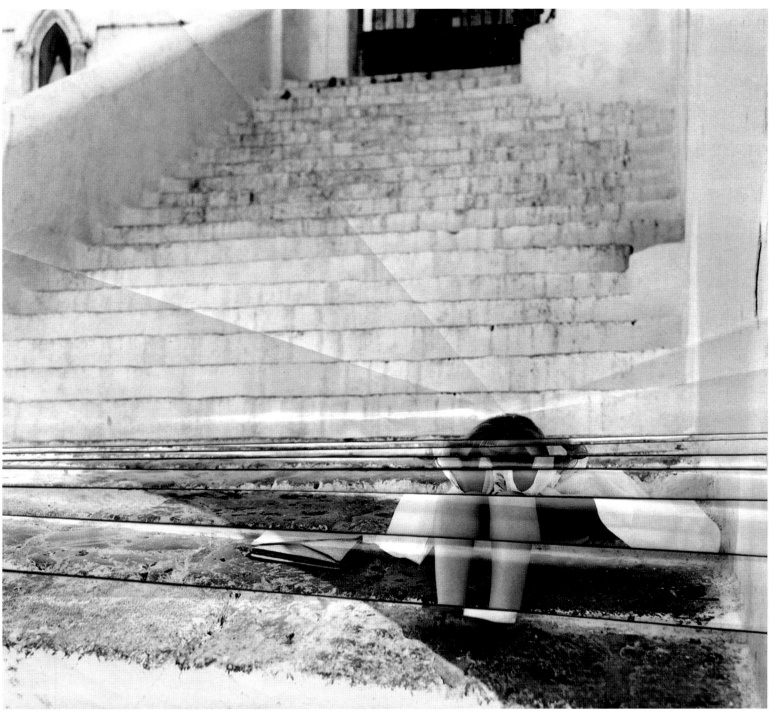

Maria, 2005, folded silver gelatin print / courtesy of the artist

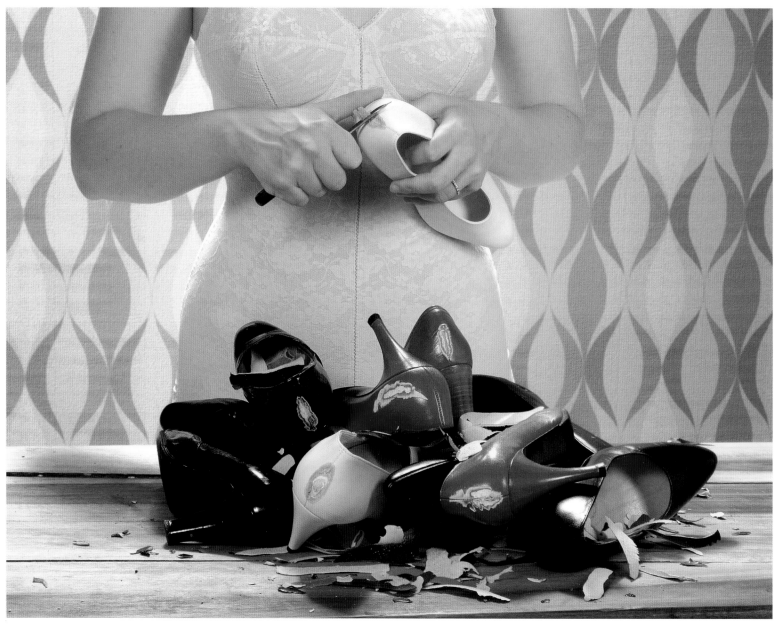

L'éplucheuse, 2008, inkjet print / courtesy of the artist

Our mutual work is based on otherness and Intimacy,
through fictional everyday scenes.

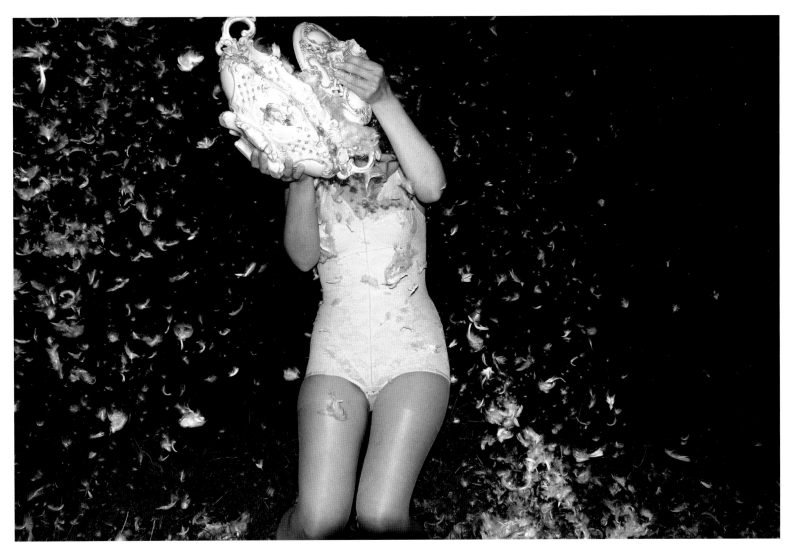

Duchesse Vanille, 2008, inkjet print / courtesy of the artist

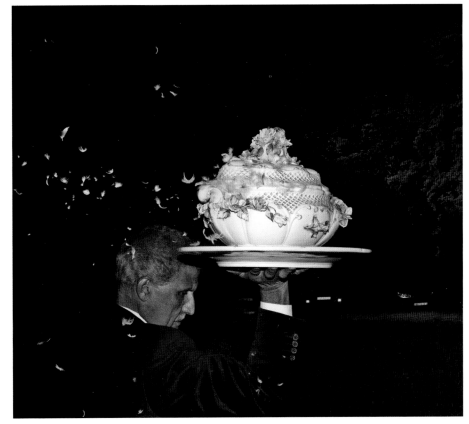

Insomnie, cotillons, 2008, inkjet print / courtesy of the artist

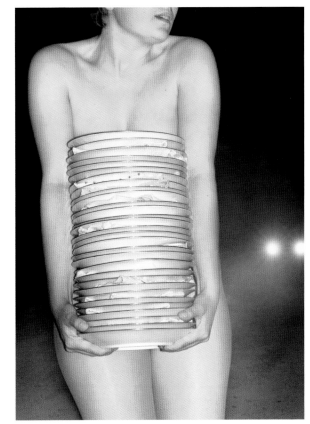

Toujours impeccable, 2008, inkjet print / courtesy of the artist

Lauren (eyes closed), 2003, lightjet print / courtesy Stills Gallery, Sydney

My aim is to approach portraits like sculpture, form is very important. In photographing Lauren I wanted to create a still and eerie portrait with an almost spiritual or mystical quality.

Lauren may be perceived as "imperfect" because she is albino, so the concept of "beauty in the aberration" underscores my imagery.

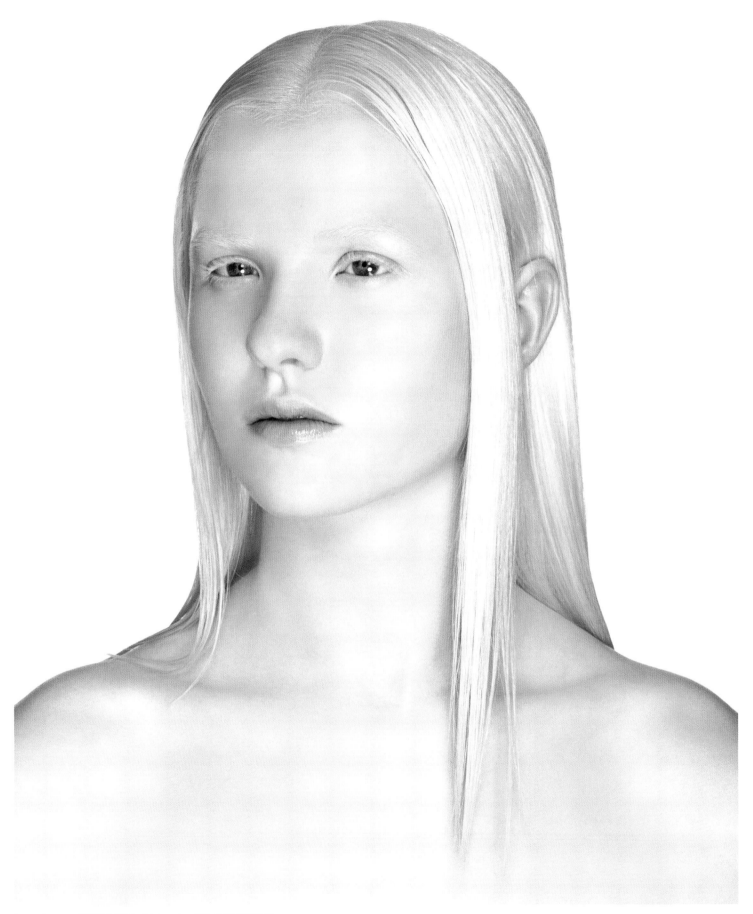

Lauren (eyes open), 2003, lightjet print / courtesy Stills Gallery, Sydney

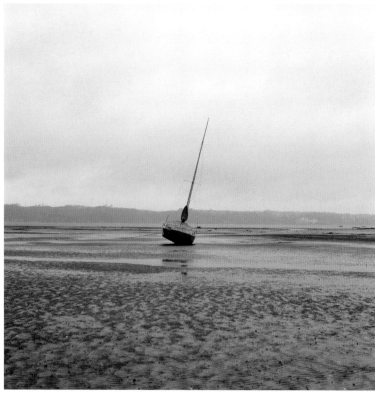

Waiting, 2007, lightjet print / courtesy Johnston Gallery, Mosman Park

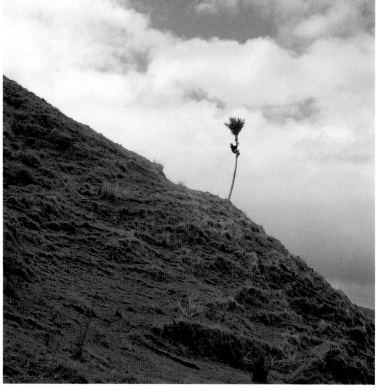

High, 2006, lightjet print / courtesy Johnston Gallery, Mosman Park

"Up with the fall, down on the diagonal"
Optimistically falling, waiting and jumping in a landscape
that is specifically Pacific.

…right in, 2007, lightjet print / courtesy Johnston Gallery, Mosman Park

Art has no standard. My way is that if I want to do something
of my own, whatever it is, my choice is to not follow rules,
and to work recklessly. Only when I don't follow the rules do I feel
I can leave systems behind. Only when I am reckless can I have
my own voice and language. Being reasonable means that you work
within the system. So my path of art is unreasonable and reckless.
This is my only standard!

My Rome, 2005, performance at Musei Capitolini, Rome / courtesy of the artist

My Rome, 2005, performance at Musei Capitolini, Rome / courtesy of the artist

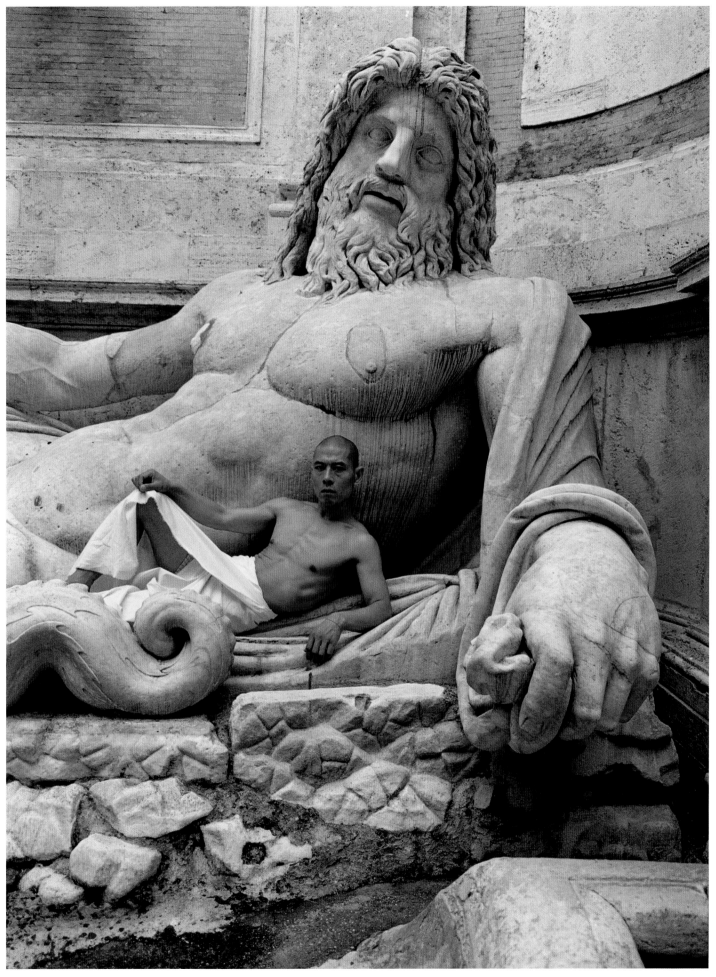

My Rome, 2005, performance at Musei Capitolini, Rome / courtesy of the artist

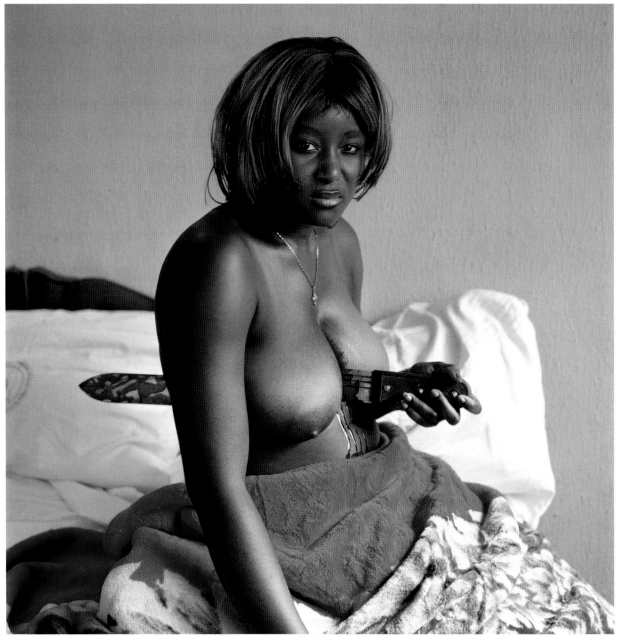

Rose Njoku (Enugu, Nigeria), 2008, C-print / courtesy Michael Stevenson Gallery, Cape Town; Yossi Milo Gallery, New York

In the introduction to his monograph, *The Hyena and Other Men*, Pieter Hugo describes his preparations before making a second trip to Nigeria, in order to pursue additional portraits for his now infamous series on these itinerant minstrels and their animals: "The project felt unresolved and I was ready to engage with the group again. I looked back at the notebooks I had kept while with them. The words 'dominance', 'co-dependence' and 'submission' kept appearing. These pictures depict much more than an exotic group of traveling performers in West Africa."

In many ways, the same could be said of Hugo's entire oeuvre. Within all of Hugo's work to date, themes of dominance, co-dependence and submission have provided the underlying foundations for the unnerving power of his imagery, helping to support his remarkably unique and captivating perspective on individual subjects, on contemporary Africa and its infinite complexities, and on photography itself.

Aaron Schuman

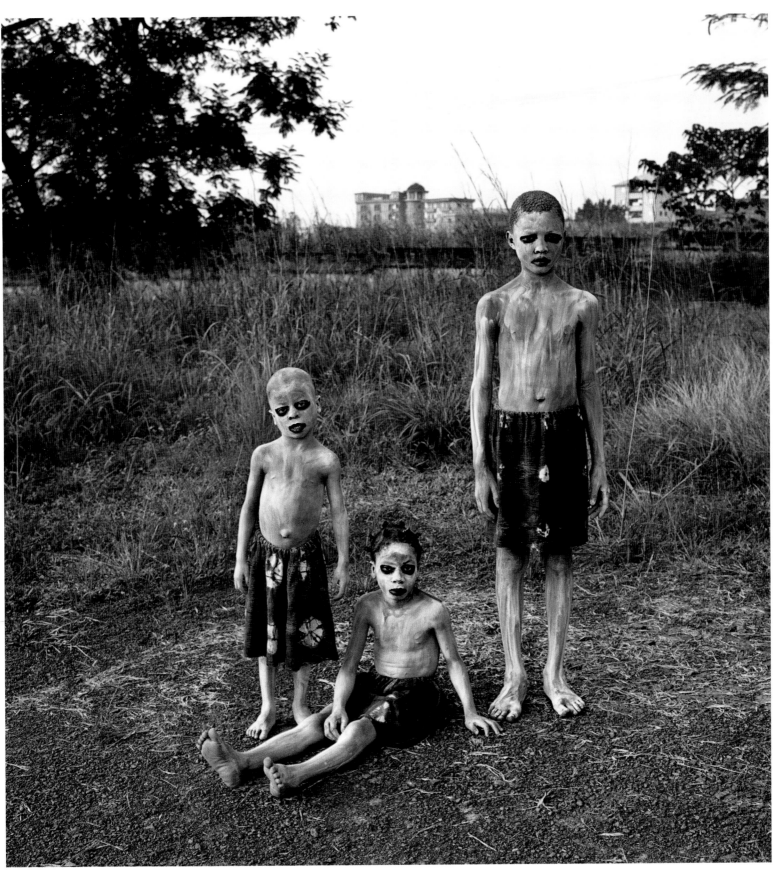

Junior Ofokansi, Chetachi Ofokansi, Mpompo Ofokansi (Enugu, Nigeria), 2008, C-print / courtesy Michael Stevenson Gallery, Cape Town; Yossi Milo Gallery, New York

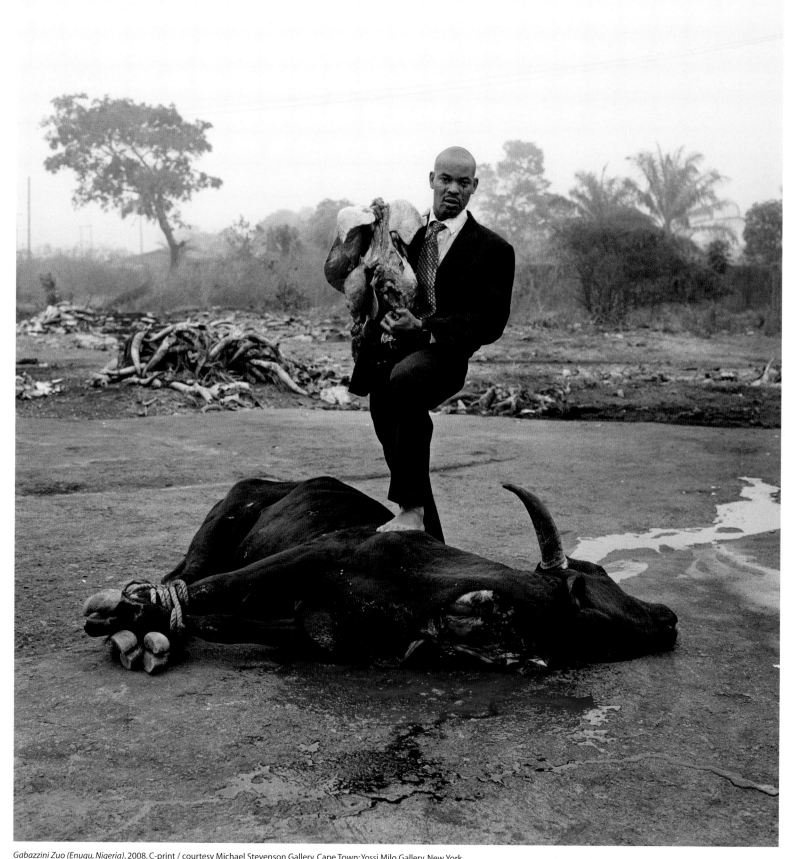

Gabazzini Zuo (Enugu, Nigeria), 2008, C-print / courtesy Michael Stevenson Gallery, Cape Town; Yossi Milo Gallery, New York

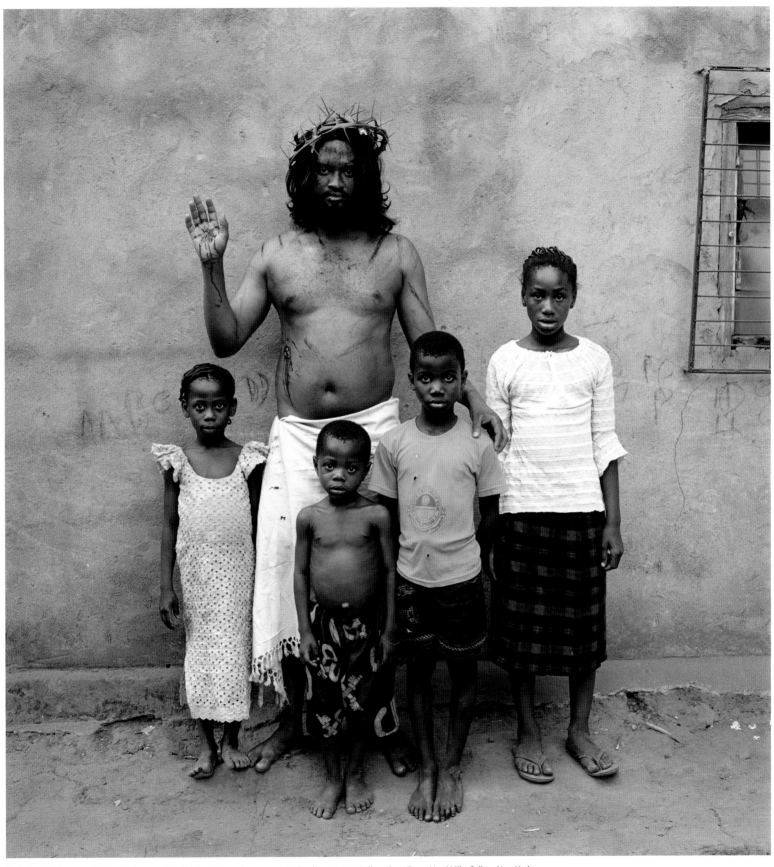

Malachy Udegbunam with children (Enugu, Nigeria), 2008, C-print / courtesy Michael Stevenson Gallery, Cape Town; Yossi Milo Gallery, New York

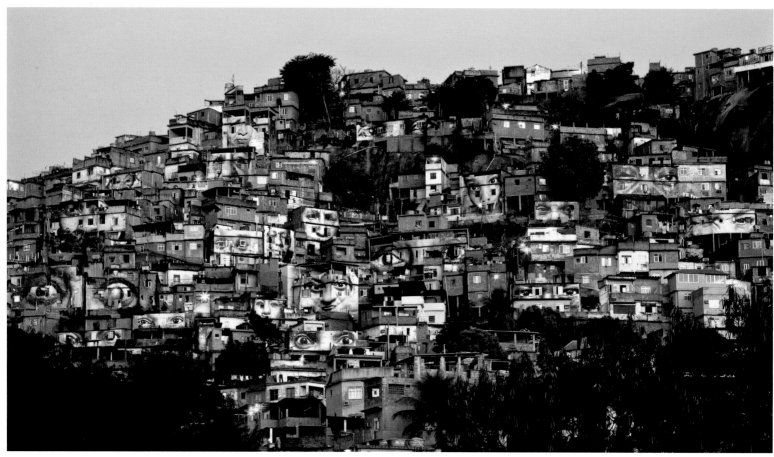

28 Millimetres, WOMEN, 2008, action in the favela Morro da Providência (Rio de Janeiro, Brazil) / courtesy of the artist

I am 26 and I own the biggest art gallery in the world. I exhibit freely
in the streets of the world, catching the attention of people who
are not museum visitors. My work mixes Art and Act, focusing
on commitment, freedom, identity and limit.
Of course my projects don't change the world, but sometimes
a single laugh in an unexpected place makes you dream that it could.
I simply create "Pervasive Art" that spreads uninvited on the
buildings of the slums around Paris, on the walls in the Middle-East,
on the broken bridges in Africa or the favelas in Brazil. People
don't just see it, they make it. Elderly women become models
for a day; kids turn artists for a week. In that Art scene,
there is no stage to separate the actors from the spectators.
As I remain anonymous and don't explain the huge full frame
portraits of people making faces, I leave the space empty
for an encounter between the subject/protagonist
and the passer-by/interpreter.

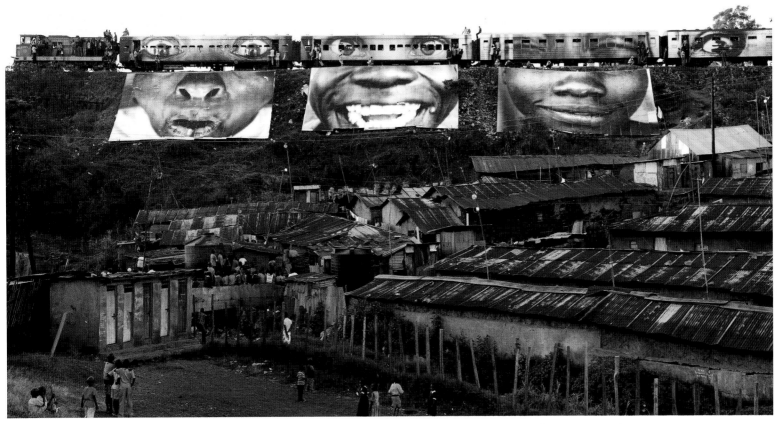

28 Millimetres, WOMEN, 2009, action in the slum of Kibera (Nairobi, Kenya) / courtesy of the artist

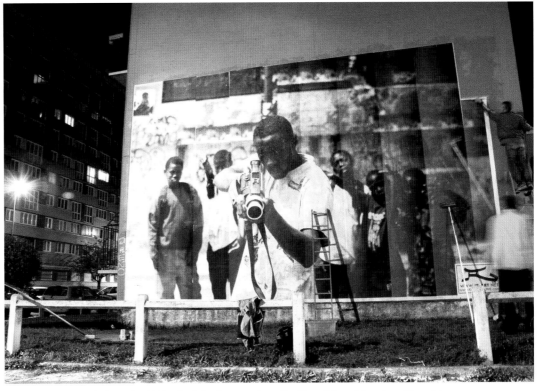

28 Millimetres, portrait of a Generation, 2004, action in Les Bosquets ghetto (Montfermeil, France) / courtesy of the artist

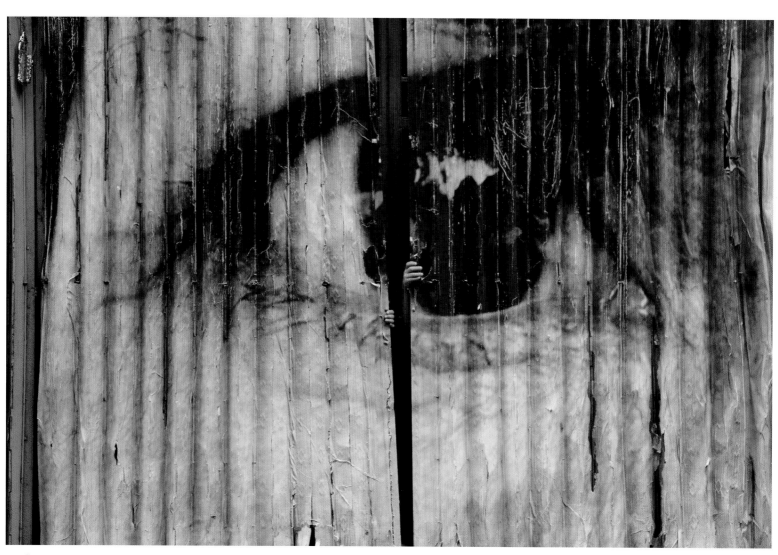

28 Millimetres, WOMEN, 2009, pasting in the streets of Phnom Penh (Cambodia) / courtesy of the artist

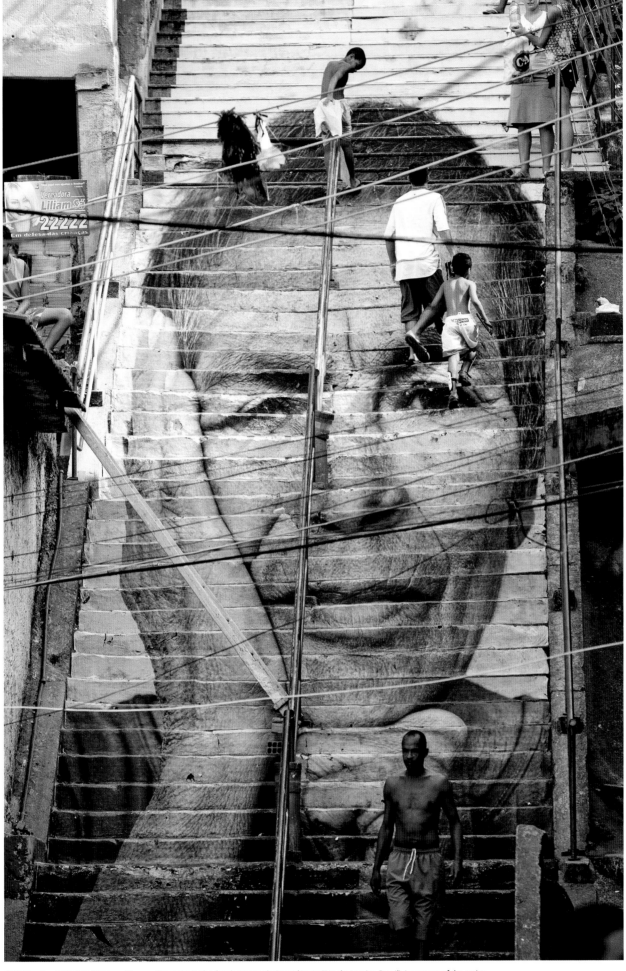

28 Millimetres, WOMEN, 2008, pasting on the stairs in the favela Morro da Providência (Rio de Janeiro, Brazil) / courtesy of the artist

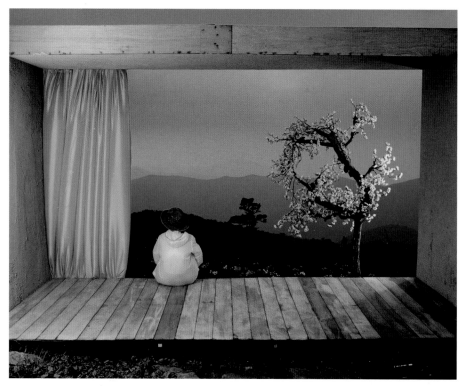

Location #1, 2004, C-print / courtesy Kukje Gallery, Seoul

The *Location* series enables me to challenge the conventions of traditional landscape photography. Unlike painters, who can create a scene from their imagination, photographers are faced with limitations inherent to the medium; they are only able to reproduce what they see through their lens at a particular moment in time.

I've always been fascinated by Hollywood and its ability to create artificial scenery. I am particularly drawn to movies that were made before computer technology was available. Set-makers had to find other ways to manufacture a reality within the artificial construct of the soundstage.

I approach my new photographic series from the opposite direction. I am trying to show how fake the real landscape can be. I want to create the illusion that the expansive scenery is actually just a part of a smaller studio set.

I like it when people look at my work and try to discern which elements are artificial and which are real. To me, everything is real and, at the same time, everything is artificial. It reminds me of the line in the Elvis Presley song *Are You Lonesome Tonight?*: "You know someone said the world is a stage / and we each must play a part…"

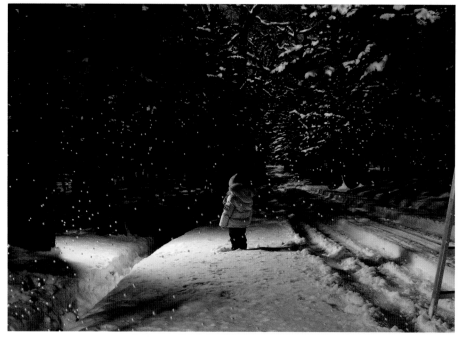

Location #7, 2006, C-print / courtesy Kukje Gallery, Seoul

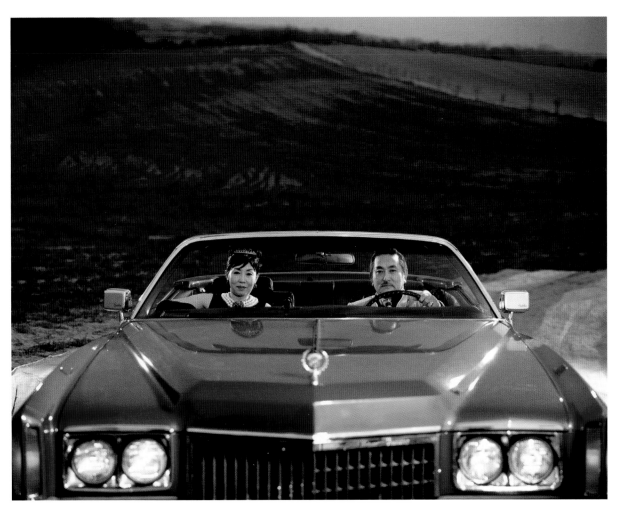

Location #12, 2006, C-print / courtesy Kukje Gallery, Seoul

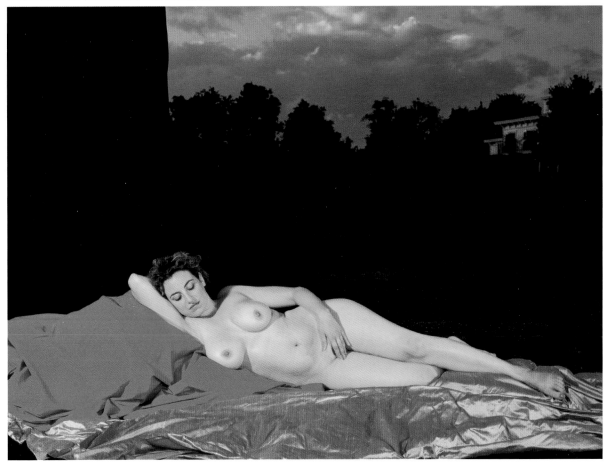

Location #18, 2006, C-print / courtesy Kukje Gallery, Seoul

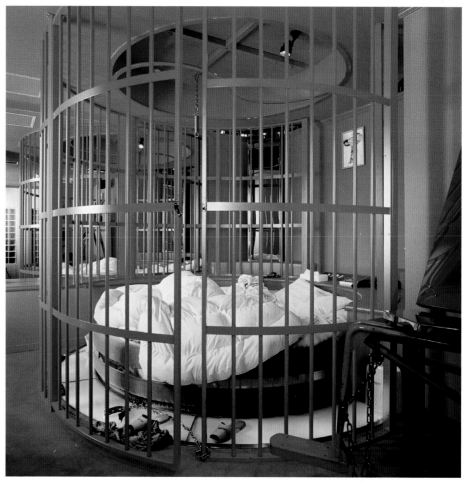

Round Caged Bed, Hotel Pamplona (Osaka), 2005, C-print / courtesy Photographs Do Not Bend Gallery, Dallas

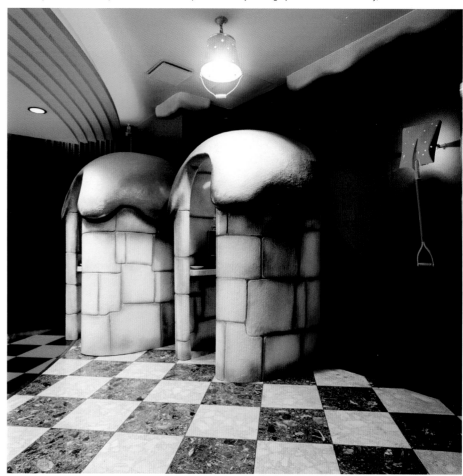

The photographs of themed rooms rented by the hour result
from a study of simultaneously public and private spaces made
while living in Japan.
The work is reflective of these unique and complex intuitions
that initially sound as though they would be full of love
but generally contain anything but.

Igloo Waiting Area, Hotel Gang Snowman (Osaka), 2005, C-print / courtesy Photographs Do Not Bend Gallery, Dallas

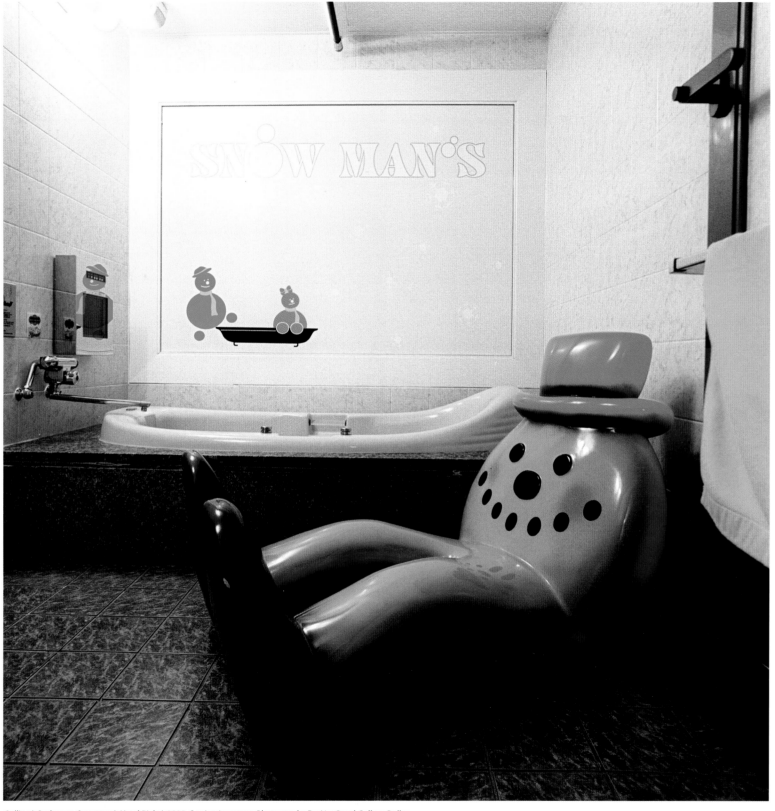

Gulliver's Bathroom, Snowman's Hotel (Kobe), 2005, C-print / courtesy Photographs Do Not Bend Gallery, Dallas

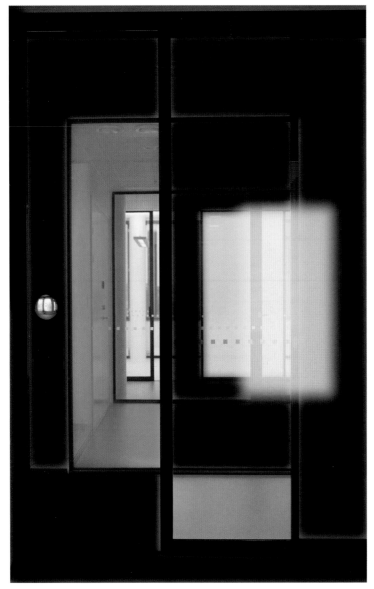

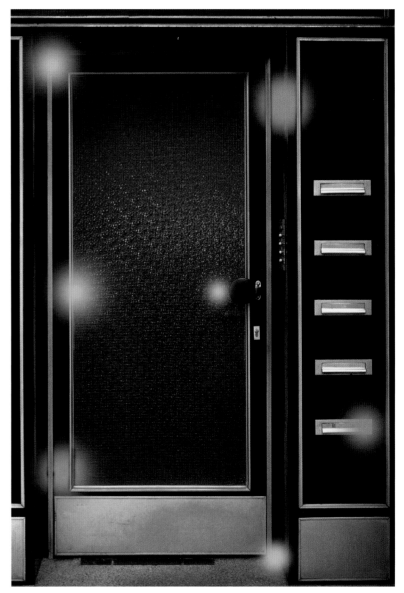

Tila (passage V), 2007, C-print on diasec / courtesy Galerie Anhava, Helsinki

Tila (black door), 2006, C-print on diasec / courtesy Galerie Anhava, Helsinki

The word *tila* has multiple meanings in the Finnish language.
It can mean for example distance between objects or human beings,
a room or space, outdoor space (landscape) or physical state of mind.

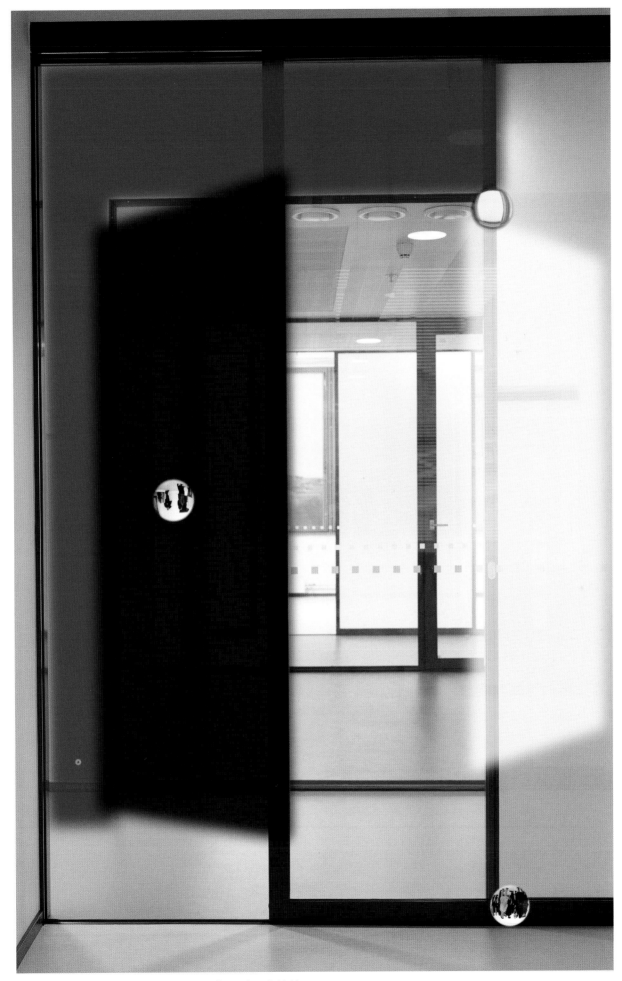

Tila (passage VII), 2008, C-print on diasec / courtesy Galerie Anhava, Helsinki

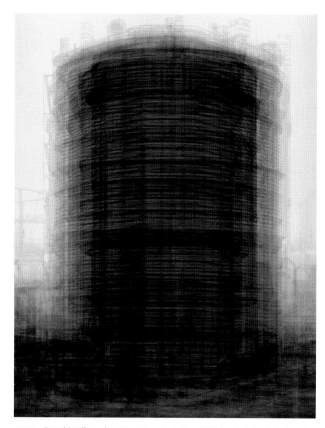

every… Bernd & Hilla Becher Prison Type Gasholder, 2003, triptych, lambda digital C-print on aluminium / courtesy Victoria Miro Gallery, London

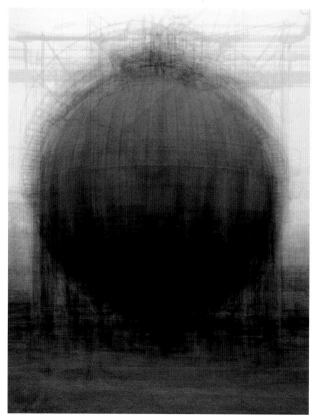

every… Bernd & Hilla Becher Spherical Type Gasholder, 2003, triptych, lambda digital C-print on aluminium / courtesy Victoria Miro Gallery, London

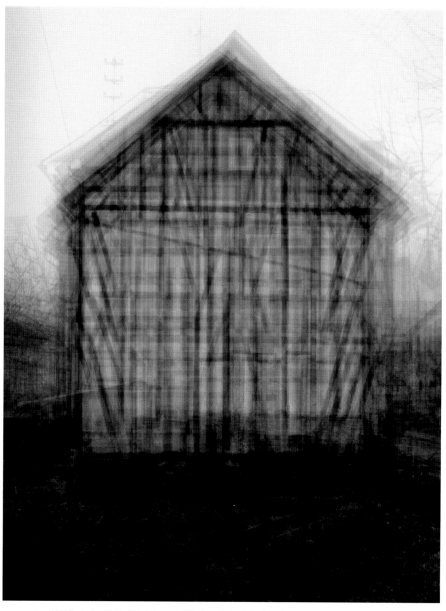

every… Bernd & Hilla Becher Gable Sided House, 2003, triptych, lambda digital C-print on aluminium / courtesy Victoria Miro Gallery, London

A return to the composite image has been very reliant on the distinctive aesthetic and abstracting effects of the process. In this respect, my work shifts away from photography. After re-photographing and then digitally layering a sequence or series of pictures, with some images given more emphasis than others, the resulting prints possess formal characteristics very distinct from instantaneous photographs and are more akin to the temporally accumulative qualities of drawings or paintings. My final prints have a shimmering quality often lost in reproduction, created by the subtle shifts in visual presence of the differing layers of images.

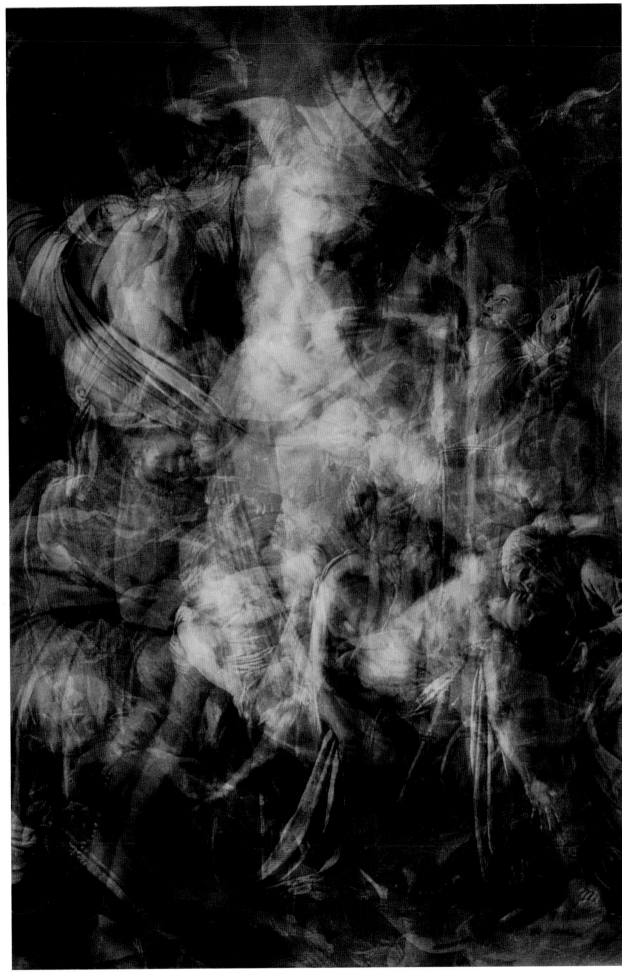

Caravaggio… The Final Years, 2006, C-print / courtesy Victoria Miro Gallery, London

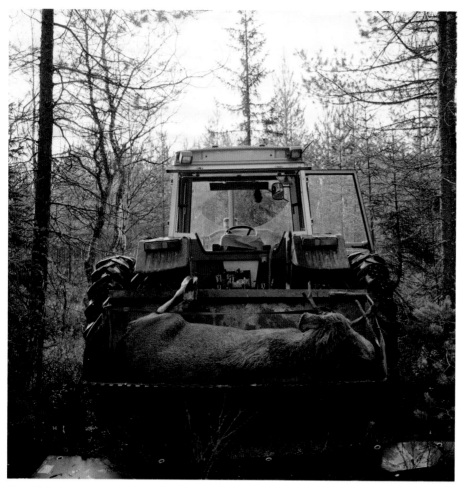

Hyrynsalmi #6, 2004, C-print on aluminium / courtesy of the artist

Hyrynsalmi #1, 2004, C-print on aluminium / courtesy of the artist

Life is coincidence, an absurd game. I don't like to plan my photos
too much, but instead let life lead me to interesting situations
and subjects. I find my inspiration in everyday life, in the emotion
or atmosphere that elevates even an ordinary subject; small details
in our everyday surroundings reveal a person's secrets.

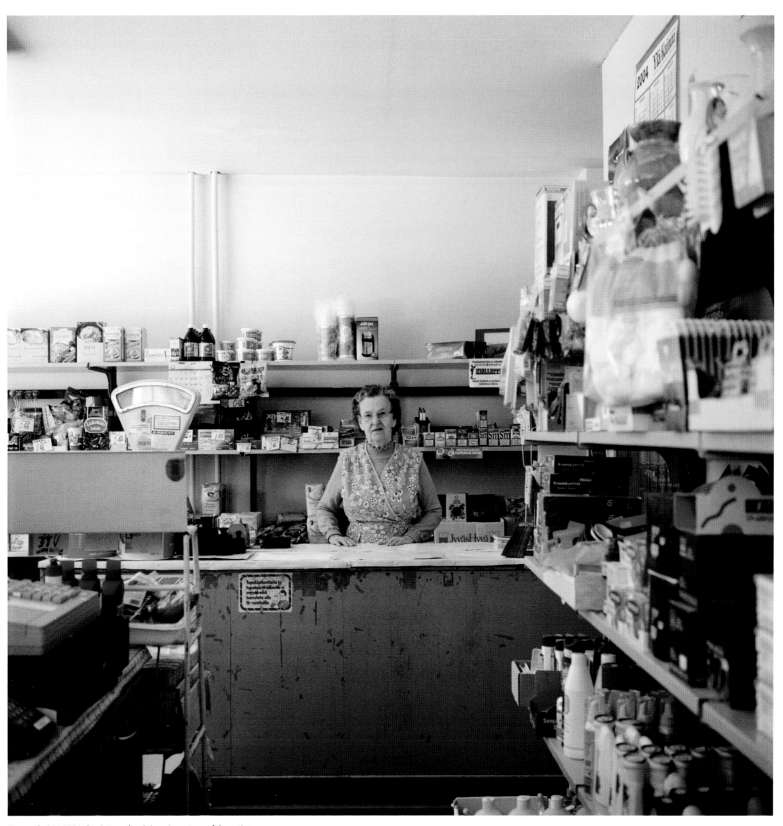

Hyrynsalmi #4, 2004, C-print on aluminium / courtesy of the artist

Untitled, from the series *Made in USSR*, 2007, digital print / courtesy of the artist

Untitled, from the series *Circus on the beach*, 2008, digital print / courtesy of the artist

In my early years I documented my close environment, the neighborhood where I grew up, home to mainly Russian families. I documented their houses and the Russian aesthetics they wanted to maintain in their homes.

I also documented my own family that lives in Israel—my father, mother and myself. This series was staged and was usually located in my parents' home.

My recent works deal with the urban environment, especially Jaffa, a mixed city of Jews and Arabs, a symbol of the Arab exile in 1948. I took photographs on the Agami shore, a deserted area in the Arab neighborhood where rich Jewish Israelis have bought property over the last few years. The Tel Aviv-Jaffa municipality decided to clean up and renovate this area in order to build a public garden to celebrate the Tel Aviv Centenary.

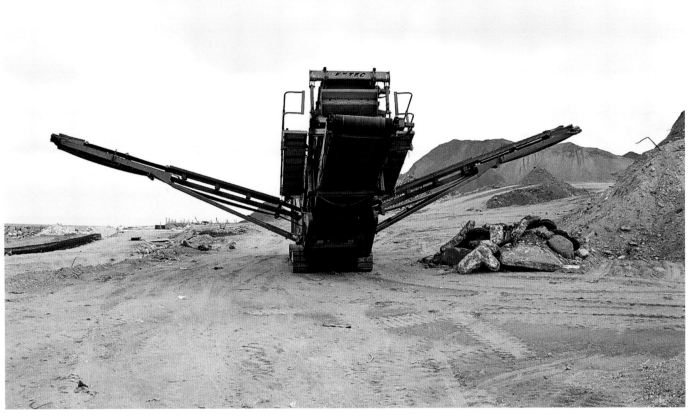

Untitled, from the series *Circus on the beach*, 2008, digital print / courtesy of the artist

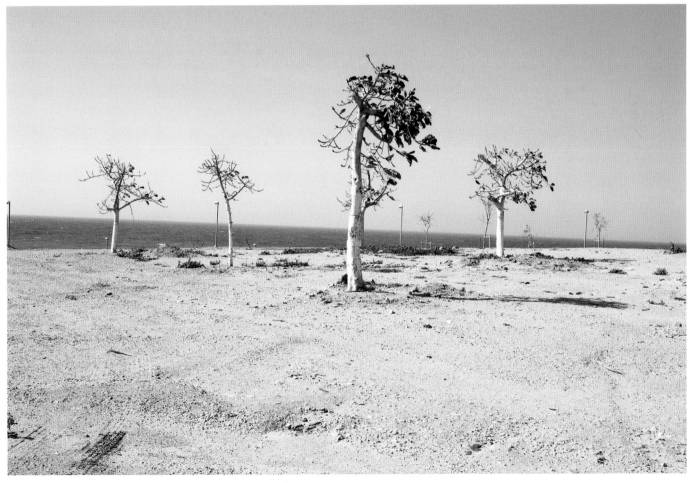

Untitled, from the series *Circus on the beach*, 2008, digital print / courtesy of the artist

Our eyes are *interfaces*, limited both in the way we see the image, and the way we comprehend it.

Mainly by using the genre of the portrait, I explore the boundaries between reality and our perception in photography. My images question the conventional rules of the genre by placing themselves somewhere between the truth and what we believe to be true.

chimères 19, 2007, lambda print / courtesy Wagner + Partner, Berlin

chimères 16, 2007, lambda print / courtesy Wagner + Partner, Berlin

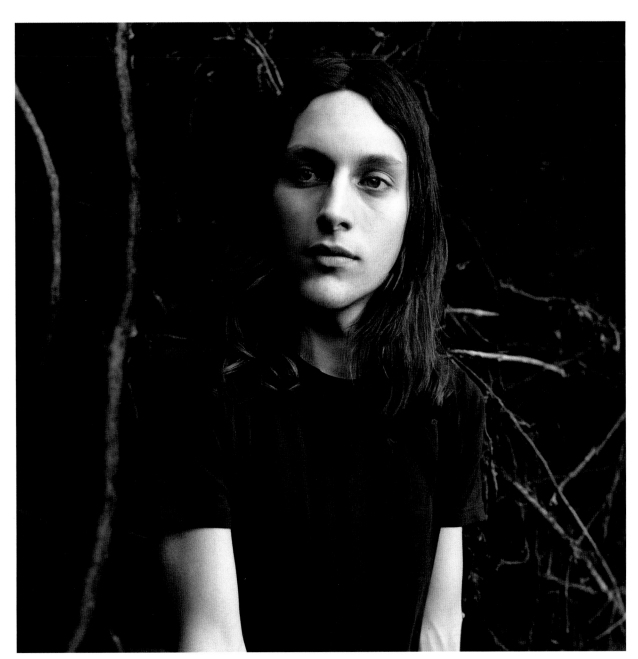

chimères 17, 2007, lambda print / courtesy Wagner + Partner, Berlin

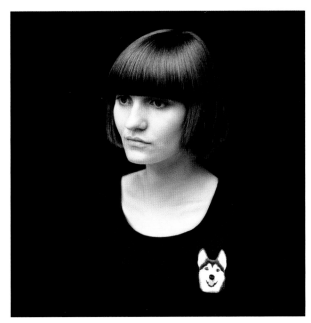

chimères 20, 2007, lambda print / courtesy Wagner + Partner, Berlin

In my landscape photography I work somewhere between photography, performance and sculpture. The theme of flying has been my main subject over the last years. I see a human being as an incomplete creature, continuously trying to fulfill his/her incompleteness. In my photographs a character tries to fly using poor constructions and it is obvious he will fail every time. More important than succeeding is the continual act of trying and believing. I'm also interested in the idea of a "failed machine", an object that does not fulfill its purpose. The early years of flying left behind plenty, some of which have been a great inspiration to me while working on this series.

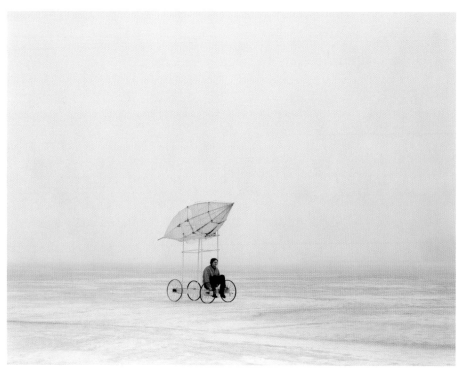

Air Ship, 2009, C-print on aluminium / courtesy Gallery TaiK, Berlin

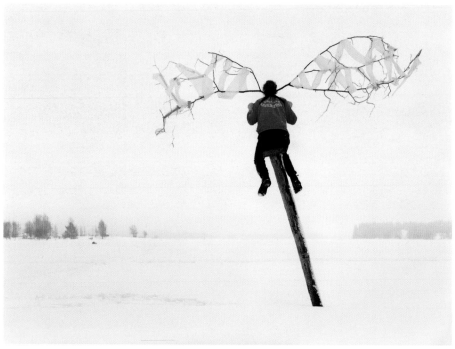

Branches, 2004, C-print on aluminium / courtesy Gallery TaiK, Berlin

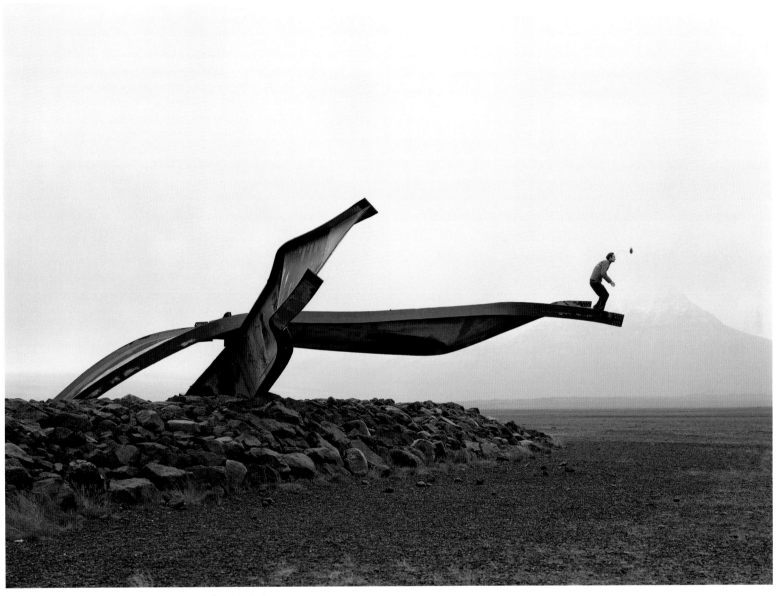

Bridge Falling, 2005, C-print on aluminium / courtesy Gallery TaiK, Berlin

Domestica Invisibile #15, 2006, C-print / courtesy of the artist

Domestica Invisibile #16, 2006, C-print / courtesy of the artist

Keywords: time / space / negative / negated / invisible / overlooked /
ignorable / camouflaged / illegitimacy / city / urban / habitat /
resident / physical / cultural / political/ historical / sarcastic / irony /
banal / poetic / search / research

Domestica Invisibile #14, 2005, C-print / courtesy of the artist

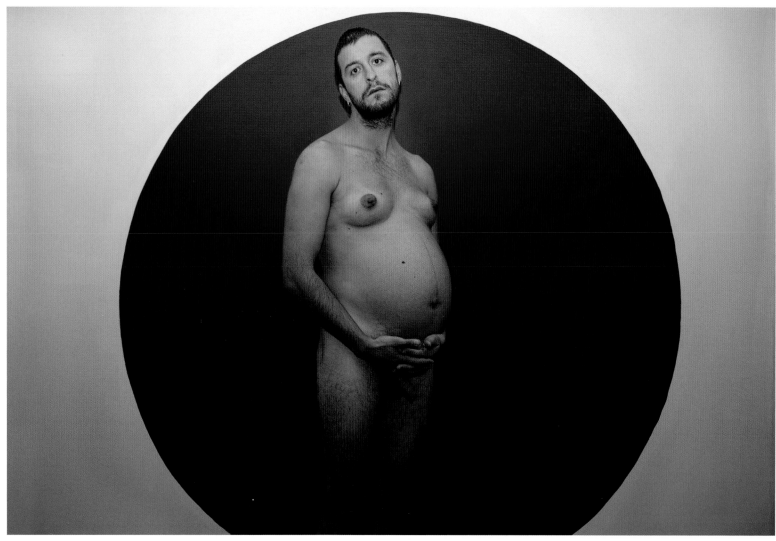

Self-portrait 6, 2008, digital print / courtesy of the artist

The way towards finding myself for a moment, often through
someone else.
Provoking notion, the search passes by the others, exits this world
in order to come back through love and painful physical matter.
The confession that the body and the soul are always linked,
but are not always together.
Images past, present and non-existent, interfacing and arguing,
till a moment of collapse and submission is captured.

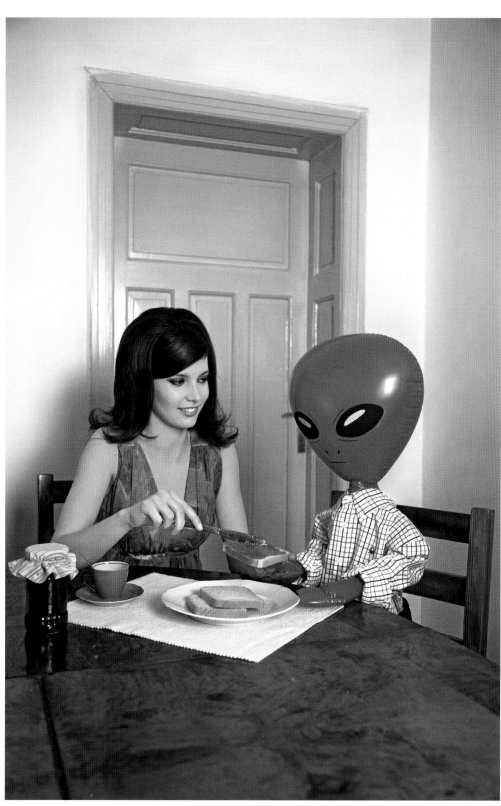

Choki, with Alexander Gerginov, 2008, digital print / courtesy of the artist

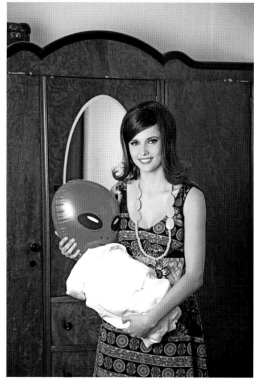

Choki, with Alexander Gerginov, 2008, digital print / courtesy of the artist

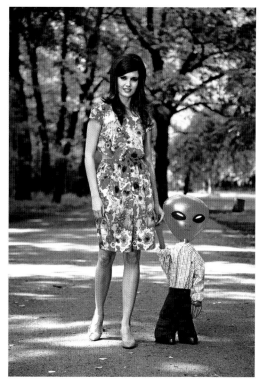

Choki, with Alexander Gerginov, 2008, digital print / courtesy of the artist

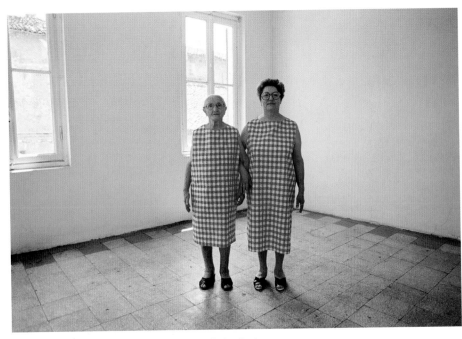

My work is born from a situation of fright.

La vertigine della signora Emilia, 1992, lambda print / private collection

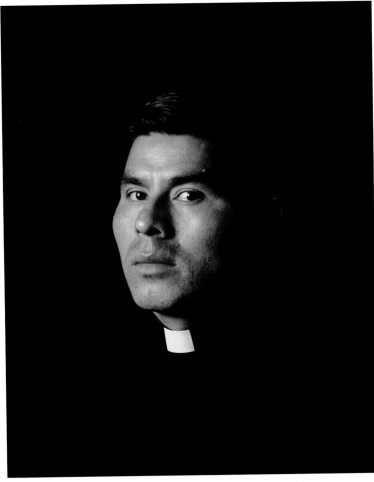

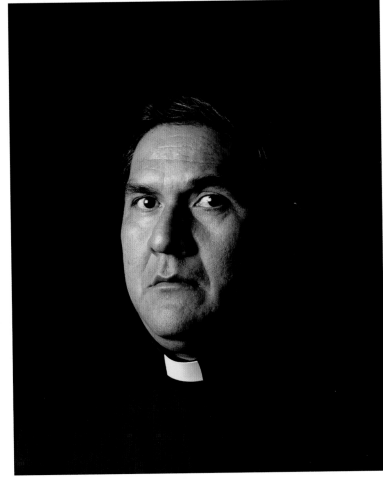

A Torino piove da Dio, 2002, lambda print / courtesy Galleria Raffaella Cortese, Milan

A Torino piove da Dio, 2002, lambda print / courtesy Galleria Raffaella Cortese, Milan

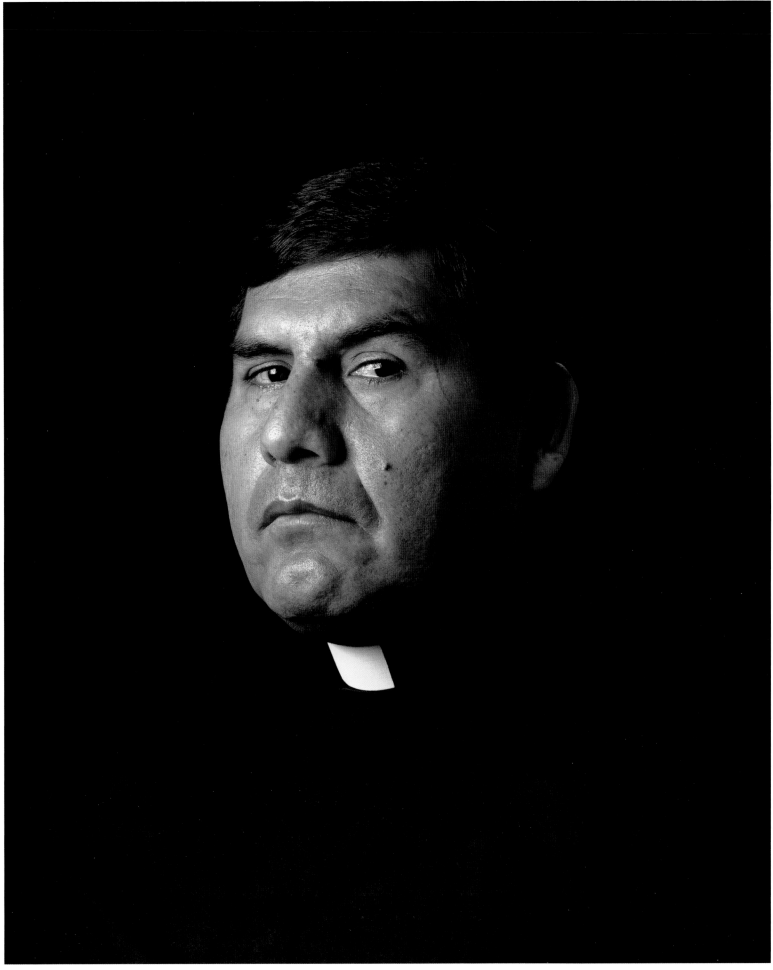

A Torino piove da Dio, 2002, lambda print / courtesy Galleria Raffaella Cortese, Milan

With *Inabitanti* ("Uninhabitants"), a work created in an abandoned
green area of Milan, the artist analyses the relationship between
the impermanent homes of a group of Romanians (inhabitants
invisible and non-existent for the people of the city)
and the surrounding vegetation, a veritable barrier/protection.

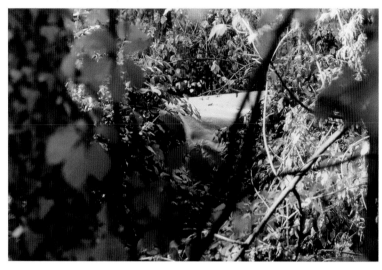

Inabitanti 01.1, 2005, C-print / courtesy Civico Archivio Fotografico, Milan

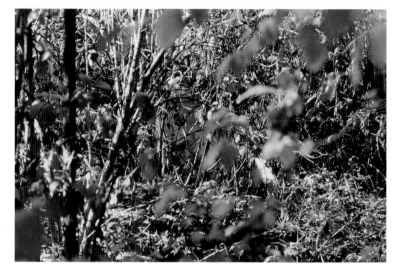

Inabitanti 03.1, 2005, C-print / courtesy Civico Archivio Fotografico, Milan

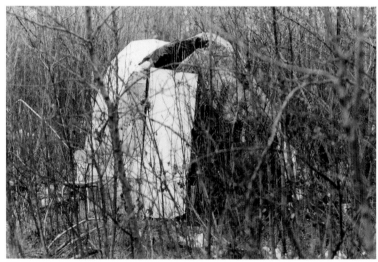

Inabitanti 18.1, 2005, C-print / courtesy Civico Archivio Fotografico, Milan

Inabitanti 10.1, 2005, C-print / courtesy Civico Archivio Fotografico, Milan

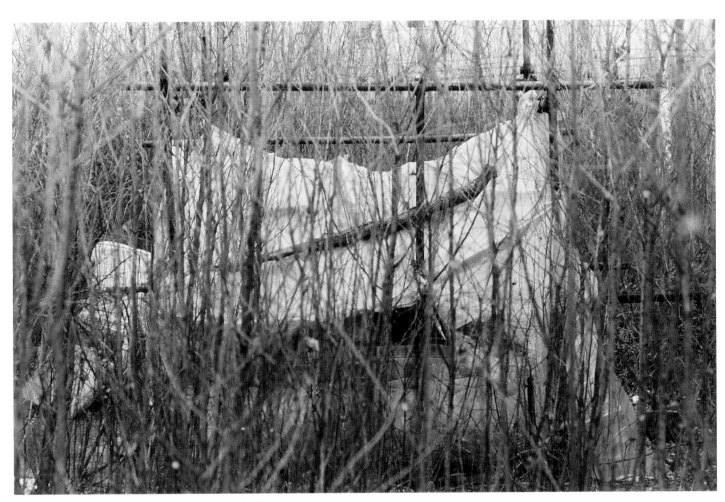

Inabitanti 16.1, 2005, C-print / courtesy Civico Archivio Fotografico, Milan

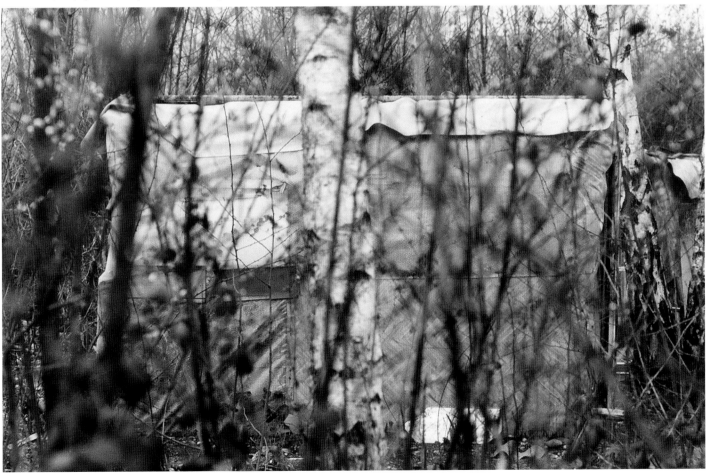

Inabitanti 17.1, 2005, C-print / courtesy Civico Archivio Fotografico, Milan

Via Arco 4, 2004, digital print / courtesy of the artist

Via Ponte Vetero 22, 2004, digital print / courtesy of the artist

What can we know, when a participation is almost always only
(tele)visual in nature?
What do we know, when we possess a knowledge gleaned
from the Internet and online, devoid of any effective knowledge
which can only come from learning, watching and learning?

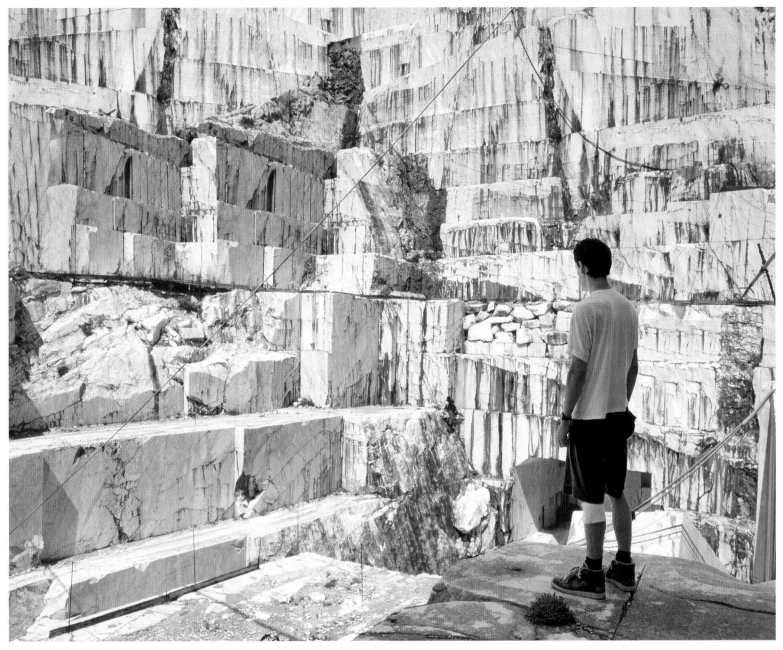

Apuane, 2007, digital print / courtesy Studio Guenzani, Milan

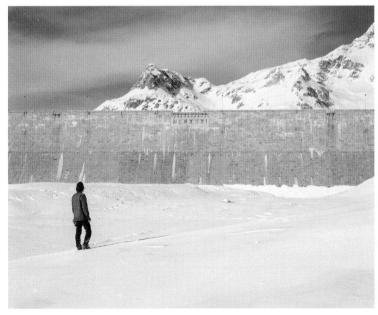

Montespluga, 2008, digital print / courtesy Studio Guenzani, Milan

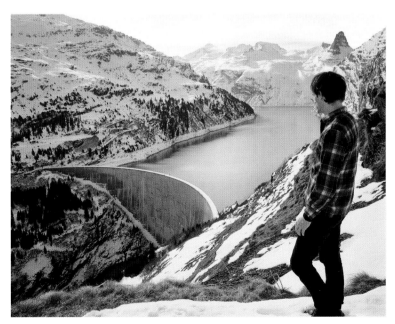

Zervreila, 2007, digital print / courtesy Studio Guenzani, Milan

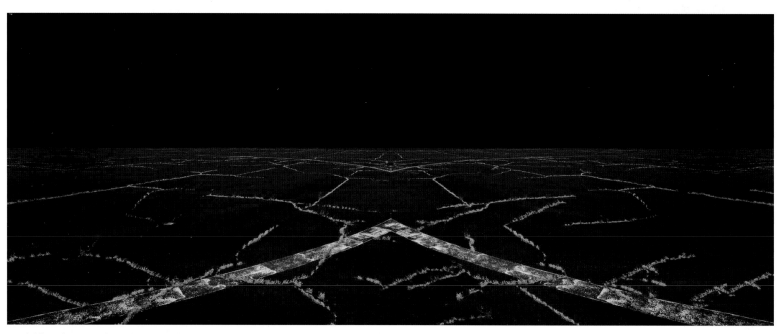

Untitled, from the series *When Light Casts no Shadow*, 2008, C-print on aluminium / courtesy The Moth House, Bedford; Galerie Caprice Horn, Berlin

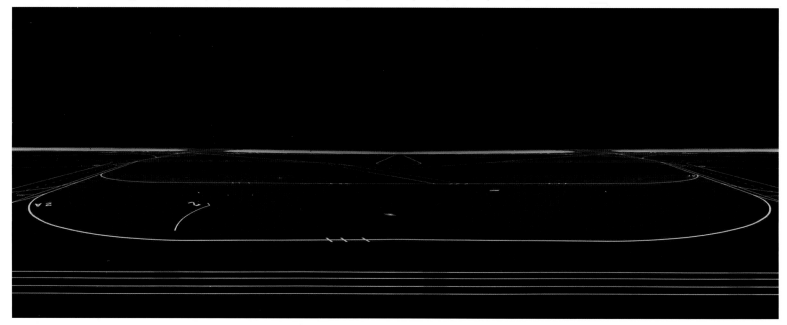

Untitled, from the series *When Light Casts no Shadow*, 2008, C-print on aluminium / courtesy The Moth House, Bedford; Galerie Caprice Horn, Berlin

Between 2006 and 2008, I was granted unrestricted access to some of the most interesting airports in Europe. I chose to photograph almost exclusively at night, utilising large format cameras (8x10 and 8x20), the airport's floodlights and long exposures of up to two hours in order to register minute tonal differences between blacktop and night sky, my camera picking out fluorescent signs and markings on the ground. With this project, I am addressing a peculiarly contemporary landscape, that ever more generic *terrain vague*—the urban, suburban, "ex-urban" peripheries. However, perhaps most relevant to this work are the ideas of cultural critic Jean Baudrillard and architect Rem Koolhaas. Indeed, Koolhaas wonders if the generic city is synonymous with the contemporary airport. He speculates that "its main attraction is its anomie". It is the space of the uprooted, and, as if to confirm the nomenclature "vague", in my images nature and constructed space are colliding, overlapping, and blurring. Sky and constructed ground merge in darkness, with only the lights and airport hieroglyphics to orientate us. Everything is indeterminate and difficult to decode. The juxtaposition of sign and shape represent an overlapping of time, of language, of space.

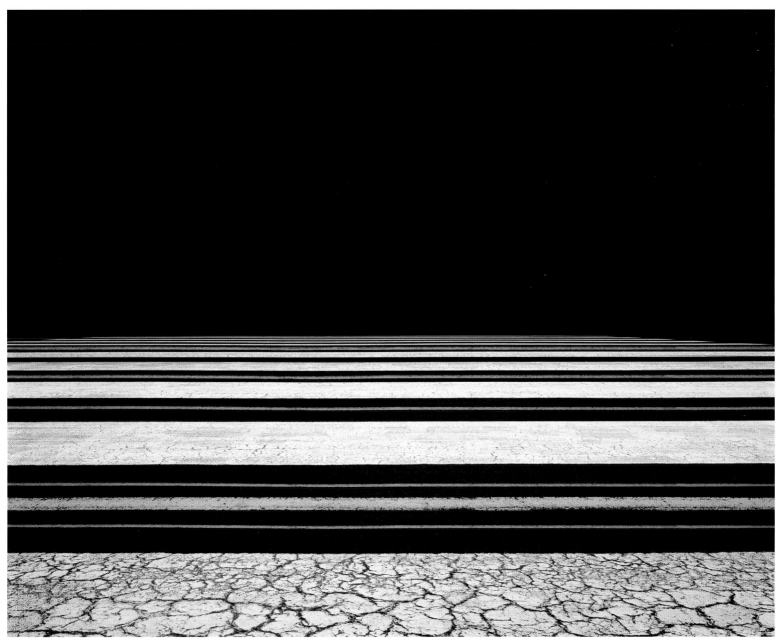

Untitled, from the series *When Light Casts no Shadow*, 2008, C-print on aluminium / courtesy The Moth House, Bedford; Galerie Caprice Horn, Berlin

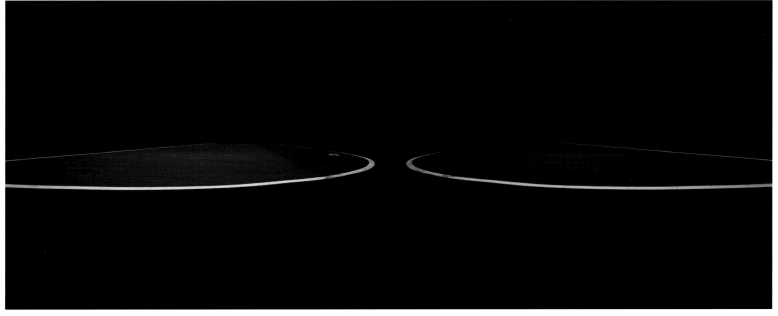

Untitled, from the series *When Light Casts no Shadow*, 2008, C-print on aluminium / courtesy The Moth House, Bedford; Galerie Caprice Horn, Berlin

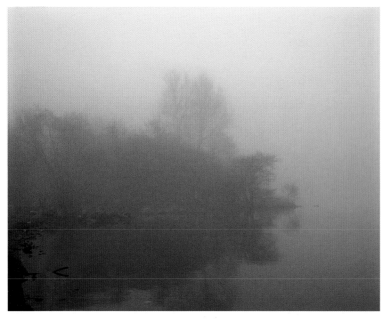

Landscape is a core element in Mary McIntyre's work. Her depictions of both rural and urban landscapes explore continuities from painting to photography, to construct a contemporary understanding of the sublime. McIntyre's work presents us with subtle vistas, imbued with a beauty and melancholy reminiscent of the 19th century painting she draws upon.

The Lough I, 2006, lightjet print on dibond / courtesy The Third Space Gallery, Belfast

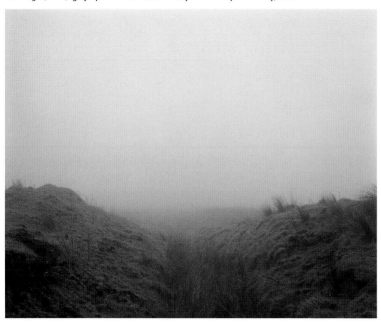

Veil VII, 2008, lightjet print on dibond / courtesy The Third Space Gallery, Belfast

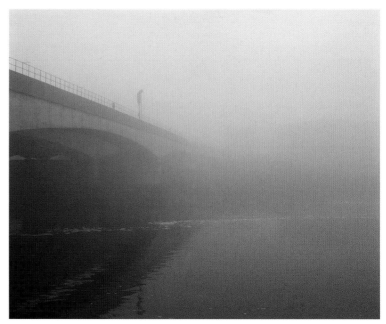

The Dream I, 2009, lightjet print on dibond / courtesy The Third Space Gallery, Belfast

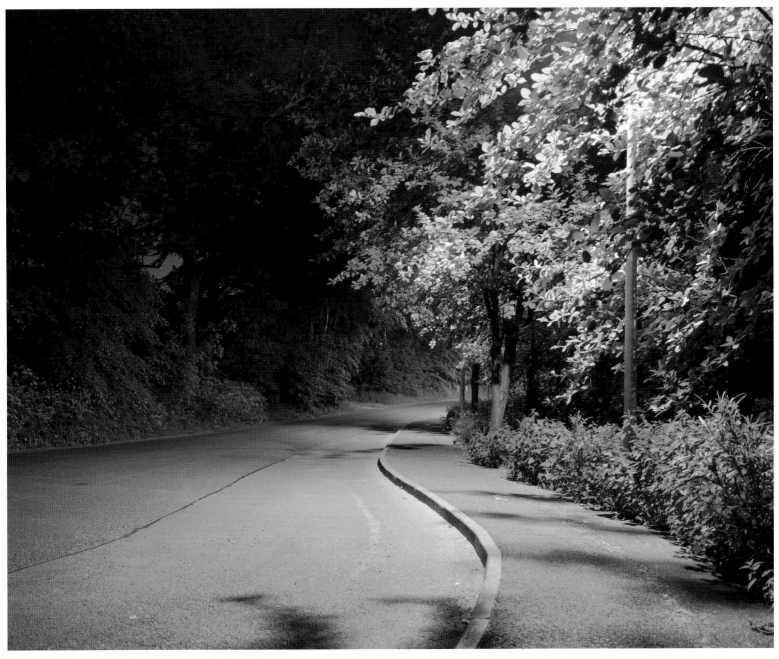

Threshold, 2004, lightjet print on dibond / courtesy The Third Space Gallery, Belfast

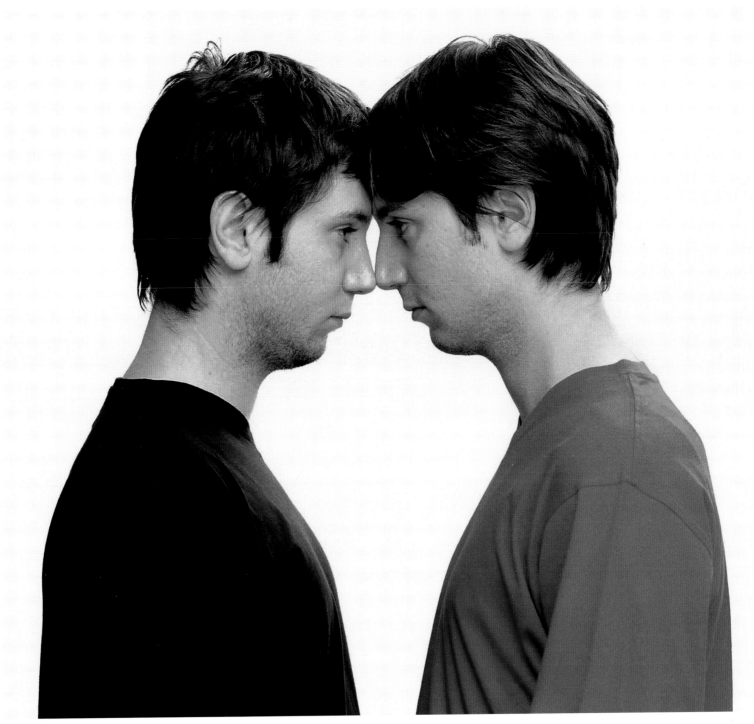

Pari o Dispari, 2004, C-print / courtesy Galleria Lia Rumma, Milan-Naples / photo Maurizio Elia

Through a wide range of languages, from video to sound,
performance to installation, drawing to the object, I articulate
the various stages of a process of research which touches
on the themes of desire, intimacy, memory, loss and obsession
as focal points of a reflection on identity.

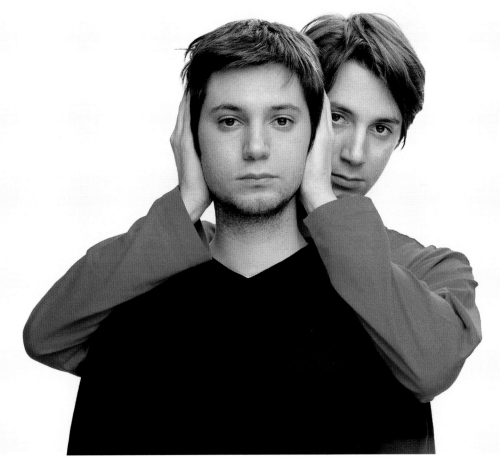

Pari o Dispari, 2004, C-print / courtesy Galleria Lia Rumma, Milan-Naples / photo Maurizio Elia

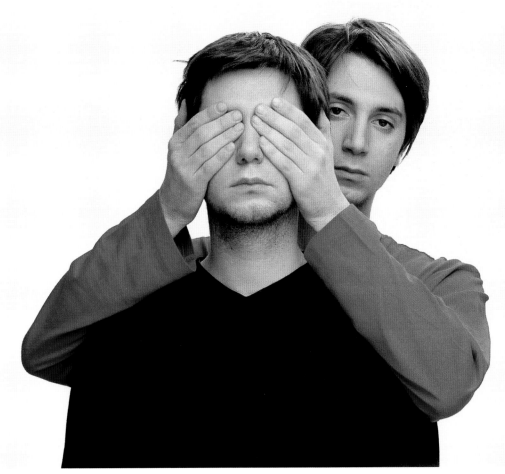

Pari o Dispari, 2004, C-print / courtesy Galleria Lia Rumma, Milan-Naples / photo Maurizio Elia

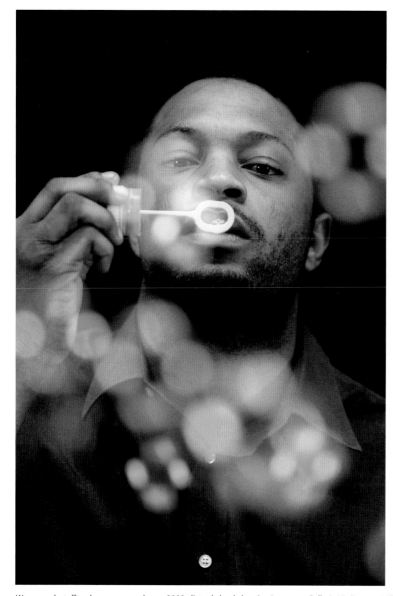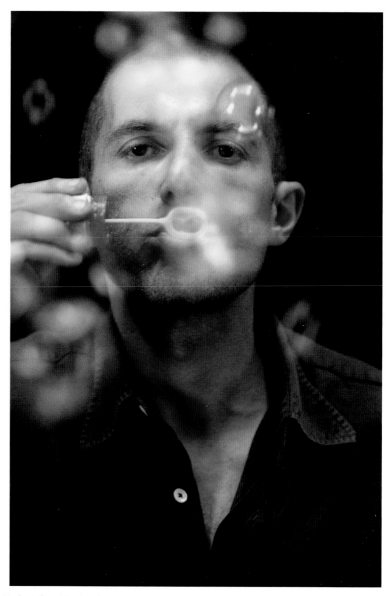

We are such stuff as dreams are made one, 2008, diptych, lambda print / courtesy Galleria Lia Rumma, Milan-Naples / photo Maurizio Elia

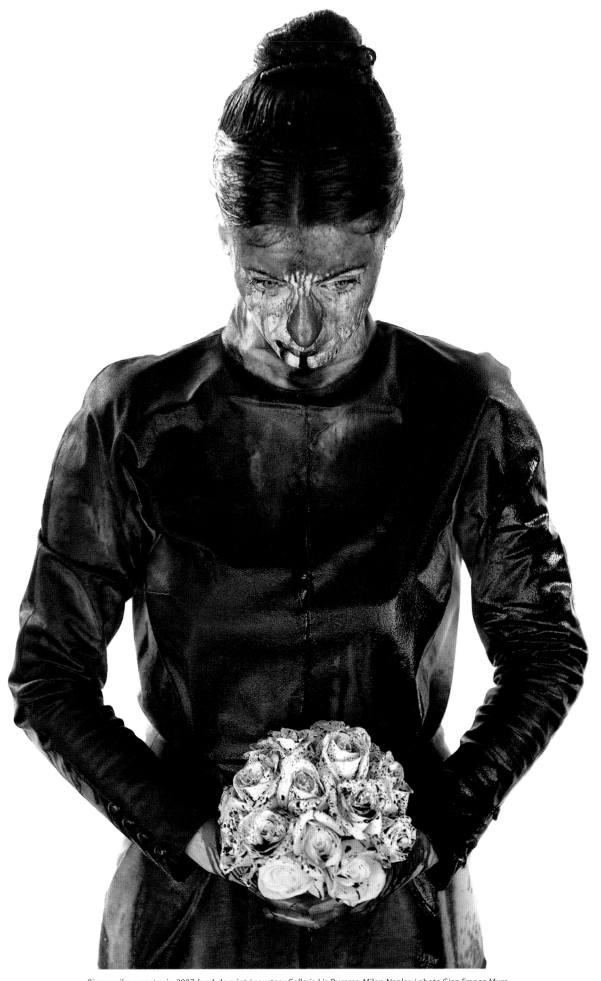

Bianca e il suo contrario, 2007, lambda print / courtesy Galleria Lia Rumma, Milan-Naples / photo Gian Franco Mura

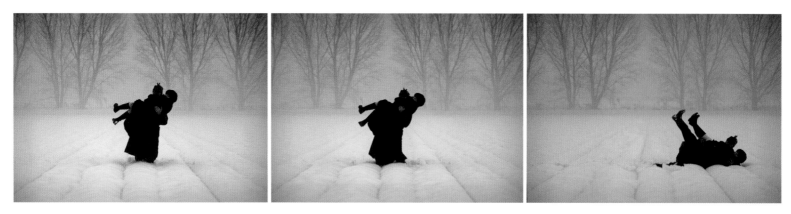

Quando cado, 2005, 3 lambda prints on aluminium / courtesy Galleria Lia Rumma, Milan-Naples

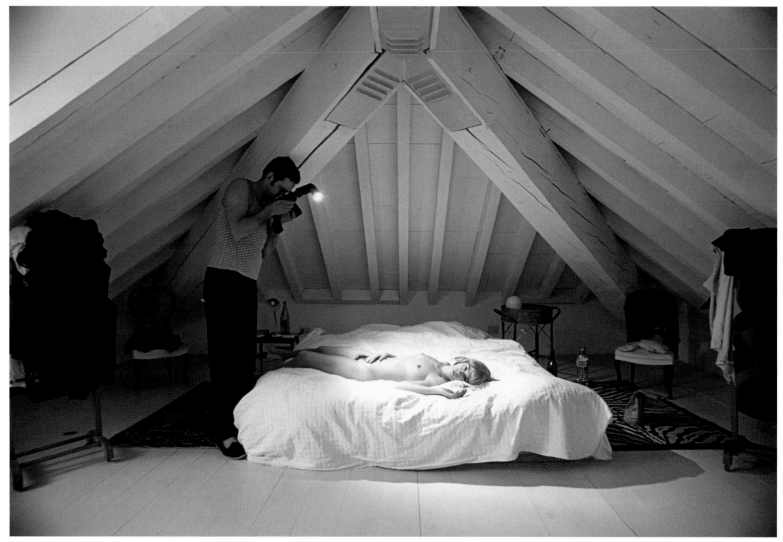

A different view to your picture, 1998, lambda print on aluminium / private collection

We met when we were children and have known each other for almost two thirds of our lives. We have recently become the parents of a delightful little Vietnamese girl called Rosa Dao, and live with her and our dogs and cats in Chiaravalle. We travel a lot, and love literature, cinema and good food.

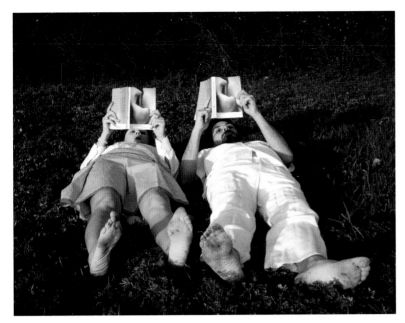

Quella sensazione di eterna felicità che si trova alla fine delle favole senza fine, 2005, lambda print on aluminium / courtesy Galleria Lia Rumma, Milan-Naples

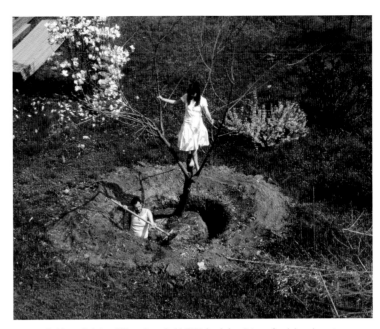

I want to hold your little hand if I can be so bold, 2006, lambda print on aluminium / courtesy Galleria Lia Rumma, Milan-Naples

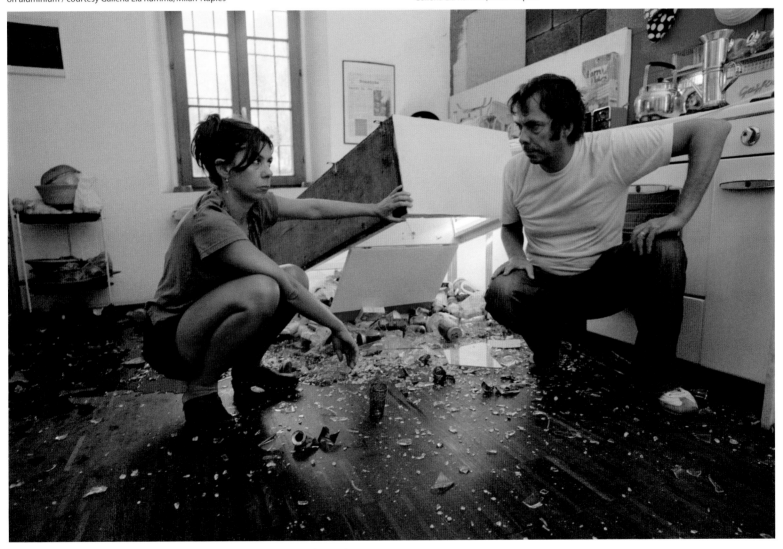

Home disaster, 2007, lambda print on aluminium / courtesy Galleria Lia Rumma Milan-Naples

The fading of the object, of the work, of the architecture as objects and their new connotation are at the heart of Pantin's photography and research, together with his archival spirit, creator of samples which plead with real experience, stripping the human inability and immobility before the seductive deception of the stage.

Alberto Salvadori

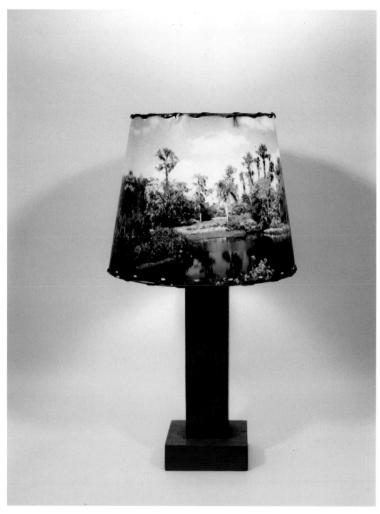

New Landscape, 1999-2000, C-print / courtesy Federico Luger Gallery, Milan

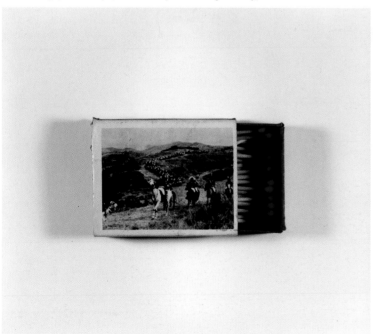

New Landscape, 1999-2000, C-print / courtesy Federico Luger Gallery, Milan

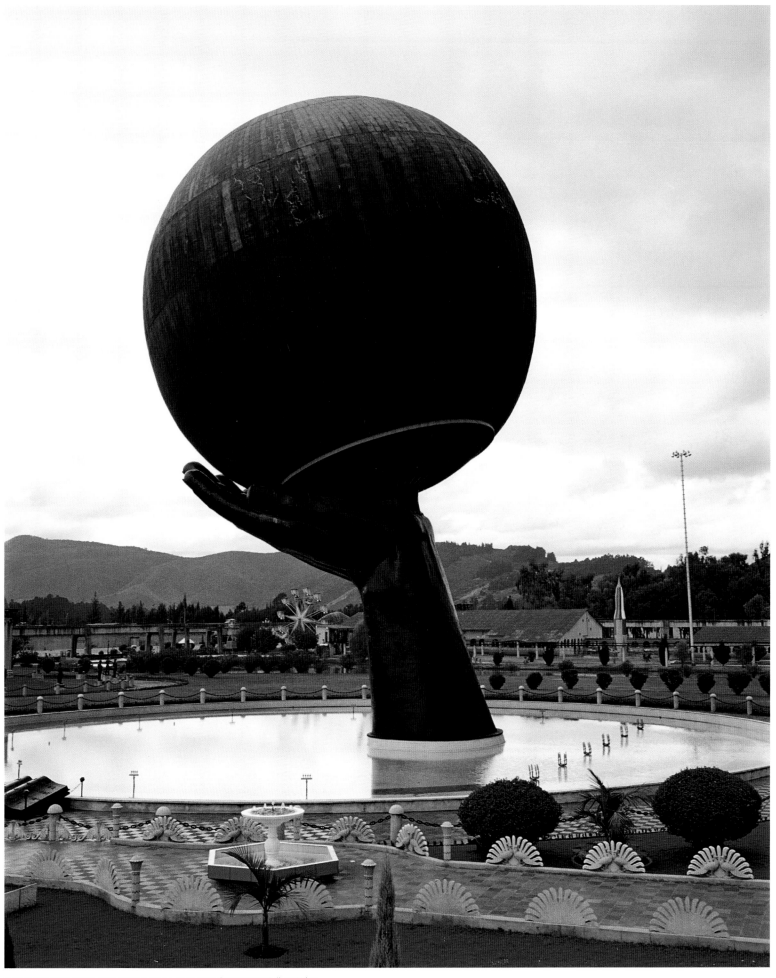

Parque Jaime Dunque 07, 2004-2005, C-print / courtesy Federico Luger Gallery, Milan

It was when I left Egypt in 2003, to live in Paris and later New York,
that I started taking self portraits. I found myself in completely
different places, with new people, which was very different
from my life in Egypt.
This made me think more of life, of existence, the idea of leaving,
and of never really feeling that you belong to a place. I have taken
these images in different cities, where I was a visitor, knowing
I would leave soon. My sense of life is similar, for me it is about
coming to a place that is not yours and then having to go.

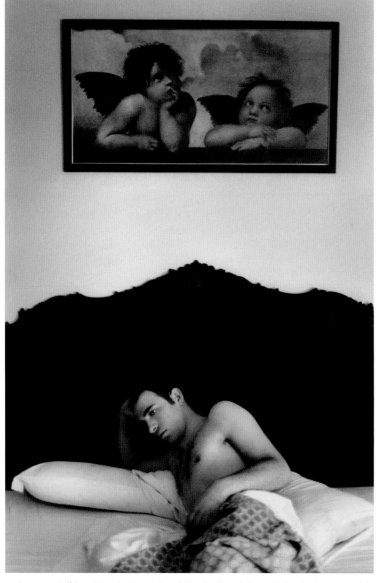
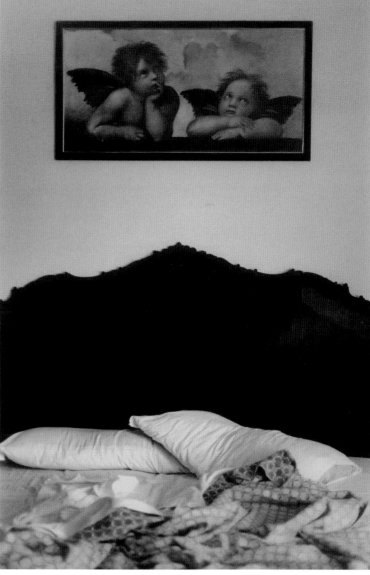

My time to go. Self-Portrait (Venice), 2007, diptych, hand-coloured silver gelatin print / courtesy Micheal Stevenson, Cape Town; e x t r a s p a z i o, Rome

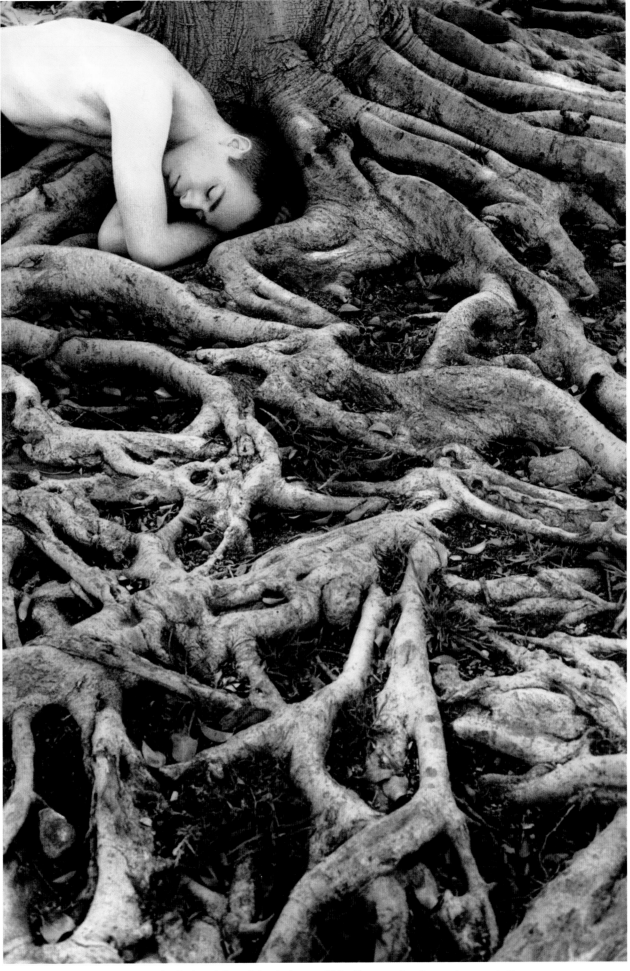

Self-Portrait with Roots (Los Angeles), 2008, hand-coloured silver gelatin print / courtesy Micheal Stevenson, Cape Town; e x t r a s p a z i o, Rome

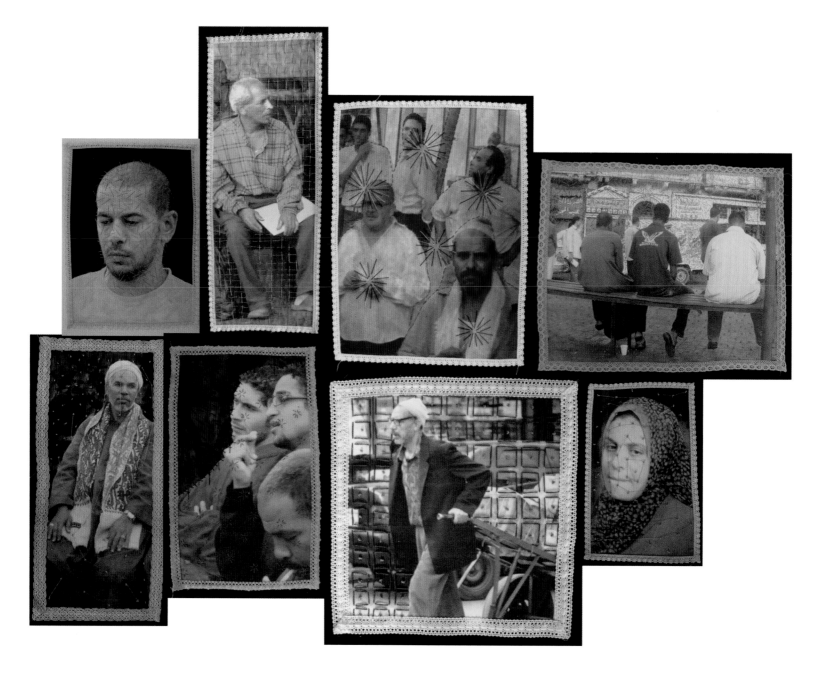

Untitled, 2009, embroidery on photograph printed on canvas / courtesy of the artist

On the surface, Sabah Naim stresses an intimate dialogue
among human figures, attempting to penetrate the thoughts
overwhelming the minds of those people.
The artist clearly develops an intimate relationship with her
human figures marked by lines and colours. Although they are
simple people, they are depicted as heroes shouldering big tasks,
surrounded by great mystique.

Mohamed Abla

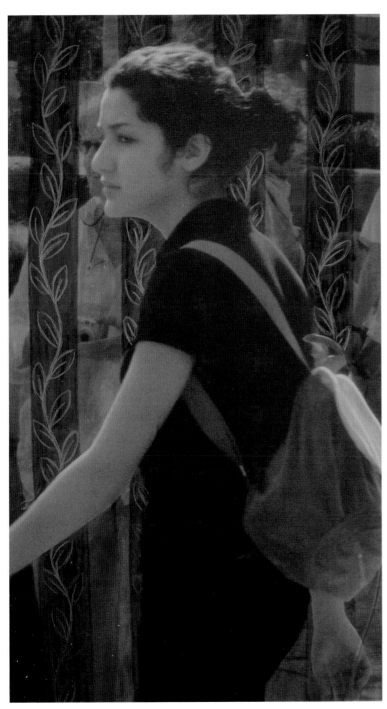

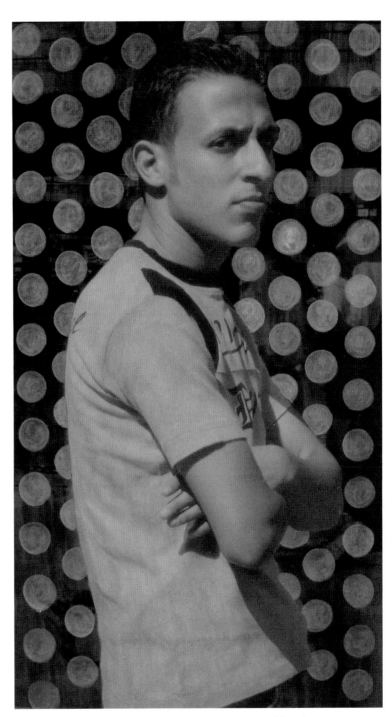

(10), 2008, mixed media on photograph printed on canvas / courtesy of the artist

(37), 2008, mixed media on photograph printed on canvas / courtesy of the artist

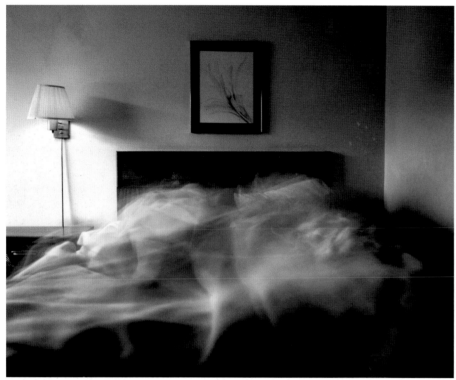

8 Hours. Cedar Rest Motel (Cedar City, Utah), 2002, lambda print / courtesy of the artist

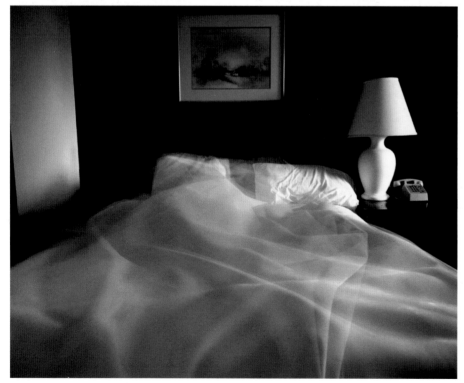

8 Hours. Parkway Motel (Grants Pass, Oregon), 2002, lambda print / courtesy of the artist

Martin Newth is interested in using the process in photography to confound his viewers' expectations of a scene. Often using the "camera obscura" and long exposures, his work explores the historical routes of photography, harking back to the era of its discovery, and raises questions about aesthetics of the medium in the new century.

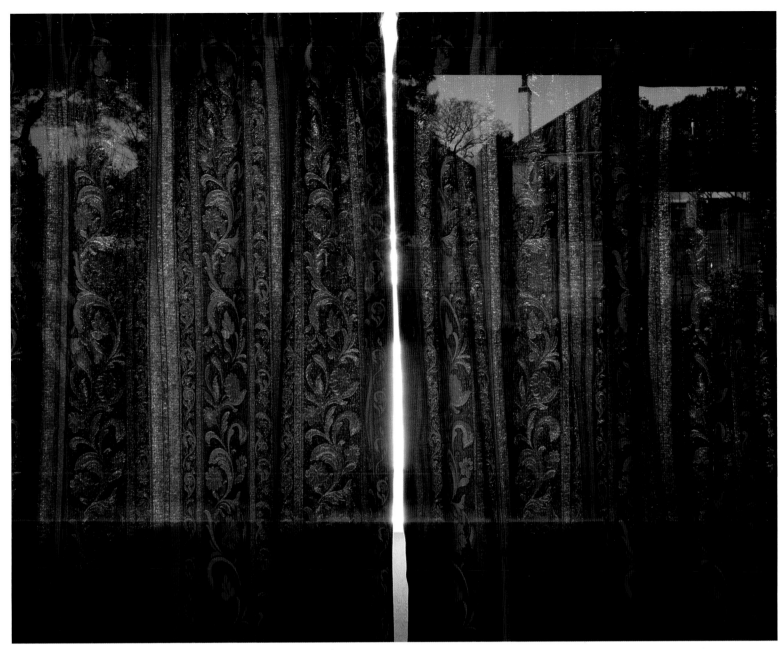

Room/Shutter 5, 2006, lambda print / courtesy of the artist

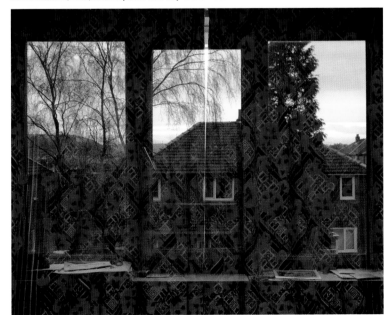

Room/Shutter 1, 2006, lambda print / courtesy of the artist

Room/Shutter 4, 2006, lambda print / courtesy of the artist

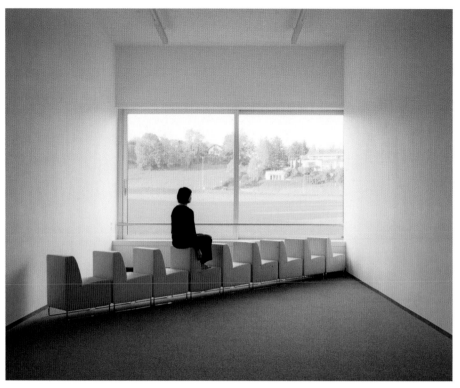

Chaises, 2007, lambda print / courtesy Galerie Esther Woerdehoff, Paris

Staging her pictures, Loan Nguyen takes on the part of an actress in scenarios where likely reconciliations between nature and culture are played out. However, as we move from one scene to the next, we do not uncover any narrative ; of her, nothing is said. She shows no intention of drawing up a self-portrait, only that of giving herself the means to accomplish a heartfelt interpretation of the landscapes. As a result, they penetrate the sphere of intimacy, becoming inner landscapes. Far from any form of anthropocentrism, the environment and its inhabitant are given the same attention, no domination of one over the other ever being felt. As a part of a whole, man recovers his rightful place, and discovers his own existence at the same time as that of the world. Subtle pictorial suggestions, for as many aesthetic visions.

Raphaëlle Stopin

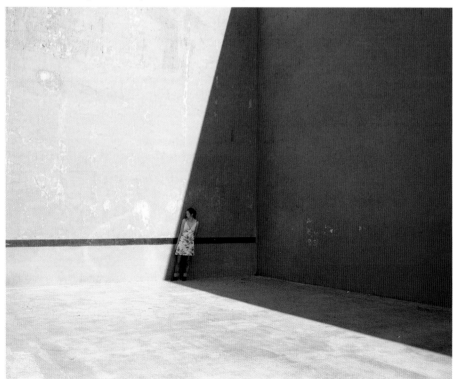

Tennis, 2004, lambda print / courtesy Galerie Esther Woerdehoff, Paris

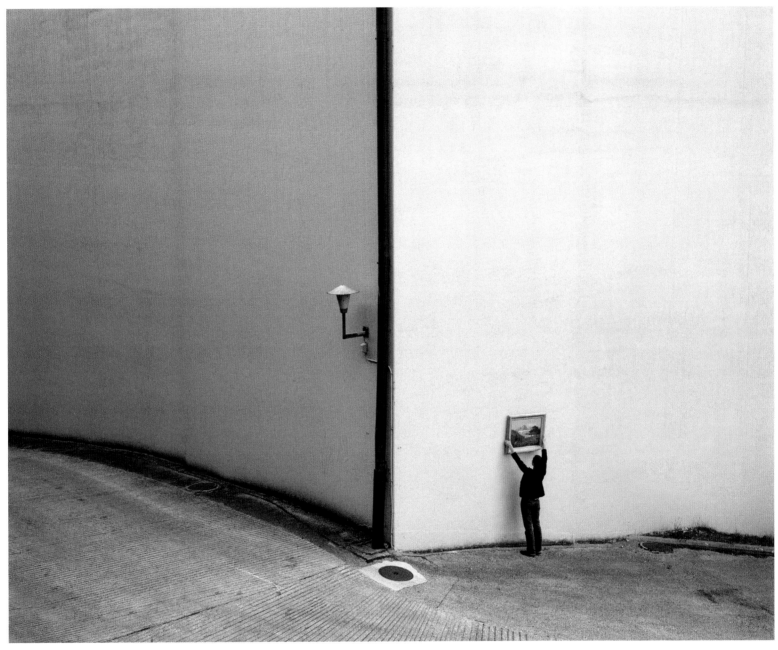

Village de montagne, 2005, lambda print / courtesy Galerie Esther Woerdehoff, Paris

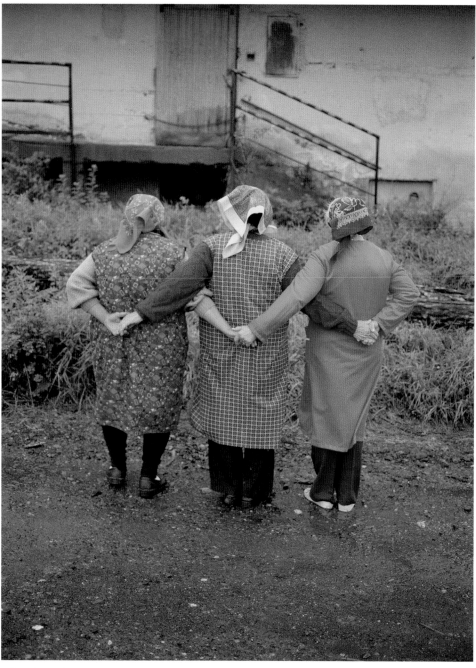

Milkmaids, 2007, lambda print / courtesy of the artist

My new series is a by-product of other work I have been doing
over the last three years. I would call it *Moments*, in which I become
an observer more than creator. In these moments, which usually
happen to me while trying to say something completely different,
I have suddenly been able to show much more than just evidence
of their existence. They are ready-made elements of the world we
live in—evidence of a certain human way of thinking in the system,
or just evidence of certain human decisions. I am a collector using
the medium of photography to document them. They are almost
invisible, but still present.

Untitled, 2007, inkjet print / courtesy of the artist

Untitled, 2007, inkjet print / courtesy of the artist

Untitled, 2006, inkjet print / courtesy of the artist

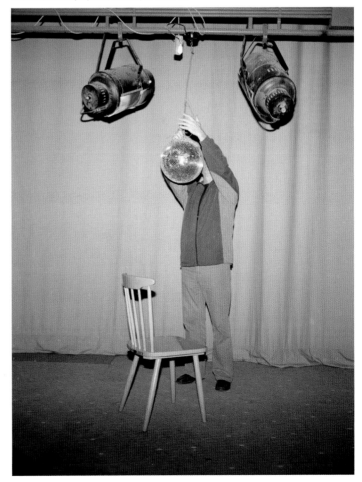

International Women's Day, 2007, lambda print / courtesy of the artist

I generally stage my photographs or rather create performances,
temporary installations, because I want to look at the world with
my own urgencies and vocabulary. For me photography draws
a balance between what is revealed and what remains a secret.
It is on this thin line that I try to create my photographs.

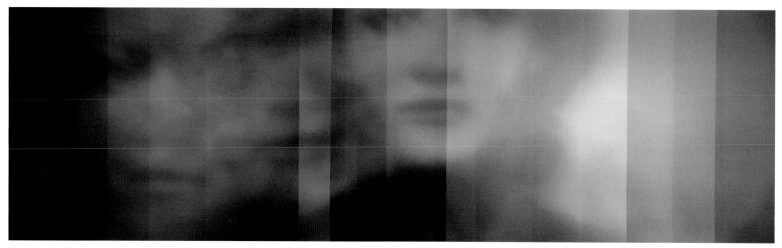

I love you inside and out, 2008, photograph from 120 roll colour film / courtesy of the artist

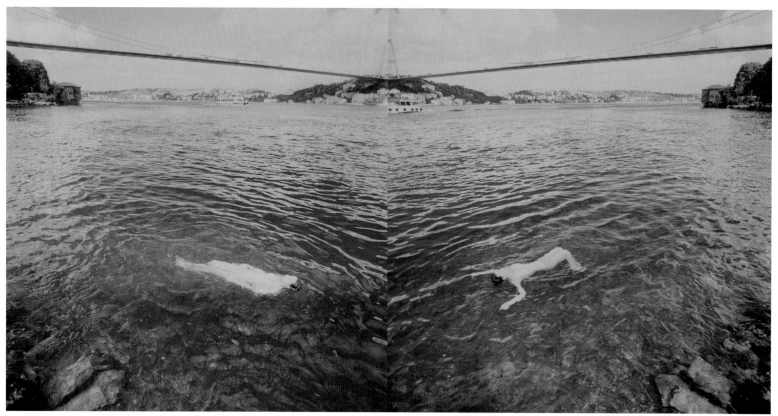

Arriving at the other shore, 2007, photograph from 120 roll colour film / courtesy of the artist

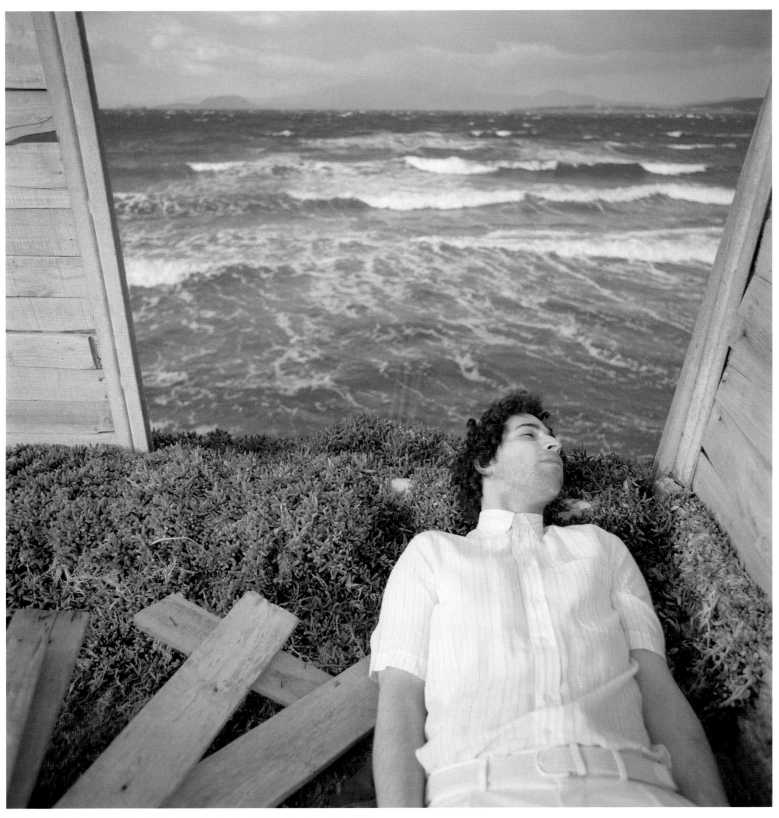

Mekasinzlar-Spaceless, 2005, photograph from 120 roll colour tungsten film / courtesy of the artist

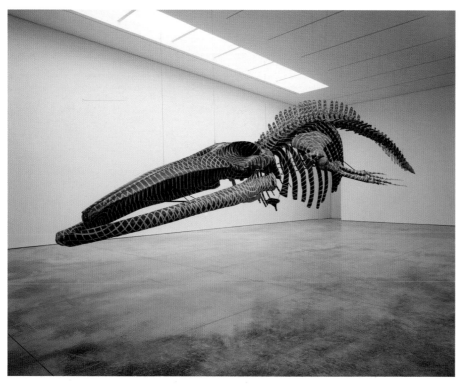

Dark Wave, 2006, calcium carbonate and resin with graphite / courtesy White Cube, London / photo Stephen White

Using objects and situations taken from the contemporary urban environment, Orozco makes visible the poetry of chance connections and paradox. In his photographs, for example, found materials or scenarios are recorded—a ball of clay, a deflated football, an abandoned kite—that, through the artist's observation or intervention, convey extraordinary aspects in the seemingly everyday. More recently, in his paintings, Orozco has explored the phenomenology of structures, in which the symbol of the circle acts as a bridge between geometry and organic matter, and the sequencing of colour is based on the principles of movement within a game of chess.

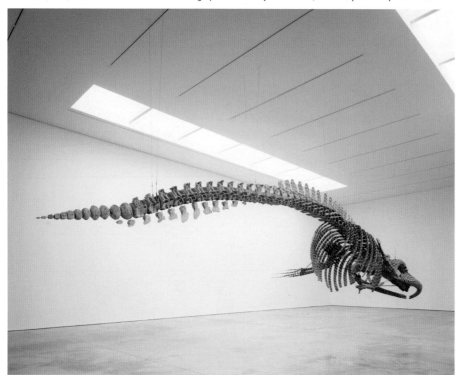

Dark Wave, 2006, calcium carbonate and resin with graphite / courtesy White Cube, London / photo Stephen White

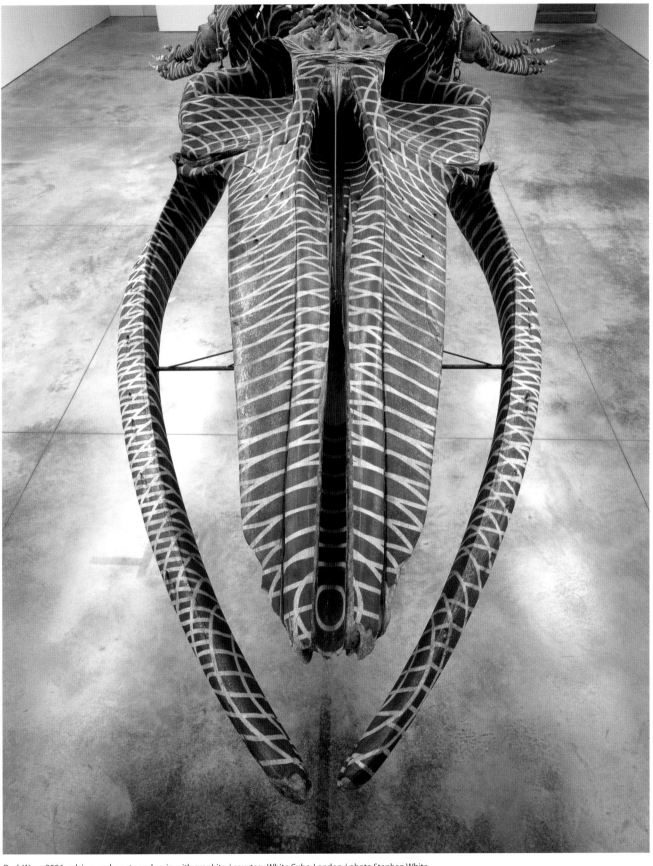

Dark Wave, 2006, calcium carbonate and resin with graphite / courtesy White Cube, London / photo Stephen White

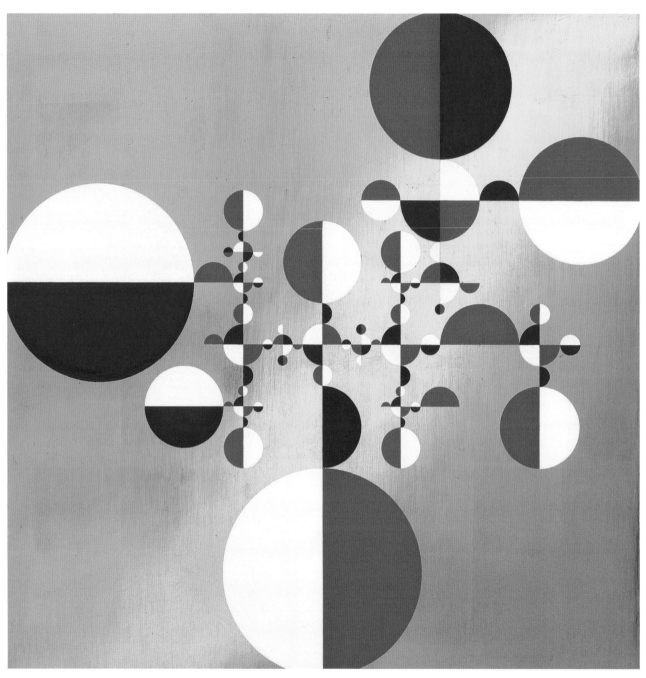

Samurai Tree 2U, 2006, egg tempera on red cedar panel with gold leaf / courtesy White Cube, London / photo Stephen White

Samurai Tree 4T, 2006, egg tempera on red cedar panel with gold leaf / courtesy White Cube, London / photo Stephen White

My photography explores themes of consumerism, work and social identity within everyday urban life. The images often feature people at work in commercial spaces, such as supermarkets and chemists, as these environments reveal the nature of consumer society through their content, design and regulations. They reference anthropological portraits and act as historical documents of contemporary life.

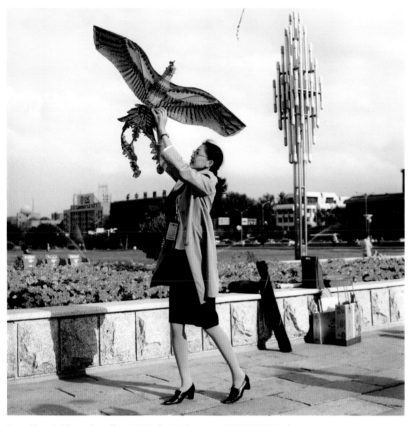

Paper Phoenix (Changchun, China), 2003, C-print / courtesy GRANTPIRRIE, Sydney; Sophie Gannon Gallery, Melbourne

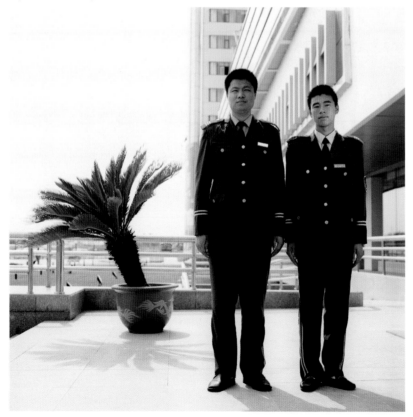

Hotel Security (Changchun, China), 2003, C-print / courtesy GRANTPIRRIE, Sydney; Sophie Gannon Gallery, Melbourne

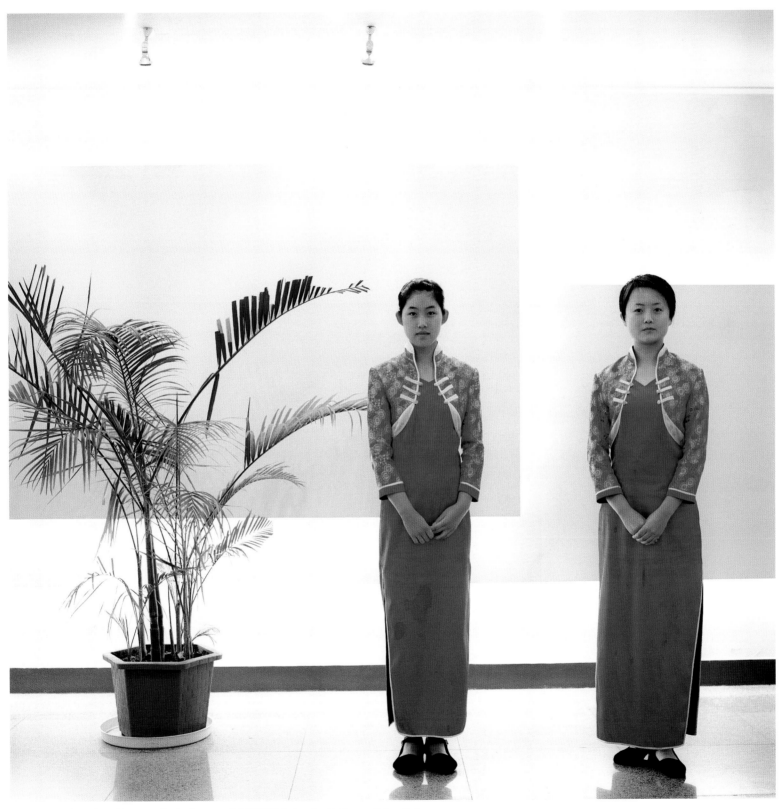

Female Ushers (Changchun, China), 2003, C-print / courtesy GRANTPIRRIE, Sydney; Sophie Gannon Gallery, Melbourne

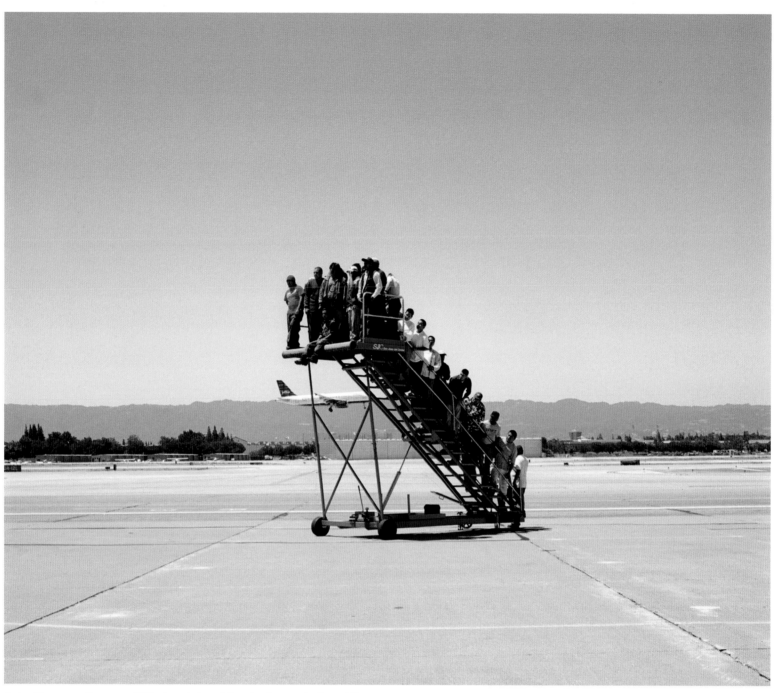

Centro di Permanenza Temporanea, 2008, colour photograph / courtesy francesca kaufmann, Milan

I am not a photographer. I have not studied photography
and often someone else takes my photographs. But when I have
an idea and I know that that idea must take shape in a photography,
I pursue it right to the end. My intention is not to create conceptual
photography in the strict sense of the word; it is simply a photograph
which is necessary. The ideas always come with a possible medium,
with a possible material, and my photographs simply try to bring
that tension of the idea-image inside me to a conclusion, and transfer
it to the spectator.

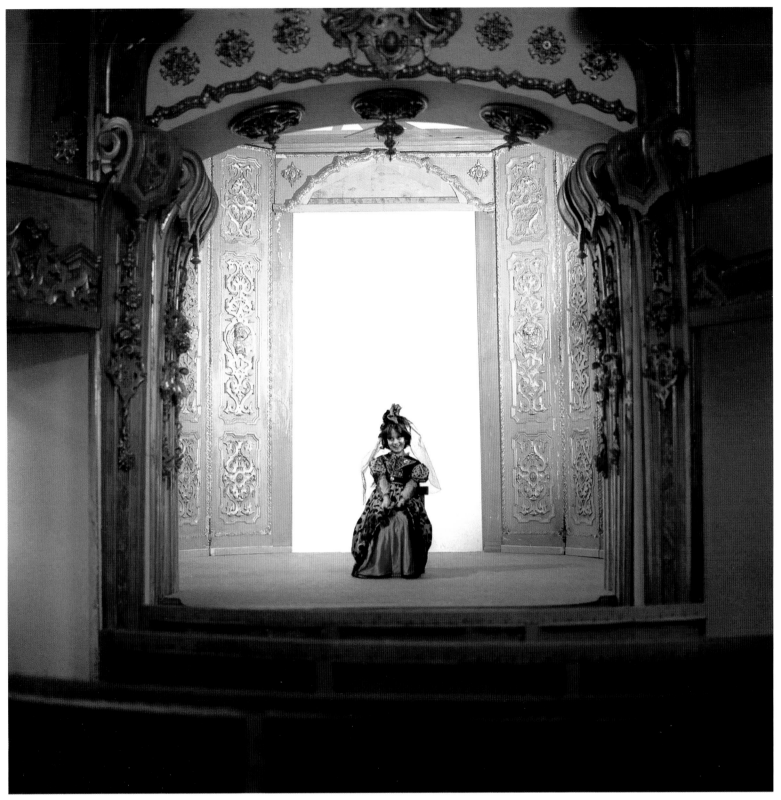

The Princess, 2003, colour photograph / courtesy francesca kaufmann, Milan

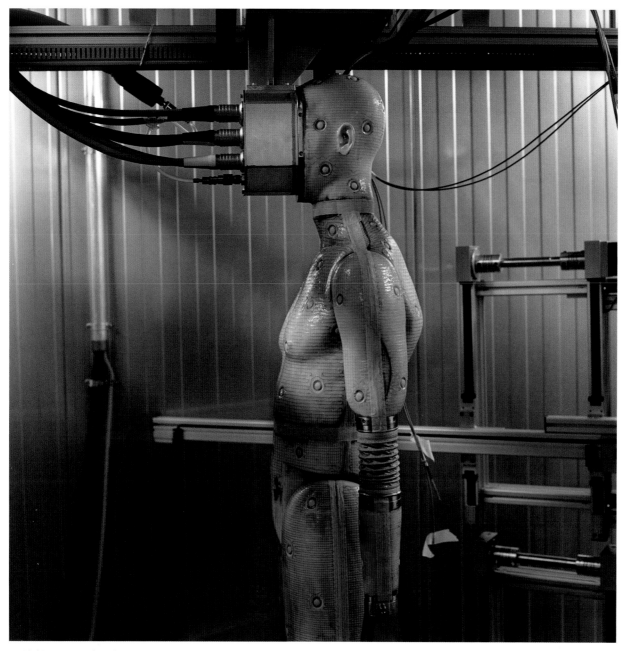

Untitled (Perspiration), from the series *Dummies*, 2004, glossy lambda print / courtesy of the artist

Through formally very different series, Danaé Panchaud explores
our relationships with the body. The *Dummies* confront us with
the commodification of body, its reduction to a perfectible sum
of functions. In *Still*, fragile and overexposed bodies fold back
on themselves in a protective but brittle intimacy, between absence
and expectation. *Medicine* shows places of violent intimacy,
of complete exposure of a body that has become a passive
and inert entity.

Still #9, 2006, glossy lambda print / courtesy Photoforum PasquArt, Biel

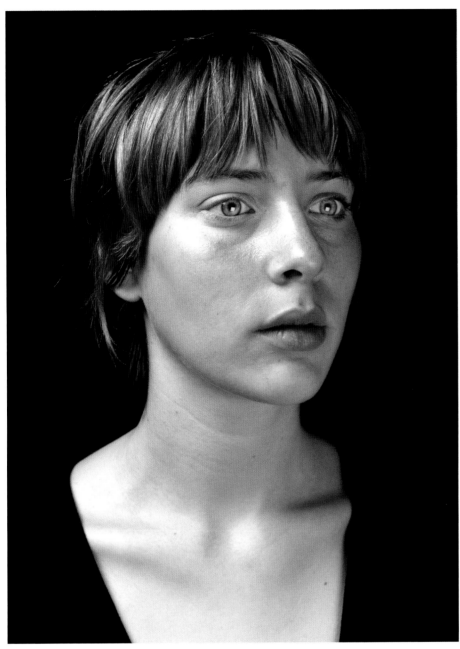

Still #1, 2006, glossy lambda print / courtesy Ville de Bienne

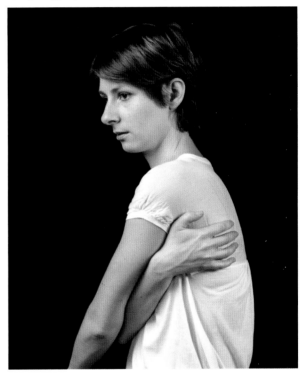

Still #12, 2007, glossy lambda print / courtesy of the artist

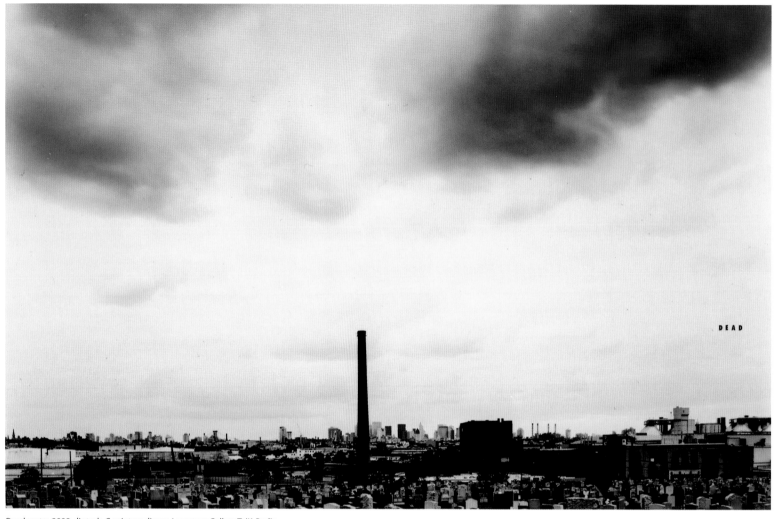

Dead centre, 2008, diptych, C-print on diasec / courtesy Gallery TaiK, Berlin

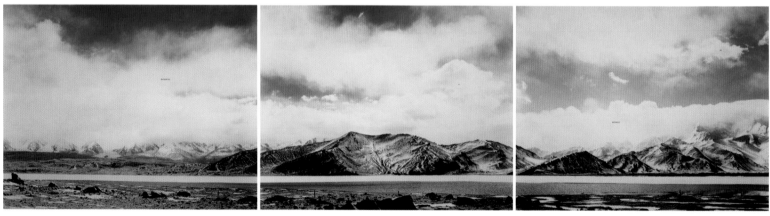

Under China clouds, 2008, triptych, C-print on diasec / courtesy Gallery TaiK, Berlin

The union between word and image plays a significant role in this series. A sense of craftsmanship was key to the creative process. I don't manipulate my photographs digitally. Instead, I work by taking the initial image and printing a proof to which I add 3D elements, such as metal threads, needles and lettering. I then photograph the collage to create the final version. The long process is designed to forge the photograph towards a painterly aesthetic and logic. Words and sentences inscribed on the images add new levels of meaning. They might politicise or poeticise. I use the words to forge a new identity for the landscape as I have observed and experienced it.

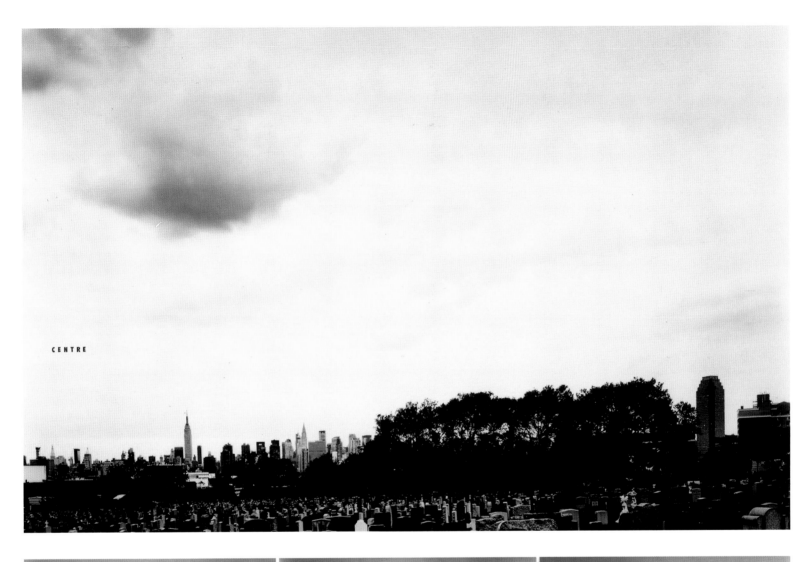

CENTRE

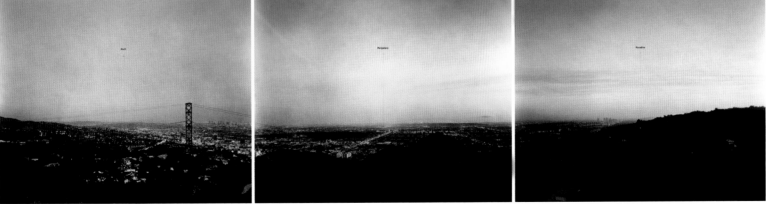

Divine Comedy (Mullholland Drive), 2008, triptych, C-print on diasec / courtesy Gallery TaiK, Berlin

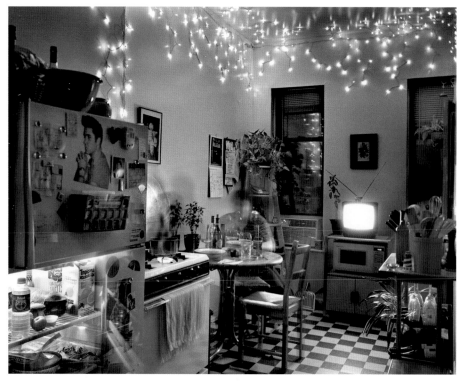

Anamika Bhatnagar & Dennis Willette, BBC World News / Access Hollywood, Thursday, October 2, 2003, 7-8pm, 2003, pigment inkjet print / courtesy Bonni Benrubi Gallery, New York

In his *Screen Lives* series of work, Pillsbury explores the role technology plays in our lives, capturing the passing of time, physically and psychologically, that we spend in front of televisions, computers and handheld devices. His long-exposure photographs allow us to reflect on the paradoxical relationship we have with technologies that allow for instant global communication but leave us increasingly physically isolated.

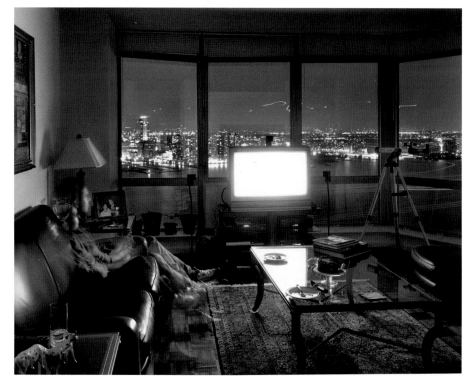

Tanya & Sartaj Gill, CSI Miami, Monday, November 25, 2002, 10-11 pm, pigment inkjet print / courtesy Bonni Benrubi Gallery, New York

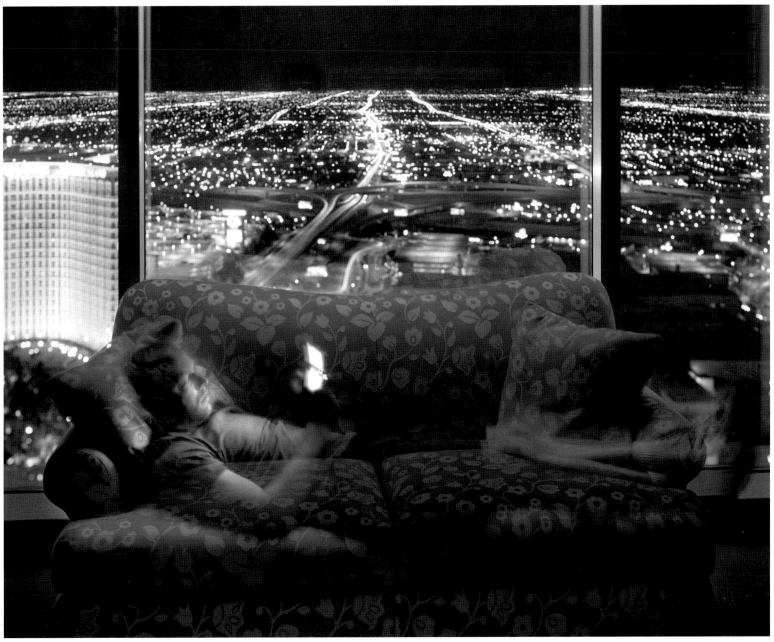

Nathan Noland, Mario Kart DS, The Star Cup, Wynn Las Vegas; Monday, July 31st, 2006, 0:34-0:52am, pigment inkjet print / courtesy Bonni Benrubi Gallery, New York

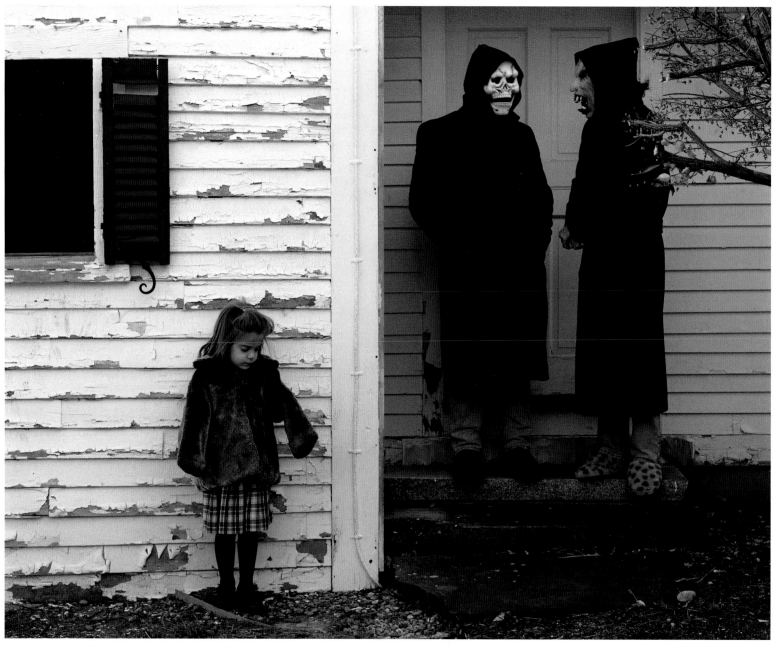

Untitled #44, 2003, cibachrome print / courtesy Yossi Milo Gallery, New York

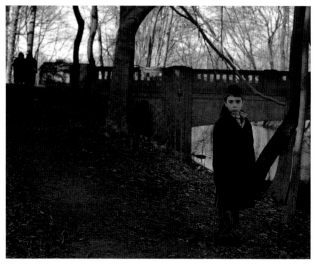

Prior delves into the complexities of childhood and depicts scenes that are tranquil in feeling yet psychologically charged. Set against the benign backdrop of small town New England, the images are quietly uncanny, and suggestive of a deceptively complex chasm between adulthood and childhood.

Untitled #97, 2004, cibachrome print / courtesy Yossi Milo Gallery, New York

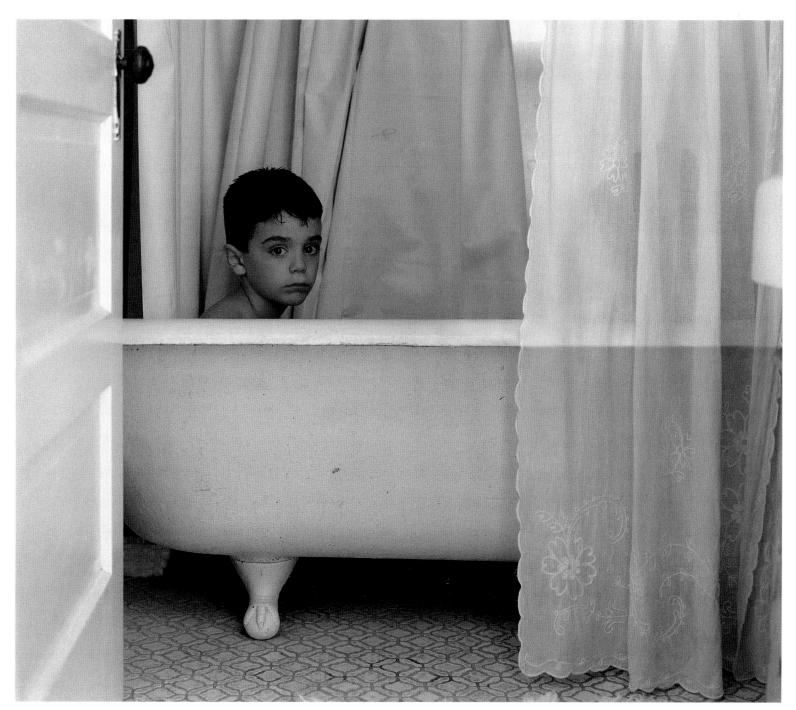

Untitled #111, 2004, cibachrome print / courtesy Yossi Milo Gallery, New York

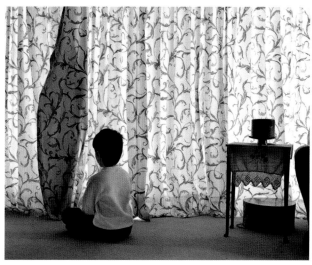

Untitled #26, 2003, cibachrome print / courtesy Yossi Milo Gallery, New York

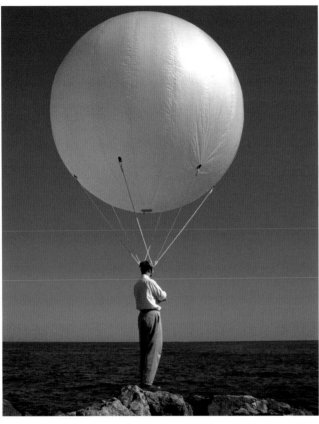

Prostheses for body and soul, the objects and situations dreamed up by Ramette are designed to improve our moral and spiritual existence in a playful way, and to free us from the limits imposed by our condition as humans, allowing us to move through the heavens or the depths of the sea in complete liberty. But there is a price to be paid just the same, a physical effort or a mortification of the body. Along with his "mentally activated" sculpture-objects, Ramette produces images where he poses in situations for which his objects were originally created.

Christian Bernard

Sans titre (Éloge de la paresse 1, utilisation), 2000, colour photograph / courtesy Galerie Xippas, Paris / photo Marc Domage

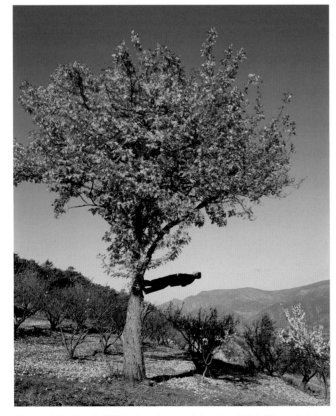

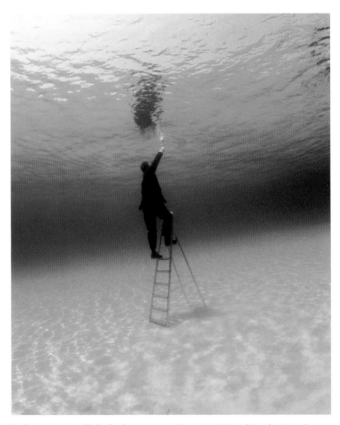

Promenade irrationnelle, 2003, colour photograph / courtesy Galerie Xippas, Paris / photo Marc Domage

Exploration rationnelle des fonds sous-marins: le contact, 2006, colour photograph / courtesy Galerie Xippas, Paris / photo Marc Domage

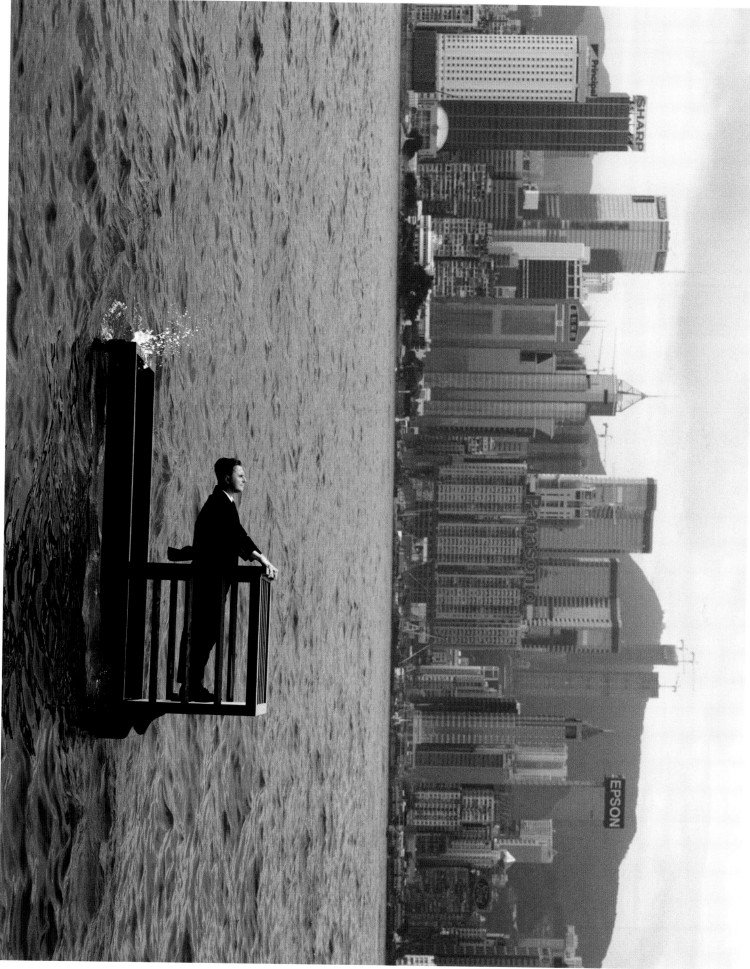

Balcon 2 (Hong Kong), 2001, colour photograph / courtesy Galerie Xippas, Paris / photo Marc Domage

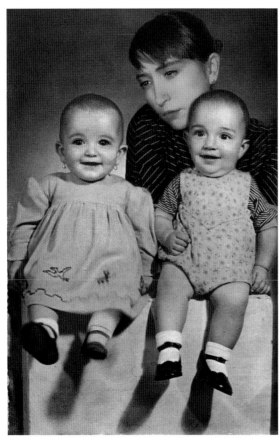

20.12.53-10.08.04 (gemellini), 2004-in progress, lambda print
on aluminium / courtesy Galleria Alessandro De March, Milan

20.12.53-10.08.04 (mamma e zia Carolina), 2004-in progress, lambda print on aluminium / courtesy
Galleria Alessandro De March, Milan

12.53-10.08.04 (da nonna), 2004-in progress, lambda print on aluminium / courtesy Galleria Alessandro De March, Milan

Moira Ricci works mainly using video and photography. At the centre
of her interests is the world of family affections and the family home:
the natural setting for these relationships. With a gaze courageously
bringing her own emotions into play, Ricci has created different
works, beginning with visual materials filmed in a family environment,
leaving their spontaneous beauty intact but reorganising them
to add further levels of interpretation. The first of these is the mirror
effect which her works generate in those who view them, the ability
to transform the account of herself into fertile ground and sparking
a reflection on our world, affections and places which—for better
or for worse—shape the identity of each of us.

Emanuela De Cecco

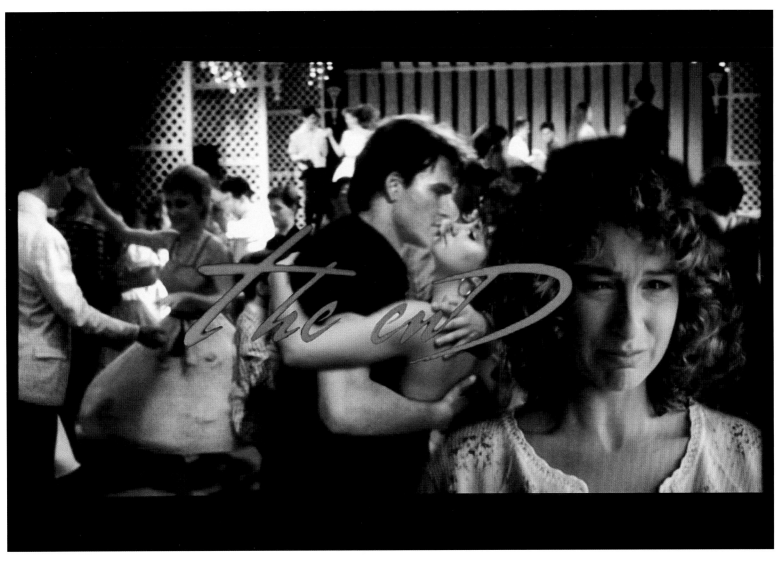

Se il "THE END" fosse stato tragico io sarei stata più abituata alle delusioni d'amore (Dirty Dancing), 2008, lambda print on aluminium / courtesy Galleria Alessandro De March, Milan

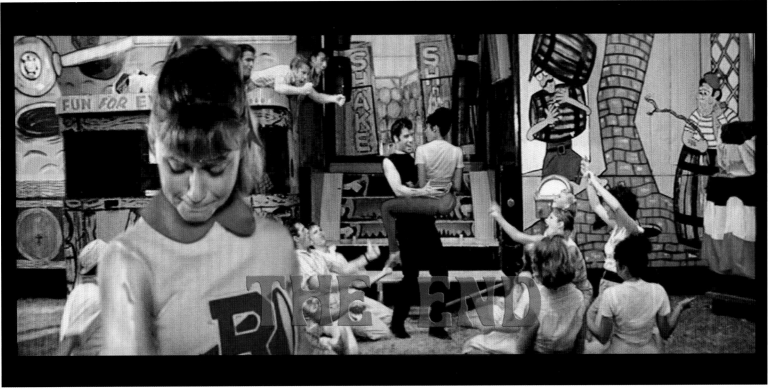

Se il "THE END" fosse stato tragico io sarei stata più abituata alle delusioni d'amore (Grease), 2008, lambda print on aluminium / courtesy Galleria Alessandro De March, Milan

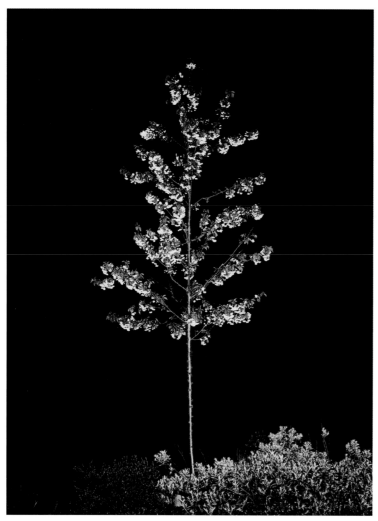

Twelve Trees 3, 2004, C-print / courtesy Alberto Peola, Turin

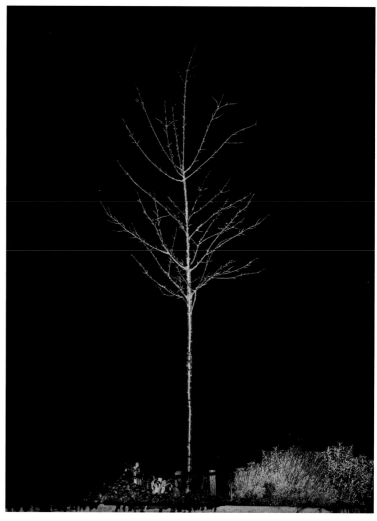

Twelve Trees 12, 2004, C-print / courtesy Alberto Peola, Turin

I work with photography and video installation, and much
of my work contemplates the relationship between the narrative
tendencies and abstract possibilities of photography.
As well as the generation of imagery, I am interested in the role
of photography and film as a mediator, and the actual physical
experience of using a camera in the "natural world".

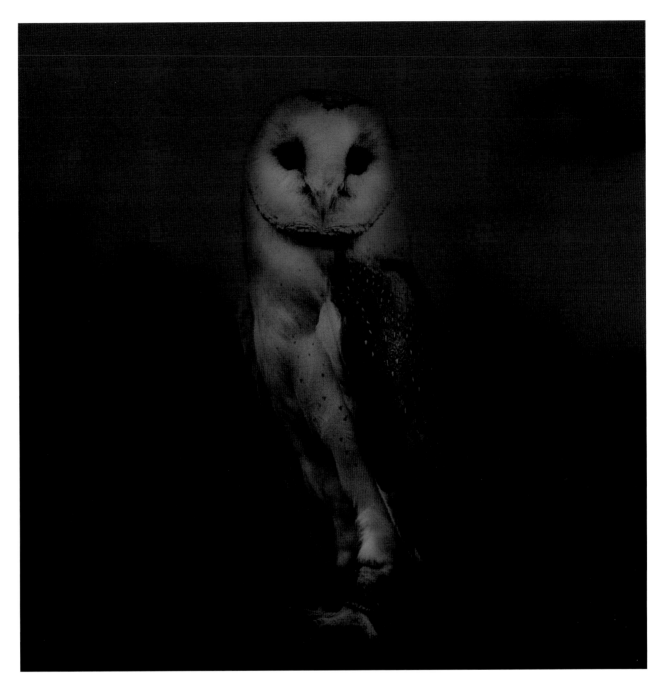

Untitled (Nature Study) 1, 2009, silver gelatin print / courtesy Alberto Peola, Turin

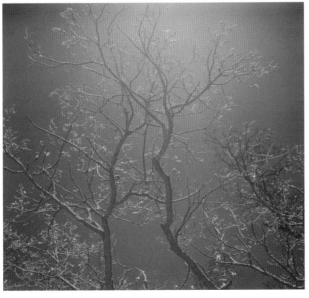

Untitled (Nature Study) 2, 2009, C-print / courtesy Alberto Peola, Turin

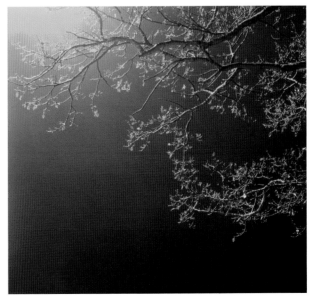

Untitled (Nature Study) 6, 2009, C-print / courtesy Alberto Peola, Turin

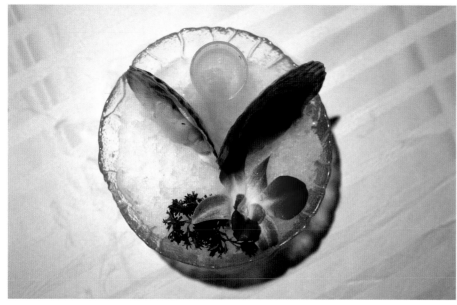

Portrait of a Lady was a project that I developed at the same time that I was discovering a new friendship with Ming Liang Wu.
As in other projects I use photography to create images that result in presumed documents of a personal perambulation in physical and emotional spaces. In *Portrait of a Lady* the feminine universe and the identification of places are provided through formal processes transforming the very precise nature of this long portrait in a document permeated by two specific qualities—ubiquitous human and thick gloom.

Portrait of a Lady, 2007, inkjet print / courtesy of the artist

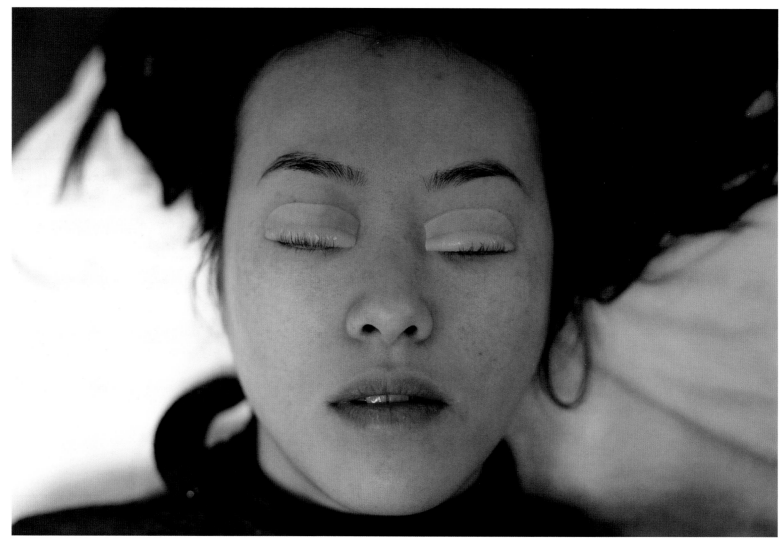

Portrait of a Lady, 2007, inkjet print / courtesy of the artist

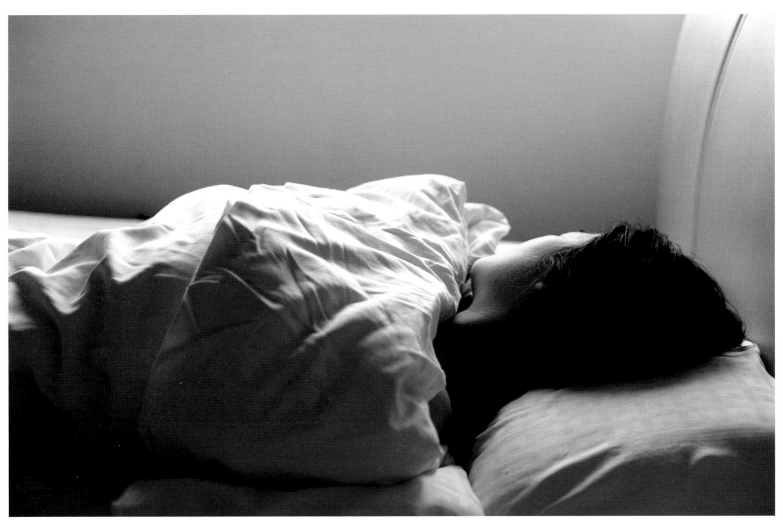

Portrait of a Lady, 2007, inkjet print / courtesy of the artist

Portrait of a Lady, 2007, inkjet print / courtesy of the artist

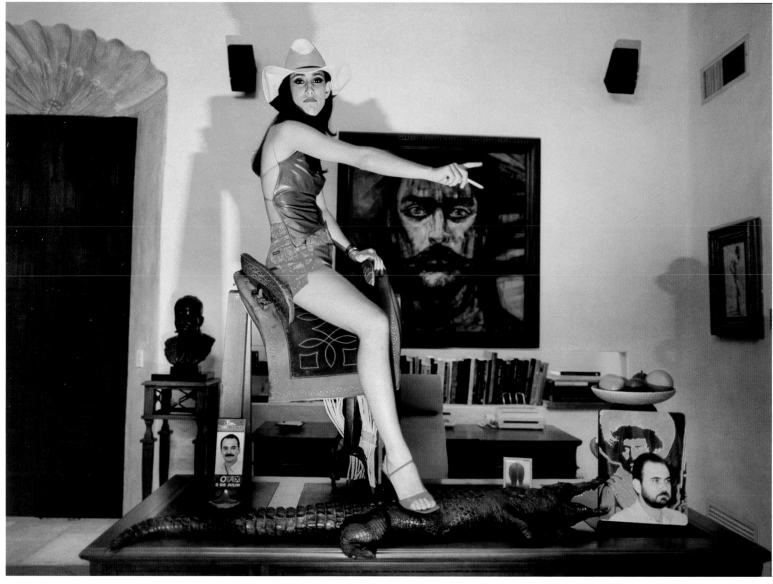

Untitled (Paulina on the desk of her father), 2000, C-print / courtesy Alberto Peola, Turin

Daniela Rossell makes series of colour photographic portraits
of young women from rich and powerful families, who appear
as parodies of a certain upper middle class. There is no didactic
tendency or moralistic judgement in her works, but rather a strong
humoristic element and an evident empathy which together
determine the camera angles.

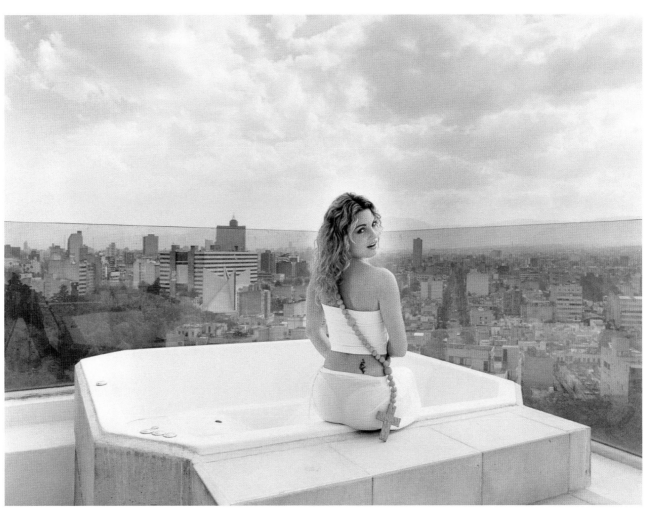

Untitled (Michelle in Jacuzzi overlooking Mexico City), 2000, C-print / courtesy Alberto Peola, Turin

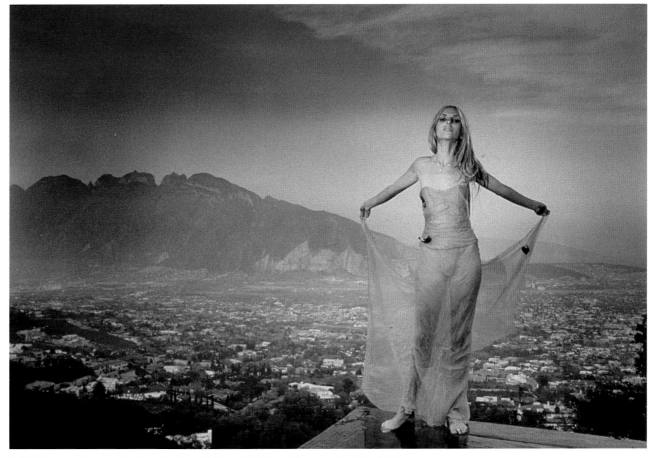

Untitled (Francis on the edge of her house, Monterey, N.L., Mexico), 2001, C-print / courtesy Alberto Peola, Turin

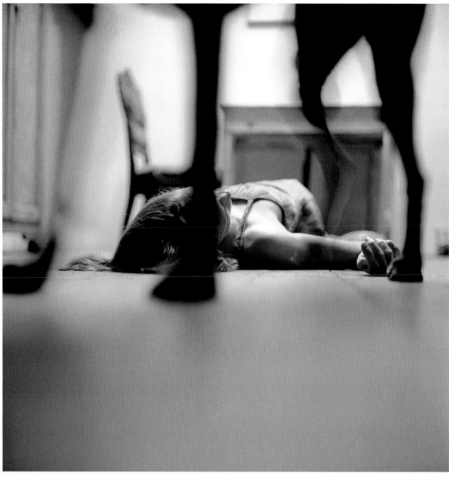

Her works are traces of a process in becoming, that which remains of an intuition put into practice; the quest for a reciprocal relationship between thought (symbol, number) and image (mirror representation) through themes such as the transformation of the landscape, a changing point of view, or those relating to memory and the duration and passing of time.

Senza titolo (Miele), 2002-2003, colour photograph / courtesy of the artist

Senza titolo (Miele), 2002-2003, colour photograph / courtesy of the artist

Senza titolo (Miele), 2002-2003, colour photograph / courtesy of the artist

Senza titolo (Miele), 2002-2003, colour photograph / courtesy of the artist

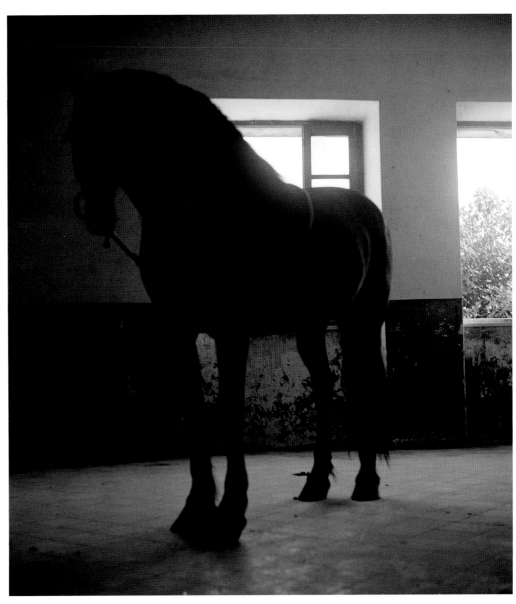

La città fantasma – Serafino, 2007, colour photograph / courtesy of the artist

La città fantasma – Banchi, 2007, colour photograph / courtesy of the artist

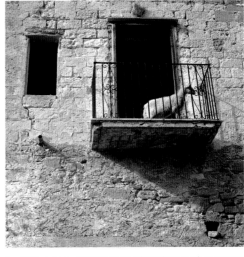

La città fantasma – Giulietta, 2007, colour photograph / courtesy of the artist

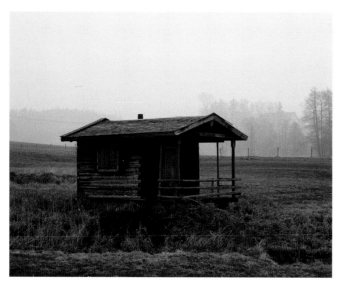

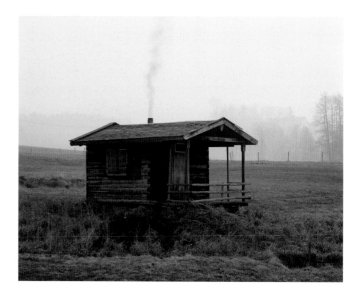

3 Ster mit Ausblick, 2002, with Jürgen Heinert, 10 cibachrome prints on dibond / courtesy Zero…, Milan / photo Siegfried Wameser

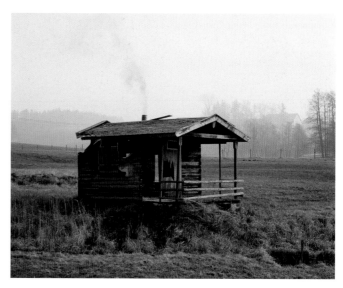

A liberating leitmotif for the sculptor Michael Sailstorfer runs as follows: "Aggression towards the material and the viewer." Created from this perspective are works with a direct connection to the present and which were earlier linked in particular to the fulfillment of yearnings, so as to possess an intimate as well as a global dimension. Thus pragmatic realizations and bold shifts of context also characterize Sailstorfer's art, which first summons up a promising euphoria only to veer round into tragedy, even though the original idea was extremely practical—but at the same time absurd.

Eveline Bernasconi

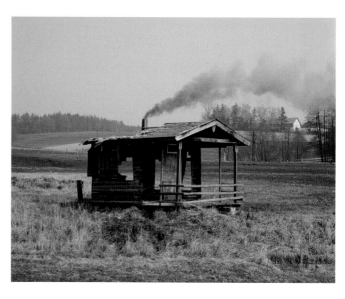

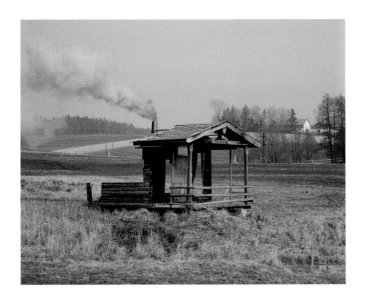
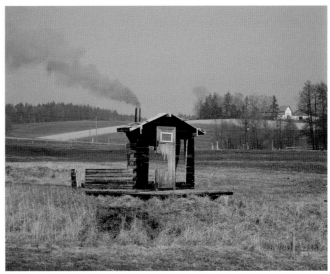
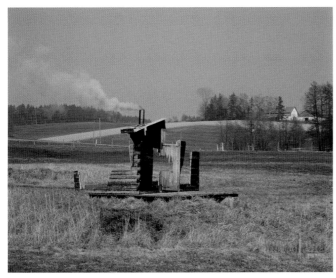
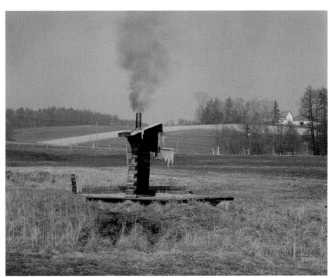
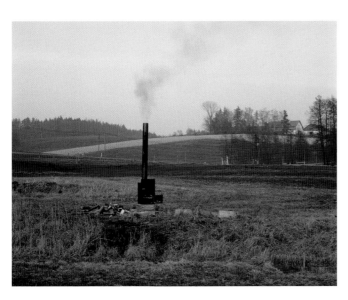
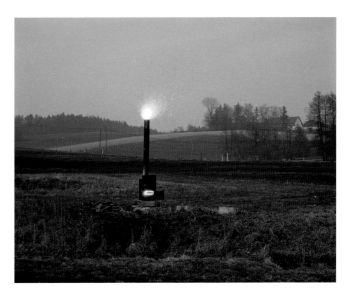

I am curious when I don't really know how to deal with something
that I am initially receptive and vulnerable to. No one likes to end
up being vulnerable, but I like starting out that way. Not knowing
exactly why something interests me has a kind of mystery
or irresolution that moves me.

Untitled, 2007, 4 black and white photographs / courtesy Galleria Alfonso Artiaco, Naples

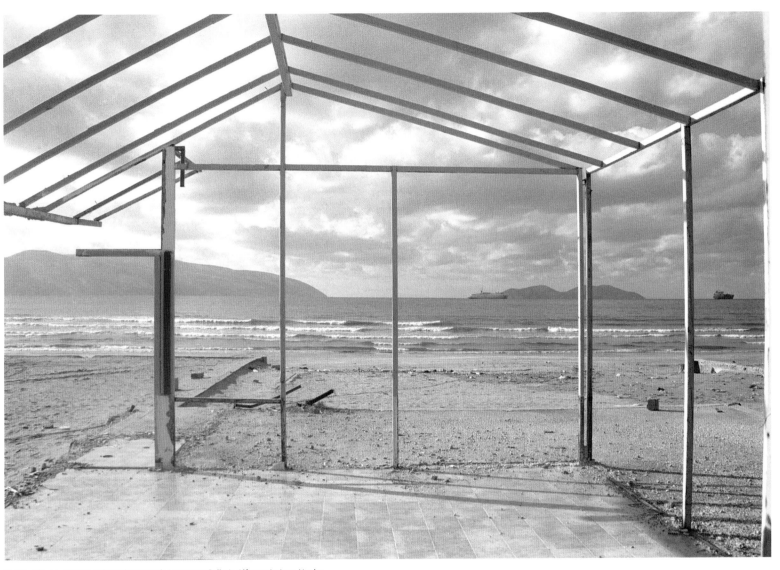

Untitled (kiosque), 2006, colour photograph / courtesy Galleria Alfonso Artiaco, Naples

Every night, before my slumbers, I hose down the inside of my brain, so I sleep like a baby. This method wasn't prescribed to me by any strange doctor, I invented it myself when I was young as a formula for mental hygiene.

I sincerely believe that happiness is the greatest gift we can give ourselves when faced with our mortal destiny. I choose photography, one of the most intense ways to look at and experience daily life. Taking photographs is also a great way to interact with people and for me, as someone as sociable as he is optimistic, this interaction with living creatures is something as necessary as breathing; but it must be a positive interaction. And here is where it is possible to see the aspects of life that fascinate me most, those which we reserve solely for searching for that fragile goal called happiness: physical and mental spaces of leisure understood as life-affirming realms, far removed from the drudgery of wage slave effort and sacrifice.

I think my way of looking has gone from surprise, irony or celebration to a contented acceptance of the manifestations of others, less and less judging, less and less reciprocal, and more and more mature.

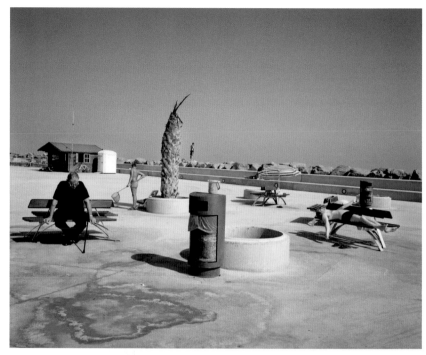

Untitled, from the series *Spanish Hits*, 2008, silver gelatin print / courtesy of the artist

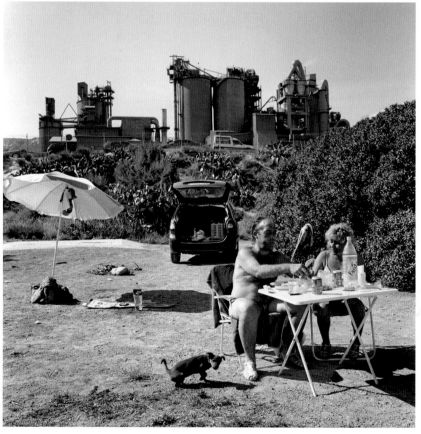

Untitled, from the series *Spanish Hits*, 2006, silver gelatin print / courtesy of the artist

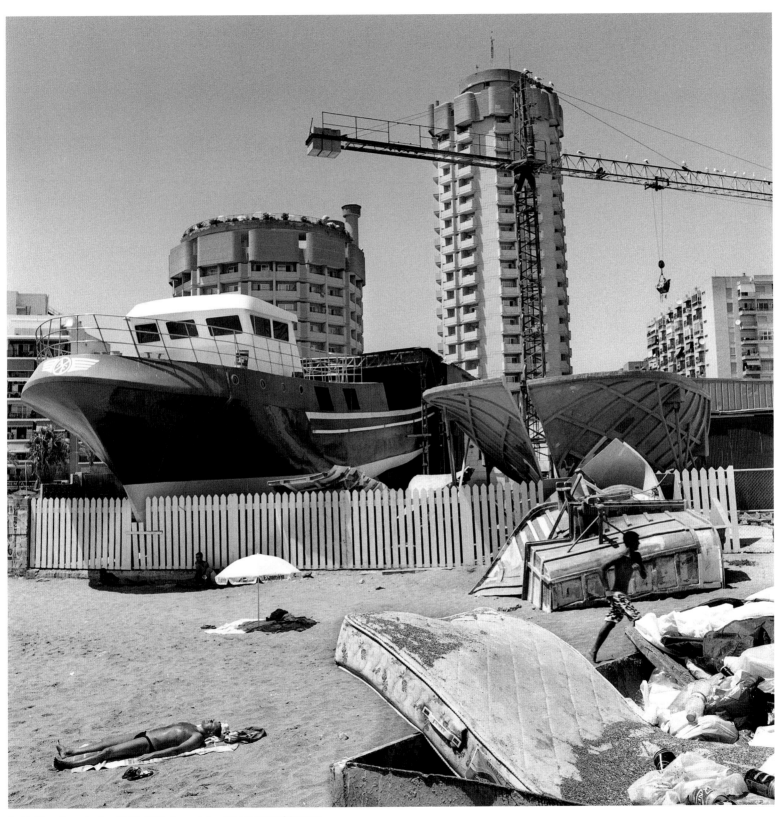

Untitled, from the series *Spanish Hits*, 2008, silver gelatin print / courtesy of the artist

In various images from a rich collection of postcards held at the
G. Panini Photographic Collection, Marco Samorè has found a new way
of reinventing the use of these postcards [...] Taking the postcards
from the archive and their transformation into objects of consumption
as a starting point, mediated by this game of pretence the artist
constructs small structures around the chosen images, structures
which show their theatrical aspect with vividness and humour.

Luca Panaro

Rimedi, 2006, colour photograph / courtesy Fotomuseo Giuseppe Panini, Modena

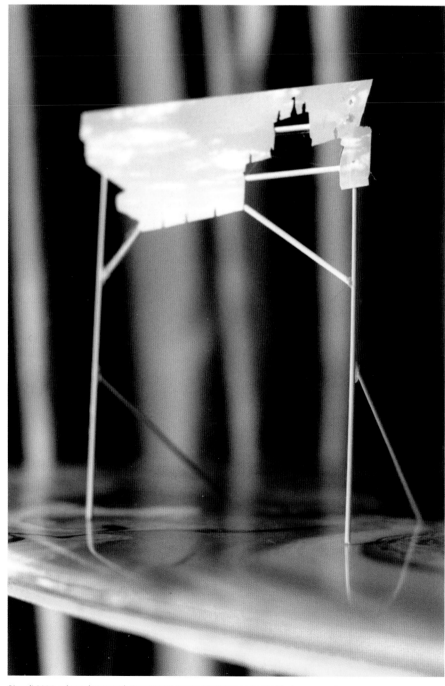

Rimedi, 2006, colour photograph / courtesy Fotomuseo Giuseppe Panini, Modena

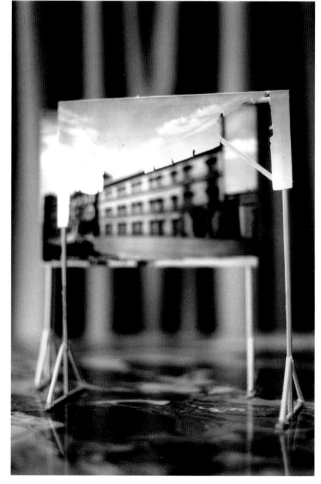

Rimedi, 2006, colour photograph / courtesy Fotomuseo Giuseppe Panini, Modena

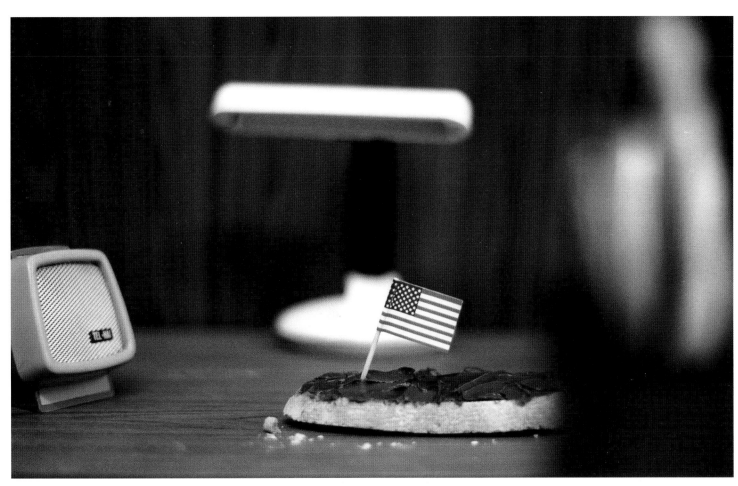

Il buon mattino, 2001, colour photograph / courtesy of the artist

Senza titolo, 2002, colour photograph / courtesy of the artist

Costruzione, 2007, sequence of imprints and frames from video projection (film 1h 14' 54" loop) / courtesy Artericambi, Verona

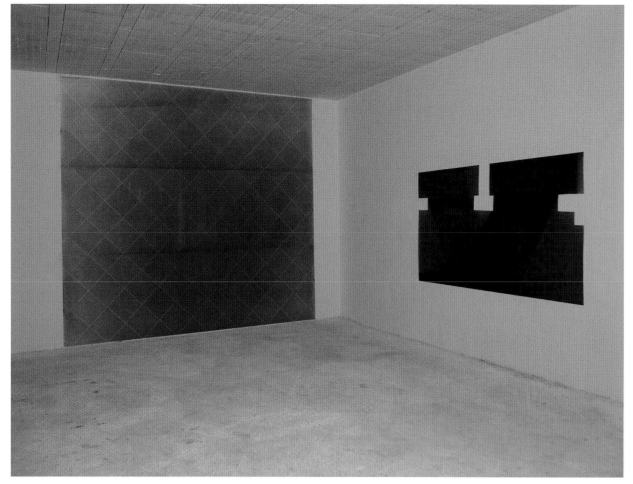

Stanza and *Frammento*, 2003, photograms, installation view at artist's studio / courtesy of the artist

I believe the idea of precipitate identifies the sense and unusual use of photography in this work of mine, which consists of recording the impression of lived-in rooms on light-sensitive paper. The paper is spread out upside-down with the emulsion-coated side in direct contact with the floor and the back turned towards the space above. This generates a "double negative", which captures the images of that situated above the paper (the light which hits the paper) and at the same time that which lies under it (refraction of the flooring material), recording space and things directly and at the very same moment. Not only those near the surface, but also those further away and in the two opposite directions of gravity and its contrary. The resulting single picture becomes a kind of section, revealing things from a point of view which sums and concentrates that which lies above and below, setting itself between them. The image is this constant recording of the precipitate materials. The forms are arranged by the person living there.

Stanza, 2007, photogram / private collection

Stanza, 2006, photogram / courtesy Artericambi, Verona

Appartamento, 2007, photogram / courtesy Artericambi, Verona

Universe at an age of two billion years, 2005, C-print plexiglass-sealed on aluminium / courtesy Andersen's Contemporary, Copenhagen-Berlin; Tanya Bonakdar Gallery, New York; pinksummer, Genoa

Universe gravity, 2005, diptych, C-print plexiglass-sealed on aluminium / courtesy Andersen's Contemporary, Copenhagen-Berlin; Tanya Bonakdar Gallery, New York; pinksummer, Genoa

Utopia exists until it is created. A hundred years ago was it not considered to be a utopian thought that people could travel by aeroplane? Now, five hundred million people fly every year. In 2010 it will be three-trillion. The idea of utopia is in constant mutation and changes according to the era. I think that the individualism that characterizes this period in history makes this concept an unstable and fragile one. Now there is an ever better consciousness of sustainability in our lives on planet Earth. In this way, my work tries to explore and interpret the present reality, using technological innovations for new social objectives

conversation with Luca Cerizza and pinksummer, Genoa

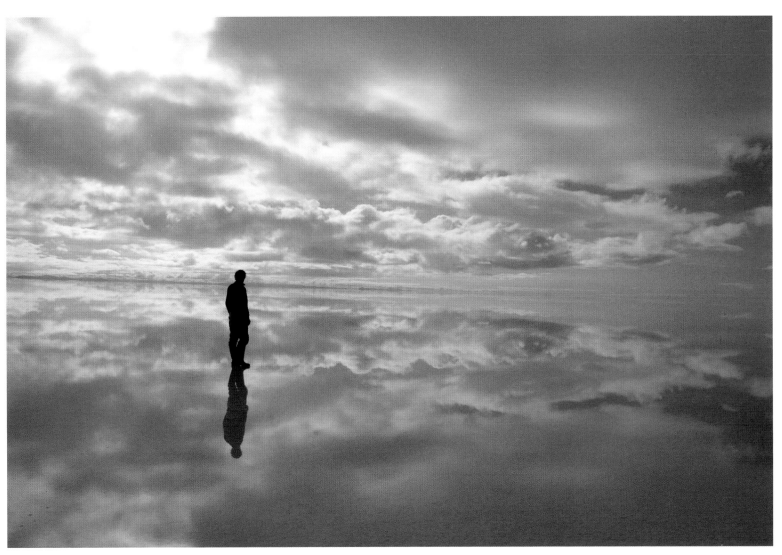

endless sky, 2006, C-print plexiglass-sealed on aluminium / courtesy Andersen's Contemporary, Copenhagen-Berlin; Tanya Bonakdar Gallery, New York; pinksummer, Genoa

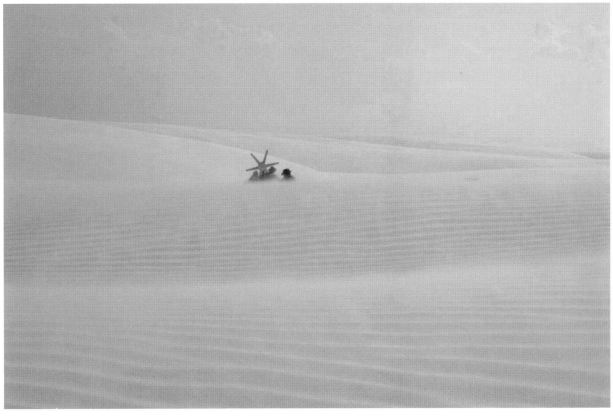

Cloudy Dunes (1), 2007, C-print / courtesy Andersen's Contemporary, Copenhagen-Berlin; Tanya Bonakdar Gallery, New York; pinksummer, Genoa

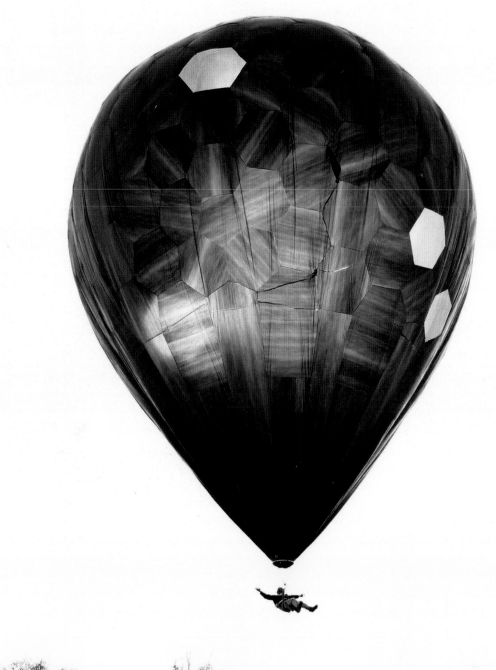

58

59

a new planet...
looking for an orbit

The version shown above is an easy version...... but with the same principles
and materials you can build more complex ones.....
Down, our sample..... .the first geodesic solar flying machine of the world......

32 – Make some cut in the borders of the wooden plate in order to be able to reach
the handles. Fix the ventilator to the wooden plate. You may cover the ventilator in order
to protect your hands.

32

33

33 – Any low capacity 12 volts battery

34 – In the upper hole of the envelope, (at the opposite side of the wheel rim and chair)
you will construct the upper part of the solar flying machine which looks like a parachute.
One string (H) is connecting the centre of the parachute to the upper part of the envelop
and the second rope (H1) goes down to the chair

34

The parachute function is to open and close the hole at the upper part of the envelope.
The parachute is carried up by the hot air blocking the hole of the envelope.
-By pulling the rope the hot air is released making the flying machine going down
(This will also be helpful when you later want to fold the flying machine).
The parachute radius (A) is 25 cm wider than the envelope hole (the parachute diameter is
50 cm wider than the envelope hole).

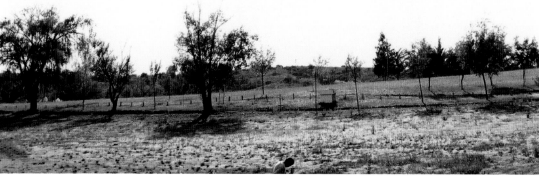

59 steps to be on air by sun power, 2003, black plethylene 15 microns, tape, sun; 14.5 m diameter, 21 m high /
courtesy Andersen's Contemporary, Copenhagen-Berlin; Tanya Bonakdar Gallery, New York; pinksummer, Genoa

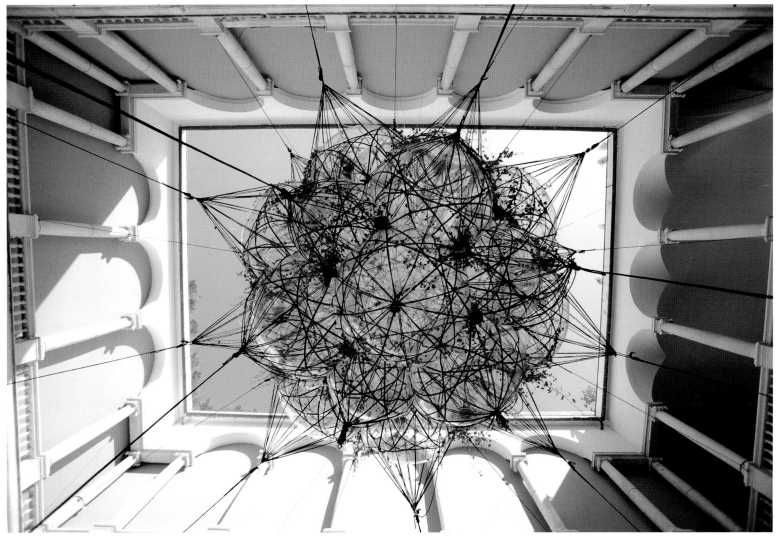

Biosphere MW32/Flying Garden/Air-Port-City, 2007, 12 elliptical pillows (128 x 75 cm), 20 elliptical pillows (170 x 100 cm), webbing, tillandsia; 4.5 m diameter / courtesy pinksummer, Genoa / photo rokma / thanks to Sharjah Biennal

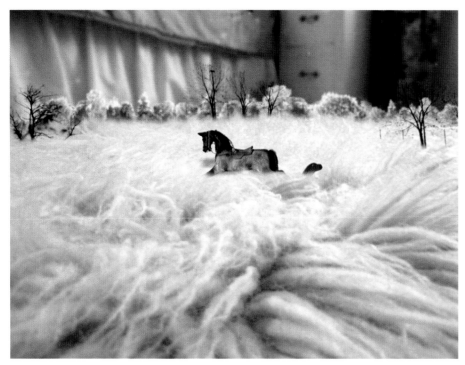

Going Places Sitting Down, 2006, still from colour digital video / courtesy James Cohan Gallery, New York;
Ota Fine Arts, Tokyo

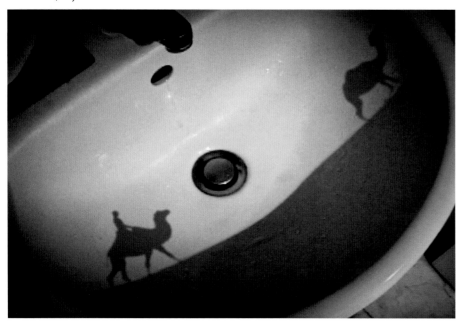

Trail, 2005, still from black and white digital video / courtesy James Cohan Gallery, New York; Ota Fine Arts, Tokyo

Hiraki Sawa works primarily with video and animation. He uses images of real objects and places to create imaginary worlds set in domestic and commonplace spaces. Animated elements that have included camels, goats, birds, airplanes and ferris wheels inhabit what he calls "in-between spaces": those that are below the ceiling and above the floor, where the carpet touches the skirting board, in the corners, and on the edges. Sawa's work occupies the space between reality and fantasy where imaginary travel and movement are possible.

Sawa comes from a sculpture-making background and sees the process of creating animation and building up moving images as akin to fashioning a physical object. Sawa starts therefore with real things and real places to which he responds in his work.

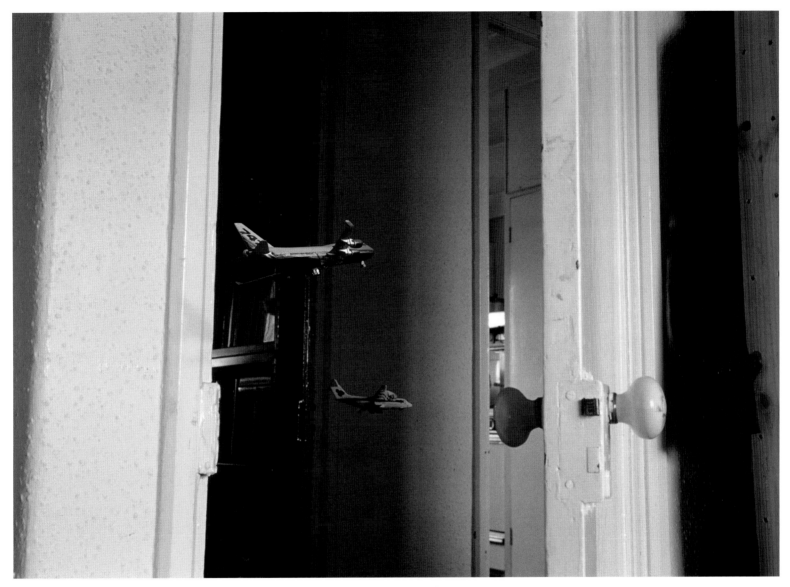

Dwelling, 2002, still from black and white digital video / courtesy James Cohan Gallery, New York; Ota Fine Arts, Tokyo

The works I have exhibited till now have all been self-portraits. Actually there have been two exceptions using footage, but other than that, my works have always consisted of photos. What I am always focusing on is the relationship between appearance and inner face, of myself as well as of others. I am always full of ideas. However, I never know when an idea will become my creation. It depends on the case that an inquiry for the show creates an opportunity to make a new series of works. Besides, I decide to produce a new series by my own timing. In any case, I develop each series on a basis of such a theme as mentioned at the beginning of this statement. This theme has affected me greatly, even if it does not lead to any definite conclusion. I intend to make new series of works based on this theme. Meanwhile, I do not focus on such themes as identity, gender or being Japanese, since various elements of these themes are already involved in my creation.

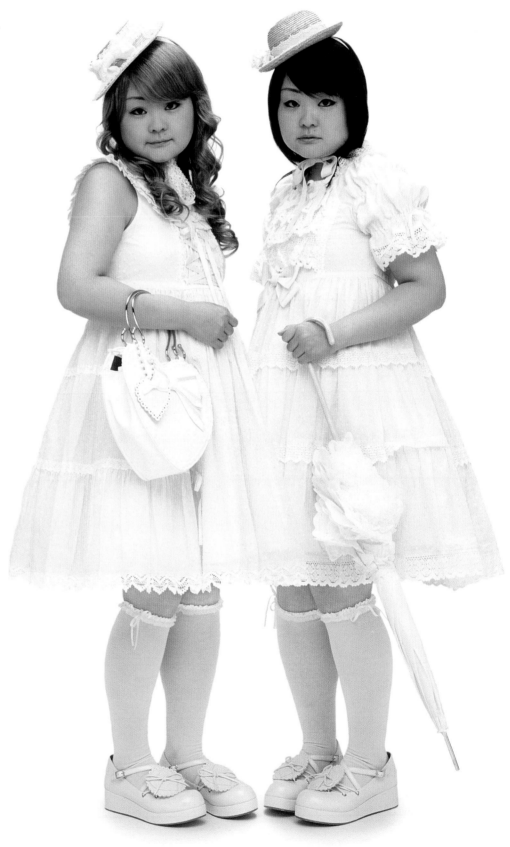

Decoration 5, 2007, lambda print / courtesy MEM, Osaka

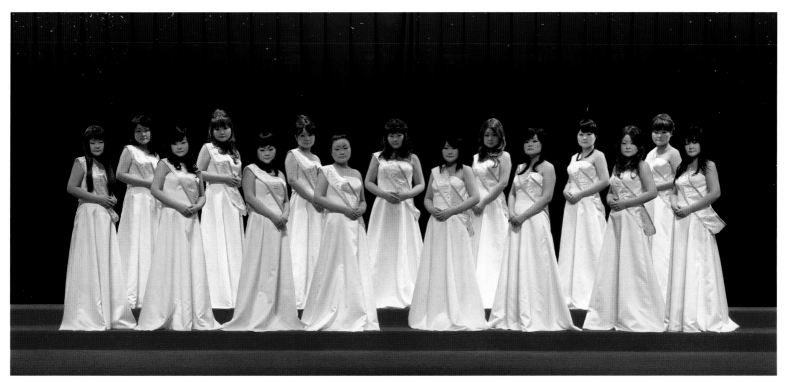

TIARA, 2007, lambda print / courtesy MEM, Osaka

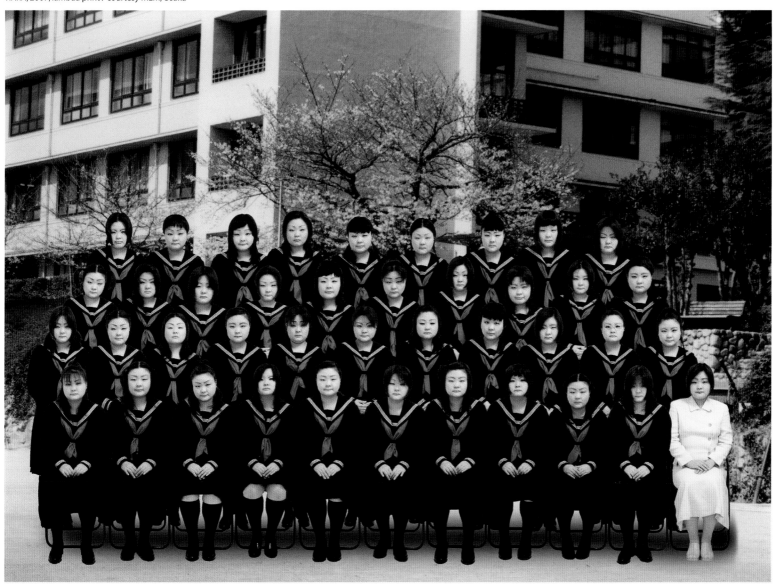

School Days/A, 2004, lambda print / courtesy MEM, Osaka

The "Improbable Museum of the Image and Contemporary Art | MIIAC"
is a fictitious entity that João Paulo Serafim began to develop
in a more systematic fashion in 2005. MIIAC functions as a temporary
corollary of a process of photographic research that is centered
on photography itself and on its new home: the Museum.
This has now become the setting for the artist's photographic
production, legitimizing his creative strategies of appropriating
and transforming images, whilst also revealing the process in the final
result and reinforcing the myriad roles performed by their author:
he is the photographer, but also the archaeologist, the archivist,
the curator and the manager of images that are sometimes fixed,
sometimes in motion. Serafim's Improbable Museum is, in the end,
an enormous room to be used for testing the freedoms of the image
and the imagination. And it not only calls upon the history of art and
photography, but also upon the artist's personal story. In it we find
a highly diversified group of culturally shared allusions and we also
encounter strangely familiar images, where anonymous people lend
themselves to poses that immortalize a given moment of conviviality,
or else figure in other genre settings—as in the various portraits—
setting in motion a series of representations of an affectionate nature
that link the spectator to his own memories.

Improbable Museum | MIIAC (from the exhibition "Museum Opening"), IM003, 2008, lambda print / courtesy of the artist

Improbable Museum | MIIAC (from the exhibition "My father was possessed by having cars taken on pictures"), PMCF000, 2008, lambda print / courtesy of the artist

Improbable Museum | MIIAC (from the exhibition "Museum Opening"), IM004, 2006, lambda print / courtesy of the artist

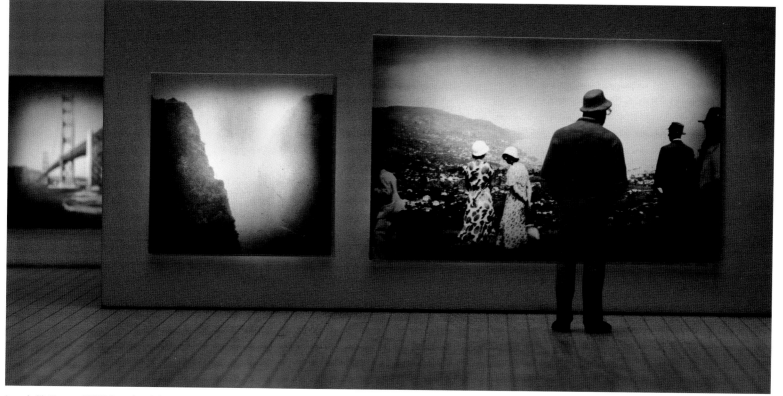

Improbable Museum | MIIAC (from the exhibition "Museum Opening"), IM006, 2007, lambda print / courtesy of the artist

Seductive and composite still life, portraits, topographical panoramas or universal representations of the landscape, Shirana Shahbazi de-contextualises subjects common both to the history of art and to our everyday lives, creating new symbolic hierarchies. Using analogue technologies, the artist re-works the relationship between the plastic object and three-dimensional transposition, constructing new possible relationships between image and space. Using a subtle play of semantic superimpositions, Shahbazi's works explore the dualism between myth and present, the role of the icon in society and the stereotypes of our visual universe.

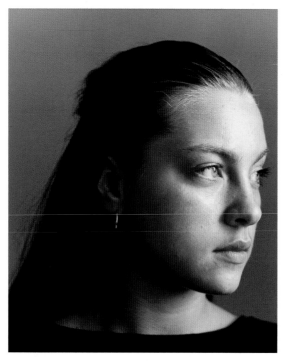

From the Series "MIR", [Ania-07-2005], 2005, C-print on aluminium / courtesy Cardi Black Box, Milan; Galerie Bob Van Orsouw, Zürich

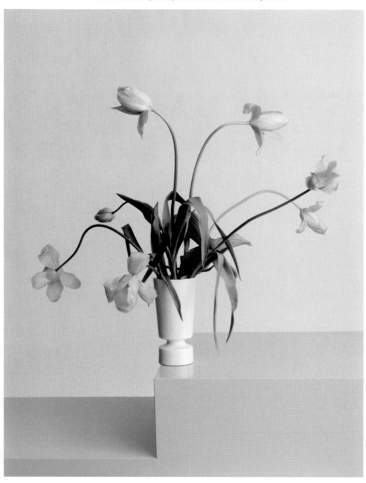

From the Series "Flowers, Fruits & Portraits", [Tulpe-01-2009] , 2009, silver gelatin print on aluminium / courtesy Cardi Black Box, Milan; Galerie Bob Van Orsouw, Zürich

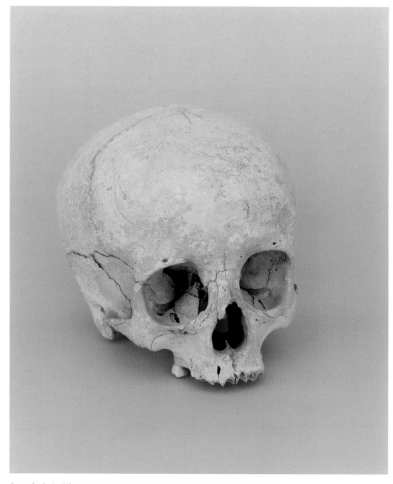

From the Series "Flowers, Fruits & Portraits", [Schaedel-01-2007], 2007, C-print on aluminium / courtesy Cardi Black Box, Milan; Galerie Bob Van Orsouw, Zürich

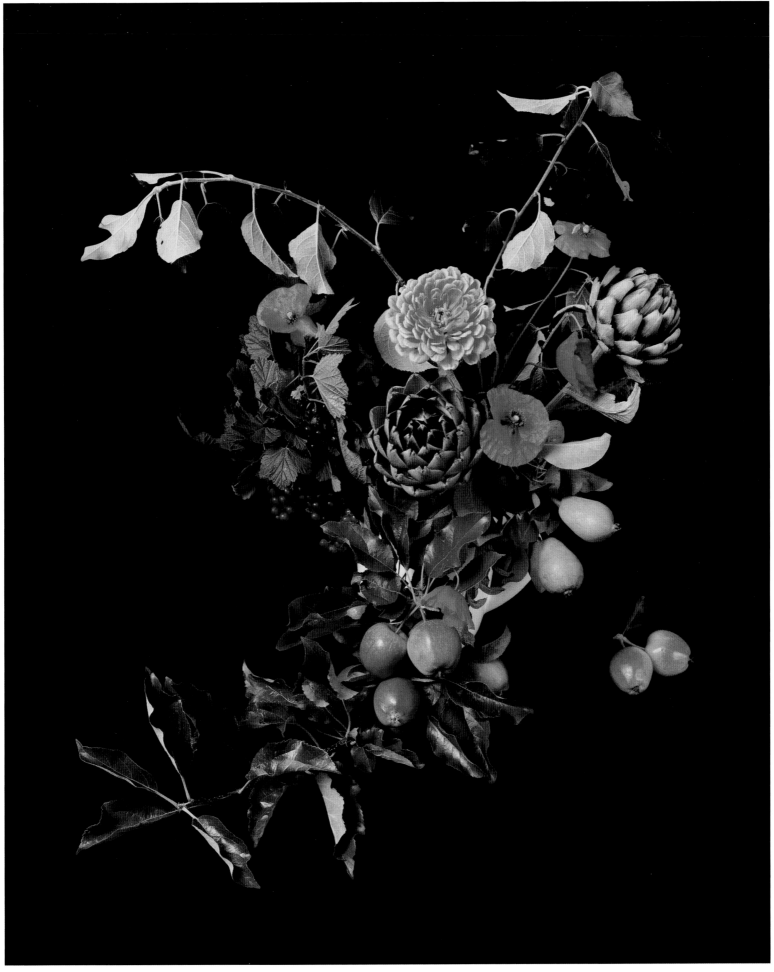

From the Series "Flowers, Fruits & Portraits", [Stilleben-22-2008], 2008, C-print on aluminium / courtesy Cardi Black Box, Milan; Galerie Bob Van Orsouw, Zürich

The subjects of my photographic and video works are fragments of reality. Through a process of subtraction, I try to eliminate the characteristics which render these fragments immediately familiar. This process of de-familiarisation contributes to removing the automatic perception of the real to which we are accustomed. From the technical point of view my work consists in a physical manipulation of the photograph by masking of some areas on the back of the image. Thanks to the partial backlighting, the light filters through the photograph itself only in certain parts, emphasizing its suspended and alienating atmosphere. Moreover, the two-dimensional nature of the photograph is increased by the creation of different spatial planes.

In addition to the *space*, this manner of back-lighting the image also acts on the *time* of the photographic medium. The very nature of photography leads to the fixing of a moment in time which automatically becomes the past. The partially back-lit images, on the other hand, render this moment continually present and open, amplifying the time of the image in an extended present which is constantly made relevant before the observer.

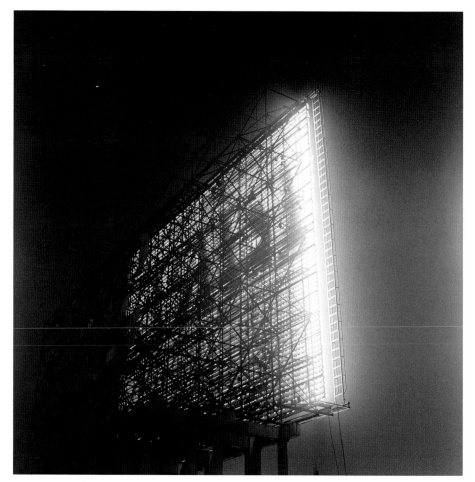

Untitled (White), 2006, partially backlit C-print on lightbox / courtesy Gió Marconi, Milan; Gagosian Gallery, London / photo Prudence Cuming Associates Ltd.

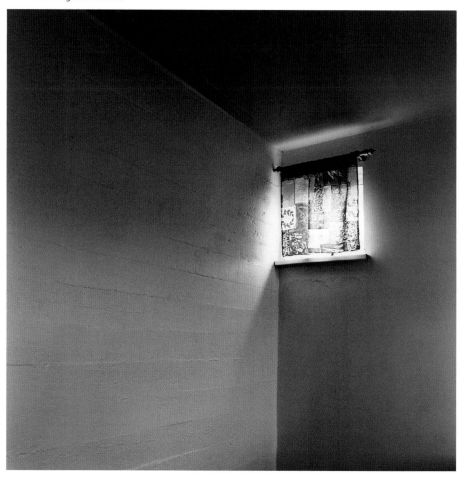

Untitled (Corner Window), 2003, partially backlit C-print on lightbox / courtesy Gagosian Gallery, London / photo José King

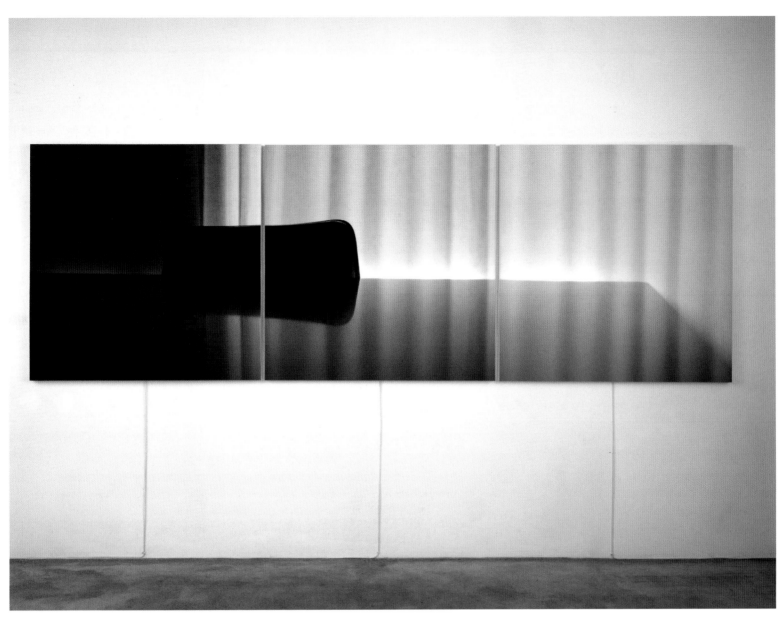

Horizontal Blank, 2002, partially backlit C-print on lightbox / courtesy Gió Marconi, Milan / photo José King

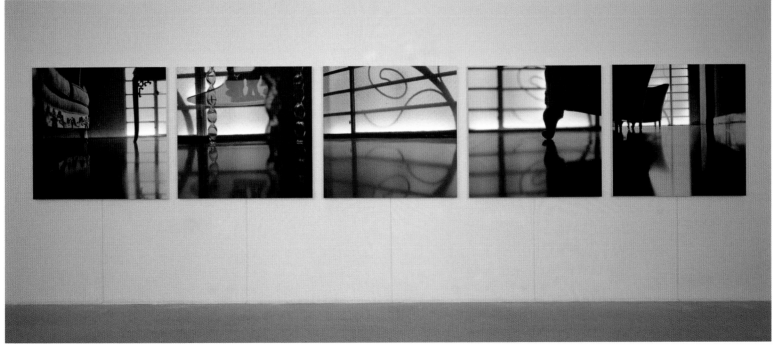

Parlour, 2002, partially backlit C-print on lightbox / courtesy Gagosian Gallery, London / photo José King

My work is born from the image, from a fascination for the "skin" of reality which has always driven me to collect photographs and clippings; a heterogeneous visual encyclopaedia that I constantly re-develop and compose in my works, in a quest for new and often surprising sensory journeys.

Esercizio #1, 2008, digital print on perforated paper / courtesy Francesca Minini, Milan

Fish (The Toy), 2008, printed paper and wood / courtesy Francesca Minini, Milan

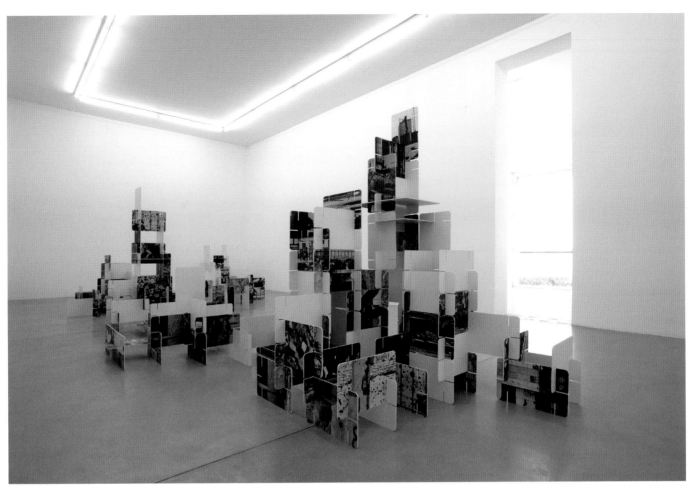

Rubble, 2007, installation view at Francesca Minini (Milan) / courtesy Francesca Minini, Milan / photo Agostino Osio

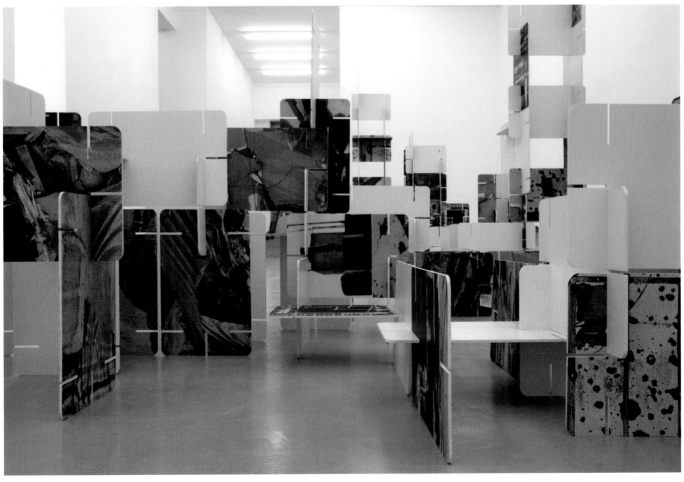

Rubble, 2007, installation view at Francesca Minini (Milan) / courtesy Francesca Minini, Milan / photo Agostino Osio

Little Adults is a series of portraits that explores the first generation of children growing up in a privileged environment in the vast and mysterious country of Russia. It is a social study on how children react with their daily life, idolization and their re-invention of tradition.

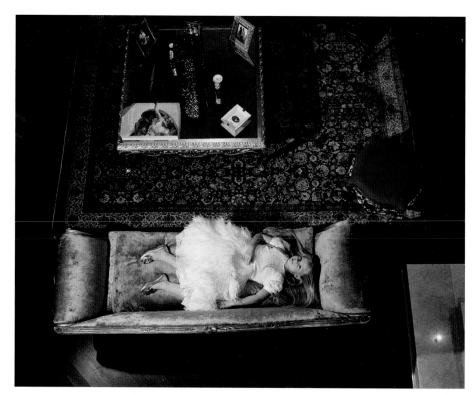

Eva In Her Home (Moscow), 2008, C-print / courtesy of the artist

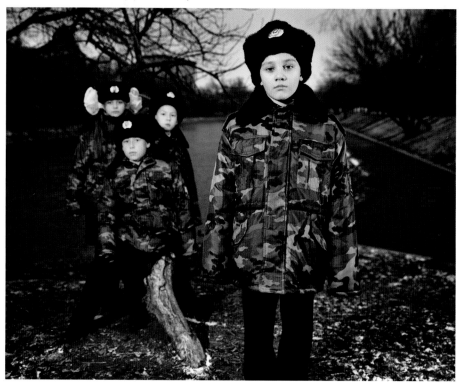

Young Cadets By The Lake (Moscow), 2008, C-print / courtesy of the artist

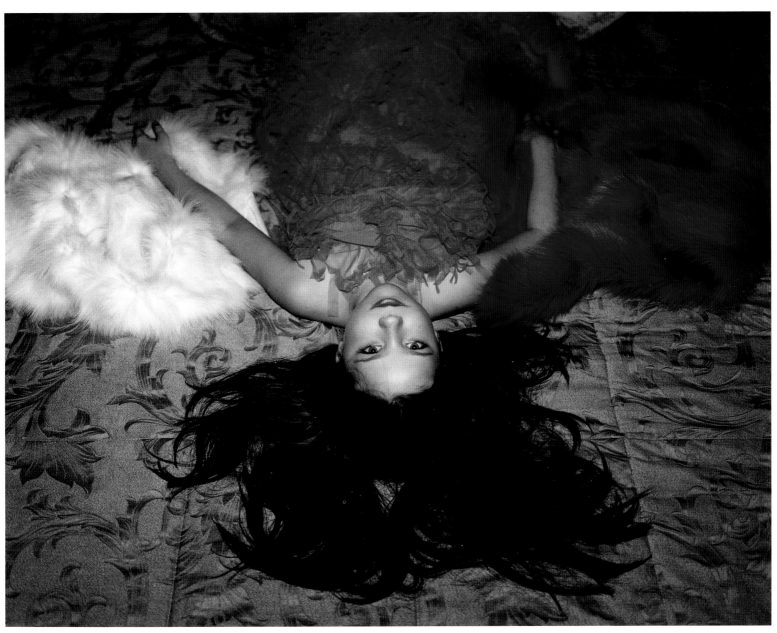

Nastia Lying On Her Bed (Moscow), 2008, C-print / courtesy of the artist

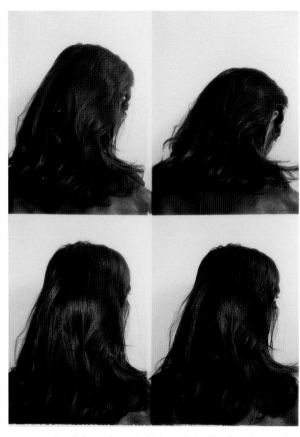

Man has a right to the enigma, and to the gestures which demand it. Overturning, moving, suspending, capsizing, lifting, uniting, breaking, moving closer or further away… nothing can rest, everything is within a movement, the gesture overturns thoughts and the gaze, and we start building the world over again once more.

Fototessera di spalle, from *Selvatico (colui che si salva)*, 2008, colour photograph on aluminium / courtesy Galleria Nicoletta Rusconi, Milan

Vendesi tavolo, from *Selvatico (colui che si salva)*, 2008, colour photograph on aluminium / courtesy Galleria Nicoletta Rusconi, Milan

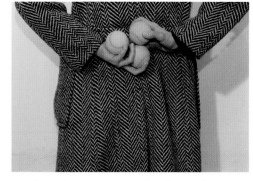

Cose che accadono #16, 2003-2008, colour photograph on aluminium / courtesy Galleria Nicoletta Rusconi, Milan

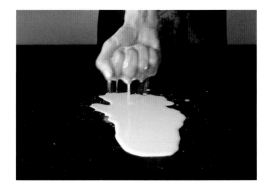

Cose che accadono #11, 2003-2008, colour photograph on aluminium / courtesy Galleria Nicoletta Rusconi, Milan

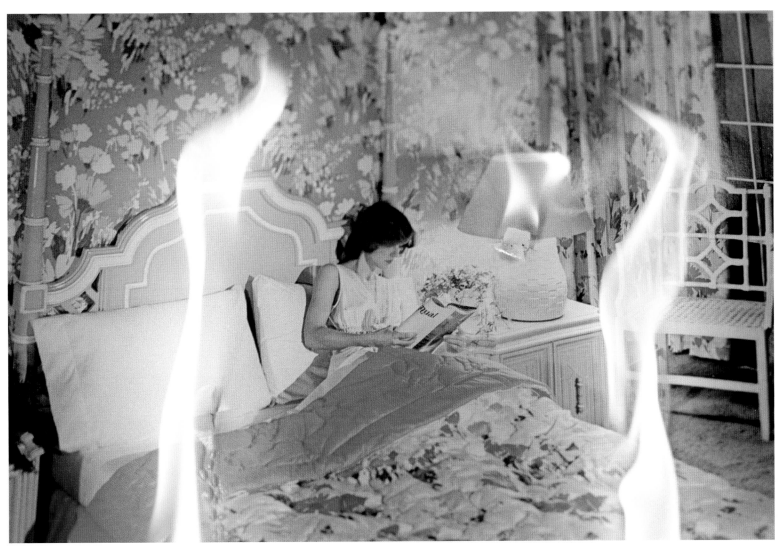

Tornando a casa #9, 1996, colour photograph on aluminium / courtesy Galleria Nicoletta Rusconi, Milan

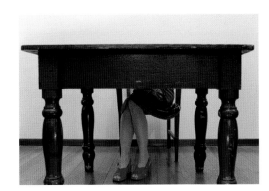

Cose che accadono #12, 2003-2008, colour photograph
on aluminium / courtesy Galleria Nicoletta Rusconi, Milan

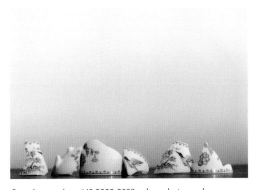

Cose che accadono #42, 2003-2008, colour photograph
on aluminium / courtesy Galleria Nicoletta Rusconi, Milan

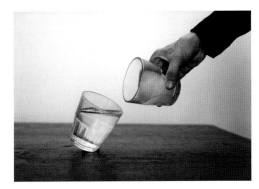

Cose che accadono #59, 2003-2008, colour photograph
on aluminium / courtesy Galleria Nicoletta Rusconi, Milan

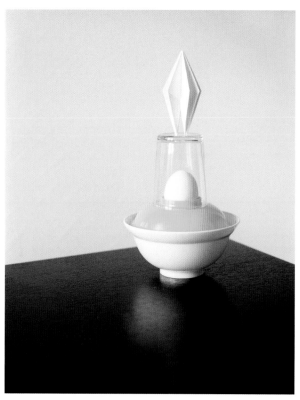

Object for a new dream, 2008, C-print / courtesy of the artist

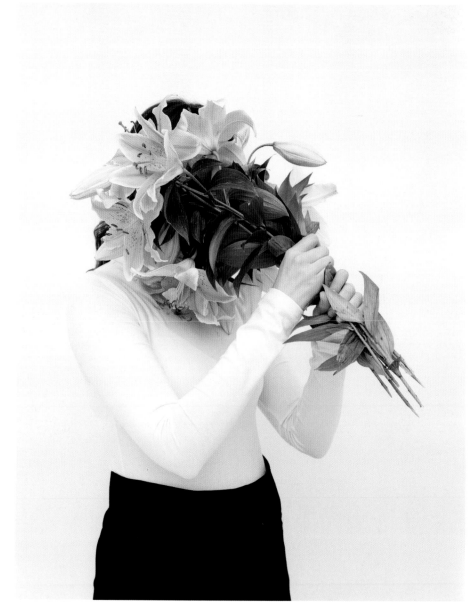

There are different ways to leave, 2008, C-print / courtesy of the artist

I work with staged photography and I often combine my photographs with short texts. To me these texts are more than titles. The limitation of both image and text when it comes to getting hold of reality fascinates me. Something else and indescribable becomes visible between the two of them.

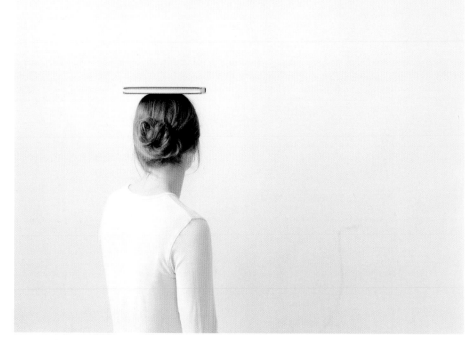

On my mind, 2007, C-print / courtesy of the artist

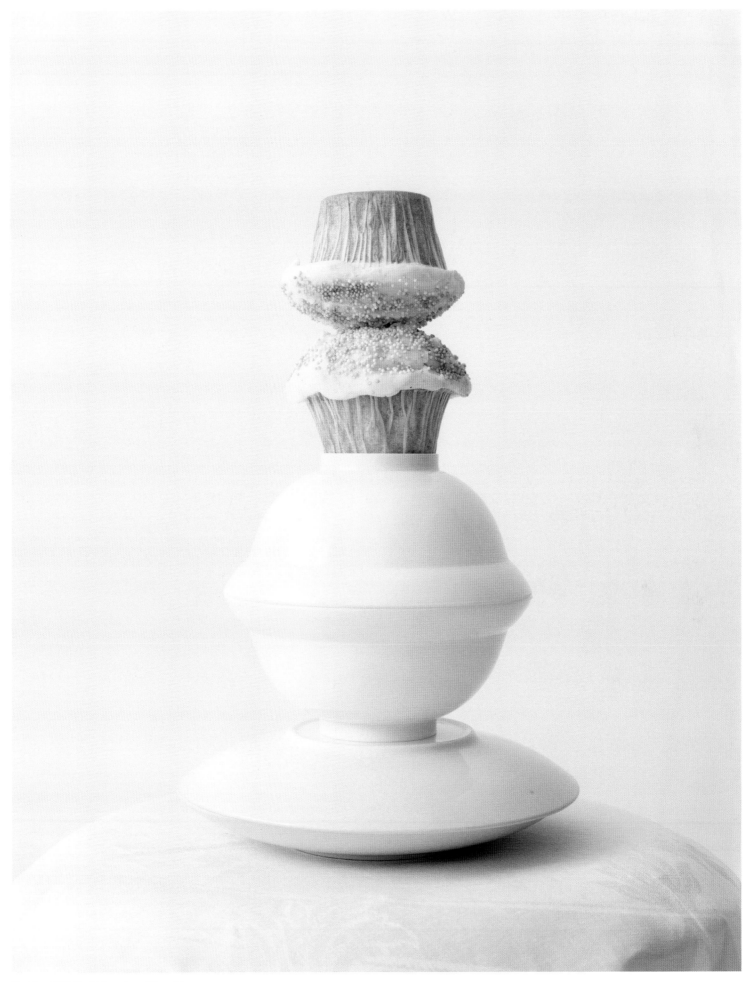

Tautology, 2009, C-print / courtesy of the artist

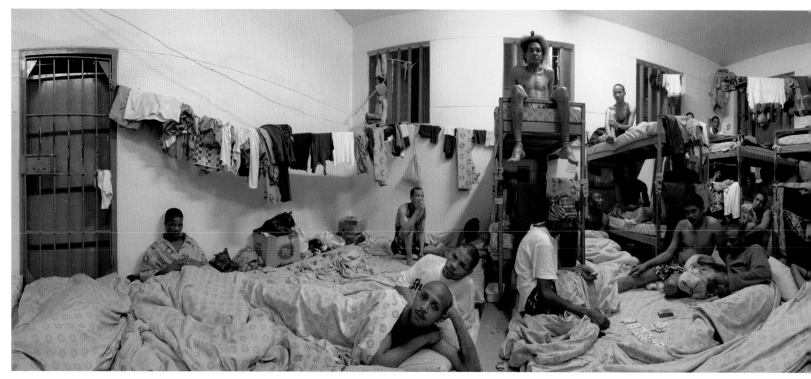

Cell 508a, Pollsmoor Maximum Security Prison, 2004, pigment print / courtesy The Goodman Gallery, Johannesburg

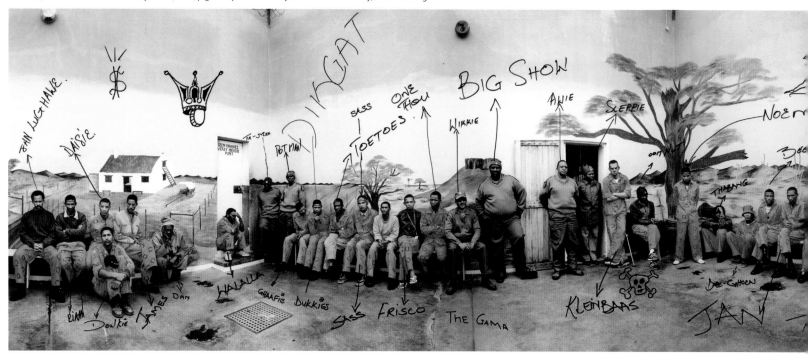

Prison Portrait in the Exercise Yard, Beaufort West Prison, 2006, lightjet print, inscribed by prisoners in permanent marker / courtesy The Goodman Gallery, Johannesburg

In Subotzky's *Beaufort West*, the motive or key is given in the peculiarities of the town itself, a pit stop on the main highway between north and south in South Africa in the present day, but when it was established, the last bastion of colonial power in the Cape Colony, beyond which lay the hostile hinterland of an unruly and untamed continent. As token of this geographical belligerence the town was, literally, built around the local prison, the symbol of a Pax Britannica [...] Subotzky's achievement with the *Beaufort West* series is to find a space where hyperrealism intersects with and is cued by a powerful sense of often theatrical unreality.

Ivor Powell

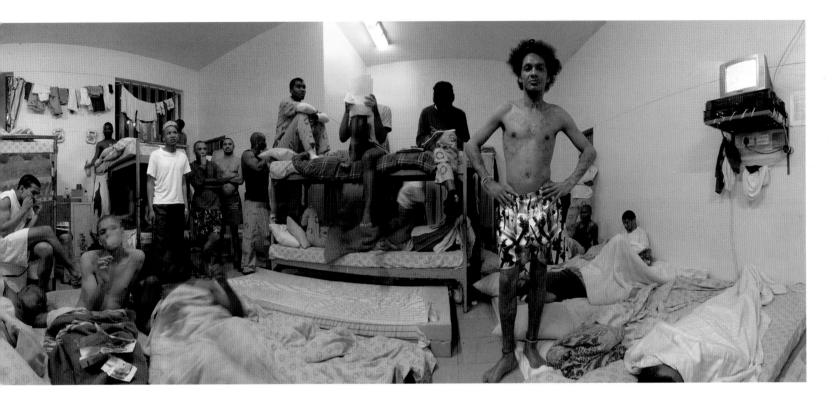

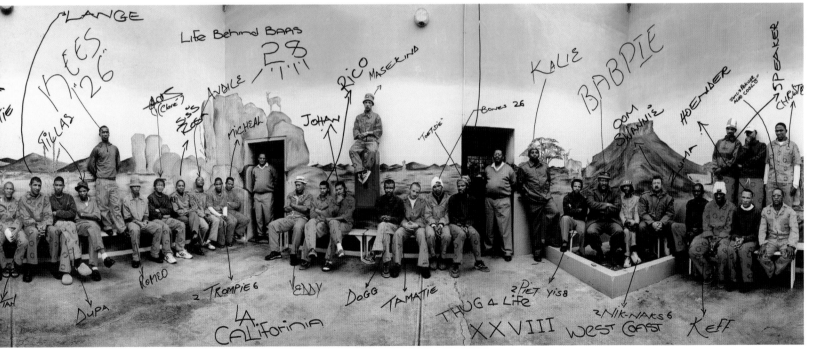

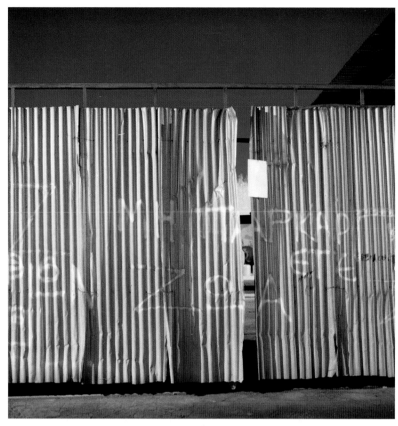

Nocturnal #6, 2003, lambda print / courtesy of the artist

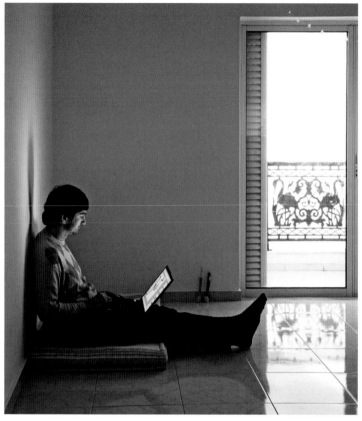

Interlude #24, 2006, lambda print / courtesy of the artist

Nocturnal #17, 2007, lambda print / courtesy of the artist

According to research, in 1961 there were 39,000 automobiles
in Athens while today there are 3.5 million, almost as many
as its residents. As a result, parking spaces are becoming rare since
many of the empty lots that used to function as paying or improvised
parking lots are being built up due to the increasing demand
for new housing and the rise of land value.
The *Nocturnals* series is a night stroll in the city of Athens.
It is an ongoing project through which the different facets
of the city are challenged and revealed. This project mainly focuses
on the relation of automobiles and the city at night; I think of cars
as traces of human presence in the city, and as mirrors of our culture.
It is no coincidence that a person's car points to his or her status,
financial situation and position in society. I am interested in what
the city dwellers leave behind when they have gone home to sleep.
The night is a time of abstraction, always surprising me.

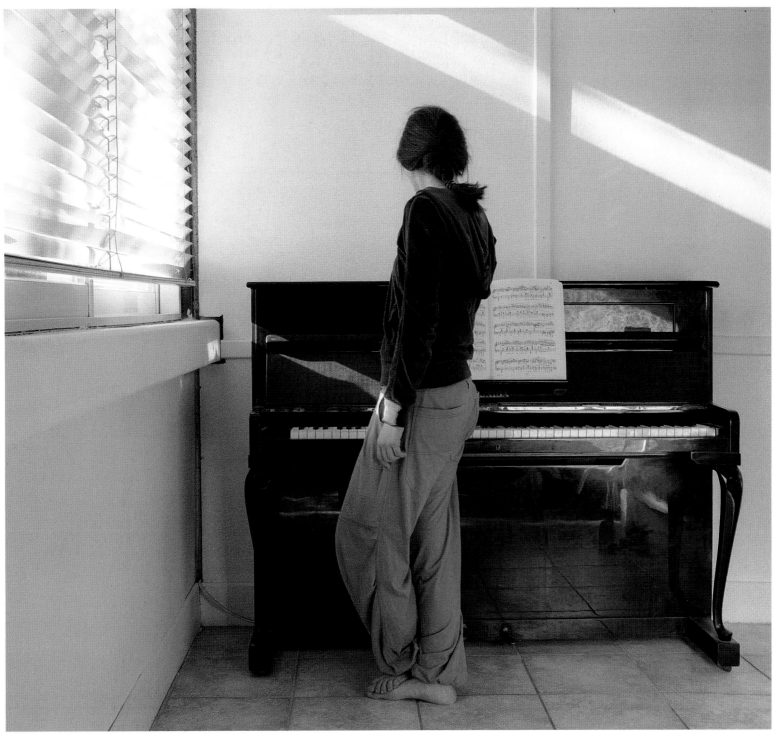

Interlude #40, 2008, lambda print / courtesy of the artist

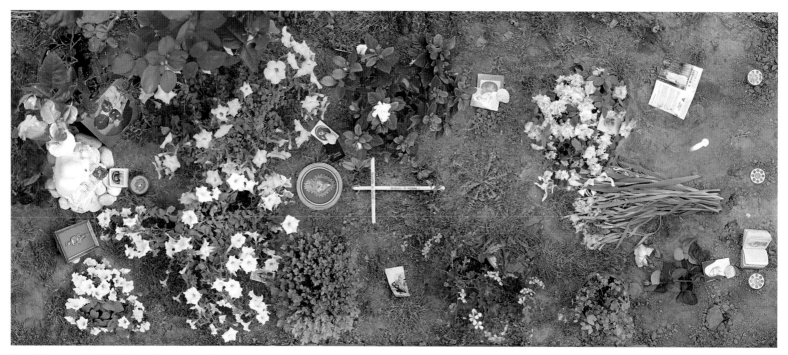

Trasudazione ematica, 2007, lightjet print / courtesy of the artist

Ghirlanda di alloro, 2008, lightjet print / courtesy of the artist

Ghirlanda di fiori, 2008, lightjet print / courtesy of the artist

Photography is used as an objective report of everyday places.
Each image is the collage of a series of frontal shots taken inch by inch,
to obtain a single image made up of infinite points of view.
The result of this process is presented on a scale of 1:1.

Tenda, 2008, 2 elements, lightjet print / courtesy of the artist

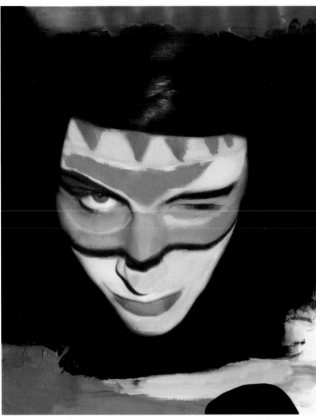

A birthday, 2008, digitalized and retouched polaroid, painted inkjet print / courtesy Galerie Clairefontaine, Luxembourg

When constructing a personal myth, choose a singular style of writing.
Photograph your visions in memory of your father.
Force yourself to apply your style to fashion photography, never ever give way to vulgarity.
Tell the stories of a lady and her gowns, turn the pages of an imaginary notebook, have fun, invite others to join the dance, cherish them.
And then, snip, scrape, compose, play on the curves, splash here and there with paint and ink, ruin and reconstruct.
Dream in technicolour, then the same dream in black and white.
Take a trip.
If you tire of the matter and prime subjects, if they're too clean, too photographical, too shiny, transform the whole with plasticity.
Free yourself of the cause of chagrin. Predicate the definite and permanent return of aesthetics.
Once you have mastered the manner, take a stroll.
And, come back!

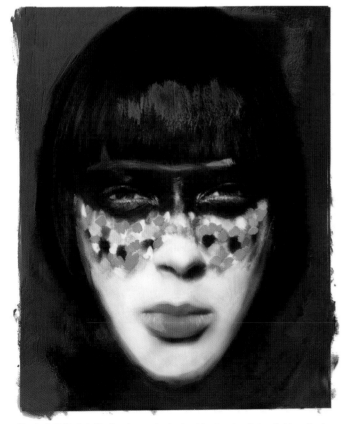

Warrior A, 2009, digitalized and retouched polaroid, painted and glued inkjet print / courtesy Galerie Clairefontaine, Luxembourg

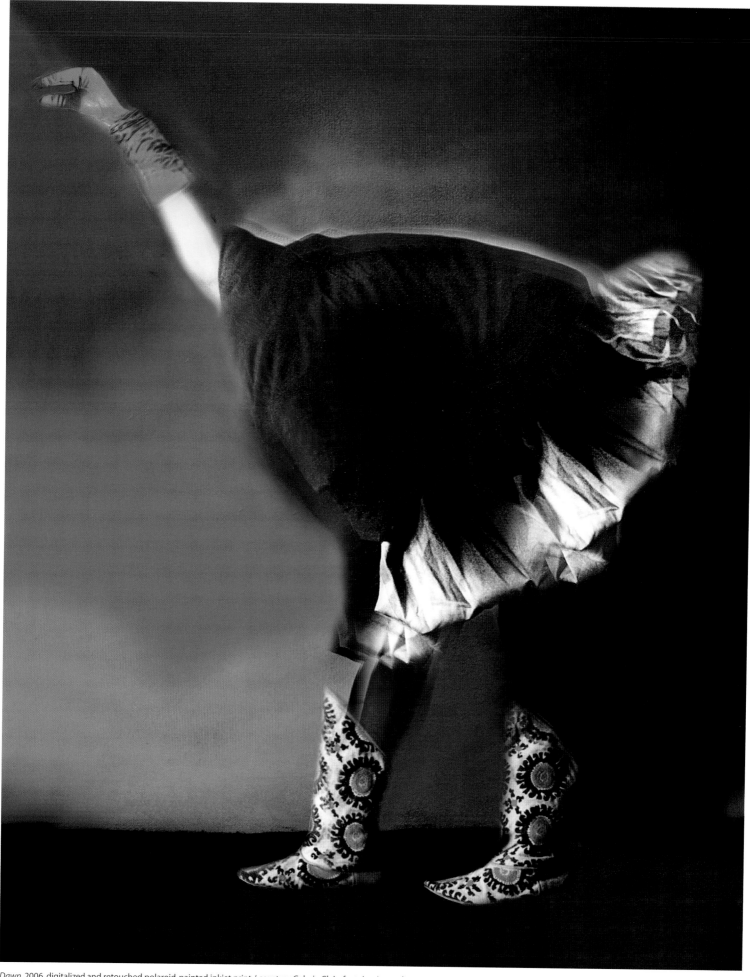

Dawn, 2006, digitalized and retouched polaroid, painted inkjet print / courtesy Galerie Clairefontaine, Luxembourg

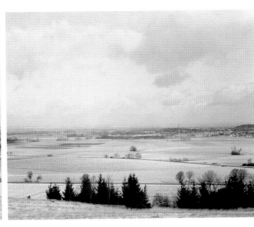
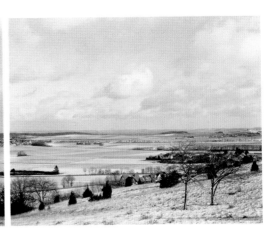

Nördlinger Ries, 2008, triptych, silver gelatin print / courtesy of the artist
Approximately 14.5 million years ago a meteorite struck with the power of more than 100,000 Hiroshima bombs, leaving a crater estimated to be 24km in diameter

Vatnajökull National Park, 2008, triptych, C-print / courtesy of the artist
During the late Sixties before the first Moon landing in 1969 NASA's astronauts simulated moon surface manoeuvres

Llano de Ucanca, 2008, triptych, C-print / courtesy of the artist
Well known shooting location where many science fiction films were supposedly filmed

Our Elusive Cosmos and *Television Studios* are two photographic series which address what is not necessarily visible within mimetic photographic representation. The former series focuses on landscapes that are historically loaded with cosmic associations, while the latter addresses television studios, charged with human and electromagnetic energies where information and heated discussions are transmitted. By literally evading what is essentially the photographic subject—the activity associated with such loaded sites—both series seek to question the truth-rhetoric attached to photography.

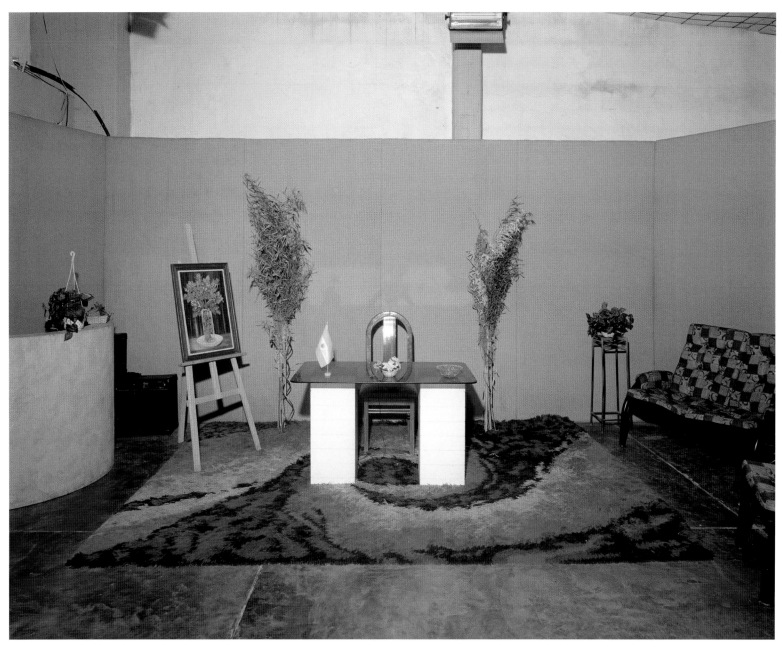

General Pacheco I, 2005, C-print / courtesy of the artist

Brussels I, 2008, C-print / courtesy of the artist

Santa Cruz de Tenerife II, 2008, C-print / courtesy of the artist

Dad #4, 2000, C-print, computer montage / courtesy c/o – Gerhardsen Gerner, Berlin

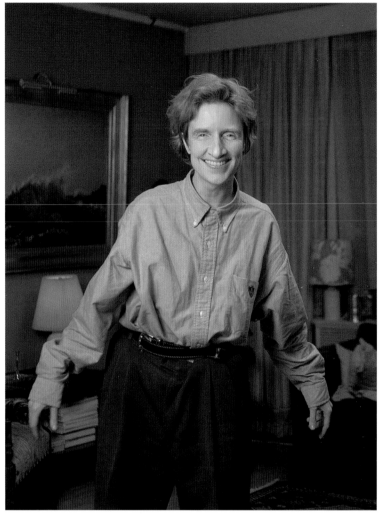

Dad #1, 2000, C-print, computer montage / courtesy c/o – Gerhardsen Gerner, Berlin

Vibeke Tandberg became famous for her digital photo collages
of the Nineties. The digital reworking of images provides a simple
way to question the truth claim of photography. It also allows
for look-alikes and twins, the doubling of the self that goes way back
in myths and legends, to be placed in the appearance of a true world.
Since 2005, the artist has started to replace the computerized cutting
tools with actual scissors for the artistic production of her collages.
She has transferred this analogue working method to photographs
again in her most recent works.

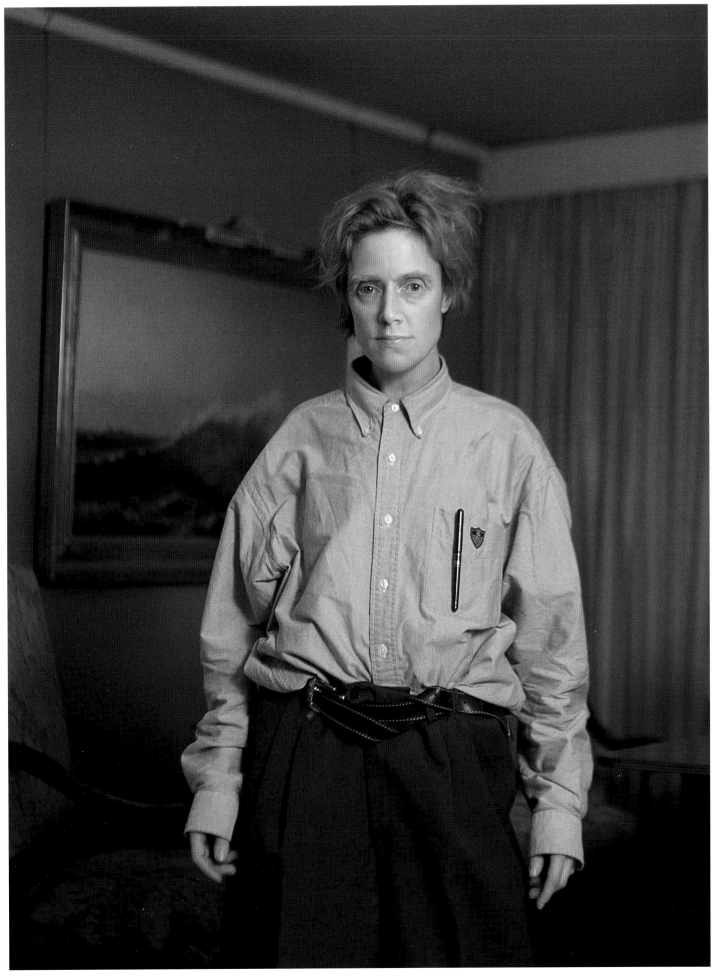

Dad #2, 2000, C-print, computer montage / courtesy c/o – Gerhardsen Gerner, Berlin

Capturing the processes of thinking in the bidimensionality of the photographic image, fixing the delicate and ethereal impression of light to transform that which at the beginning is only a gaze in a "vision of thought".

Marinella Paderni

Balena, 2004, true giclée print, double plexiglass and aluminium / courtesy Galleria Nicoletta Rusconi, Milan

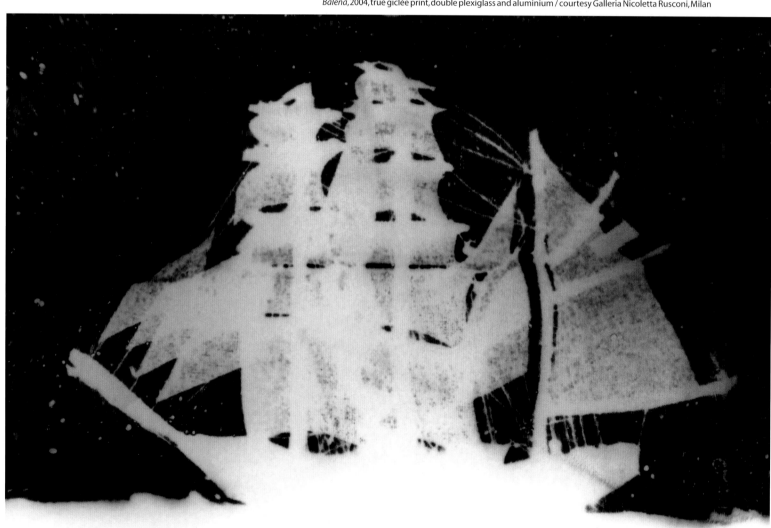

In altro mare #1, 2009, true giclée print on dibond / courtesy Galleria Nicoletta Rusconi, Milan

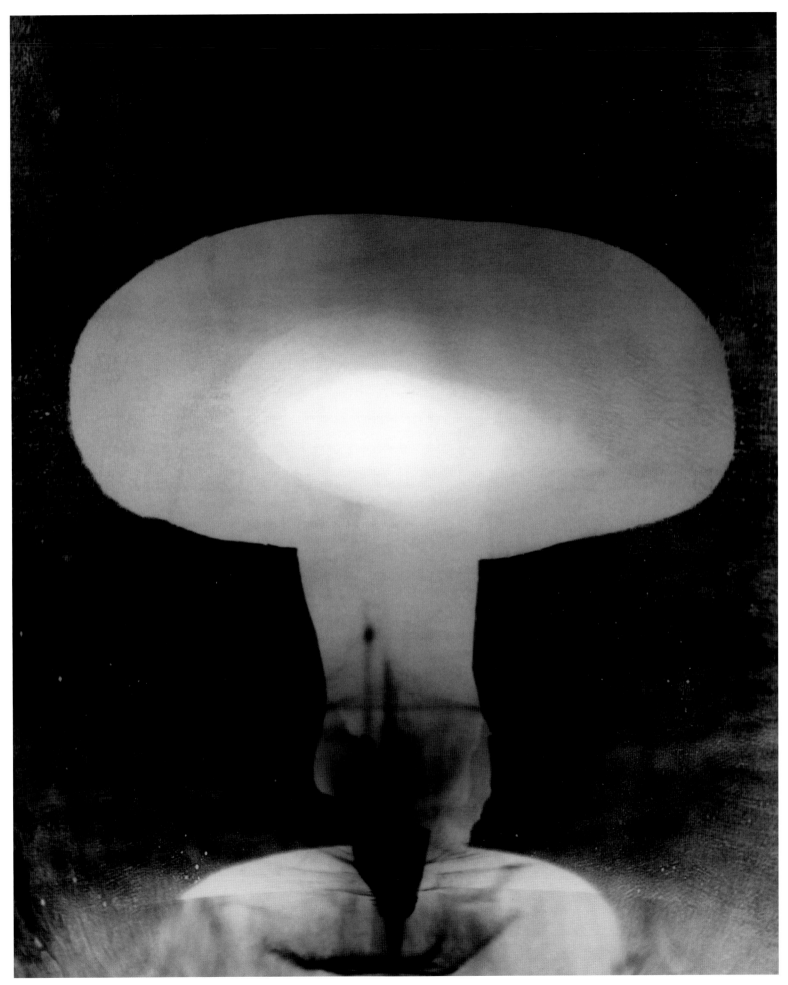

Fungo Atomico #1, 2009, true giclée print on dibond / courtesy Galleria Nicoletta Rusconi, Milan

Through the globe #18, 2003, C-print, double plexiglass and aluminium / courtesy of the artist

Through the globe #15, 2003, C-print, double plexiglass and aluminium / courtesy of the artist

Through the globe #17, 2003, C-print, double plexiglass and aluminium / courtesy of the artist

Everything is going to be alright (Gulf of Bothnia), 2007, still from colour digital video / courtesy of the artist / photo Ben Geraerts

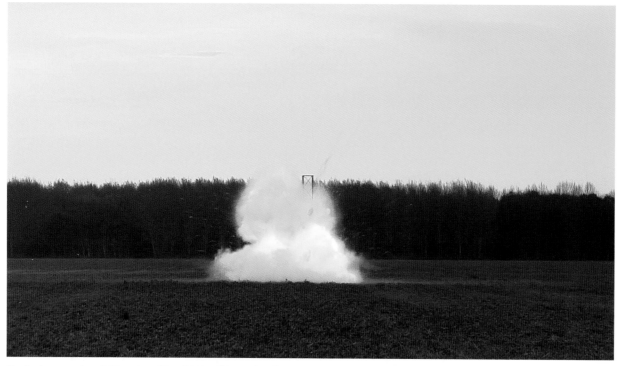

The clouds are more beautiful from above (Almere), 2006, still from colour digital video / courtesy of the artist / photo Ben Geraerts

I work very instinctively and use my state of mind as a guide light
to find elements that move me for some reason or another. I try
to abstract these elements into the smallest possible core, hoping that
this process of abstraction will give my work a greater universal quality.

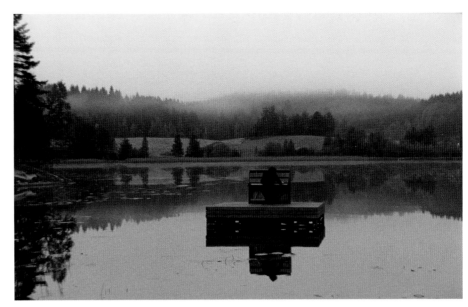

I don't want to be part of this (Siitama), 2004, still from colour digital video / courtesy of the artist / photo Ben Geraerts

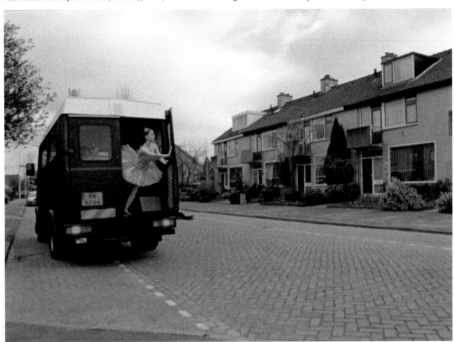

Just because I'm standing here, doesn't mean I want to (Papendrecht), 2003, still from colour digital video / courtesy of the artist / photo Ben Geraerts

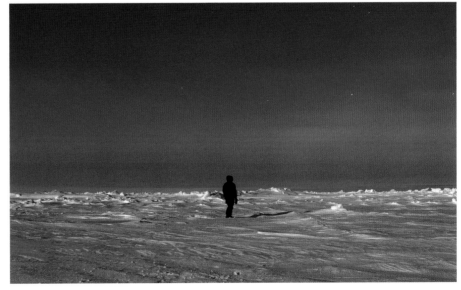

The day I didn't turn with the world (Geographic Northpole), 2007, still from colour digital video / courtesy of the artist / photo Ben Geraerts

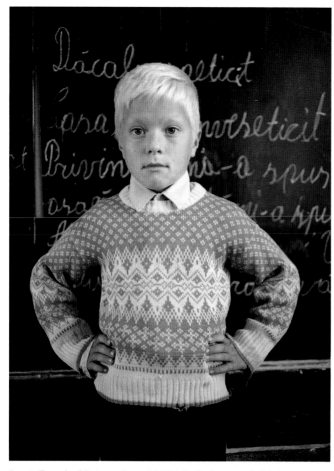

Boy at villageschool (Periprava, Romania), 2001, C-print / courtesy Cokkie Snoei, Rotterdam

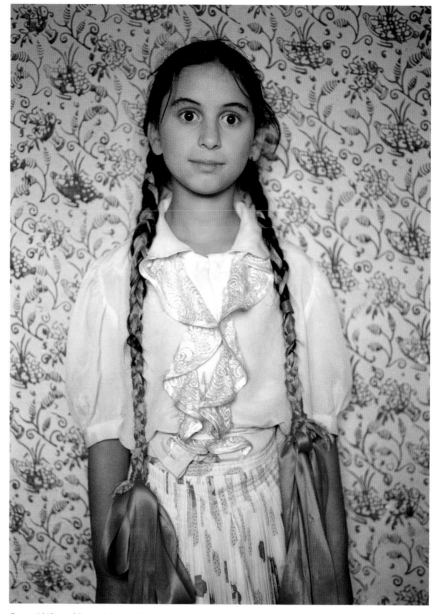

Gypsy girl (Corund, Romania), 2003, C-print / courtesy Cokkie Snoei, Rotterdam

Marco van Duyvendijk is a colourist in the true sense of the term. A subtle use of colour and a warm palette characterize the photographs he has taken on his long travels through Eastern European and Asian countries. As a photographer he is self-taught, and has been taking photographs from an early age. After having lived for a year in Romania upon graduation and not only learning the language there but primarily taking photographs, he considers himself a photographer. In Romania, he refined his photography with portraits of children and young people to whom he returns and visits every year. For Van Duyvendijk, personal contact with the subject is essential for the success of the photograph. In recent years he has been moving towards Asia with projects in Mongolia, China, Taiwan, South Korea and Japan.

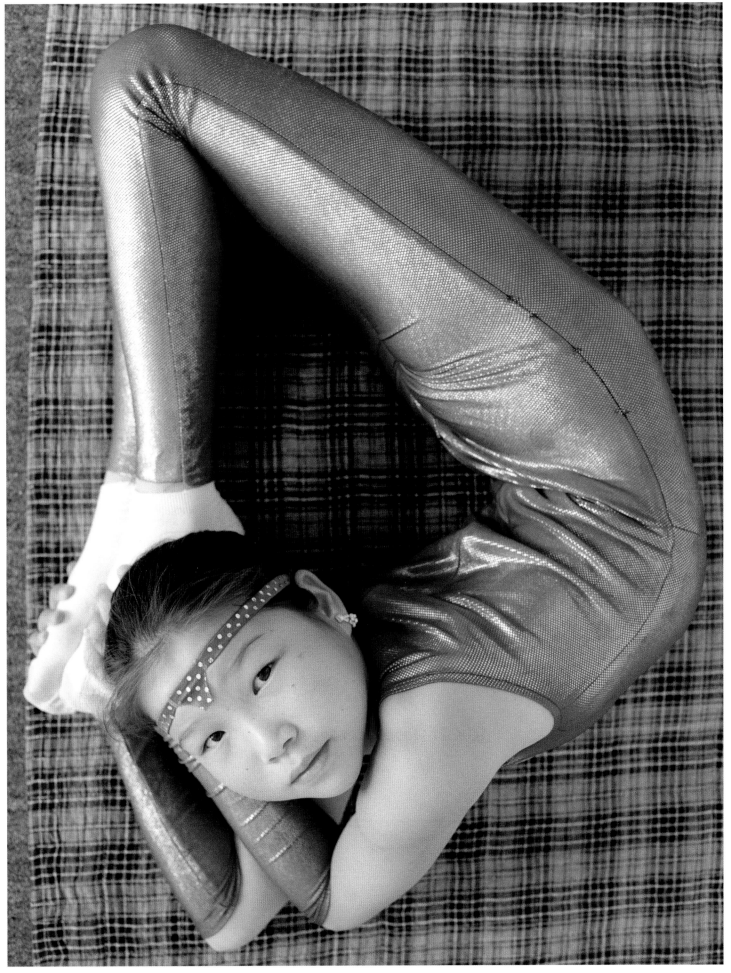

Erdenesuvd (Ulaanbaatar, Mongolia), 2004, C-print / courtesy Cokkie Snoei, Rotterdam

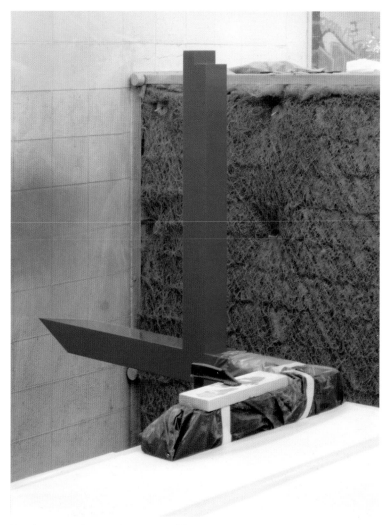

Homologue, 2009, pigment print / courtesy of the artist

Homologue, 2009, pigment print / courtesy of the artist

Marianne Vierø works in the fields of photography, sculpture and installation, often as interrelated entities, where even the flat surface of the photograph explores spatial properties. Recurring themes in her work include ambiguity of status and the distance between ideal and illusion. She continuously examines structures, patterns and subtle distortions of perceptual preconceptions, leaving room for contradictions and introducing a loss of orientation.

Homologue, 2009, pigment print / courtesy of the artist

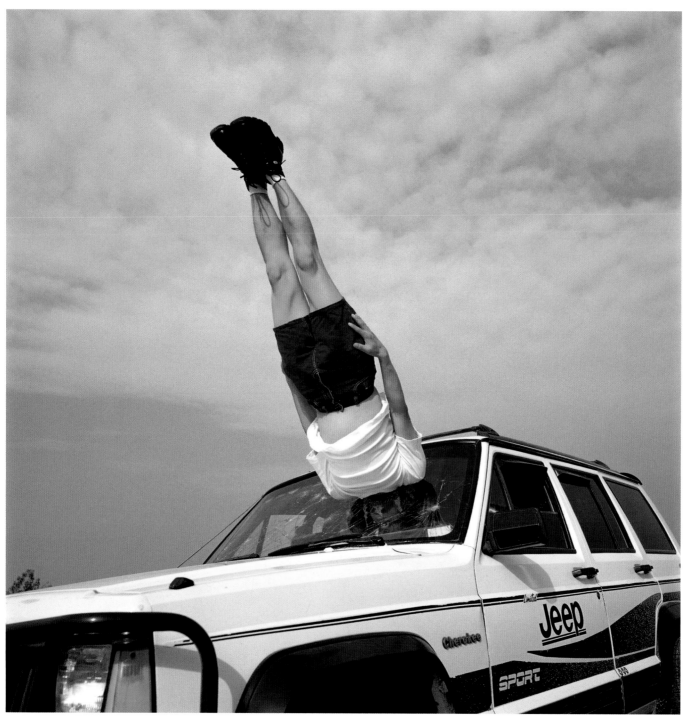

Li Wei falls into the car, 2003, C-print / courtesy of the artist

Performance has been a kind of taboo for official explanation of what art is: the latter is always apt to consider performances as gaudy acts or as superficial tactics. But in reality, performance has an intense impact upon people's conceptions, and gives rise to the collapse of stereotypes with regard to the definition of art. This is why when Li Wei jumps into the sea or flings himself outwards through windows or on to ceilings, people feel unexpectedly shocked and silenced, gaining indistinctive and fresh experiences which means more possibilities of reorganizing the world around us. This is done by our body—an everlasting field of conceptual embodiment—to act against the normality of our senses but towards the infinite space of multiple representations of the artistic structure.

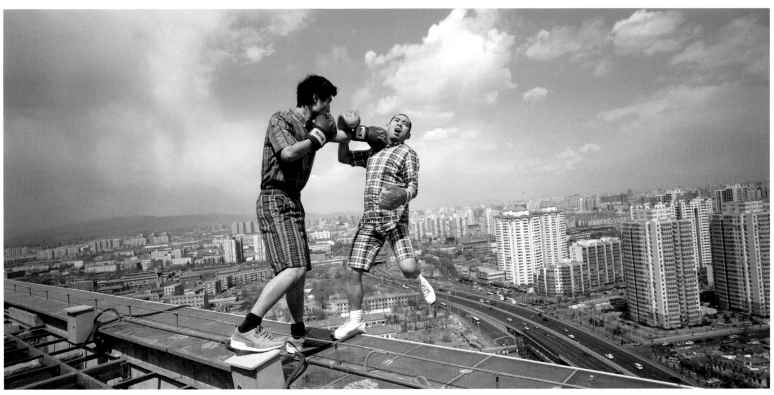

Boxing, 2009, C-print / courtesy of the artist

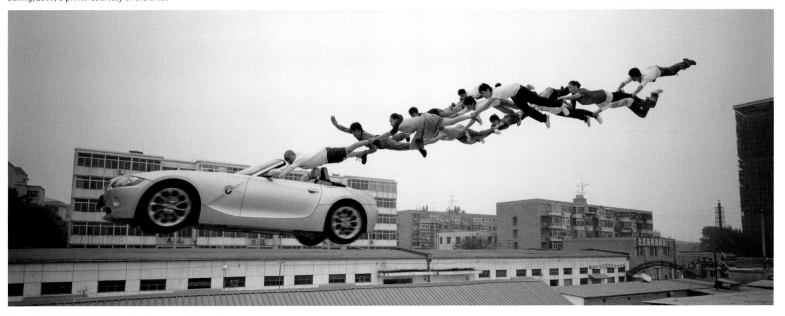

Live at the high place 5, 2008, C-print / courtesy of the artist

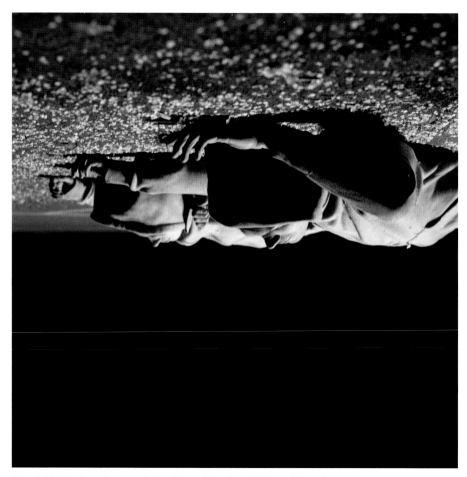

Away II, 2007, diasec / courtesy Galerie Conrads, Düsseldorf; Galeria Toni Tàpies, Barcelona; Galerie zur Stockeregg, Zürich

Grounded II, 2007, diasec / courtesy Galerie Conrads, Düsseldorf; Galeria Toni Tàpies, Barcelona; Galerie zur Stockeregg, Zürich

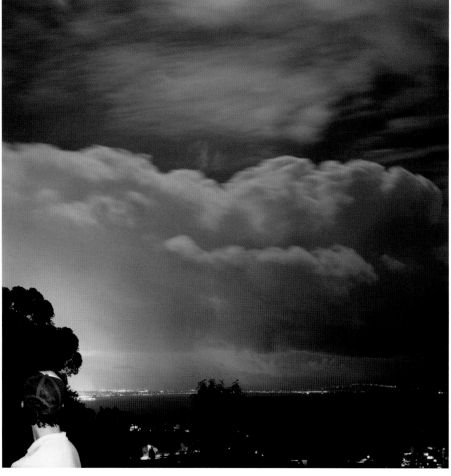

Aurora II, 2005, diasec / courtesy Galerie Conrads, Düsseldorf; Galeria Toni Tàpies, Barcelona; Galerie zur Stockeregg, Zürich

The artist uses transformation to break up the aesthetic. He touches upon imagination, upon the details of our lives, without making reference to anything excessive, without distorting the dimensions and size of the object. The motifs and titles are biographical references and metaphors of what has been experienced—a game played with communication and also a re-evaluation that is linked to specific people. It is left up to the viewer to discover where these images come from, or to continue the narrative in his or her own way, helped with pointers from the artist.

Dorothea Schöne

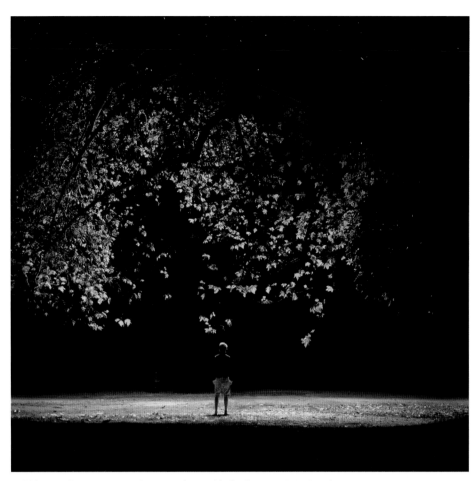

Unfold II, 2006, diasec / courtesy Galerie Conrads, Düsseldorf; Galeria Toni Tàpies, Barcelona;
Galerie zur Stockeregg, Zürich

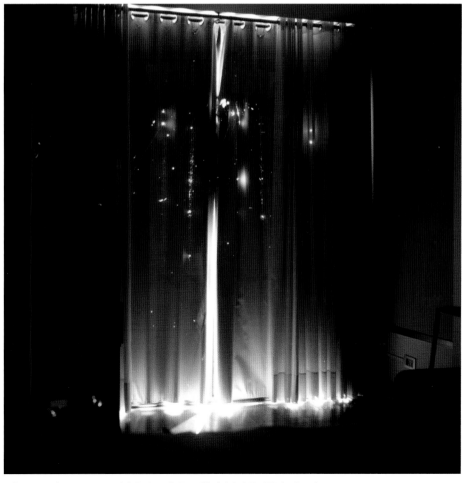

Bullit II, 2008, diasec / courtesy Galerie Conrads, Düsseldorf; Galeria Toni Tàpies, Barcelona;
Galerie zur Stockeregg, Zürich

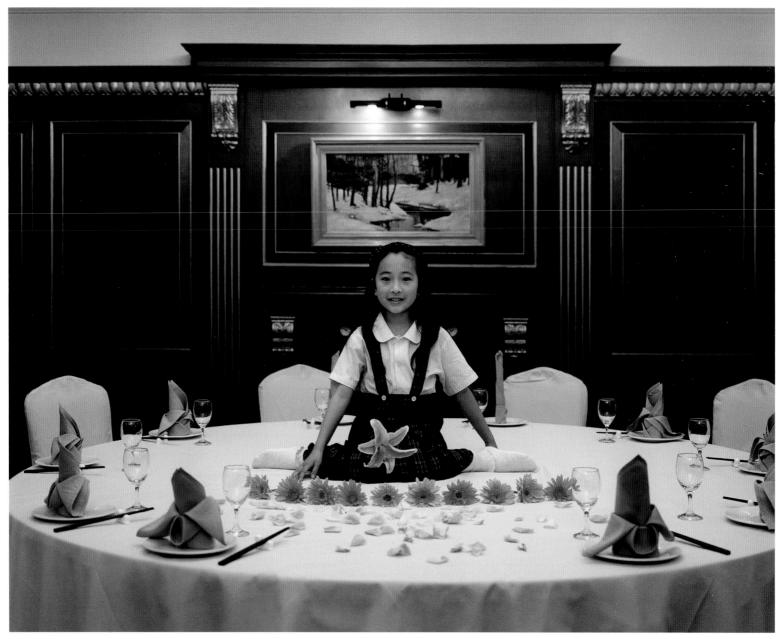

Childhood 01, 2008, C-print / courtesy of the artist

Photography is a spirit and an attitude more than a technique,
a medium which can protect us from loss when we feel we are
beginning to lose our soul. The photographer is a person who tries
to create, and I look at photography as a way of "giving birth";
it is only through personal experience that one can experience
the joy and the difficulties that this experience brings. All my images
are my "babies", a way for me to soberly observe the world. I hope all
my babies will be mirrors of this diverse society.

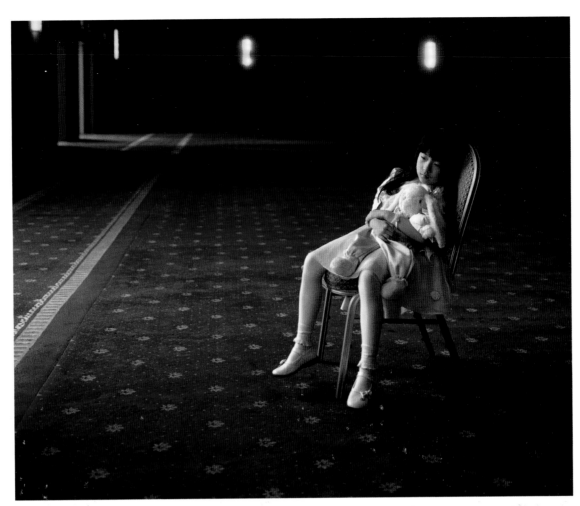

Childhood 03, 2008, C-print / courtesy of the artist

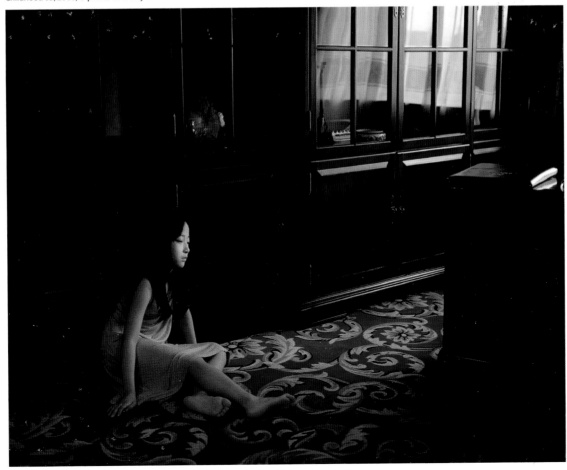

Childhood 06, 2008, C-print / courtesy of the artist

Utility Store "Faith", 2007, C-print on aluminium / courtesy Antje Wachs Gallery, Berlin

Utility Store "Hope", 2007, C-print on aluminium / courtesy Antje Wachs Gallery, Berlin

The series *Visuals/Udmurtia* is made up of images from a journey to the outskirts of consumer culture, through the ruins of lives, monuments, landscapes. They radiate an absolute, oceanic, almost cosmic sadness and loneliness.

The lonely travelling eye, capturing the iconicity of objects, stages a ritual aesthetic action. It brings out new patterns or structures from chaos and decay.

Three of the twelve original images of the series form its conceptual base: they show façades of rural utility stores in the Republic of Udmurtia bearing the Russian women's names *Vera* ("Faith"), *Nadežda* ("Hope") and *Lyubov* ("Love").

Together they can be read as a slogan, a representation of fundamental Christian spiritual values that are of particular importance in the culture of post-communist countries.

Utility Store "Love", 2007, C-print on aluminium / courtesy Antje Wachs Gallery, Berlin

1941-1945, 2007, C-print on aluminium / courtesy Antje Wachs Gallery, Berlin

THOMAS**ALLEN**_GRETA**ANDERSON**_BROOK**ANDREW**_MIRIAM**BÄCKSTRÖM**_

ARNIS**BALČUS**_EMMANUELLE**BAYART**_CARLO**BENVENUTO**_ELIN**BERGE**_

MATHIEU**BERNARD-REYMOND**_RICHARD**BILLINGHAM**_LIU**BOLIN**_

MELANIE**BONAJO**_ANDREA**BOTTO**_CANDICE**BREITZ**_MATTHIEU**BROUILLARD**_

MATTHIAS**BRUGGMANN**_MAGGIE**CARDELÚS**_CRISTIAN**CHIRONI**_

DANIEL**GUSTAVCRAMER**_LEA**CRESPI**_ALEXANDRA**CROITORU**_PAOLA**DEPIETRI**_

WIM**DELVOYE**_ALEXANDRA**DEMENKOVA**_PAOLA**DIBELLO**_

DOTT.PORKA'S**P-PROJ**_OLEG**DOU**_OLAFUR**ELIASSON**_LÉA**EOUZAN**_

HARIS**EPAMINONDA**_IGOR**EŠKINJA**_JANIETA**EYRE**_DÀVINA**FEINBERG**_MICHAEL**FLIRI**_

SAMUEL**FOSSO**_JULIA**FULLERTON-BATTEN**_STEFANIA**GALEGATI**_ANDREA**GALVANI**_

SHADI**GHADIRIAN**_GAURI**GILL**_CLAUS**GOEDICKE**_

GJOKE**GOJANI**_ALEXANDER**GRONSKY**_ALBERT**GUSI**_WOLFRAM**HAHN**_

CAROLINE**EMANUELAHEIDER**_CÉCILE**HESSE**+GAËL**ROMIER**_PETRINA**HICKS**_

REBECCA**ANNHOBBS**_ZHANG**HUAN**_PIETER**HUGO**_JR_YEONDOO**JUNG**_

MISTY**KEASLER**_PERTTI**KEKARAINEN**_IDRIS**KHAN**_HANNA**KOIKKALAINEN**_

_FELIX**KRIS**_EVA**LAUTERLEIN**_JANNE**LEHTINEN**_LEUNGCHI**WO LUBRI**

_MARCELLO**MALOBERTI**_TANCREDI**MANGANO**_MARCELLO**MARIANA**_EDGAR**MARTINS**

_MARY**MCINTYRE**_MARZIA**MIGLIORA**_OTTONELLA**MOCELLIN+NICOLAPELLEGRINI**

_LUIS**MOLINA-PANTIN**_YOUSSEF**NABIL**_SABAH**NAIM**_MARTIN**NEWTH**_LOAN**NGUYEN**

_LUCIA**NIMCOVA**_MELISA**ÖNEL**_GABRIEL**OROZCO**_SELINA**OU**_ADRIAN**PACI**

_DANAÉ**PANCHAUD**_JYRKI**PARANTAINEN**_MATTHEW**PILLSBURY**_NICHOLAS**PRIOR**

_PHILIPPE**RAMETTE**_MOIRA**RICCI**_SOPHY**RICKETT**_SANDRA**ROCHA**_DANIELA**ROSSELL**

_SARA**ROSSI**_MICHAEL**SAILSTORFER**_ANRI**SALA**_TXEMA**SALVANS**

_MARCO**SAMORÈ**_FABIO**SANDRI**_TOMAS**SARACENO** **BIO & W.I.P.**

_HIRAKI**SAWA**_TOMOKO**SAWADA**_JOÃOPAULO**SERAFIM**_SHIRANA**SHAHBAZI**

_ELISA**SIGHICELLI**_FRANCESCO**SIMETI**_ANNA**SKLADMANN**_ALESSANDRA**SPRANZI**

_ANNA**STRAND**_MIKHAEL**SUBOTZKY**_ANGELA**SVORONOU**_RICHARD**SYMPSON**

_MARIE**TAILLEFER**_SHIGERU**TAKATO**_VIBEKE**TANDBERG**_DAVIDE**TRANCHINA**

_GUIDO**VANDERWERVE**_MARCO**VANDUYVENDIJK**_MARIANNE**VIERØ**

_LI**WEI**_SASCHA**WEIDNER**_FU**YUZHU**_DARIUS**ŽIŪRA**

Note
The following artist biographies list only a selection of their personal and collective exhibitions held between 2000 and 2009.

■ THOMAS **ALLEN**
Born Highland Park (Michigan, US), 1963
Lives and works in Coloma (Michigan, US)
www.thomasallenonline.com

Solo exhibitions
2008
Cheap Trade, Carrol and Sons Art Gallery, Boston
Thomas Allen, Light & Sie Gallery, Dallas
2007
New Releases, Foley Gallery, New York
2006
Out of Print, Bernard Toale Gallery, Boston
2004
Uncovered, Foley Gallery, New York

Group exhibitions
2009
5+1: From a Big Crash to a New Deal, 1000eventi, Milan
2007
Empty Nest, Nathan A. Bernstein & Co. Ltd., New York

Work in progress
He is presently working on photographing book covers that are cut, hand-embossed and photographed from the inside out.

■ GRETA **ANDERSON**
Born Auckland (NZ), 1968
Lives and works in Auckland (NZ)
www.gretaanderson.com

Group exhibitions
2009
Picturing Eden, The John and Mable Ringling Museum of Art, Sarasota
2008
Hijacked, Australian Centre for Photography, Sydney
2007
Picturing Eden, The Museum of Photographic Arts, San Diego
2006
If You Leave Me, Can I Come Too?, Australian Centre for Photography, Sydney
Picturing Eden, George Eastman House - International Museum of Photography and Film, Rochester

Work in progress
She is currently working on three short films that belong to a collection titled *Walking and Talking*. Her experience as a commercial photographer has encouraged her to extend her interest into making moving images in the advertising industry.

■ BROOK **ANDREW**
Born Sydney (AU), 1970
Lives and works in Melbourne (AU)
www.brookandrew.com

Solo exhibitions
2009
Theme Park, Museum voor hedendaagse Aboriginal kunst, Utrecht
2008
The Island, Museum of Archaeology and Anthropology, Cambridge
2006
YOU'VEALWAYSWANTEDTOBEBLACK, National Gallery of Victoria, Melbourne

Group exhibitions
2008
typical! Clichés of Jews and Others, Jüdisches Museum Berlin, Berlin
2007
Prism: Contemporary Australian Art, Bridgestone Museum of Art, Tokyo
Alfred Metraux. From Fieldwork to Human Rights, Smithsonian Institution, Washington
2006
TRANS VERSA. Conversaciones con el sur, Museo de Arte Contemporáneo, Santiago
Bangu Yilbara. Works from the MCA Collection, Museum of Contemporary Art, Sydney
Points of View: Australian Photography 1985-95, Art Gallery of New South Wales, Sydney
HIGH TIDE, Zachęta Narodowa Galeria Sztuki, Warsaw; Šiuolaikinio meno centras, Vilnius

Work in progress
The artist's next solo exhibition utilises an archive consisting of photocopies and magazine clippings representing images of 18th-20th century interiors from the USA and England, combined through collage with six months of headlines from "The New York Times".

■ MIRIAM **BÄCKSTRÖM**
Born Stockholm (SE), 1967
Lives and works in Stockholm (SE)
www.elbabenitez.com
www.niklasbelenius.com
www.nilsstaerk.dk

Solo exhibitions
2008
Passage Amplifié, with Carsten Höller, permanent sound installation, Allée des Justes, Paris
2006
Miriam Bäckström, Nils Stærk, Copenhagen
Miriam Bäckström & Carsten Höller, Centre de la photographie, Geneva
2005
Betraktaren / The viewer, Galería Elba Benítez, Madrid
2003
Miriam Bäckström, Galerie Nordenhake, Stockholm
2002
Miriam Bäckström, Galleria Raucci/Santamaria, Naples

Group exhibitions
2009
Showroom: Miriam Bäckström / Torbjørn Rødland / Esko Männikkö, Mai 36 Galerie, Zürich
2006
Unlimited ID: the portrait as concept, Dazibao - Centre de photographies actuelles, Montreal
2005
Göteborg International Biennial for Contemporary Art 2005, Gothenburg
51ª Esposizione Internazionale d'Arte, Venice

Work in progress
She is working on the series *Mirrors*, which presents a number of human characters from fiction and reality, the past and the future, who are all surrounded by a round mirror, coloured or clear.

■ ARNIS **BALČUS**
Born Riga (LV), 1978
Lives and works in London (UK) and Riga (LV)
www.arnisbalcus.co.uk

Solo exhibitions
2009
Amnesia, Riga Art Space, Riga
2005
Naked, Matthew Bown Gallery, London
2004
Arnis Balcus, Latvijas Nacionālais mākslas muzejs, Riga
2003
Myself, Friends, Lovers and Others, Giedre Bartelt Gallery, Berlin

Group exhibitions
2008
From M to ZZZ, Langhans Gallery, Prague
2008
Privat, Winzavod - Moscow Contemporary Art Centre, Moscow
2004
Screen Spirit, Städtische Galerie im Buntentor, Bremen
2000
2nd Ars Baltica Triennial of Photographic Art, Kunsthaus Dresden, Dresden

Work in progress
Since 2008 the artist has been working on the photographic series *Amnesia* that represents the past ways of living in Latvia and Eastern Europe. The artist stages daily rituals that once were common but now are forgotten.

■ EMMANUELLE **BAYART**
Born Amiens (FR), 1981
Lives and works in Geneva (CH)
www.near.li

Group exhibitions
2009
Near Documentary, Fondation Esp'Asse, Nyon

2008
Jeunevois, Centre de la photographie, Geneva
Voyage d'artiste, Ferme-Asile, Sion
2007
A mille lieues, Halle Nord - Art en Île, Geneva
Plattform07, Zürich

Work in progress
She is working on the issue of representation
in representation, on the relationship of man
with history, on subways in the world to establish
a global view, and on portraits.

■ CARLO **BENVENUTO**
Born Stresa (IT), 1966
Lives and works in Milan (IT)
www.galleriamazzoli.com
www.suzyshammah.com

Solo exhibitions
2008
I Came To Hear The Music, Galleria Suzy Shammah,
Milan
2007
Natura Muta, Galleria Mazzoli, Modena
2003
Carlo Benvenuto, Galerie Site Odeon 5, Paris
Carlo Benvenuto, Museo di Arte Contemporanea
di Roma, Rome
2002
Fuoco Pallido, Galleria Mazzoli, Modena

Group exhibitions
2008
Focus On Contemporary Italian Art, Museo d'Arte
Moderna di Bologna, Bologna
2006
Italy Made In Art: Now, Museum of Contemporary Art,
Shanghai
2005
51ª Esposizione Internazionale d'Arte, Venice
2003
Italianamente, Unge Kunstneres Samfund, Oslo
2001
Il Dono, Palazzo delle Papesse, Siena; Bronx Museum,
New York; Stadtgalerie, Klagenfurt; Mary and
Leigh Block Museum of Art, Evanston; Art Gallery
of Hamilton, Hamilton; Scottsdale Museum of
Contemporary Art, Scottsdale

Work in progress
Carlo Benvenuto's poetics involve the constant
re-formulation of limits, form and composition;
a quest which sees him involved in the preparation
of new photographs and sculptures in porcelain.

■ ELIN **BERGE**
Born Stockholm (SE), 1978
Lives and works in Umeå (SE)
www.elinberge.com

Solo exhibitions
2009
Drottninglandet, Hasselblad Center, Gothenburg
2008
Ragazze suicidio / ragazze velate, Menotrentuno –
Young European Photography in Sardinia, Alghero
2006
Slöjor, Galleri Kontrast, Stockholm

Group exhibitions
2004
Dölja eller framhäva, Kulturhuset, Stockholm

Awards
2007
Fine Art Grant, Västerbottens Läns Landsting, Umeå
2006
Georg and Hjordis Andersson Grant, Umeå
Swedish Arts Grants Committee's Grant for long-term
project, Stockholm

Work in progress
Elin Berge's upcoming work, *Drottninglandet*
(*Queensland*) will be presented at the prestigious
Hasselblad Center in Gothenburg.

■ MATHIEU **BERNARD-REYMOND**
Born Gap (FR), 1976
Lives and works in Lausanne (CH)
www.monsieurmathieu.com

Solo exhibitions
2009
TV, 14-1 Galerie, Stuttgart
2008
TV, Caixa Cultural, São Paulo
2007
Reality Reloaded, 14-1 Galerie, Stuttgart
2006
Intervalles, Photobiennale 2006, Moscow
Mathieu Bernard-Reymond, Galerie Baudoin Lebon, Paris
Disparitions, 14-1 Galerie, Stuttgart
2005
Les Rencontres d'Arles 2005, Arles

Group exhibitions
2008
Double Vision, Kunst Büro, Berlin
Silent Raptures, Centre for Contemporary Photography,
Fitzroy, Melbourne

Work in progress
He is promoting the book and exhibition *TV*,
and a new series yet to be publicised.

■ RICHARD **BILLINGHAM**
Born Cradley Heath (UK), 1970
Lives and works in Wales (UK)
www.anthonyreynolds.com

Solo exhibitions
2007
People, Places, Animals, Australian Center for
Contemporary Art, Melbourne
Zoo, Wolverhampton Art Gallery, Wolverhampton
2006
Zoo, Compton Verney, Warwickshire
2005
Black Country, Anthony Reynolds Gallery, London
2004
Landscapes, Sint Lukas, Brussels
2002
Fishtank, Temple Bar, Dublin
2000-2001
Richard Billingham, Ikon Gallery, Birmingham;
Douglas Hyde Gallery, Dublin; Kunsthallen
Nikolaj, Copenhagen; Kunsthalle Wilhelmshaven,
Wilhelmshaven

Group exhibitions
2008
Damaged Romanticism, University Museum, Houston
2006
The Photographers' Contract, Akademie der Kunst, Berlin
2003
A Bigger Splash. British Art From the Tate 1960-2003,
Oca - Instituto Tomie Ohtake, São Paulo

Work in progress
He is currently working on exhibitions and a
publication of small and medium format landscape
images, mainly in black-and-white. Following his
earlier work with video he is also at an advanced
stage with a project for a feature film.

■ LIU **BOLIN**
Born Shandong (CN), 1973
Lives and works in Beijing (CN)
www.liubolinart.com

Solo exhibitions
2008
Hide and seek, Boxart Galleria d'Arte, Verona
Hide and seek, Galerie Bertin-Toublanc, Paris
Liu Bolin: China Report, Eli Klein Fine Art, New York
2007
Liu Bolin, Galerie Bertin-Toublanc, Miami
Sculpture's Exhibition of Liu Bolin, Hotsun Art Space, 798
Art Zone, Beijing

Group exhibitions
2008
Dialogue China Part I, Elins Eagles-Smith Gallery,
San Francisco
Stairway to Heaven, Bates College Museum of Arts,
Lewiston

2007
Modern China: Lost in Transition, Eli Klein Fine Art, New York
After..., Beijing New Art Projects, 798 Art Zone, Beijing
Far Away From City, Ifa Contemporary Art Center, Shanghai
Les Rencontres d'Arles 2007, Arles

Work in progress
He is creating new works for the *Hiding in the City* series.

■ MELANIE **BONAJO**
Born Heerlen (NL), 1978
Lives and works in Amsterdam (NL)
www.melaniebonajo.com

Solo exhibitions
2009
As Thrown Down From Heaven, P·P·O·W Gallery, New York
2008
Modern Life of the Soul, fette's gallery, Los Angeles
2007
The culture that doesn't exist, Galerie Fons Welters - Playstation, Amsterdam

Group exhibitions
2009
Rebelle - Kunst & Feminisme 1969-2009, Museum voor Moderne Kunst Arnhem, Arnhem
Thank you for hurting me, I really needed it, Stedelijk Museum, Amsterdam
2007
Capricious. Young Photographers, Stedelijk Museum Bureau, Amsterdam
Are All Cliche's True, Moderna Galerija, Ljubljana
2005
Cadres revistés // Frames Revisited, Institut Néerlandais - Centre culturel des Pays-Bas, Paris
Dutch insight - Contemporary netherlands photo & Video, Kumho Museum of Art, Seoul
Confrontation, FOAM_Fotografiemuseum Amsterdam, Amsterdam

Work in progress
She is currently a resident artist at the Rijksakademie van Beeldende Kunsten in Amsterdam preparing upcoming exhibitions and a publication.

■ ANDREA **BOTTO**
Born Rapallo (IT), 1973
Lives and works in Rapallo (IT)
www.andreabotto.it

Group exhibitions
2009
Las Proyecciones, Galeria La Fábrica, Barcelona
FotoGrafia - Festival Internazionale di Roma, Rome

2008
Somewhen, Jarach Gallery, Venice
Bi6 - Biennale dell'Immagine, Chiasso
2007
Atlante Italiano⁰⁰⁷_rischio paesaggio, Museo MAXXI, Rome
2005
Trans Emilia. The Linea di Confine Collection, Fotomuseum Winterthur, Winterthur
European Prize of Architectural Photography, Bundeskunsthalle, Bonn
2004
Empowerment / Cantiere Italia, Museo d'Arte Contemporanea di Villa Croce, Genoa
2002
PhotoEspaña 2002, Madrid
2001
Portfolio 2001. Giovane fotografia italiana, Galleria Civica di Modena, Modena

Work in progress
He continues to explore the concepts of *limit and time*, with the series *Horizons* and *Blast*, in an unstable equilibrium on the horizon of events.

■ CANDICE **BREITZ**
Born Johannesburg (ZA), 1972
Lives and works in Berlin (DE)
www.candicebreitz.net

Solo exhibitions
2009
On View. Candice Breitz, San Francisco Museum of Modern Art, San Francisco
2008
Candice Breitz. Inner + Outer Space, Temporäre Kunsthalle Berlin, Berlin
2007
Candice Breitz. New Work, White Cube, London
2006
Candice Breitz. Working Class Hero, Bawag Foundation, Vienna
2005
Candice Breitz. Mother + Father, Museo d´arte contemporanea Castello di Rivoli, Rivoli

Group exhibitions
2009
Mi Vida. From Heaven to Hell, Műcsarnok Kunsthalle, Budapest
Polyglottolalia, Tensta Konsthall, Spånga
2008
Recent acquisitions. Australian, International and Asian and Pacific Collections, Queensland Art Gallery / Gallery of Modern Art, Brisbane
The Cinema Effect: Illusion, Reality, and the Moving Image, Hirshhorn Museum and Sculpture Garden, Washington
2007
Star Power. Museum as Body Electric, Museum of Contemporary Art, Denver

2005
51ª Esposizione Internazionale d'Arte, Venice
2003
Göteborg International Biennial for Contemporary Art 2003, Gothenburg

Work in progress
Personal exhibitions at the San Francisco Museum of Modern Art and The Power Plant, Toronto.

■ MATTHIEU **BROUILLARD**
Born Montreal (CA), 1976
Lives and works in Montreal (CA) and Zürich (CH)

Solo exhibitions
2006
Matthieu Brouillard, VU Centre de diffusion et de Production de la Photographie, Québec
2005
Les cadavres anticipés, Dazibao - Centre de photographies actuelles, Montreal

Group exhibitions
2009
contemporary art ruhr 09, Essen
2008
Ostrale '08, OSTRALE - Zentrum für Zeitgenössische Kunst, Dresden
2005
PROOF 12-Emerging Canadian Photographers, Gallery 44, Toronto

Work in progress
He is working on a photographic series that draws upon *The Resurrection*, a panel from the Isenheim altarpiece by painter Matthias Grünewald, and explores the issues of metamorphosis and drifting of meaning.

■ MATTHIAS **BRUGGMANN**
Born Aix-en-Provence (FR), 1978
Lives in Lausanne (CH)
www.boring.ch/matt/

Solo exhibitions
2007
Somalie, Photoforum PasquArt, Biel

Group exhibitions
2006
reGeneration, Aperture Gallery, New York
2006 Pingyao International Photography Show, Pingyao
2005
reGeneration, Musée de l'Elysée, Lausanne; Galleria Carla Sozzani, Milan
2004
11ᵗʰ Noorderlicht Photofestival 2004, Stichting Fotografie Noorderlicht, Groningen
Conditions urbaines, Donzé van Saanen, Lausanne

Work in progress
He will probably continue working on *Somalia* for the foreseeable future, but doesn't know what else there will be – it depends on funding, and on what happens in the world.

■ MAGGIE **CARDELÚS**
Born Alexandria (Virginia, US), 1962
Lives and works in Milan (IT)
www.maggiecardelus.com

Solo exhibitions
2007
Maggie Cardelús. Looking for time, francesca kaufmann, Milan
2004
Bird People, Galerie Thaddaeus Ropac, Paris
Zoo's Days, Galería Fúcares, Madrid
2001
Maggie Cardelús, Deitch Projects, New York

Group exhibitions
2009
Echigo-Tsumari Art Triennal 2009, Echigo-Tsumari
Cluster, Galleria Maria Grazia Del Prete, Rome
2008
ARTIFACTS. Album di Famiglia nell'arte contemporanea, Mirafiori Motor Village, Turin
Cohabitation: 13 artists and collage, francesca kaufmann, Milan
2007
La Femenidad del Arte, Fundación Caja Castellón, Valencia
2005
Alternative Paradise, 21st Century Museum of Contemporary Art, Kanazawa
2002
ExIT: Nuove geografie della creatività italiana, Fondazione Sandretto Re Rebaudengo, Turin

Work in progress
She will be a member of the Otemachi Public Arts Competition Commission, Tokyo Art Beat, Tokyo.

■ CRISTIAN **CHIRONI**
Born Nuoro (IT), 1974
Lives and works in Orani (IT) and Bologna (IT)
www.cristianchironi.it

Solo exhibitions and performances
2009
DK, Art Fall 09, Padiglione Arte Contemporanea, Ferrara
2008
Propp, Galleria Placentia Arte, Piacenza
International Prize for Performance, Teatro sociale, Trento
Mirfestival, Akis Davis Theatre, Athens
Plateaux Festival, Mousonturm, Frankfurt

Group exhibitions
2009
Prague Biennale 4, Prague
2008
Soft Cell: dinamiche nello spazio in Italia, Galleria Comunale d'Arte Contemporanea, Monfalcone
2006
Video REPORT ITALIA 04_05, Galleria Comunale d'Arte Contemporanea, Monfalcone
SS9 - Strade BluArte, Galleria d'Arte Moderna di Bologna, Bologna; Galleria Comunale di San Pietro Terme, Castel San Pietro Terme; Pinacoteca Comunale di Imola, Imola
2002
Casa dolce Casa, Museo Arte Provincia di Nuoro, Nuoro

Work in progress
He is currently working on *DK* (the catalogue abbreviation of the Diabolik comic book series), a code which identifies a process of research into the theft of the aura of the Work of Art and its place of conservation, the Museum, making them collide with the comic book imagination of the Thief.

■ DANIEL GUSTAV **CRAMER**
Born Düsseldorf (DE), 1975
Lives and works in Berlin (DE)
www.danielgustavcramer.com

Solo exhibitions
2009
Ten Works, Vera Cortês, Lisbon
Cramer & Epaminonda, BolteLang, Zürich
Saturn, Jerwood Room - LMH, Oxford
2008
Infinite Library, NADA Art Fair 2008, Miami
2007
Daniel Gustav Cramer, Vera Cortês, Lisbon
Mountain, Goethe-Institut and DOMOBAAL, London
2006
Trilogy, Galleria Carla Sozzani, Milan

Group exhibitions
2009
2nd Athens Biennale, Athens
2008
5. Berlin Biennale für Zeitgenössische Kunst (guest of Haris Epaminonda), Berlin
2006
Open Call Förderpreis 2006, Westfälischer Kunstverein, Münster
2005
Jerwood Photography Award 2005, Jerwood Space, London

Work in progress
He is working on a new series called *Tales* and on a catalogue. He is also editing different books, mainly in collaboration with Haris Epaminonda.

■ LEA **CRESPI**
Born Paris (FR), 1978
Lives and works in Paris (FR)
www.boring.ch/lea/

Solo exhibitions
2009
Lieux, Prison de Pontaniou Brest, Centre Atlantique de Photographie, Quartz Brest
2008
Lieux 2002-2007, Galerie VU', Paris
2007
Lieux, Le Château d'Eau, Toulouse
2002
Lieux, Galerie le Lieux, Lorient

Group exhibitions
2008
Les Rencontres d'Arles 2008, Arles
2007
transformer 2, Photoforum PasquArt, Biel
2006
Des corps dans la ville, Lyon Septembre de la photographie 2006, Lyon
2005
Galerie VU', Paris, Langhans Galerie, Prague
2003
Claude Batho, Annelies Strba, Léa Crespi, La Galerie de La Filature, Mulhouse

Work in progress
The artist is creating portrait works for several magazines. She is still working on the *Lieux* project, always trying to take it further, until it or she breaks.

■ ALEXANDRA **CROITORU**
Born Bucharest (RO), 1975
Lives and works in Bucharest (RO)
www.andreianamihail.com
www.plan-b.ro
www.tomchristoffersen.dk

Solo exhibitions
2009
RE-, Galleri Tom Christoffersen, Copenhagen
2007
A Work about Work and a Duel to the Death, FUTURA Centre for Contemporary Art, Prague
An Exhibition on Photography, Andreiana Mihail Gallery, Bucharest
No Photo, Siemens_artLab, Vienna

Group exhibitions
2009
Translation Paradoxes and Misunderstandings, Shedhalle, Zürich
2008
Soft Manipulation. Who is afraid of the new now?, Casino Luxembourg - Forum d'Art Contemporain, Luxembourg
The World is Flat, Overgaden - Institute of Contemporary Art, Copenhagen

2007
CORCORAN, Strategies of Confinement in the Age of Biopolitics, Muzej savremene umetnosti, Belgrade
normal love / precarious sex. precarious work, Künstlerhaus Bethanien, Berlin
2006
47. Oktobarski Salon / 47th October Salon, Belgrade
How to Do Things? In the Middle of (No)Where…, Kunsthallen Nikolaj, Copenaghen
2005
Critique of Pure Image. Between Fake and Quotation, ATA Center for Contemporary Art, Plovdiv
No significant incidents to report, Galeria Noua, Bucharest

Work in progress
Research on *The Legacy of Brancusi* for a book publication and a PhD thesis at The National University of Arts, Bucharest.

■ PAOLA **DE PIETRI**
Born Reggio Emilia (IT), 1960
Lives and works in Reggio Emilia (IT)

Solo exhibitions
2007
Io parto, Museo di Fotografia Contemporanea, Cinisello Balsamo
2003
Trentuno dicembre millenovecentosessanta, Forte Belvedere, Florence
Images au Centre 03, Palais Jacques Coeur, Bourges
2001
Spazio Aperto, Galleria d'Arte Moderna di Bologna, Bologna

Group exhibitions
2008
Archeologia del presente, Museo delle Arti di Catanzaro, Catanzaro
2006
Italy made in Art: Now, Museum of Contemporary Art, Shanghai
2005
La dolce crisi, Villa Manin, Codroipo
Trans Emilia. The Linea di Confine Collection, Fotomuseum Winterthur, Winterthur
2004
Suburbia, Chiostri di San Domenico, Reggio Emilia
2003
X Biennale Internazionale di Fotografia, Turin

Work in progress
She is working on the project *To face*.

■ WIM **DELVOYE**
Born Wervik (BE), 1965
Lives and works in Gentbrugge (BE)
www.wimdelvoye.be

Solo exhibitions
2009
Wim Delvoye: Torre, Guggenheim Collection, Venice
2008
Wim Delvoye, Műcsarnok Nkft, Budapest
2007
Galerie Emmanuel Perrotin, Paris
Cloaca Quattro, Xin Beijing Gallery, Beijing
Wim Delvoye: Cloaca 2000-2007, Casino Luxembourg - Forum d'Art Contemporain, Luxembourg
2006
Bronzes, de Pury & Luxembourg, Zürich
2003
Fabrica, C-Arte, Prato
2002
Cloaca – New and Improved, New Museum, New York
Gothic Works, Manchester City Art Galleries, Manchester
2000
CLOACA, Museum van Hedendaagse Kunst, Antwerp

Work in progress
He is working on the second part (the bottom) of *Torre*, a lasercut corten steel tower shown at the Peggy Guggenheim Collection during the 53rd Venice Biennale.

■ ALEXANDRA **DEMENKOVA**
Born Kingisepp (RU), 1980
Lives and works in Amsterdam (NL)
www.alexandrademenkova.com

Solo exhibitions
2009
Images and Likenesses, Museum of the History of Photography, Saint Petersburg

Group exhibitions
2009
Russian Style, Gallery.Photographer.ru, Moscow
2008
OpenAteliers, Rijksakademie van Beeldende Kunsten, Amsterdam
Lumix Festival of Young Photojournalism, Hannover

Awards
2006
The Best Press-Photographer 2006, Saint Petersburg: grand prix
2005
The Ian Parry Scholarship, London: 3rd prize
2004
Nothern Palmyra, Saint Petersburg: grand prix

Work in progress
Recently she has taken photographs of transvestites who frequent a famous bar near her home in Amsterdam. But she is finding it increasingly important to return to Russia and continue doing projects there.

■ PAOLA **DI BELLO**
Born Naples (IT), 1961
Lives and works in Milan (IT)
www.paoladibello.com

Solo exhibitions
2007
Strip, Milano, Federico Bianchi Contemporary Art, Lecco
2004
Framing Devices, The Agency Contemporary, London
Cosa si vede a Mirafiori. Cosa vede Mirafiori, Fondazione Sandretto Re Rebaudengo, Turin

Group exhibitions
2007
La parola nell'Arte, Museo di Arte Moderna e Contemporanea di Trento e Rovereto, Rovereto
2006
Busan Biennale, Busan
2005
La dolce crisi, Villa Manin, Codroipo
2003
50a Esposizione Internazionale d'Arte, Venice
2002
ExIT: Nuove geografie della creatività italiana, Fondazione Sandretto Re Rebaudengo, Turin
Idea di Metropoli, Museo di Fotografia Contemporanea, Cinisello Balsamo
2001
The Overexcited Body, SESC Pompeia, São Paulo

Work in progress
She is working on the concept of *Bildung*, "Education". The artist is creating a third series of photographs of young people who she photographed in 1995 and 2000.

■ **DOTT. PORKA'S** P-PROJ
Collective of three artists
Born Southern Italy, second half of the Seventies
Live and work in Turin (IT), Bari (IT) and Bologna (IT)
www.porka.biz

Group exhibitions
2008
Immagini del gusto percorsi contemporanei sul cibo, Centro Italiano della Fotografia d'Autore, Bibbiena
XIII Biennal of Young Artists from Europa and the Mediterranean, Puglia-Bari
Slideluck Potshow 2008, Milan
Torino Geodesign, Turin

2007
IN SEDE - Che Scatto! Fotografi a Torino, Divisione Servizi Culturali della Città di Torino, Turin
SalernoInVita, Salerno
Gemini Muse 2007, Bari
2006
GAP - Giovani Artisti Pugliesi 2006, Sala Murat, Bari
2005-2006
Crack! Fumetti Dirompenti, Rome
2005
La fotografia: vedere è rivedere, Galleria d'Arte Moderna e Contemporanea, Turin

Work in progress
They are working on the post-production of the grotesque photo-novel *Boys don't cry* and the publication of the art book in comic book format with a limited print run, entitled *Le vicende di Savoia Monpadano e quelle storie.*

■ OLEG **DOU**
Born Moscow (RU), 1983
Lives and works in Moscow (RU)
www.douart.ru

Solo exhibitions
2009
Toystory, Flatland Gallery, Utrecht
Oleg Dou, Galeria SENDA - espai 2nou2, Barcelona
The Faces, Interalia, Seoul
Tears, Espace Art 22, Brussels
2008
Toy story, Aidan Gallery, Moscow

Group exhibitions
2009
SU:MBISORI 63, Jeju Museum of Art, Jeju City
2007
Russia. Four Generations, Duncan Miller Gallery, Los Angeles
White fair, Espace Art 22, Brussels

Awards
2008
2008 International Photography Awards: photographer of the year, "Fine Arts"
2007
2007 International Photography Awards: "Photographer of the Year Special"
2007 International Color Awards: 1st place "Photograph of the Year"
2007 International Color Awards: 1st place "Outstanding Achievement in Fine Art"

Work in progress
He is working on the new series *Magic Forest*.

■ OLAFUR **ELIASSON**
Born Copenhagen (DK), 1967
Lives and works in Copenhagen (DK) and Berlin (DE)
www.olafureliasson.net

Solo exhibitions
2009
Projekt Sammlung (6): Olafur Eliasson: The moving museum, Kunsthaus Zug, Zug
2007-2009
Take your time: Olafur Eliasson, San Francisco Museum of Modern Art, San Francisco; The Museum of Modern Art and P.S.1, New York; Dallas Museum of Art, Dallas; Museum of Contemporary Art, Chicago; Museum of Contemporary Art, Sydney
2005
Notion motion, Museum Boijmans van Beuningen, Rotterdam
The light setup, Malmö Konsthall, Malmö; Lunds Konsthall, Lunds
2004
Frost activity, Reykjavik Art Museum - Hafnarhús, Reykjavik
Photographs, Menil Collection, Houston
Your Lighthouse: Works with light 1991-2004, Kunstmuseum Wolfsburg, Wolfsburg
2003
The blind pavilion, 50ª Esposizione Internazionale d'Arte, Venice
The weather project, The Unilever Series, Tate Modern, London
2002
Chaque matin je me sens différent, chaque soir je me sens le même, Musée d'Art Moderne de la Ville de Paris, Paris
2001
The mediated motion, Kunsthaus Bregenz, Bregenz

Work in progress
The Institut für Raumexperimente (Institute for Spatial Experiments) is an educational research project by Prof. Olafur Eliasson, affiliated to the College of Fine Arts at the Berlin University of the Arts (UdK) and supported by the Senate for Education, Science and Research in Berlin.

■ LÉA **EOUZAN**
Born Bastia (FR), 1980
Lives and works in Lyon (FR) and Bastia (FR)
www.leaeouzan.com

Solo exhibitions
2009
On n'oublie jamais ceux que l'on aime, Le Bleu du Ciel - Burdeau, Lyon
2008
Archéologies urbaines, CAUE Haute-Corse, Bastia
2007
Histoire(s) contemporaine(s)…, La Librairie (Forum ENS), Lyon

Group exhibitions
2006
Menotrentuno: Tourism Revolution, Alghero
FotoGrafia - Festival Internazionale di Roma, Rome
Duels, FRAC Provence-Alpes-Côte d'Azur, Marseille

Awards
2007
Grand Prix d'Arts Plastiques de la Collectivité Territoriale de Corse, section "Prix Jeune Création"

Work in progress
Currently, she is working on "remarkable spaces" in Corsica. Nowadays heavily discussed, these spaces could disappear to become building areas. This subject is just part of a broader interest in new ways of consuming landscape without taking into consideration the history of the place, which includes contemporary attitudes concerning historical places, such as former concentrations camps in Poland or France.

■ HARIS **EPAMINONDA**
Born Nicosia (CY), 1980
Lives and works in Berlin (DE)
www.harisepaminonda.com

Solo exhibitions
2009
Haris Epaminonda, Rodeo Gallery, Istanbul
VOL. I, II & III, Malmö Konsthall, Malmö
2008
Tarahi IIII, V, VI, Circus, Berlin
Haris Epaminonda, Künstlerhaus Bethanien, Berlin
2006
Haris Epaminonda, DOMOBAAL, London

Group exhibitions
2009
2nd Athens Bienniale, Athens
Deste Prize 2009, Museum of Cycladic Art, Athens
The Generational: Younger Than Jesus, New Museum of Contemporary Art, New York
2008
5. Berlin Biennale für Zeitgenössische Kunst, Berlin
2007
52ª Esposizione Internazionale d'Arte, Venice

Work in progress
Since 2007 Epaminonda is developing an ongoing project, *The Infinite Library*, together with German artist Daniel Gustav Cramer.

■ IGOR **EŠKINJA**
Born Rijeka (HR), 1975
Lives and works in Rijeka (HR), Milan (IT) and Venice (IT)
www.federicolugergallery.com

Solo exhibitions
2009
Made In:Side, Bardini Contemporanea, Florence
Project For Unsuccessful Gathering, Casino Luxembourg - Forum d'Art Contemporain, Luxembourg

2008
Igor Eškinja, Federico Luger Gallery, Milan; Centro de Arte Caja de Burgos, Burgos
2007
Igor Eškinja, Gallery Krobath Wimmer, Vienna

Group exhibitions
2009
Fifty/Fifty, Wien Museum, Vienna
2008
Complicity, Rena Bransten Gallery, San Francisco
Manifesta 7, Trentino and Südtirol
2007
Prague Biennale 3, Prague

Work in progress
He is currently experimenting with new forms and materials for a new photographic series entitled *Impossible images*.

■ JANIETA **EYRE**
Born London (UK), 1966
Lives and works in Toronto (CA)
www.janietaeyre.com

Solo exhibitions
2008
In the scream of things, Begoña Malone, Madrid
2006
Janieta Eyre, DA2 - Domus Artium 2002, Salamanca
2005
What I haven't told you, Christopher Cutts, Toronto
Janieta Eyre, B&D Studio Contemporanea, Milan
2002
Motherhood & Natural History Museum, Cristinerose Gallery, New York
Staging, Contemporary Art Museum, Saint Louis
2000
Lady Lazarus, Francesco Girondini Arte Contemporanea, Verona

Group exhibitions
2006
Faking Death, Jack Shainman Gallery, New York
2004
Annina Nosei Gallery, New York
Them (sound and photography installation), TAAFI, Drake Hotel, Toronto
2003
How Human: Life in the Post-Genome Era, International Centre for Photography, New York

Work in progress
Currently she is working on a series of black and white photographs called *The Mute Book*.

■ DAVINA **FEINBERG**
Born Chaing Mai (TH), 1974
Lives and works in New York (New York, US)
www.davinafeinberg.com

Group exhibitions
2008
TEEN CITY. L'aventure adolescente, Musée de l'Elysée, Lausanne
2006
Mixed Emotions, Haifa Museum of Art, Haifa
2004
Love is in the Air, Zman Le'Omanut, Tel Aviv
2003
Israeli Contemporary Art, The Robert Sanderson Gallery, London

Work in progress
Her next series will explore the illusion of perfection within family relationships.

■ MICHAEL **FLIRI**
Born Silandro (IT), 1978
Lives and works in Vienna (AT) and Italy
www.galleriaraffeallacortese.com

Solo exhibitions
2008
Getting too old to die young, Galleria Raffaella Cortese, Milan
2007
Gravity, Eurac - Projectroom Museion, Bolzano

Group exhibitions
2009
3rd Moscow Biennale of Contemporary Art, Moscow
Hopes and Doubts, Fondazione Merz, Turin; Dome City Center, Beirut
New Entries!, Museion, Bolzano
2008
The Rocky Mountain People Show, Galleria Civica d'Arte Contemporanea, Trento
The Sovereign European Art Prize, Somerset House, London
Video REPORT ITALIA 06_07, Galleria Comunale d'Arte Contemporanea, Monfalcone
2007
Looking for the boarder, De Garage, Mechelen; Cultuurcentrum Strombekk, Grimbergen; Fondazione Stelline, Milan
As it screams please love me, FormContent, London

Work in progress
He is working on a video, a new series of photographs, and on sculptures.

■ SAMUEL **FOSSO**
Born Kumba (CM), 1962
Lives and works in Bangui (CF)
www.extraspazio.it

Solo exhibitions
2008
You Will Be Handsome, Stylish, Sensitive and Easy to Recognize, Les Rencontres d'Arles 2008, Arles
2006
Samuel Fosso, e x t r a s p a z i o, Rome
2004
Samuel Fosso, Istituto Nazionale per la Grafica-Calcografia, Rome; Centro Internazionale di Fotografia Scavi Scaligeri, Verona

Group exhibitions
2009
En todas as partes. Políticas da diversidade sexual na arte, Centro Galego de Arte Contemporánea, Santiago de Compostela
Bamako 07. 7th African Photography Meeting, Centre de Cultura Contemporània de Barcelona, Barcelona
2008
Street & Studio: an Urban History of Photography, Tate Modern, London
2007
Tapping Currents: Contemporary African Art and the Diaspora, The Nelson-Atkins Museum of Art, Kansas City
2006
Masquerade, Museum of Contemporary Art, Sydney
2004-2008
Africa Remix, Stiftung Museum Kunst Palast, Düsseldorf; Hayward Gallery, London; Centre Pompidou, Paris; Mori Art Museum, Tokyo; Moderna Museet, Stockholm; Johannesburg Art Gallery, Johannesburg
2001-2002
The Short Century: Independence and Liberation Movements in Africa 1945-1994, P.S.1 MoMA, New York; Museum Villa Stuck, Munich; Haus der Kulturen der Welt, Berlin

Work in progress
Samuel Fosso has been working on the series *African Spirits* since 2008, a kind of personal Pantheon. For his self-portraits, the artist borrows the identities of famous people fundamental in the fight for the independence of the African states, the North American civil rights movement and cultural icons, both African and Afro-American: Léopold Sédar Senghor, Aimé Césaire, Muhammad Ali, Miles Davis, Kwame Nkrumah, Salif Keita, Patrice Lumumba, Angela Davis, Martin Luther King, Hailé Sélassié, Malcolm X, Nelson Mandela, Tommie Smith and Barack Obama.

JULIA **FULLERTON-BATTEN**
Born Bremen (DE), 1970
Lives and works in London (UK)
www.juliafullerton-batten.com

Solo exhibitions
2009
Teenage Stories, La Galerie de La Filature, Mulhouse
2008
In Between, Randall Scott Gallery, Washington
School Play, Galerie Caprice Horn, Berlin
Teenage Stories, Galerie Les Filles du Calvaire, Brussels
2006
A Picture of Health, National Portrait Gallery, London
Teenage Stories, Charing X Gallery, London

Group exhibitions
2009
Winter Haiku, Jenkins Johnson Gallery, New York
2008
Lianzhou International Photo Festival 08, Lianzhou
TEEN CITY. L'aventure adolescente, Musée de l'Elysée,
Lausanne
2007
Les Rencontres d'Arles 2007, Arles
ESCALAS, Galería Siboney, Santander
Like There Is No Tomorrow, Galerie Caprice Horn, Berlin
2006
Perfect 10, Richard Levy Gallery, Albuquerque

Work in progress
She is currently working on her last series
of the *In Between* project.

STEFANIA **GALEGATI**
Born Bagnocavallo (IT), 1973
Lives and works in Palermo (IT)
www.galegati.net

Solo exhibitions
2008
Critica in arte, Museo d'Arte della città di Ravenna,
Ravenna
2007
As a drop of water on the k-way, con Marco Raparelli,
Careof, Milan; Uqbar, Berlin
Stefania Galegati Shines, francesco pantaleone arte
e Contemporanea, Palermo
2006
Stefania Galegati, pinksummer, Genoa
Memoria, Futuraproject, Prague
2005
Bier für öl + ein blinder passagier, con Tatjana Doll -
Teufel #2, Kunstverein Bremerhaven, Bremerhaven

Group exhibitions
2008
Video REPORT ITALIA 06_07, Galleria Comunale d'Arte
Contemporanea, Monfalcone
Identities in touch, Waseda University, Tokyo

2007
2007 Domestic Irony, Museion, Bolzano
Clearly Invisible, An (invisible) Archive, Centre d'Art
Santa Mònica, Barcelona
2006
Young Italian Artists At The Turn Of The Millennium,
Galleria Continua, Beijing

Work in progress
She is currently finishing editing a series of seven
videos, filmed as notes over the last two years.

ANDREA **GALVANI**
Born Verona (IT), 1973
Lives and works in Milan (IT) and New York (New York, US)
www.andreagalvani.com

Solo exhibitions
2008
La triade di Bichat III, Museo di Castelvecchio, Verona
2007
L'intelligenza del male, Circuit, Lausanne
N⁻¹, Artericambi, Verona
2006
Andrea Galvani 2003-2006, Galleria Comunale d'Arte
Contemporanea, Monfalcone
2005
*Decostruzione di una montagna e la morte
di un'immagine*, Artopia, Milan

Group exhibitions
2009
DUST JACKET Vol.1 Temporary geometry, Italian Cultural
Institute, New York
PS: Parsing Spirituality, Affirmation Arts, New York
2008
Under Influence, Phillips de Pury & Company, New York
2007
BAC! 07 Babylon, Centre de Cultura Contemporània de
Barcelona, Barcelona
Carnegie Art Award 2006, Oslo Plads, Copenhagen
2006
Lovely Daze, Whitney Museum of American Art, New York
Visioni del Paradiso, Istituto Svizzero di Roma, Rome

Work in progress
This autumn he will take part in Arctic Circle 2009, a
research project which will see his involvement in an
expedition to cross the Arctic Circle. Accompanying
him on board a hi-tech yacht will be a team of polar
exploration experts and two scientists. The work
produced during the journey will then be presented over
the following months, with the support of the Scope
Foundation, at five major art events: Art Basel Miami
2009, ARCO Madrid 2010, The Armory Show 2010, Art
Basel Basel 2010 and Frieze Art Fair London 2010.

SHADI **GHADIRIAN**
Born Teheran (IR), 1974
Lives and works in Teheran (IR)
www.aeroplastics.net

Solo exhibitions
2009
Shadi Ghadirian, aeroplastics contemporary***,
Brussels
2008
Shadi Ghadirian, Silk Road, Teheran
Los Angeles County Museum of Art, Los Angeles

Group exhibitions
2009
New Art From the Middle East, The Saatchi Gallery,
London
2008
Blessed are the Merciful, Feigen Contemporary,
New York

Work in progress
Although her work is closely related to her identity as
a Muslim woman living in Iran, she wants to explore
the ideas of censorship, religion, modernity, and the
status of women in other parts of the world.

GAURI **GILL**
Born Chandigarh (IN), 1970
Lives and works in New Delhi (IN)
www.naturemorte.com

Solo exhibitions
2008-2009
The Americans, Bose Pacia Gallery, New York; Nature
Morte Gallery, New Delhi; FOSS-GANDI at C&L
Gallery, Mumbai; Thomas Welton Stanford Art Gallery,
Stanford; Chicago Cultural Center, Chicago; Bose Pacia
Gallery, Kolkata

Group exhibitions
2009
Rememory, con Tomoko Yoneda, Galerie Lucy
Mackintosh, Lausanne
*The Self and The Other - Portraiture in Contemporary
Indian Photography*, La Virreina - Centre de la Imatge,
Barcelona
Shifting Shapes - Unstable Signs, Yale University Art
Gallery, New Haven

Awards
2002
Fifty Crows Award, San Francisco

Work in progress
Gill is working with rural communities in Western
Rajasthan, on cities in transition, rehabilitation sites
in New Delhi, as well as her neighbourhood at night.

■ CLAUS **GOEDICKE**
Born Cologne (DE), 1966
Lives and works in Berlin (DE)
www.ft-contemporary.com

Solo exhibitions
2007
Claus Goedicke, Galleria H, Seoul
2006
Polierte Hieroglyphen, fiedler contemporary, Cologne
2005
Claus Goedicke, Galerie Thaddaeus Ropac, Paris
2004
Claus Goedicke, Galerie Thaddaeus Ropac, Salzburg

Group exhibitions
2009
ftc. in Berlin, ftc. fiedler taubert contemporary, Berlin
2006
*Les Peintres de la vie moderne. Donation - Collection
photographique de la Caisse des Dépôts*, Centre
Pompidou, Paris
*Fotokunst aus 60 Jahren. Kunst aus NRW
unterwegs*, Museum der Stadt Ratingen, Ratingen
2004
Sammlung Plum, Museum Kurhaus Kleve, Kleve
Je t'envisage. La disparition du portrait, Musée de
l'Elysée, Lausanne

Work in progress
He takes pictures of everyday objects, such as
a pencil and a potato, a slice of bread and a handful
of coins, a watch, a pair of compasses, a plaster, a piece
of soap, a book, pills, scissors, and an old photograph
of somebody with his dog, pondering the relationship
between manmade products and us, and how we look
at them.

■ GJOKE **GOJANI**
Born Peje (KS), 1981
Lives and works in Bergamo (IT)
www.saturnaliaprogetti.com/gjoke.swf

Group exhibitions
2009
Alice nella città, Cremona
2008
Galleria Manzù, Bergamo
2007
Decantazione, Hublab Gallery, Milan
Galleria Manzoni, Bergamo
Les cultures, Galleria Melesi, Lecco
2003
Muslim Mulliqi, Kosova Art Gallery, Prishtina

Work in progress
He is currently working on a photographic project
called *Uomo Vitruviano*.

■ ALEXANDER **GRONSKY**
Born Tallinn (EE), 1980
Lives and works in Moscow (RU)
www.alexandergronsky.com

Solo exhibitions
2008
Background, Gallery.Photographer.ru, Moscow

Awards
2009
Linhof Young Photographer Award, Munich: 1st place
2008
Kandinsky Prize, Moscow: finalist
2007
Silver Camera 2006, Moscow: 2nd place
2004
Ian Parry Scholarship, London: finalist
2003
Press Photo Russia Contest: 1st place
2000-2001
Press Photo Russia Contest: 1st place

Work in progress
He is currently working on a project about the
boundaries of Moscow.

■ ALBERT **GUSI**
Born Castellbisbal (ES), 1970
Lives and works in Castellbisbal (ES)
www.albertgusi.com

Solo exhibitions and performances
2009
Horizons-Sancy, Massif du Sancy, Clermont-Ferrand
2008
Aproximació a una Geografia Cultural Catalana,
Museu de l'Empordà, Figueres
Un Nou Camp a Sant Jaume de Frontanyà, performance
nel paesaggio, Sant Jaume de Frontanyà
2007
Simulació d'una fumarola al volcà Montsacopa,
performance at Montsacopa, Olot
Messor: les formigues (re)col·leccionistes, Museu
de Ciències Naturals, Granollers
2006
*A una hora lluny, per damunt de les muntanyes
i els límits*, Museu Pintura, Sant Pol de Mar
2004
*L'artista-intervencionista, el territori, la fotografia
i el rastre*, Museu d'Art Modern, Tarragona

Group exhibitions
2009
Fotografia spagnola contemporanea, Real Academia
de España en Roma, Rome
2004
En Guerra, Centre de Cultura Contemporània
de Barcelona, Barcelona
2000
Images de guerre, images de paix, Museu Historial
de la Grande Guerre, Peronne

Work in progress
The *OhScale* project sets the spectator high above
of the city, on a 4-metre high platform with steps,
allowing its users to observe a landscape seen
a thousand times before, this time with new eyes.
A platform to watch from above what we have always
known and seen from below.

■ WOLFRAM **HAHN**
Born Crailsheim (DE), 1979
Lives and works in Berlin (DE)
www.wolframhahn.de

Solo exhibitions
2009
Underground station U8 "Rosenthaler Platz", Berlin
Instituto Cultural de Chile, Valparaíso
2008
Goethe-Institut, Washington
A Disenchanted Playroom, Starkwhite Gallery, Auckland
2007
Talents 07. Entzaubert. Wolfram Hahn/Daniel Klemm,
C/O Berlin - International Forum For Visual Dialogues,
Berlin

Group exhibitions
2009
Lichtmesz, Kulturzentrum bei den Minoriten, Graz
Walk The Line, Galerie AL/MA, Montpellier
2008
enfance - purpose projection 4, École Nationale
Supérieure d'Architecture de Paris La Villette, Paris
Deutsche Börse Group, Frankfurt

Awards
2008
Unicef "Photo of the Year 2007", Photokina, Cologne

Work in progress
The infiltration of digital and electronic media
into our daily living environment makes it difficult
to differentiate between lived events and those
consumed from the media. Both forms fuse together
in a hybrid space that constitutes personal experience.
This is the point of departure for a project he recently
began about the self-portrait in digital age.

■ CAROLINE EMANUELA **HEIDER**
Born Munich (DE), 1978
Lives and works in Vienna (AT) and Carinthia (AT)
www.pinocchio1-2.blogspot.com

Solo exhibitions
2008
Like Models, Thomas K. Lang Gallery, Webster
University, Vienna
2007
White lies, Demonstrationsraum, Akademie
der bildenden Künste Wien, Vienna

Group exhibitions
2009
Portrait, Fotogalerie Wien, Vienna
2008
Investigations on Anything, Something and Nothing,
Gallery Winiarczyk, Vienna
Recent Changes, Galerie 5020, Salzburg
Holz, Kunstforum Montafon, Schruns
2007
*Blickwechsel No. 3 aus der Sammlung, Kunstankäufe
05/06*, Museum Moderner Kunst Kärnten, Klagenfurt
DIS*PLACE*, Galerie Fotohof, Salzburg
2006
Erzählungen -35/65, Kunsthaus Graz, Graz
2005
I can see clearly now, Krinzinger Projekte, Vienna
REAL. Junges Österreich, Kunsthalle Krems, Krems

Work in progress
She is currently working on the history of fur for a
new series of folded images, while another project
concerns the idea of time spent and long forgotten
experiments. Identity and combating racism, exposed
through observation and the approach to images are
also central to her work here.

■ CÉCILE **HESSE** + GAËL **ROMIER**
Cécile Hesse (born Thionville, FR, 1977)
Gaël Romier (born Firminy, FR, 1974)
Live and work in Auvergne (FR)
www.kephyr.fr

Solo exhibitions
2008
Duchesse Vanille, Centre d'art contemporain
de Montélimar, Montélimar
Pour le meilleur et pour le pire, Aperti, standard/deluxe,
Lausanne
Pour le meilleur et pour le pire, VOG, Fontaine
2003
*Cécile Hesse et Gaël Romier - Bienvenue chez
vous*, Musée d'Art Contemporain, Lyon
2002
Miroirs sans tain, La Galerie de La Filature, Mulhouse

Group exhibitions
2006
artbrussels 2006, Brussels
2005
Slot, Spazio della volta, Genoa
2004
Artothèque d'Angers, Angers
2002
Sans consentement, Centre d'Art Neuchâtel, Neuchâtel

Work in progress
"Duchesse Vanille" is one of the names of a famous
French patisserie. It could also be a character.
The images are glimpses of a decadent supper.
We work on sets half way between everyday life
and an eroticised banquet. The eyes are varnished,
the laughter swells, the heels bang and pitch and toss.

■ PETRINA **HICKS**
Born Sydney (AU), 1972
Lives and works in Sydney (AU)
www.petrinahicks.com
www.stillsgallery.com.au

Solo exhibitions
2008
The Descendants, Stills Gallery, Sydney
2007
Flawless, Museum of Brisbane, Brisbane
2006
Petrina Hicks, Stills Gallery, Sydney
*Petrina Hicks. Australia-Japan, The Exchange
of Viewpoints,* Early Gallery, Osaka
2005
Petrina Hicks, Stills Gallery, Sydney

Group exhibitions
2009
Thirteen, Stills Gallery, Sydney
2007
NY C Photo, Phillips de Pury & Company, New York
Pet Project, Australian Centre for Photography, Sydney
Light Sensitive, National Gallery of Victoria
International, Melbourne
2006
In Cold Light, Centre for Contemporary Photography,
Melbourne

Work in progress
Petrina Hicks is currently producing a new series of
images, portraits of teenagers and children; this work
is being created in The Netherlands, Germany and
Russia, where Hicks will be based in 2009-2010.

■ REBECCA ANN **HOBBS**
Born Townsville (AU), 1976
Lives and works in Auckland (NZ)
www.johnstongallery.com.au

Solo exhibitions
2009
Rebecca Ann Hobbs, Sutton Gallery, Fitzroy, Melbourne
2007
Up with the fall, down on the diagonal, Stills Gallery,
Sydney
Rebecca Ann Hobbs, Sutton Gallery, Fitzroy, Melbourne
2002
Rebecca Ann Hobbs, Centre for Contemporary
Photography, Fitzroy, Melbourne

Group exhibitions
2007
Vertigo, Perth Institute of Contemporary Arts, Perth
Light Sensitive, National Gallery of Victoria
International, Melbourne
2006
In Cold Light, Centre for Contemporary Photography,
Fitzroy, Melbourne
Group Show, Stills Gallery, Sydney

2005
Awkward Silences, Linden Gallery, Melbourne
2004
Zeitgeist, Australian Centre for Photography, Sydney

Work in progress
To Do: actively negotiating small structures whilst
thinking about far away places.

■ ZHANG **HUAN**
Born An Yang City (CN), 1965
Lives and works in Shanghai (CN) and New York
(New York, US)
www.zhanghuan.com

Solo exhibitions
2009
Semele, artistic director and stage design,
Theatre Royal de La Monnaie | de Munt, Brussels
Zhang Huan, Zhu Gangqiang, White Cube, London
2008
Zhang Huan. Blessings, PaceWildenstein, New York
Zhang Huan. Altered States, Vancouver Art Gallery,
Vancouver
2007
Zhang Huan. Altered States, Asia Society, New York
Zhang Huan, PhotoEspaña 2007, Madrid

Group exhibitions
2009
Steel Life, La Triennale di Milano, Milan
2008
Christian Dior & Chinese Artists, Ullens Center
for Contemporary Art, Beijing
Sculpture at Pilane 2008, Tjorn
2007
*Exposed. Defining Moments in Photography from the MCA
Collection*, Museum of Contemporary Art, Chicago

Work in progress
Solo exhibitions at PaceWildenstein. Commissions
for the Shanghai World Expo 2010 and the Toronto
Shangri-La.

■ PIETER **HUGO**
Born Johannesburg (ZA), 1976
Lives and works in Cape Town (ZA)
www.pieterhugo.com

Solo exhibitions
2009
Nollywood, Michael Stevenson Gallery, Cape Town
2008
The Hyena and Other Men, FOAM_Fotografiemuseum,
Amsterdam
Pieter Hugo: Portraits, Open Eye Gallery, Liverpool
God's Time is the Best, Cokkie Snoei Gallery, Rotterdam
2007
The Hyena & Other Men, Yossi Milo Gallery, New York

Group exhibitions
2009
Three Stories, Centre national de l'audiovisuel, Luxembourg
Stigmata, Musée International de la Croix-Rouge et du Croissant-Rouge, Geneva
2008
Street & Studio. An urban history of photography, Tate Modern, London
2006
27ª Bienal de São Paulo, São Paulo

Work in progress
He is in the process of publishing a book called *Nollywood*, which explores the multilayered reality of the Nigerian film industry.

■ **JR**
Active since 2001
www.jr-art.net

Solo exhibitions, actions and performances
2009
Les Rencontres d'Arles 2009, Arles
2008
WOMEN, Casa França Brasil, Arcos de Lapa, Teatro João Caetano and Salla Cecília, Rio de Janeiro
Lazarides Gallery, London
Manette Street, London
Tate Modern, London
Bowery & E Houston, New York
Women are Heroes, Quai aux Barques, Gare Centrale, Boulevard Anspach, Rue Saint-Gery, Brussels
Face 2 Face, Maison des arts du Grütli, Geneva
2007
Face 2 Face, Place Igor Stravinsky, Rue de Rivoli, Rue Saint-Merri, Paris
Face 2 Face, Checkpoint Charlie, Friedrichstrasse, Charlottenstrasse, Berlin

Work in progress
JR is now finishing the *WOMEN* project by editing the movie *Women are Heroes*, which should be ready for cinema release in 2010. An exhibition tour is also planned in Paris, New Delhi and Geneva.

■ YEONDOO **JUNG**
Born Jinju (KR), 1969
Lives and works in Seoul (KR)
www.yeondoojung.com

Solo exhibitions
2009
Yendoo Jung. Handmade Memories, Tina Kim Gallery, New York
2008
Handmade Memories, Kukje Gallery, Seoul
For Your Loneliness (II), Galerie Gebr. Lehmann, Berlin

2007
Locations, Tina Kim Gallery, New York
Memories of You - Artist of the Year 2007, National Museum of Contemporary Art Korea, Gwacheon
Wonderland, Galería Espacio Mínimo, Madrid

Group exhibitions
2009
Prague Biennale 4, Prague
Try to make a simple gesture, no matter how small!, Trafó Kortárs Művészetek Háza, Budapest
2008
Asian Dub Photography, Fondazione Cassa di Risparmio di Modena, Modena
2007
Elastic Taboos - Koreanische Kunst der Gegenwart, Kunsthalle Wien, Vienna
2005
51ª Esposizione Internazionale d'Arte, Venice

Work in progress
He is preparing the performance/video work called *CineMagician*. We normally watch a 120-minute movie that is produced following many months of hard work. The artist is trying to shoot a 120-minute movie in 120 minutes inside the theater with the technique of "One Scene One Take". It will be a magical creation of the camera trick.

■ MISTY **KEASLER**
Born Houston (Texas, US), 1978
Lives and works in Dallas (Texas, US)
www.mistykeasler.com

Solo exhibitions
2006
Hallworks, Dallas Contemporary Arts Center, Dallas
Love Hotels, The Museum of Contemporary Photography, Chicago; PDNB Gallery, Dallas; Jenkins Johnson Gallery, New York
2004
Guatemala City Dump, Women & Their Work Gallery, Austin
Misty Keasler, PDNB Gallery, Dallas
2003
East Texas, Galveston Arts Center, Galveston

Group exhibitions
2009
Life in Space: Staging Identity, Dallas Museum of Art, Dallas
2005
Disturbed Landscape, Julie Saul Gallery, New York

Awards
2004
DeGoyler Award, Dallas Museum of Art
2003
Lange-Taylor Prize, Center for Documentary Studies, Duke University

Work in progress
Keasler is currently working on her second monograph, the culmination of studying the politics and people centered around trash in developing countries. The work has taken place over several years and includes dumps in Central America, Asia, and Africa.

■ PERTTI **KEKARAINEN**
Born Oulu (FI), 1965
Lives and works in Helsinki (FI)
www.anhava.com

Solo exhibitions
2009
Pertti Kekarainen, Villa Oppenheim, Berlin
Photography 1990-2009, Stadtgalerie Kiel, Kiel
2008
Pertti Kekarainen, Galerie Robert Drees, Hannover
2006
Tila, Bildmuseet, Umeå
2005
Pertti Kekarainen, Galerie Anhava, Helsinki

Group exhibitions
2009
Auf der Spitze des Eisbergs - Neue Fotografie aus Finnland, Kunstmuseum Wolfsburg, Wolfsburg
2007
Carnegie Art Award, Nykytaiteen museo Kiasma, Helsinki
Photo Finnish - The Helsinki School, Stenersenmuseet, Oslo
2006
Breaking the Ice, Kunstmuseum Bonn, Bonn
2005
IBCA Biennale 2005, Prague

Work in progress
Working and thinking continues…

■ IDRIS **KHAN**
Born Birmingham (UK), 1978
Lives and works in London (UK)
www.victoria-miro.com

Solo exhibitions
2009
Be Lost in the Call, Elementa, Dubai
2008
Every…, K20 Kunstsammlung Nordrhein-Westfalen, Düsseldorf
2007
Idris Khan, Yvon Lambert Gallery, New York
Idris Khan, Thomas Schulte Galerie, Berlin
2006
A Memory After Bach's Cello Suites, Yvon Lambert, Paris
Idris Khan, Victoria Miro Gallery, London
A Memory After Bach's Cello Suites, inIVA, London
Idris Khan, Fraenkel Gallery, San Francisco

Group exhibitions
2009
The Collection, Victoria Miro Gallery, London
Ecritures Silencieuses, Espace Culturel Louis Vuitton, Paris
Natural Wonders: New Art from London, Baibakov Art Projects, Moscow
2008
Order from Chaos, Centro Andaluz de la Fotografía, Almería
A Memory After Bach's Cello Suites, Kunst Film Biennale, Cologne
P2P, Casino Luxembourg - Forum d'Art Contemporain, Luxembourg
2007
All Tomorrow's Pictures, Institute of Contemporary Arts, London

Work in progress
Forthcoming group show *Taswir. Pictorial Mappings of Islam and Modernity* (Martin-Gropius-Bau, Berlin, November 2009 - January 2010) and solo show (Victoria Miro Gallery, London, 2010).

■ HANNA **KOIKKALAINEN**
Born Imatra (FI), 1980
Lives and works in Helsinki (FI)
www.hannakoikkalainen.com

Solo exhibitions
2006
Kallio, Valtimo-theatre, Valtimo

Group exhibitions
2009
Löytö / Discovery, South-Karelia Art Museum, Lappeenranta
2008
Helsinki Biennale 2008, Helsinki
2005
Voimat / Forces, Fiskars
Toivoa on, South-Karelia Art Museum, Lappeenranta
2004
Taiteilijaelämää, Nykytaiteen museo Kiasma, Helsinki
2003
Same Sea-Same Passion, Kerava Art Museum, Kerava
The Black Yovos, Galleria Myymälä 2, Helsinki
2002
Kärpäspaperi, Media Centre Lume, Helsinki

Work in progress
Photographs of the border.

■ FELIX **KRIS**
Born Khersen (UA), 1978
Lives and works in Tel Aviv (IL)

Group exhibitions
2009
Asurim, Asirei Hamachtarot Museum, Jerusalem
2008
Felix Kris, 3 Meter Gallery, Tel Aviv
2007
Graduates of Photography Departments in Israel, Tel Hai Museum of Photography, Tel Hai
Final Project, Minshar Gallery, Tel Aviv

Work in progress
Currently he is working on a new series called *I have no aim*, staged pictures taken in Eastern Europe.

■ EVA **LAUTERLEIN**
Born Lausanne (CH), 1977
Lives and works in Vevey (CH)
www.evalauterlein.net
www.galerie-wagner-partner.com

Solo exhibitions
2008
Chimery, Centrum Kultury Zamek, Galeria Fotografii "pf", Poznań
2007
Chimères, Herrmann & Wagner, Berlin

Group exhibitions
2009
One step beyond reality, Wagner + Partner, Berlin
Définitions, Photoforum PasquArt, Biel
2008
F/Stop 2, Internationales Fotografiefestival Leipzig, Leipzig
2006
reGeneration, Aperture Gallery, New York
Speed, Rotwand - Sabina Kohler & Bettina Meier-Bickel, Zürich
2005
reGeneration, Musée de l'Elysée, Lausanne; Galleria Carla Sozzani, Milan
2004
Je t'envisage. La disparition du portrait, Musée de l'Elysée, Lausanne

Work in progress
She is working on a new series of portraits about resemblance and perceptions of similarity, connections, boundaries and time.

■ JANNE **LEHTINEN**
Born Karhula (FI), 1970
Lives and works in Loviisa (FI)
www.helsinkischool.fi

Solo exhibitions
2009
Sacred Bird, Gallery TaiK, Berlin
Sacred Bird, Stadthaus, Ulm
2008
Night Shift, Kluuvi Gallery, Helsinki
In natura. A Finnish trilogy, Photology Gallery, Milan
2005
Sacred Bird, Le Château d'Eau, Toulouse
2003
Sacred Bird, 779 Galerie + Editions, Paris

Group exhibitions
2008
Ecole d'Helsinki, dialogue entre 4 générations, Galerie Baudoin Lebon, Paris
Laughing in a Foreign Language, The Hayward Gallery, London
2007
Les Rencontres d'Arles 2007, Arles
2004
Short Stories, PhotoMuseum, Antwerp

Work in progress
The artist is working in Russia for a new landscape series.

■ **LEUNG** CHI WO
Born Hong Kong (CN), 1968
Lives and works in Hong Kong (CN)
www.leungchiwo.com

Solo exhibitions
2009
Asia's World City, Goethe-Institut, Hong Kong
2007
Text Format, Hanart TZ Gallery, Hong Kong
2000
Something About City Sky, Queens Museum of Art, New York

Group exhibitions
2009
Das Paradies ist anderswo, ifa-Galerie Stuttgart, Stuttgart
2008
Lights Out, Museu da Imagem e do Som de São Paulo, São Paulo
3rd Guangzhou Triennial, Guangzhou
2007
Reversing Horizons, Museum of Contemporary Art, Shanghai
2005
A Strange Heaven: Contemporary Chinese Photography, Helsingin kaupungin taidemuseo, Helsinki
2004
Para/Site: Open Work, Centre A, Vancouver

2003
A Strange Heaven: Contemporary Chinese Photography, Rudolfinum, Prague
2001
49ª Esposizione Internazionale d'Arte, Venice

Work in progress
He is working on the projects *Asia's World City* and *In the name of Victoria*.

■ **LUBRI**
Born Sofia (BG), 1977
Lives and works in Sofia (BG)
www.photo.lubri.org

Solo exhibitions
2007
Boys Don't Cry Indeed, Pistolet Gallery, Sofia

Group exhibitions
2008
a-a-h! (All About Him), Goethe-Institut Bulgarien e "39 grama", Sofia
2007-2008
Photonic Moments, 3rd Photography Month, Ljubljana; Fotogalerie der Rathhaus, Graz

Work in progress
He is working on a project based on images of his new born baby girl.

■ MARCELLO **MALOBERTI**
Born Codogno (IT), 1966
Lives and works in Milan (IT)
www.marcellomaloberti.com

Solo exhibitions
2009
Raptus, Galleria d'Arte Moderna e Contemporanea, Bergamo
2007
Tagadà, Galleria Raffaella Cortese, Milan
Circus, francesco pantaleone arte Contemporanea, Palermo
2006
Acrobazie#2, Atelier Adriano e Michele, Centro Fatebenefratelli, San Colombano al Lambro
2004
Marcello Maloberti, Galleria Raffaella Cortese, Milan

Group exhibitions
2009
Living with…, Galleria Raffaella Cortese, Milan
2008
Sguardo periferico e corpo collettivo, Museion, Bolzano
2006
Girato a Palermo, Ex deposito Sant'Erasmo, Palermo
2005
La dolce crisi, Villa Manin, Codroipo
2004
ON-AIR. Video in onda dall'Italia, Galleria Comunale d'Arte Contemporanea, Monfalcone

Work in progress
He is currently devising a new performance: a boy runs and jumps on the spot, surrounded by his peers who throw an endless stream of firecrackers at his feet; the explosions and trails of light break the silent, twilight atmosphere. Maloberti's intention is to create photographs which bring out the effect of the trails of light and translate the sudden noises into images.

■ TANCREDI **MANGANO**
Born Lisieux (FR), 1969
Lives and works in Milan (IT)

Solo exhibitions
2005
Eden, Nepente Art Gallery, Milan
2000
In superficie, Dryphoto arte contemporanea, Prato

Group exhibitions
2009
Il cielo in una stanza: per un'osservazione eccentrica del paesaggio, Galleria Comunale d'Arte Contemporanea, Monfalcone
Terzo Paesaggio. Fotografia Italiana Oggi. Civica Galleria d'Arte Moderna, Gallarate
2007
Ereditare il paesaggio, Museo del territorio Biellese, Biella
2006
Ex Fabrica. Identità e mutamenti ai confini della metropoli, Sale Viscontee del Castello Sforzesco, Milan
La dolce crisi, Villa Manin, Codroipo
2005
Fragments of Contemporary Urban Life, City Hall Art Space and Istituto Italiano di Cultura, San Francisco
2003
X Biennale Internazionale di Fotografia, Turin
2002
Da Guarene all'Etna, via mare, via terra, Padiglione Italia, Giardini di Castello, Venice

Work in progress
At the moment he is continuing work on the project *Da una certa distanza* ("From a certain distance"), a sneak preview of which was presented at the collective exhibition *Da Guarene all'Etna 2009* at the Fondazione Sandretto Re Rebaudengo in Guarene d'Alba.

■ MARCELLO **MARIANA**
Born Lecco (IT), 1977
Lives and works in Valtellina (IT)
www.studioguenzani.it

Solo exhibitions
2009
Claudio Gobbi – Marcello Mariana, Studio Guenzani, Milan
2007
People from the Mountains, Limited No Art Gallery, Milan

Group exhibitions
2008
European Month of Photography, Bratislava
F/Stop 2, Internationales Fotografiefestival Leipzig, Leipzig
Les Rencontres d'Arles 2008, Arles
Festival International de l'Image Environnementale, Paris
Quale Venezia / Which Venice?, Fondazione Bevilacqua La Masa, Venice
2006
reGeneration, Aperture Gallery, New York
2005
reGeneration, Musée de l'Elysée, Lausanne; Galleria Carla Sozzani, Milan

Work in progress
His work is currently focusing on the contemporary landscape and its interactions with human beings.

■ EDGAR **MARTINS**
Born Évora (PT), 1977
Lives and works in Bedford (UK)
www.edgarmartins.com

Solo exhibitions
2009
Topologies, Fundação Oriente Museu, Lisbon

Group exhibitions
2009
Lá Fora, Portuguese Artists, Museu da Electricidade, Lisbon
BES Photo Award, Berardo Museum, Centro Cultural de Belém, Lisbon
Format International Photography Festival, Derby
FotoFestiwal 2009, Łódź
2008
Lianzhou International Photo Festival 08, Lianzhou
ING Real Photography Award, Las Palmas Museum, Rotterdam
Contemporary Portuguese Photography, Museu da Presidência da República, Viana do Castelo
That Was Then… This is Now, P.S.1 MoMA, New York
2007
On the Wall: Aperture Magazine '05-'06, Aperture Gallery, New York
Migratory Phenomena: Photography and Video + Film Cycle, Economic and Social European Committee, Brussels

Work in progress
Working against the grain of still-life photography, his new work deploys the metaphor of the struggle between man and forces of nature to suggest a place uncertain of its future. Time and space have become an incipient forum of disruptive experiences and expression. *Architectural Improbabilities: Crude Metaphors* explores the difficult relationship between architecture, commercial development and the natural landscape and summons a disquieting conjunction of reality, hyper-reality, fantasy and fiction. In this work, fragile landscapes stage cultural dramas.

■ MARY **MCINTYRE**
Born Coleraine (UK), 1966
Lives and works in Belfast (UK)
www.marymcintyre.org

Solo exhibitions
2009
Mary McIntyre, The Third Space Gallery, Belfast
2006
Space of Doubt, Goethe-Institut, Dublino
2005
Esterno notte, Artericambi, Verona
2004
Nocturnal, Kevin Kavanagh Gallery, Dublino

Group exhibitions
2008
Different Dimension, Novosibirsk International Festival
of Contemporary Photography, Novosibirsk
2007
Mary McIntyre & Cassie Howard, St.Paul's Art Space,
London
2006
Tides, Regina Gouger Miller Gallery, Purnell Center
of the Arts, Pittsburgh
Dogs Have no Religion, České muzeum výtvarných
umění, Prague
2005
51ª Esposizione Internazionale d'Arte, Venice
The Belfast Way, Herzliya Museum, Tel Aviv

Work in progress
McIntyre's recent work explores the subject of
landscape, which unfolds in her imagery through
a number of different strands—these strands are
all inter-connected, and common themes recur
throughout.

■ MARZIA **MIGLIORA**
Born Alessandria (IT), 1972
Lives and works in Turin (IT)
www.marziamigliora.com

Solo exhibitions
2008
My no man's land, Art Agents Gallery, Hamburg
Meteorite in giardino, Concerto per naufragio,
Fondazione Merz, Turin
2007
Bianca e il suo contrario, Galleria Lia Rumma, Milan
2006
Tanatosi, Fondazione Merz, Turin
2005
The Agony & The Ecstasy, The Foundation for Art
& Creative Technology, Liverpool
Marianne, Percy Miller Gallery, London
Download-now, Italian Cultural Institute, London
2004
Pari o Dispari, Fondazione Sandretto Re Rebaudengo,
Turin
Pitfall, with Elisa Sighicelli, Galerie Zürcher, Paris;
Národní Muzeum, Prague

2001
Punto croce, Galleria Civica d'Arte Moderna
e Contemporanea, Turin

Work in progress
She is currently preparing her next personal exhibition
at the Lia Rumma gallery in Naples. The exhibition will
consist of four installations and a 35 millimetre film.
Inspiration for the project came from the fresco on the
Tomb of the Diver in Paestum.

■ OTTONELLA **MOCELLIN** + NICOLA **PELLEGRINI**
Ottonella Mocellin (born Milan, IT, 1966)
Nicola Pellegrini (born Milan, IT, 1962)
Live in Milan (IT)
www.liarumma.it

Solo exhibitions
2009
An incongruent beam of beauty over the Gaza Strip,
Participant Inc., New York
2008
With the occasional rainbow visiting, Galleria
Lia Rumma, Naples
2003
In the mood for love, MUAR, Moscow

Group exhibitions
2008
Timecode, Museo d'Arte Moderna di Bologna, Bologna
2007
La parola nell'arte, Museo di Arte Moderna
e Contemporanea di Trento e Rovereto, Rovereto
2006
D'ombra, Palazzo delle Papesse, Siena; Museo
d'Arte Provincia di Nuoro, Nuoro; Compton Verney,
Warwickshire
2005
XIV Quadriennale di Roma, Rome
2004
Biennale internazionale di fotografia, Brescia
2003
Tirana Biennale 02, Tirana
2002
Listening to new voices, P.S.1 MoMA, New York

Work in progress
They are currently working on a project which
takes a critical look at the family; its status as an
"untouchable institution", but often also a place
of abuse and violence.

■ LUIS **MOLINA-PANTIN**
Born Geneva (CH), 1969
Lives and works in Caracas (VE)
www.federicolugergallery.com

Solo exhibitions
2009
Nuevas Adquisiciones, Periférico Caracas, Caracas
2008
*Estudio informal de la arquitectura híbrida vol. 1:
La narco-arquitectura y sus contribuciones
a la comunidad, Cali-Bogotá, Colombia,* Federico Luger
Gallery, Milan; Galería Marta Cervera, Madrid
Luis Molina-Pantin, Fondazione Villa Bardini, Florence

Group exhibitions
2009
Islands+Ghettos, NGB; Kunstraum Kreuzberg/
Bethanien, Berlin
The Non-Age, Kunsthalle Winterthur, Winterthur
X Bienal Internacional de Cuenca, Cuenca
2008
7ᵗʰ Gwangju Biennale, Gwangju
2007
*Constructing a poetic universe: The Diane and Bruce
Halle Collection*, Museum of Fine Arts, Houston
*Jump Cuts: Arte Venezolano Contemporáneo, Colección
Mercantil*, Cisneros Fontanals Art Foundation, Miami
2006
*Cruces de miradas: Visiones de America latina, Colección
Cisneros,* Palacio Museo de Bellas Artes, Mexico City

Work in progress
Having concluded *Estudio informal de la arquitectura
híbrida* in Colombia, he is currently working on the
development of the project in different countries of
the world.

■ YOUSSEF **NABIL**
Born Cairo (EG), 1972
Lives and works in New York (New York, US)
www.youssefnabil.com

Solo exhibitions
2009
Youssef Nabil. I Won't Let You Die, Villa Medici, Rome
Youssef Nabil, Galerie Volker Diehl, Berlin
2008
CINEMA, Michael Stevenson Gallery, Cape Town
2003
Pour un Moment d'Éternité, Les Rencontres d'Arles
2003, Arles
2001
Obsesiones, Centro de la Imagen, Mexico City

Group exhibitions
2009
53ª Esposizione Internazionale d'Arte, Venice
2007
*Gegenwart aus Jahrtausenden. Zeitgenössische Kunst
aus Ägypten*, Kunstmuseum Bonn, Bonn

2006
Word into Art, British Museum, London
Regards des photographes arabes contemporains,
Institut du Monde Arabe, Paris
2004
Bamako 03. Contemporary African Photography, Centre
de Cultura Contemporània de Barcelona, Barcelona

Work in progress
Youssef Nabil is currently working on his first movie.

■ SABAH **NAIM**
Born Cairo (EG), 1967
Lives and works in Cairo (EG)
www.sabahnaim.com

Solo exhibitions
2009
Sabah Naim, Townhouse Gallery, Cairo
2008
Street Studio, B21 Gallery, Dubai
2007
Sabah Naim, Galleria Lia Rumma, Naples
2006
Sabah Naim, Karim Francis, Cairo
2004
Sabah Naim, Galleria Lia Rumma, Milan

Group exhibitions
2009
Isabelle Huppert: Woman of Many Faces, Ullens Center
for Contemporary Art, Beijing
2008
*Trilogie Méditerranéenne: from Athens to Marseille
to Cairo*, Palais des Arts de Marseille, Marseille
2007
Occidentalism: the West as Seen by Egyptian Artists,
Espace Karim Francis, Cairo
2006
Word into Art: Artists of the Modern Middle East,
British Museum, London
2003
50ª Esposizione Internazionale d'Arte, Venice

Work in progress
Her last work is an attempt to use materials new for her,
such as golden and silver colors, textile strips, plastic
backgrounds and flowers used normally in embroidery.
She is trying to create a dialogue between the photos
and these small objects which create symbols and also
atmospheres. They can express feminine symbols, for
example, as well as joyful play.

■ MARTIN **NEWTH**
Born Manchester (UK), 1973
Lives and works in London (UK)
www.martinnewth.com

Solo exhibitions
2008
Ausblick, Axel Lapp Projects, Berlin

2007
Slow Burn, Focal Point Gallery, Southend-on-Sea
2006
Solar Cinema, Cannizaro Park, Wimbledon
2005
Rush Hour, BCA Gallery, Bedford

Group exhibitions
2008
Concrete Dreams, APT Gallery, London
Menschen und Orte, Kunstverein Konstanz, Konstanz
2007
Andmoreagain, Open Eye Gallery, Liverpool

Work in progress
Martin Newth is currently working on a project for
which he is transforming Second World War "pillboxes"
(prefabricated concrete bunkers made to observe and
defend against the enemy in WWII) into dark rooms
in order to make large colour prints directly onto
photographic paper.

■ LOAN **NGUYEN**
Born Lausanne (CH), 1977
Lives and works in Lausanne (CH)
www.madameloan.com

Solo exhibitions
2009
Stellenweise, Kunsthalle Erfurt, Erfurt
2008
Mobile, Ego Gallery, Barcelona
2007
Mobile, Herrmann & Wagner, Berlin
Loan Nguyen, Duncan Miller Gallery, Los Angeles
2005
Loan Nguyen, Galerie Esther Woerdehoff, Paris

Group exhibitions
2008
Held together with Water, Istanbul Museum of Modern
Art, Istanbul
Reflecting Vietnam II, Forum für Fotografie, Cologne
2007
Mobile, Galerie Esther Woerdehoff, Paris
Alone Together, Kunsthalle Palazzo, Liestal
2006
Alone Together, Galerie Nouvelles Images, The Hague

Work in progress
At present she is working on a new chapter of her
Mobile series, called *Weather*.

■ LUCIA **NIMCOVA**
Born Humenne (SK), 1977
Lives and works in Amsterdam (NL)
www.luco.sk

Solo exhibitions
2009
Why bandits run faster than policemen?,
Heppen Transfer, Warsaw

2008
Unofficial III, Kunstforum / Tresor, Vienna
Unofficial, Palazzo delle Esposizioni, Rome
2006
Instant Women, Art Hall Gallery, Tallinn
2003
Slovakia 003, Profil Gallery, Bratislava

Group exhibitions
2009
Prague Biennale 4, Prague
2008
Young Visual Artists Awards, Magacin, Belgrade
2007
Prague Biennale 3, Prague
Facelift, A.I.R. Gallery, New York
2006
The Urban Condition, Museum De Paviljoens, Almere
2005
*Instant Europe. Photography and Video from
the New Europe*, Villa Manin, Codroipo

Work in progress
Currently she is finishing her book *Leftovers*—
featuring photographs of kids in Slovakia
during the Eigthies.

■ MELISA **ÖNEL**
Born Izmir (TR), 1980
Lives and works in Istanbul (TR)
www.melisaonel.com
www.reccollective.org

Group exhibitions
2009
Crosscurrent, C.A.M gallery, Istanbul
Photoquai 2009, Paris
XIV Biennial of Young Artists from Europe
and the Mediterranean, Skopje
2007
Photonic Moments, Mesec Fotografije, Ljubljana
2006
1st Photography Biennial, Istanbul
Portraits, Kasa Gallery, Istanbul
Hussein Chalayan: Compassion Fatigue,
Garanti Gallery, Istanbul
2003
Parallel Time, China Academy of Art, Huanghzou

Work in progress
Crosscurrent is a project that she is dwelling on—about
the tides of the sea, what the sea brings back and
suddenly appears in its depths.

■ GABRIEL **OROZCO**
Born Jalapa (MX), 1962
Lives and works in New York (New York, US), Paris (FR)
and Mexico City (MX)
www.whitecube.com

Solo exhibitions
2008
Gabriel Orozco: Recent Work, Marian Goodman Gallery,
New York
2007
Dépilage, Galerie Chantal Crousel, Paris
2006
Twelve Paintings and a Drawing, White Cube
Mason's Yard, London
Gabriel Orozco, Museo del Palacio de Bellas Artes,
Mexico City
2005
Gabriel Orozco, Palacio de Velázquez, Museo Nacional
Centro de Arte Reina Sofía, Madrid
2004
Photographs, Hirshhorn Museum and Sculpture
Garden, Washington
Gabriel Orozco, Serpentine Gallery, London

Group exhibitions
2007
*New Perspectives in Latin American Art 1930-2006:
Selections from a Decade of Acquisitions*, Museum
of Modern Art, New York
2005
51ª Esposizione Internazionale d'Arte, Venice
2003
50ª Esposizione Internazionale d'Arte, Venice
2002
Documenta XI, Kassel

■ SELINA **OU**
Born Kinabalu (MY), 1977
Lives and works in Melbourne (AU)
www.grantpirrie.com
www.sophiegannongallery.com.au

Solo exhibitions
2008
Mono/Mono, Gallery Raku, Kyoto
Japan Portraits, Centre for Contemporary Photography,
Fitzroy, Melbourne
2007
Chile, GRANTPIRRIE, Sydney
2006
Sakura Season, Sophie Gannon Gallery, Melbourne
2005
Ciudad, PhotoEspaña 2005, Madrid

Group exhibitions
2008
Art as a Bridge, Asahi Beer Oyamazaki Villa Museum
of Art, Kyoto
2007
Light Sensitive, National Gallery of Victoria, Melbourne

2006
TRANS VERSA. Conversaciones con el sur, Museo
de Arte Contemporáneo, Santiago
2005
The All-Australian Show, LipanjePuntin
Artecontemporanea, Trieste
2004
Zeitgeist, Australian Centre for Photography, Sydney

Work in progress
She is currently working on a series of portraits
taken during an artist residency in Oyamazaki, Kyoto,
Japan, 2008.

■ ADRIAN **PACI**
Born Scutari (AL), 1969
Lives and works in Milan (IT)
www.francescakaufmann.com
www.peterblumgallery.com
www.peterkilchmann.com

Solo exhibitions
2008
Adrian Paci. Subjects in Transit, Center
for Contemporary Art, Tel Aviv
Adrian Paci, Kunstverein Hannover, Hannover
2007
Adrian Paci. Passages, Peter Blum, New York
2006
Adrian Paci, Galleria Civica di Modena, Modena
2005
Adrian Paci, P.S.1 MoMA, New York

Group exhibitions
2009
10th Habana Biennale, Havana
2006,
Biennale of Sydney 2006, Sydney
2005
51ª Esposizione Internazionale d'Arte, Venice
2004
2004 Sevilla Biennale, Seville
2000
Manifesta 3, Ljubljana

Work in progress
In 2009 he will be participating in various
collective exhibitions, including the 10e Biennial of
Contemporary Art in Lyon, the 8th Baltic Contemporary
Art Biennial (Szczecin); in 2010 he will hold a personal
exhibition at the Kunsthaus Zürich.

■ DANAÉ **PANCHAUD**
Born Vevey (CH), 1983
Lives and works in Lausanne (CH) and Geneva (CH)
www.near.li

Solo exhibitions
2008
Nos montagne ne nous protègent plus, standard/deluxe,
Lausanne

2007
Face-à-face(s), Université de Lausanne, Lausanne

Group exhibitions
2008
Weihnachtausstellung, espace temporaire, Geneva
WORK TO DO!, Shedhalle, Zürich
2007
Weihnachtsaustellung, standard/deluxe, Lausanne
*The Return of Physiognomy – To be life everyone – or
almost*, Bunkier Sztuki, Kraków
Contrasted Working Worlds", O3one, Belgrade
2006
Retour sur la physionomie, Journées photographiques
de Bienne, Biel
2004
Images '04, Vevey

Work in progress
In addition to the ongoing series about the body,
Danaé Panchaud's projects focus on the traces left by
recent but faded history and on places dedicated to
science, their architecture, design and furnishing.

■ JYRKI **PARANTAINEN**
Born Tampere (FI), 1962
Lives and works in Helsinki (FI)
www.helsinkischool.fi

Solo exhibitions
2008
Jyrki Parantainen, KFA Gallery, Berlin
2007
Dreams and Disappointments, Herrmann & Wagner,
Berlin
2006
Dreams and Disappointments, Amos Anderson
Art Museum, Helsinki
2005
Orientation, Herrmann & Wagner, Berlin
2002
Näyttämö, Galleria Krista Mikkola, Helsinki

Group exhibitions
2008
Helsinki School, Purdy Hicks Gallery, London
Helsinki by Night, Gallery TaiK, Berlin
2007
Grey Matters - Aftercop, Suomen valokuvataiteen
museum, Helsinki
2005
The 110th Artist's Exhibition, Kunsthalle / Taidehalli
Helsinki, Helsinki
2004
30 by TaiK - The Helsinki School, Suomen
valokuvataiteen museum, Helsinki

Work in progress
He is continuing his process with a combination
of panoramic landscapes and words.

■ MATTHEW **PILLSBURY**
Born Neuilly (FR), 1973
Lives and works in New York (New York, US)
www.bonnibenrubi.com
www.matthewpillsbury.com

Solo exhibitions
2009
*An American in the City of Light: Paris as Seen
by Matthew Pillsbury*, The French Institute Alliance
Française, New York
2008
Elapsed, Bonni Benrubi Gallery, New York
2007
London, Michael Hoppen Gallery, London
Time Frame, Phillips de Pury & Company, New York;
Galerie Baudoin Lebon, Paris
2006
Matthew Pillsbury, Galerie Negulesco, Munich
Time Frame, Bonni Benrubi Gallery, New York
2005
Screen Lives, Galleria Valentina Moncada, Rome
2004
Screen Lives, Michael Hoppen, London; Bonni Benrubi
Gallery, New York

Group exhibitions
2008
Photographic Figures, Museum of Fine Arts, Boston
2007
*An Instinctive Eye. A Selection of Contemporary
Photographs from the Sir Elton John Collection*,
PinchukArtCenter, Kiev

Work in progress
Pillsbury's current photographs continue to address
the themes of movement and transience, but
increasingly in the public sphere of cosmopolitan
spaces. Using natural ambient light, his long exposure
technique renders the human figures nearly ethereal
in a flurry of activity, while capturing the relationship
to the space they inhabit in perfect detail.

■ NICHOLAS **PRIOR**
Born New York (New York, US), 1966
Lives and works in New York (New York, US)
www.nicholasprior.com

Solo exhibitions
2006
Nicholas Prior, Robert Koch Gallery, San Francisco
2005
Nicholas Prior, Yossi Milo Gallery, New York

Group exhibitions
2009
Hearst 8x10 Photography Biennial, New York
The Poetics of Space, Kemper Museum of Art, Kansas City
2008
F/Stop2, Internationales Fotografiefestival Leipzig, Leipzig
*Presumed Innocence: Photographic Perspectives of
Children*, DeCordova Museum, Lincoln

2007
Spitting image, V1 Gallery, Copenhagen
Degrees of Separation, Peer Gallery, New York
2006
Offspring, Boston University Art Gallery, Boston
reGeneration, Aperture Gallery, New York
2005
reGeneration, Musée de l'Elysée, Lausanne; Galleria
Carla Sozzani, Milan

Work in progress
He is currently working on a new project titled *Based
on a True Story*, which explores the documentary and
fictive elements prevalent in all photographs.

■ PHILIPPE **RAMETTE**
Born Auxerre (FR), 1961
Lives and works in Paris (FR)
www.xippas.com

Solo exhibitions
2009
Philippe Ramette, PhotoEspaña, Institut Français, Madrid
Philippe Ramette, Institut Franco-Japonais, Tokyo
2008
Gardons nos illusions 1987-2008, Musée d'Art Moderne
et Contemporain, Geneva
2007
Philippe Ramette, Domaine Départemental de
Chamarande, Chamarande
2006
Philippe Ramette, Galerie Xippas, Paris
2005
Philippe Ramette, Koldo Mitxelena Kulturunea, San
Sebastian

Group exhibitions
2009
Play Time, Parcours Saint Germain, Boutique Louis
Vuitton, Paris
2008
Palimpseste un bon pre-texte, Galerie Xippas, Paris
2007
Toronto Photography Festival, Toronto
2006
Les peintres de la vie moderne, Centre Pompidou, Paris
2005
L'idiotie, Expérience Pommery 2, Domaine Pommery,
Reims
(my private) HEROES, Marta Herford Museum, Herford

Work in progress
He is currently dividing his time between research
on the creation of new sculptures and the making
of a new photograph which will be part of the *Balcony*
series. This photograph will be taken in Peru, and will
be imbued with an oneiric atmosphere that can be
interpreted as a return to the dream, which is at the
origin of this series. For the first time, other people
besides him will appear in the image.

■ MOIRA **RICCI**
Born Orbetello (IT), 1977
Lives and works in Grosseto (IT) and Milan (IT)
www.alessandrodemarch.it

Solo exhibitions
2006
Interfuit, Artopia, Milan

Group exhibitions
2009
Les Rencontres d'Arles 2009, Arles
Eppur si Muove, Palazzo Re Rebaudengo, Guarene d'Alba
Hors pistes 2009, Centre Pompidou, Paris
Terzo Paesaggio. Fotografia Italiana Oggi, Civica Galleria
d'Arte Moderna, Gallarate
2008
*Other things seen, other things heard - Ailsa Lochhead
and Moira Ricci*, Market Gallery, Glasgow
A long time ago, Galerija Kortil, Rijeka
A snake on a tree, White Box, New York
Location1 project's room, Location1's Gallery, New York

Work in progress
She is currently working on a series of photographic
and video documents of stories recounted
but never seen.

■ SOPHY **RICKETT**
Born London (UK), 1970
Lives and works in London (UK)
www.albertopeola.com

Solo exhibitions
2009
Auditorium and recent photoworks, Nichido
Contemporary Art, Tokyo
2008
Auditorium, Alberto Peola, Turin
Auditorium and recent photoworks, Ffotogallery, Cardiff
2007
Auditorium, De La Warr Pavilion, Bexhill-on-Sea
2005
Sophy Rickett, Emily Tsingou Gallery, London

Group exhibitions
2009
*elles@centrepompidou, Women artists in the collections
of the National Modern Art Museum*, Centre Pompidou,
Paris
*Time Warp, Explorer le temps. Künstler explorieren die
Zeit*, Centre Rhénan d'Art Contemporain, Altkirch
2008
In our world - New photography in Britain, Galleria
Civica di Modena, Modena
2007
Les Peintres de la Vie Moderne, Centre Pompidou, Paris
Fotografierte Landschaften, Museum der bildenden
Künste, Leipzig

Work in progress
New film installation work currently in production.

■ SANDRA **ROCHA**
Born Azores (PT), 1974
Lives and works in Lisbon (PT)
www.kameraphoto.com

Solo exhibitions
2009
Há Metafisica bastante em não pensar em nada,
Casa Fernando Pessoa, Lisbon
Love Stream, Galeria Fonseca Macedo, Azores
2006
(In)definições Atlânticas, Casa da Cultura, Ponta
Delgada

Group exhibitions
2008
Testemunhos, Centro de Congressos da Alfândega,
Porto
3, KGaleria, Lisbon
Portrait of a Lady, Fundação Calouste Gulbenkian, Lisbon
2007
Kameraphoto no Museu de Braga, Museu da Imagem,
Braga
Lusofonia, Berlaymont Building, Brussels
2006
Que sei eu do que serei, eu que não sei quem sou?, Casa
Fernando Pessoa, Lisbon
©Madalena, KGaleria, Lisbon

Work in progress
Currently developing a project in collaboration with the
Calouste Gulbenkian Foundation.

■ DANIELA **ROSSELL**
Born Mexico City (MX), 1973
Lives and works in Mexico City (MX)
www.albertopeola.com

Solo exhibitions
2004
Rich and Famous, Kunsthallen Nikolaj, Copenhagen
Ricas y Famosas, Produzentengalerie, Hamburg
Ricas y Famosas, The Art Museum of the University
of Houston, Houston
2003
ArtPace, San Antonio
Terror Chic, Monika Sprüth Magers Projekte, Munich
Ricas y Famosas, Sala de Exposiciones Centro Cultural
de Caja Canarias, Tenerife
2002
Third World Blondes Have More Money, Greene Naftali,
New York
Ricas y Famosas, PhotoEspaña 2002, Casa de América,
Madrid
Mi casa no es tu casa, Pop, Mexico
2001
Daniela Rossell, Alberto Peola, Turin

Work in progress
She is continuing her work on the *Ricas y Famosas*
series.

■ SARA **ROSSI**
Born Milan (IT), 1970
Lives and works in Milan (IT)
www.sararossi.net

Solo exhibitions
2007
Critica in arte - Sara Rossi, Museo d'Arte della città
di Ravenna, Ravenna
Acrobazie#3 Sara Rossi, Atelier Adriano e Michele,
Centro Fatebenefratelli, San Colombano al Lambro

Group exhibitions
2009
Venezia Salva - Omaggio a Simone Weil, Magazzini
del Sale, Venice
Scénographies, de Dan Graham à Hubert Robert,
Musée de Valence, Valence
2008
Manifesta 7, Trentino and Südtirol
2005
Arte all'Arte 10, Linari
2004
Bambini nel Tempo, Palazzo Te, Mantua
2003
50ª Esposizione Internazionale d'Arte, Venice
7e Biennale d'Art Contemporain de Lyon, Lyon
X Biennale Internazionale di Fotografia, Turin

Work in progress
Her latest project, *Mose*, a book written as a tribute to
the writer Simone Weil, paints a portrait of the city and
the building works of one of the most controversial
large-scale projects in recent times—the MOSE in
Venice—through 40 photographs and 13 engravings.

■ MICHAEL **SAILSTORFER**
Born Velden (DE), 1979
Lives and works in Berlin (DE)
www.sailstorfer.com

Solo exhibitions
2009
No Light, Galerie Emmanuel Perrotin, Paris
2008
Michael Stailstorfer, Johann König, Berlin
10 000 Steine, Schirn Kunsthalle, Frankfurt

Group exhibitions
2009
The Quick and the Dead, Walker Art Center, Minneapolis
2da. Bienal del Fin del Mundo, Ushuaia
2007
2nd Moscow Biennale of Contemporary Art, Moscow
Made in Germany, Kestnergesellschaft, Kunstverein,
Sprengel Museum, Hannover

Work in progress
At the moment, his interest is focused on the "character
study" of sculpture. With questions such as "What can
be considered to be sculpture?" and "How do you
create an object by removing material?" Sailstorfer
touches upon aspects of spatial extension which
induce him to move beyond the borders of a sculpture
that is bound to the human body.

■ ANRI **SALA**
Born Tirana (AL), 1974
Lives and works in Berlin (DE)
www.alfonsoartiaco.com

Solo exhibitions
2009
Anri Sala: Purchase Not By Moonlight, Contemporary
Arts Center, Cincinnati
2008
Long Sorrow, De Pont Museum of Contemporary Art,
Tilburg
Anri Sala: Purchase Not By Moonlight, Museum
of Contemporary Art North Miami, Miami
Contemporary Arts Center, Cincinnati
Anri Sala, Center for Contemporary Art Kitakyushu
Project Gallery, Kitakyushu
Kabinett für aktuelle Kunst im Haus des Kunstverein,
Bremerhaven
2007
Anri Sala. Thinking Architecture #1, Extra City, Antwerp
2005
Long Sorrow, Fondazione Nicola Trussardi, Milan
Centrum Sztuki Współczesnej Zamek Ujazdowski,
Warsaw
Anri Sala. Artist in Focus, Museum Boijmans
Van Beuningen, Rotterdam
Anri Sala. Artist in Focus, 34th International Film
Festival Rotterdam, Rotterdam
Anri Sala. Time after Time, The RISD Museum of Art,
Providence
Anri Sala: Dammi i colori, The Rose Art Museum
of Brandeis University, Waltham

■ TXEMA **SALVANS**
Born Barcelona (ES), 1971
Lives and works in Barcelona (ES)
www.txemasalvans.com

Solo exhibitions
2009
Vida Extra, Caja Madrid, Barcelona
Generalitat de Catalunya, Madrid
2008
Turismo, espacios de ficción, Disseny HUB, Barcelona
Laberinto de miradas, travelling exhibition
in South America
2007
Centre d'art La Panera, Lleida
Palau Robert, Centre d'Informació de la Catalunya,
Madrid
Origens, Museu de Zoologia, Barcelona

2006
Generación 2006, travelling exhibition, Barcelona
Fotoencuentros06, Colegio de Arquitectos, Murcia

Work in progress
España.

■ MARCO **SAMORÈ**
Born Faenza (IT), 1964
Lives and works in Faenza (IT)

Solo exhibitions
2005
Il Fortino, Museo Laboratorio, Città Sant'Angelo
2003
Storia di uno che se ne andò in cerca della paura,
Paggeria di Palazzo Ducale, Sassuolo
2002
Marco Samorè - Christoph Hinterhuber, Galleria Plastica,
Bologna
2000
Domestica, Ex deposito Todeschini, Faenza
Standard, Galleria Valentina Moncada, Rome

Group exhibitions
2009
Prague Biennale 4, Prague
2008
Residenza d'artista, VII edizione, Hotel Vittoria, Faenza
2007
Play Graphic, Agenzia04, Bologna
2006
Immagini a contatto '06. Artisti in archivio, Fotomuseo
Giuseppe Panini, Modena
2004
P.C./A.C. Palermo Change/Autori Cambi, Ex deposito
Sant'Erasmo, Palermo
2001
Espresso, Ex Manifattura Tabacchi, Florence

Work in progress
He is creating projects in which photography, collage
and ceramics are combined in a single body of work.

■ FABIO **SANDRI**
Born Valdagno (IT), 1964
Lives and works in Brogliano (IT)
www.artericambi.org

Solo exhibitions
2007
Appartamento, Artericambi, Verona
2006
Fotosensibilità, neon>campobase, Bologna
2003
Strame, Museo Casabianca, Malo

Group exhibitions
2009
Lichtklang + Shattenblitz, Kulturhaus Karlshorst, Berlin
Fotografia Europea 2009, Reggio Emilia

2008
Foto, tempo e creatività, Osart Gallery, Milan
2007
Schads Photogramme, Kurpfalzischmuseum,
Heilderberg
2006
1:1, Kettle's Yard, Cambridge
2003
N-E, O' Artoteca, Milan
2001
Carte sparse, Bertolt Brecht, Milan

Work in progress
He is currently involved in the realisation of projects
in which sensitivity to light, film and space combine
in a single body of work.

■ TOMAS **SARACENO**
Born Tucuman (AR), 1973
Lives and works in Frankfurt (DE)
www.andersen-s.dk
www.pinksummer.com
www.tanyabonakdargallery.com

Solo exhibitions
2009
Lighter than air, Walker Art Center, Minneapolis
Tomas Saraceno, Musée d'Arte Moderne Grand-Duc
Jean, Luxembourg
Biosphere, Statens Museum for Kunst, Copenhagen
2008
*Galaxy Forming along Filaments, like Droplets along
the Strands of a Spiders Web*, Tanya Bonakdar Gallery,
New York
2007
Biosphere MW32 Air-Port-City, pinksummer, Genoa

Group exhibitions
2009
53ª Esposizione Internazionale d'Arte, Venice
In Defense of Nature, Barbican Art Center, London
2008
Psycho Buildings. Artists take on Architecture,
The Hayward Gallery, London
Liverpool Biennial 2008, Liverpool
2007
9ᵉ Biennale d'Art Contemporain de Lyon, Lyon
2006
27ª Bienal de São Paulo, São Paulo

Work in progress
The future is in space with you.

■ HIRAKI **SAWA**
Born Ishikawa (JP), 1977
Lives and works in London (UK)
www.softkipper.com

Solo exhibitions
2009
Hiraki Sawa, Ota Fine Arts, Tokyo

2008
Hiraki Sawa - Hako, Centro de Arte Caja de Burgos,
Burgos
2007
Hiraki Sawa - Hako, Chisenhale Gallery, London
2006
Six Good Reasons to Stay at Home, National Gallery
of Victoria, Melbourne
Going Places Sitting Down, James Cohan Gallery,
New York
2005
Hiraki Sawa, Hirshhorn Museum and Sculpture Garden,
Washington

Group exhibitions
2008
Artist File 2008, National Art Centre Tokyo, Tokyo
2005
3ʳᵈ International Triennale of Contemporary Art
Yokohama 2005, Yokohama
2003
7ᵉ Biennale d'Art Contemporain de Lyon, Lyon

Work in progress
Current projects include a commission for Le Coin du
Miroir New Patrons in Bourgogne and Le Consortium,
Dijon, France; and a commission by the Queensland
Art Gallery for the 6ᵗʰ Asia Pacific Triennial of
Contemporary Art, to be held in December 2009.

■ TOMOKO **SAWADA**
Born Kobe (JP), 1977
Lives and works in New York (New York, US)
www.mem-inc.jp

Solo exhibitions
2008
Identitas, Fundació Joan Miró, Barcelona
Decoration, Zabriskie Gallery, New York
Bride, MEM, Osaka
2006
MASQUERADE, KIRIN Plaza, Osaka
2005
Schoolgirls - School Days + cover/Face, MEM, Osaka

Group exhibitions
2008
On your body, Tokyo Metropolitan Museum
of Photography, Tokyo
Heavy Light: Recent Photography and Video from Japan,
International Center of Photography, New York
2007
Girl Parade, Australian Centre for Photography, Sydney
2005
Present Portrait - You Are Here, Parthenon Tama, Tokyo
Manufactured Self, The Museum of Contemporary
Photography, Chicago

Work in progress
It is basically always secret.

■ JOÃO PAULO **SERAFIM**
Born Paris (FR), 1974
Lives and works in Lisbon (PT)
www.miiac.com

Solo exhibitions
2009
Museum Underconstruction…, Galeria Baginski-Projectos, Lisbon
Rembrandt no acervo do Museu Improvável | MIIAC, Sala bebé do Espaço Avenida 211, Lisbon
2008
Museo Improbable | MIIAC, Museo Blanes, Montevideo
Musée Improbable, Centre Culturel Gulbenkian, Paris
2007
Colecção de Fragmentos, Atelier EA+, São Miguel
2006
Je t aime moi non plus, Box 4, Rio de Janeiro
2005
Je t´aime moi non plus, Baginski Galeria / Projectos, Lisbon

Group exhibitions
2009
Paisagem & Povoamento #2, exposição do Colectivo 12, Montemor-o-Novo
2008
Substance, Spike Island, Bristol
Paisagem e Povoamento, Centro Cultural Emmerico Nunes, Sines
2007
Remembering Jack Kerouac, Espaço Av. da Liberdade 211, Lisbon
2004
Collectiv Exposition of Photographics, Baginski Galeria / Projectos, Lisbon

Work in progress
Continuing work in the Improbable Museum and developing his identity in several ways and media.

■ SHIRANA **SHAHBAZI**
Born Teheran (IR), 1974
Lives and works in Zürich (CH)
www.cardiblackbox.com

Solo exhibitions
2008
Shirana Shahbazi, The Hammer Museum, Los Angeles
Shirana Shabazi. Still Life with Shells, Museum Boijmans van Beuningen, Rotterdam
Shirana Shahbazi, Centre Culturel Suisse, Paris
2007
The Curve, Barbican Art Gallery, London
Meanwhile, Swiss Institute, New York
2005
Shirana Shahbazi. Accept the Expected, Centre d'Art Contemporain, Geneva
2004
Flower, Fruits & Portraits, Salon 94, New York

2003
Shirana Shahbazi: Goftare Nik / Good Words, Museum of Contemporary Photography, Chicago

Group exhibitions
2006
4. Berlin Biennale, Berlin
2003
50ª Esposizione Internazionale d'Arte, Venice

Work in progress
She chooses to work mainly with photography, her technique reminiscent also of painting, the image in movement and sculpture. Her productions are designed so that the same works interact with each other, creating a complex genre exploration, expression and representation. While she often challenges space and depth through objects floating against monochrome backgrounds, leaving open infinite relationships with the surrounding environment, she has introduced an architectural element in her recent compositions which influences the spatial hierarchy.

■ ELISA **SIGHICELLI**
Born Turin (IT), 1968
Lives and works in Turin (IT) and London (IT)
www.gagosian.com
www.giomarconi.com

Solo exhibitions
2007
Elisa Sighicelli, Galleria Civica d'Arte Moderna e Contemporanea, Turin
2006
The River Suite, Gagosian Gallery, London
Phi, Gió Marconi, Milan
2005
Sottovoce, Palazzo delle Papesse, Siena
2003
Elisa Sighicelli, Gagosian Gallery, London
2002
Elisa Sighicelli, Cohan Leslie & Browne, New York
2001
Frost, Gagosian Gallery, Beverly Hills

Group exhibitions
2009
53ª Esposizione Internazionale d'Arte, Venice
2003
Liquid Sea, Museum of Contemporary Art, Sydney
2002
No World Without Wou, Reflection and Identity in New British Art, Hertzliya Museum, Tel Aviv

Work in progress
She is preparing a personal exhibition at New York's Gagosian Gallery for next January, using videos and lightboxes.

■ FRANCESCO **SIMETI**
Born Palermo (IT), 1968
Lives and works in New York (New York, US)
www.francescaminini.it

Solo exhibitions
2009
Una facciata per Palazzo Riso, Riso Museo d'Arte Contemporanea, Palermo
Aviary, Artists Space, New York
2008
Plastic Eden, francesco pantaleone arte Contemporanea, Palermo
2007
No place like home, Francesca Minini, Milan
2005
Woodsy, Italian Academy, Columbia University, New York

Group exhibitions
2008
XV Quadriennale di Roma, Rome
2007
System error: war is a force that gives us meaning, Palazzo delle Papesse, Siena
2005
Framing exposure: process and politics, Institute of Contemporary Art, Philadelphia
2003
On the wall, The RISD Museum of Art, Providence
2002
Officina America, Villa delle Rose, Bologna
Cache Cache Camouflage, Musée de Design et d'Arts Appliqués Contemporains, Lausanne

Work in progress
At the moment he is continuing his study of William Morris and the Arts and Crafts movement in terms of its social and political values for a new series of works. This process of research tends to compare and contaminate this world with the universe of the Eames, and more generally with the visual and design culture of the Fifties and early Sixties.

■ ANNA **SKLADMANN**
Born Bremen (DE), 1986
Lives and works in New York (New York, US) and Moscow (RU)
www.annaskladmann.com

Group exhibitions
2009
NYMPHOTO, Sasha Wolf Gallery, New York
The New York Photo Festival 2009, New York
2008
Parsons B.F.A Graduation Show, Calumet Gallery, New York
Group Show no.21, Humble Art Foundation, New York
2007
Feast, Parsons School of Design, New York
2006
Espace Commines, Paris

Work in progress
She is currently taking her project *Little Adults* around Russia.

■ ALESSANDRA **SPRANZI**
Born Milan (IT), 1962
Lives and works in Milan (IT)

Solo exhibitions
2008
Selvatico (colui che si salva), Fotografia Italiana arte contemporanea, Milan
2005
Cose che accadono, Fotografia Italiana arte contemporanea, Milan
2001
La donna barbuta, Galleria Emi Fontana, Milan; Galerie Drantman, Brussels
2000
Dove sei?, Galleria Emi Fontana, Milan

Group exhibitions
2009
Fotomontaggi, Assab One, Milan
2007
Storie immaginate in luoghi reali, Museo di Fotografia Contemporanea, Cinisello Balsamo
2004
On air. Video in onda dall'Italia, Galleria Comunale d'Arte Contemporanea, Monfalcone
2002
Con Art: Magic / Object / Action, Site Gallery, Sheffield
Nel bosco, Monica De Cardenas, Milan
2001
Museo Entr'acte, Museo Marino Marini, Florence

Work in progress
Her work continues on the theme of the gestures and things which reach us from a distance; one which cannot be shortened, and the melancholy and the wonder that follow it. What remains of the things, images and thoughts when they are stripped of their protection, and moved to another place with no shelter.

■ ANNA **STRAND**
Born Lund (SE), 1979
Lives and works in Malmö (SE)
www.annastrand.se

Solo exhibitions
2009
Never complain, never explain, Galleri Ping Pong, Malmö
2007
The Director, Galleri Ping Pong, Malmö
2005
Moving a mountain, Gallery Spark, Copenhagen

Group exhibitions
2009
Photography: now, Karlskrona Konsthall, Karlskrona

2008
Nordic Moods. Landscape Photography of our Time, Arken Museum for Moderne Kunst, Copenhagen
2007
Photography: now, Centrum för fotografi, Stockholm
Liljevalchs Spring Saloon, Stockholm
2006
New Nordic Photography, Hasselblad Center, Gothenburg

Work in progress
She is currently working on narrowing down fragments from rituals, dreams and strange coincidences to new images and texts. *Tautology* is the first work in this series.

■ MIKHAEL **SUBOTZKY**
Born Cape Town (ZA), 1981
Lives and works in Johannesburg (ZA)
www.imagesby.com

Solo exhibitions
2009
Mikhael Subotzky: Recent Works, The Goodman Gallery, Johannesburg
2007
Mikhael Subotzky, Studio La Città, Verona
Beaufort West, FOAM_Fotografiemuseum, Amsterdam
Beaufort West, Goodman Gallery Cape, Cape Town
2006
Die Vier Hoeke / Umjiegwana, The Goodman Gallery, Johannesburg

Group exhibitions
2009
Three Stories, Centre National de l'Audiovisuel, Dudelange
Still Revolution: Suspended In Time, Contact Photo Festival, Toronto
Nation States, Goodman Gallery Cape, Cape Town
Mythologies, Haunch of Venison, London
2008
New Photography 2008: Josephine Meckseper and Mikhael Subotzky, Museum of Modern Art, New York

Work in progress
Mikhael Subotzky is working on *Ponte City* in collaboration with Patrick Waterhouse.

■ ANGELA **SVORONOU**
Born Athens (GR), 1976
Lives and works in Athens (GR)
www.svoronou.com

Solo exhibitions
2006
Spacemark Project, Goethe-Institut, Thessaloniki

Group exhibitions
2009
2nd Athens Biennale, Athens
I Create Therefore I Am, State Museum of Contemporary Art, Thessaloniki
2008
A Dialogue Between Ten Artists, Thessaloniki Museum of Photography, Thessaloniki
XIII Biennial of Young Artists of Europe and the Mediterranean, Puglia-Bari
20th International Photography Meeting / PhotoBiennale of Thessaloniki, Thessaloniki
2006
Visual Arts Festival, Thessaloniki
Les Rencontres d'Arles 2006, Arles
Worlds Through The Lens, The Walk Gallery, London

Work in progress
Visually excited by her environment, the artist works with her camera as a painter on the easel, looking at a detail of composition, the play of light and shadow, small nuances in the expression or pose of her models, all the minutiae that constitute "everyday nothingness". Her photography is not about capturing a moment but rather condensing time.

■ RICHARD **SYMPSON**
Cosimo Pichierri (born Manduria, IT, 1976)
Marco Trinca Colonel (born Tirano, IT, 1980)
www.richardsympson.com

Group exhibitions
2009
Terzo Paesaggio. Fotografia Italiana Oggi, Civica Galleria d'Arte Moderna, Gallarate
Beyond the Picturesque, Stedelijk Museum of Contemporary Art, Gent
Il cielo in una stanza: per un'osservazione eccentrica del paesaggio, Galleria Comunale d'Arte Contemporanea, Monfalcone
Pittoresk - Neue Perspektiven auf das Landschaftsbild, MARTa, Herford
2008
Ereditare il paesaggio, Museo del Territorio Biellese, Biella
Same democracy, neon>campobase, Bologna
Bi6 - Biennale dell'Immagine, Chiasso
2007
Racconto di un luogo, Museo di Fotografia Contemporanea, Cinisello Balsamo
FotoGrafia - Festival Internazionale di Roma, Rome

Work in progress
In parallel with an investigation of the landscape in the series *Palmo a Palmo* ("Inch by Inch"), they are working on two new still life projects.

■ MARIE **TAILLEFER**
Born Bourg-St-Maurice (FR), 1978
Lives and works in Paris (FR)
www.marietaillefer.fr

Solo exhibitions
2009
Photography meets Paintings, Galerie Clairefontaine - Espace 1, Luxembourg
2007
à jour, Galerie Clairefontaine - Espace 1, Luxembourg
2005
A mon père, Galerie Clairefontaine - Espace 1, Luxembourg

Group exhibitions
2008
Portraits >< Self-portraits, Galerie Clairefontaine - Espace 1, Luxembourg
Unevenness even, Galerie Clairefontaine - Espace 1, Luxembourg
2007
Olivier Metzger, Daniel Sannwald, Marie Taillefer, La Galerie de La Filature, Mulhouse
Blue Stag Hype, Galerie Clairefontaine - Espace 1, Luxembourg
2006
Les Indépendances, Les Indépendances, Enghien-les-Bains
2005
Photomeetings Luxembourg 2005, Luxembourg

Work in progress
Fashion photography... advertising, editorials, catalogues... on and off.

■ SHIGERU **TAKATO**
Born Ohita (JP), 1972
Lives and works in Cologne (DE)
www.shigerutakato.de

Solo exhibitions
2008
Buildings from National Socialist Era, Galerie Heinz Bossert, Cologne
2003
Back to the Garden, Ramp Gallery, Hamilton

Group exhibitions
2009
reGeneration, Preus Museum, Horten
2008
Projekt (1), Galerie Heinz Bossert, Cologne
Grosse Kunstausstellung NRW Düsseldorf 2008, Museum Kunst Palast, Düsseldorf
2007
Regarding Düsseldorf 2, 701 eV, Düsseldorf
2006
reGeneration, Aperture Gallery, New York

2005
reGeneration, Musée de l'Elysée, Lausanne; Galleria Carla Sozzani, Milan
03-04, NRW-Forum, Düsseldorf; Kunstraum Walcheturm, Zürich
2003
Lost in Space, Old Government House, Auckland

Work in progress
He is working on violent landscape.

■ VIBEKE **TANDBERG**
Born Oslo (NO), 1967
Lives and works in Oslo (NO) and Berlin (DE)
www.gerhardsengerner.com

Solo exhibitions
2009
Vibeke Tandberg, Norrköping Art Museum, Norrköping
2008
A Piece of Me, c/o – Atle Gerhardsen & Klosterfelde, Berlin
2007
Vibeke Tandberg, Lillehammer Kunstmuseum, Lillehammer
2005
Vikebe Tandberg, Sprengel Museum, Hannover
2004
Vikebe Tandberg, Astrup Fearnley Museet for Moderne Kunst, Oslo

Group exhibitions
2009
Der Schmerz sitzt tief, Opelvillen, Rüsselsheim
2008
28ª Bienal de São Paulo, São Paulo
"Ich kann mir nicht jeden Tag ein Ohr abschneiden", Dekonstruktionen des Künstlermythos, Hamburger Bahnhof, Berlin
2006
5 Tage bis zum Ende der Kunst – Fremd bin ich eingezogen, Kunsthalle Fridericianum, Kassel
2002
13th Biennale of Sydney, Sydney
2000
Ich ist etwas Anderes. Kunst am Ende des 20. Jahrhunderts, Kunstsamlung Nordrhein-Westfalen, Düsseldorf

Work in progress
Currently working on large scale collages based on various forms of photographs and other printed material.

■ DAVIDE **TRANCHINA**
Born Bologna (IT), 1972
Lives and works in Bologna (IT) and Milan (IT)
www.davidetranchina.it
www.nicolettarusconi.com

Solo exhibitions
2009
Davide Tranchina, Galleria Nicoletta Rusconi, Milan
2005
Lettere anonime, Alliance Française, Bologna
2004
Cresci-Tranchina Analogie, con Mario Cresci, Fotografia Italiana arte contemporanea, Milan
2003
Davide Tranchina, con Margherita Morgantin, Spazio Aperto, Bologna
2002
Through the globe, Studio Mascarella, Bologna

Group exhibitions
2009
Prague Biennale 4, Prague
Bergamo Arte Fiera 2009, Bergamo
2007
The true men show, Galleria d'Arte Contemporanea, Castel San Pietro
2006
SS9, Galleria d'Arte Contemporanea, Castel San Pietro
2005
Italian Camera, Isola di San Servolo, Venice

Work in progress
He is currently working on the photographic representation of "very distant worlds", created in the microcosm of the camera obscura.

■ GUIDO **VAN DER WERVE**
Born Papendrecht (NL), 1977
Lives and works in New York (New York, US), Amsterdam (NL) and Finland
www.roofvogel.org

Solo exhibitions
2009
Blackbox, Hirshhorn Museum, Washington
2008
Nummer twee, La Maison Rouge - la Vestibule, Paris
Everything is going to be alright, Hayward Gallery, London
On parity of days, Kunsthalle Basel, Basel
2006
The clouds are more beautiful from above, Stedelijk Museum Bureau, Amsterdam

Group exhibitions
2009
Performa 09, New York
2008
Busan Biennial, Busan
Torino Trienniale 2, Turin

2007
Art Summer University, Tate Modern, London

Work in progress
He is working on a triptych film about the parallels between chess and piano and the perpetual nature of fleetingness.

■ MARCO **VAN DUYVENDIJK**
Born Den Helder (NL), 1974
Lives and works in Utrecht (NL)
www.marcovanduyvendijk.nl

Solo exhibitions
2008
Spring Island and other stories, Chinese European Art Center, Xiamen
2006
Marco van Duyvendijk. Portraits from Asia, Faulconer Gallery, Grinnell
Betel Nut Beauties en ander Aziatisch werk, Cokkie Snoei, Rotterdam
2005
The Chinese Rooms, Landhuis Oud-Amelisweerd, Centraal Museum, Utrecht
Mongolia, Melkweg Fotogalerie, Amsterdam

Group exhibitions
2009
The Art of Caring, New Orleans Museum of Art, New Orleans
2008
TEEN CITY. L'aventure adolescente, Musée de l'Elysée, Lausanne
2005
H x W x D. Dutch modern art from the Rabobank collection, Gemeentemuseum Den Haag, The Hague
2004
Take Five! - Huis Marseille Turns Five, Huis Marseille stichting voor fotografie, Amsterdam
2003
The First Round, Huis Marseille stichting voor fotografie, Amsterdam

Work in progress
This year he stayed one month on the Chinese Island Gulangyu, where he created a photo series inspired on the famous story *Spring-Island* (1933) by Dutch writer J. Slauerhoff. The original text and Chinese translation together with his photos were published as a book. He has completed projects in Abkhazia, Georgia, Azerbaijan and Nagorno-Karabakh.

■ MARIANNE **VIERØ**
Born Copenhagen (DK), 1979
Lives and works in Amsterdam (NL)
www.marianneviero.com

Solo exhibitions
2009
Modern Indoor Gardening, Number 35, New York
2007
Arrangements of Beautiful Resemblance, Künstlerhaus Bethanien, Berlin

Group exhibitions
2009
Rietveld Arsenale, Arsenale Novissimo, Venice
Archivio, MK Galerie, Berlin
Ung Dansk Fotografi, Fotografisk Center, København
OAOA Annual, The Oceans Academy of Arts, Amsterdam
2008
New Visions, Kunsthaus Essen, Essen
2007
Capricious, Stedelijk Museum Bureau, Amsterdam
2005
Start, Gelerie Fons Welters, Amsterdam

Work in progress
At present Vierø is researching the origins of synthetic pigments.

■ LI **WEI**
Born Hubei (CN), 1970
Lives and works in Beijing (CN)
www.liweiart.com

Solo exhibitions
2009
The amazing mirror maze of the self, Michael Schultz Gallery, Beijing
Besides Gravity, Mogadishni, Copenhagen
2008
Li Wei, Yeh Rong Jia Culture & Art Foundation, Taiwan
2006
Li Wei, 10 Chancery Lane Gallery, Hong Kong
2005
Illusory Reality, Prima Marella Gallery, Beijing

Group exhibitions
2009
Mouvement d'Art Public / Make Art Public (MAP), Canada
Incarnations, Paris-Beijing Photo Gallery, Beijing
2008
Beijing 2008, Olympic Museum, Lausanne
Body Art: New photography from China, Asian Art Coordinating Council, Denver
Drawn in the Clouds: Contemporary Asian Art, Nykytaiteen museo Kiasma, Helsinki

2007
Red Hot. Asian Art Today from the Chaney Family Collection, Museum of Fine Arts, Houston
Made in China-China art Now, Louisiana Museum, Humlebæk
Liwei Weihong Huanyan, Barbara Davis Gallery, Houston

Work in progress
A collaboration with a Chinese golf magazine, to be shot on a golf course.

■ SASCHA **WEIDNER**
Born Osnabrück (DE), 1976
Lives and works in Belm (DE) and Berlin (DE)
www.saschaweidner.de

Solo exhibitions
2009
Was übrig bleibt, Museum für Photographie, Braunschweig
Am Wasser gebaut, ZEPHYR Raum für Fotografie / Museum Weltkulturen der Reiss-Engelhorn-Museen, Mannheim
2008
bis es wehtut, Kunstverein Wolfenbüttel, Wolfenbüttel
2007
Bleiben ist nirgends, FOAM_Fotografiemuseum, Amsterdam
2005
Untold Photographie, Junge Kunst e.V., Wolfsburg

Group exhibitions
2009
Leichtigkeit und Enthusiasmus. Junge Kunst und die Moderne, Kunstmuseum Wolfsburg, Wolfsburg
until it hurts, OpeneyeGallery, Liverpool
los angeles-berlin, artHAUS2009, Los Angeles
2007
Concept: Photography – Dialogues & Attitudes, Ludwig Múzeum - Kortárs Művészeti Múzeum, Budapest
Die Liebe zum Licht. Fotografie des 20. und 21. Jahrhunderts, Kunstmuseum Bochum, Bochum

Work in progress
He is driven, constantly searching, a romantically inclined traveler, restless, as though greeting the world for the first time with a cry.
The strongest impulse in his work is his own life, an interplay of contradictions: the beautiful becomes ugly, the ugly beautiful. The romantic collides with the radical. In this way, indirectly, he generates an autobiographical chronicle, one that finds its way onto the walls as a patchwork of photographs.

■ FU **YUZHU**
Born Harbin (CN), 1978
Lives and works in Shenyang (CN)

Group exhibitions
2007
Seasonal Disease, Art Space, Shenyang
2006
Lianzhou International Photo Festival 06, Lianzhou

Work in progress
The artist is working on *Childhood*, *The Generation of Idol*, *Baby doll in the Industrial Society*.

■ DARIUS **ŽIŪRA**
Born Joniškėlis (LT), 1968
Lives and works in Vilnius (LT)

Solo exhibitions
2007
Collection, Antje Wachs Gallery, Berlin
2005-2006
Portraits, Šiuolaikinio meno centras, Vilnius
2005
Altre voci, altre stanze / Other Voices, Other Rooms,
Magazzino d'Arte Moderna, Rome
Arrivals>Lithuania, Turner Contemporary, Margate

Group exhibitions
2008
Manifesta 7, Trentino and Südtirol
Eurasia. Dissolvenze geografiche dell'arte, Museo d'Arte
Moderna e Contemporanea di Trento e Rovereto,
Rovereto
North by North-East: The Continental Unconscious,
Eesti Kunstimuuseum, Tallinn
2004
Manifesta 5, Donostia-San Sebastian
*Instant Europe. Photography and Video from
the New Europe*, Villa Manin, Codroipo
2001
ARS 01, Nykytaiteen museo Kiasma, Helsinki

Work in progress
He is currently working on a series of portraits
of women who have involuntarily become
sex workers. The images are pronouncedly frontal
and impersonal portraits, depicting the subjects
in everyday dress and with neutral facial expressions.